At a Distance

LEONARDO

Roger F. Malina, series editor

The Visual Mind, edited by Michele Emmer, 1993

Leonardo Almanac, edited by Craig Harris, 1994

Designing Information Technology, Richard Coyne, 1995

Immersed in Technology: Art and Virtual Environments, edited by Mary Anne Moser with Douglas MacLeod, 1996

Technoromanticism: Digital Narrative, Holism, and the Romance of the Real, Richard Coyne, 1999

Art and Innovation: The Xerox PARC Artist-in-Residence Program, edited by Craig Harris, 1999

The Digital Dialectic: New Essays on New Media, edited by Peter Lunenfeld, 1999

The Robot in the Garden: Telerobotics and Telepistemology in the Age of the Internet, edited by Ken Goldberg, 2000

The Language of New Media, Lev Manovich, 2000

Metal and Flesh: The Evolution of Man: Technology Takes Over, Ollivier Dyens, 2001

Uncanny Networks: Dialogues with the Virtual Intelligentsia, Geert Lovink, 2002

Information Arts: Intersections of Art, Science, and Technology, Stephen Wilson, 2002

Virtual Art: From Illusion to Immersion, Oliver Grau, 2002

Women, Art, and Technology, edited by Judy Malloy, 2003

Protocol: How Control Exists after Decentralization, Alexander R. Galloway, 2004

At a Distance: Precursors to Art and Activism on the Internet, edited by Annmarie Chandler and Norie Neumark, 2005

At a Distance

Precursors to Art and Activism on the Internet

Edited by Annmarie Chandler and Norie Neumark

The MIT Press Cambridge, Massachusetts London, England

This book was set in Garamond 3 and Bell Gothic by Graphic Composition, Inc. Printed and bound in the United States of America.

Library of Congress Cataloging-in-Publication Data

At a distance : precursors to art and activism on the Internet / edited by Annmarie Chandler and Norie Neumark
 p. cm. — (Leonardo)
 Includes bibliographical references and index.
 ISBN 0-262-03328-3 (hc.: alk. paper)
 1. Art and telecommunication. 2. Art, Modern—20th century. 3. Art and society.
I. Chandler, Annmarie. II. Neumark, Norie. III. Leonardo (Series) (Cambridge, Mass.)
N72.T45A86 2005
709'.047—dc22 2004057856

10 9 8 7 6 5 4 3 2 1

To Evelyn Novick Neumark and Val Chandler

Contents

SERIES FOREWORD ix

FOREWORD, *Joel Slayton* xi

ACKNOWLEDGMENTS xiii

INTRODUCTION: RELAYS, DELAYS, AND DISTANCE
ART/ACTIVISM, *Norie Neumark* 2

I Critical Perspectives on Distance Art/Activist Practices **26**

1. INTERACTIVE, ALGORITHMIC, NETWORKED: AESTHETICS OF
 NEW MEDIA ART, *Johanna Drucker* 34

2. IMMATERIAL MATERIAL: PHYSICALITY, CORPORALITY, AND
 DEMATERIALIZATION IN TELECOMMUNICATION ARTWORKS,
 Tilman Baumgärtel 60

3. FROM REPRESENTATION TO NETWORKS: INTERPLAYS OF
 VISUALITIES, APPARATUSES, DISCOURSES, TERRITORIES
 AND BODIES, *Reinhard Braun (Translated by Cecilia White)* 72

4. THE MAIL ART EXHIBITION: PERSONAL WORLDS TO
 CULTURAL STRATEGIES, *John Held, Jr.* 88

5. FLUXUS PRAXIS: AN EXPLORATION OF CONNECTIONS,
 CREATIVITY, AND COMMUNITY, *Owen F. Smith* 116

II Artists/Activists Re-view Their Projects **140**

6. ANIMATING THE SOCIAL: MOBILE IMAGE/KIT GALLOWAY
 AND SHERRIE RABINOWITZ, *Annmarie Chandler* 152

7. AN UNSUSPECTED FUTURE IN BROADCASTING:
 NEGATIVLAND, *Don Joyce* 176

8. MINI-FM: PERFORMING MICROSCOPIC DISTANCE (AN E-MAIL
 INTERVIEW WITH TETSUO KOGAWA), *Tetsuo Kogawa with
 Annmarie Chandler and Norie Neumark* 190

9. FROM THE GULF WAR TO THE BATTLE OF SEATTLE:
 BUILDING AN INTERNATIONAL ALTERNATIVE MEDIA
 NETWORK, *Jesse Drew* 210
10. *THE FORM: 1970–1979* AND OTHER EXTEMPORANEOUS
 ANOMALOUS ASSEMBLINGS, *Melody Sumner Carnahan* 226
11. NETWORKED PSYCHOANALYSIS: A DIALOGUE WITH ANNA
 FREUD BANANA, *Craig Saper* 246
12. FROM MAIL ART TO TELEPRESENCE: COMMUNICATION AT A
 DISTANCE IN THE WORKS OF PAULO BRUSCKY AND EDUARDO
 KAC, *Simone Osthoff* 260
13. DISTANCE MAKES THE ART GROW FURTHER: DISTRIBUTED
 AUTHORSHIP AND TELEMATIC TEXTUALITY IN *LA PLISSURE
 DU TEXTE, Roy Ascott* 282
14. FROM BBS TO WIRELESS: A STORY OF ART IN CHIPS,
 Andrew Garton 298
15. *REALTIME* — RADIO ART, TELEMATIC ART, AND
 TELEROBOTICS: TWO EXAMPLES, *Heidi Grundmann* 314

III Networking Art/Activist Practices **336**
16. *ESTRI-DENTISTAS:* TAKING THE TEETH OUT OF FUTURISM,
 María Fernández 342
17. COMPUTER NETWORK MUSIC BANDS: A HISTORY OF THE
 LEAGUE OF AUTOMATIC MUSIC COMPOSERS AND THE HUB,
 Chris Brown and John Bischoff 372
18. ASSEMBLING MAGAZINES AND ALTERNATIVE ARTISTS'
 NETWORKS, *Stephen Perkins* 392
19. THE WEALTH AND POVERTY OF NETWORKS, *Ken Friedman* 408

Contents

20. FROM INTERNATIONALISM TO TRANSNATIONS: NETWORKED
ART AND ACTIVISM, *Sean Cubitt* 424

CONCLUSION, *Annmarie Chandler and Norie Neumark* 438

TIMELINE 444
LIST OF CONTRIBUTORS 470
INDEX 476

Series Foreword

The cultural convergence of art, science, and technology provides ample opportunity for artists to challenge the very notion of how art is produced and to call into question its subject matter and its function in society. The mission of the Leonardo book series, published by The MIT Press, is to publish texts by artists, scientists, researchers, and scholars that present innovative discourse on the convergence of art, science, and technology.

Envisioned as a catalyst for enterprise, research, and creative and scholarly experimentation, the book series enables diverse intellectual communities to explore common grounds of expertise. The Leonardo book series provides a context for the discussion of contemporary practice, ideas, and frameworks in this rapidly evolving arena where art and science connect.

To find more information about Leonardo/ISAST and to order our publications, go to Leonardo Online at <http://mitpress.mit.edu/e-journals/Leonardo/isast/leobooks.html> or send e-mail to <leonardobooks.mitpress.mit.edu>.

Joel Slayton
Chair, Leonardo Book Series
Book Series Advisory Committee: Annick Bureaud, Pamela Grant Ryan, Craig Harris, Margaret Morse, Michael Punt, Douglas Sery, Allen Strange

Leonardo/International Society for the Arts, Sciences, and Technology (ISAST)

Leonardo, the International Society for the Arts, Sciences, and Technology, and the affiliated French organization Association Leonardo have two very simple goals:

1. to document and make known the work of artists, researchers, and scholars interested in the ways that the contemporary arts interact with science and technology, and

2. to create a forum and meeting places where artists, scientists, and engineers can meet, exchange ideas, and, where appropriate, collaborate.

When the journal *Leonardo* was started some thirty-five years ago, these creative disciplines existed in segregated institutional and social networks, a situation dramatized at that time by the "Two Cultures" debates initiated by C. P. Snow. Today we live in a different time of cross-disciplinary ferment, collaboration and intellectual confrontation enabled by new hybrid organizations, new funding sponsors, and the shared tools of computers and the Internet. Above all, new generations of artist-researchers and researcher-artists are now at work individually and in collaborative teams bridging the art, science, and technology disciplines. Perhaps in our lifetime we will see the emergence of "new Leonardos," creative individuals or teams who will not only develop a meaningful art for our times but also drive new agendas in science and stimulate technological innovation that addresses today's human needs.

For more information on the activities of the Leonardo organizations and networks, please visit our Web site at <http://mitpress.mit.edu/Leonardo>.

Roger F. Malina
Chair, Leonardo/ISAST

ISAST Board of Directors: Martin Anderson, Mark Resch, Ed Payne, Sonya Rapoport, Stephen Wilson, Lynn Hershman Leeson, Joel Slayton, Penelope Finnie, Curtis Karnow, Mina Bissell, Beverly Reiser, Piero Scaruffi

Foreword

Joel Slayton

A consequence of the transformative nature of information technology is a forgetting of the past. Memories drift, transform, and become more distant over time.

At a Distance: Precursors to Art and Activism on the Internet, edited by Annmarie Chandler and Norie Neumark, examines the non-neutrality of using and interacting with information as media. More precisely the collection is about the memories of theorists and artists-theorists about experimental projects in 1970s and 1980s that employed the technologies of distance media to enable *new* forms of participation and distribution. Annmarie Chandler and Norie Neumark reflect on how distance maps connections and social spaces that enabled alternative trajectories of artistic practice to be shaped around conceptions of information as experience. The collection of essays and commentaries critically recall specific enactments of art's relationship to activism that serve to illustrate the multiplicity of ideas and practices that occurred in different situations and contexts. *At a Distance: Precursors to Art and Activism on the Internet* exposes the tensions between emerging forms of new media, activism, and creative practice that ultimately feed the operative frameworks for Internet exploration by contemporary artists. Annmarie Chandler and Norie Neumark sucessfully convey the complexities of this often forgotten past.

Invaluable to artists and scholars, the collection of essays operates as examples of social relations, collaborations, cultural strategies, and economic and political concerns that typify the changing aesthetic considerations of the times. The essays offer analyses of the interlacing concerns of artists and activists and their attempts to address an escalating attention economy

dependent on information as experience. Conventional conceptions of the immateriality of information, the dissolving relationship of author/audience, the paradigm of interiority/exteriority, and the relativism of object/subject relations are critically examined. By reflecting on the past to expose the present, *At a Distance: Precursors to Art and Activism on the Internet* contains a diverse set of discussions that together illuminate the strategies of *distance* as precursor to cultural producton involving the Internet. There is no single thread, no single theory, and no set of observations to be generalized from this text. Rather, the interrelated discourses provide a historicism of the methods and motivations of an era of artists and activists, the tension between them, and the implications of their actions. Contributing authors include Roy Ascott, Tilman Baumgärtel, John Bischoff, Reinhard Braun, Chris Brown, Melody Sumner Carnahan, Sean Cubitt, Jesse Drew, Johanna Drucker, Maria Fernández, Ken Friedman, Andrew Garton, Heidi Grundmann, John Held, Jr., Don Joyce, Tetsuo Kogawa, Simone Osthoff, Craig Saper, and Owen F. Smith.

Within this collection we find not only precursors to the present but trajectories for the future. As the attention economy continues to transform through the introduction of media technology, new subjectivities necessarily arise. Simulation, ubiquitous computing, interactive media, knowledge engineering, virtuality, distributed networks, and the promise of artificial intelligence will no doubt add to the consequences of dramatic epistemological change. As this *new* media is redefined within frameworks of autonomy and protocol, it is not surprising that a profound challenge to our humanity arises: the challenge of participation. *At a Distance: Precursors to Art and Activism on the Internet* asserts this anticipation by foregrounding collaborations and collectives of the immediate past. The Leonardo Book Series is pleased to include *At a Distance: Precursors to Art and Activism on the Internet,* edited by Annmarie Chandler and Norie Neumark.

Acknowledgments

In many ways this book has been possible because of the rich history of distance art and activism in Australia, where distance has long been a vital concern for artists and theorists. The strong research and collegial culture at the University of Technology, Sydney, has also fostered and nourished this project from its inception. We would like to thank Paul Ashton, Ross Gibson, Liz Jacka, Joyce Kirk, and Stephen Muecke, for both intellectual engagement and practical support. In particular, we would like to acknowledge one of our colleagues, Douglas Kahn, who had a most valuable role with the conceptual directions of the early stages of the project, before taking up his appointment to the University of California, Davis, in 2001. Doug generously contributed his extensive knowledge of the media arts, editorial experience, and enthusiasm for the project. His assistance with identifying and approaching many of the authors was also invaluable.

We would like to thank the contributors, who of course are the heart of the book. Working with us, at a physical distance for most, has not always been easy. For many of the artists it involved a complex process of searching for, collecting, and revisiting archival material. They had to fossick for work among unpublished and undocumented projects dating back 25 to 30 years. As with all the contributors, their perseverance and engagement with the project has been outstanding, and their generosity in sharing their ideas, archives, and self-reflections has been remarkable.

Melanie Swalwell also contributed valuably to the project with her thoughtful preparation of the timeline. August Black generously provided assistance with final stages of translations of German text.

We are particularly grateful to our editors at MIT. Doug Sery provided astute and sensitive advice and encouragement. Deborah Cantor-Adams and Michael Harrup read the final manuscript with great care and insight. Valerie Geary gave invaluable and patient organizational assistance.

Finally, we would like to gratefully acknowledge our partners, Alan Swanton and Maria Miranda, for their profound engagement with the project and for their intellectual and personal support.

At a Distance

Introduction:
Relays, Delays, and Distance
Art/Activism

Norie Neumark

Distance is . . .

In the second half of the twentieth century, artists turned communication media into their art media. At that moment art, activism, and media fundamentally reconfigured each other—at a distance. The projects they engaged with ranged from mail art to radio art to satellite art and beyond and between. This book focuses mainly on experimental projects of the 1970s and 1980s, the period of intense and extensive activity in what we are calling distance art/activism.

Distance is always multiple and relative in its configurations. It is colored by geography, technology, temporality, emotion; or it may reference the gap, space, or interval between two points, lines, or objects. The authors in this book write at all these distances: geographically—from each other; temporally—from their objects of study; and emotionally—as some write about practices they were intimately engaged with and others engage in more critical overviews. And the gaps, spaces, and intervals within and among their practices further shape the meanings of art and activism at a distance.

In the chapters that follow, there is no single approach. In certain ways the book's project is Foucauldian: an attempt to work with archives and to understand the discourses that shaped and were shaped by artistic and activist practices. In other ways it is Deleuzian: a multiplicity of engagements, which open up lines of flight, to the rich potentiality of the virtual. But it should be noted that most of the authors are not necessarily "into" Deleuze or Foucault themselves. They engage with their material and with each other in provocative rather than uniform ways. Some contributors write as theorists, some as artists who were directly involved, and others as artist/theorists— discussing distance art and activist projects and their attendant discourses and cultures. What holds them together in this collection is not a single perspective, but their force and their singularity, as well as their shared concerns and themes: communication, activism, art, collaboration, performativity, and, of course, distance. The differing contexts and engagements with these concerns are what create in this collection a productive tension befitting distance art and activism.

As editors, we have sought to distance this project from the all-consuming pull of the Internet with its presentness and presence. Instead we focus on the preceding period of distance art. While the Net continues to raise concerns for artists, communities, media, and publics, our aim here is to widen the field of questioning. Thus this book is not a "history," in the

sense of primarily reading backward from Internet practices and ideas, or even a genealogy that will let us see how the Internet came about. Rather it engages with the practices and ideas of the Net's precursors, as much as possible in their own terms, to open up new trajectories that may intersect with current practices and concerns but may also touch upon other possibilities.

Rather than try here either to "represent" all the authors' views and approaches or to repeat the artistic, social, and political contextualizing that they provide, my aim is to introduce and locate some of the issues and practices that weave through the book. At the end of this introduction, I will outline the shape of the book and signal the significance of its contributions for students, artists, activists, and scholars. But before turning to the book's key issues, I will begin on a more theoretical register by delving into the world of envelopes and exploring the postal. What I will suggest is that the postal system provides provocative and relevant technological contexts and discourses. Although electronic projects, playing on the border of materiality and immateriality, would engage with a number of very different issues, nonetheless, the postal system and envelopes in particular open up some significant concerns for distance art and activism that did not magically disappear with the electromagnetic age.

For me an interest in the envelope began with the noisy, and personal, story of the envelope machine. My grandfather, who refused his destiny as a tailor and became an engineer, used his knowledge of sewing machines to invent scores of envelope machines for a New York firm at the turn of the twentieth century. He left his family several volumes of his patents, and as a child I was amazed that such a big and noisy machine could do something so intricate as folding an envelope; as an adult, I was fascinated by the complex drawings and specifications of the patents (figure 1). Recently these noisy envelope machines inspired me to research the genealogy of e-mail. I was interested in how we have been delivered from the noise, materiality, and emotionality of mail (noisy envelope machines, unpredictable postal deliveries, the careful reading of letters) to the speed, instrumentalism, and informationality of e-mail. It was during this research that I first seriously explored Mail Art. At the intersection of communication art, Fluxus, and what Craig Saper has elsewhere analyzed as intimate bureaucratic art practice,[1] Mail Art envelopes, packages, and events seemed more than prescient. They not only expanded the boundaries of art, media, and communication, they defi(n)ed them. They traveled not as vehicles, but as meaningful cultural and artistic

Fig. 3

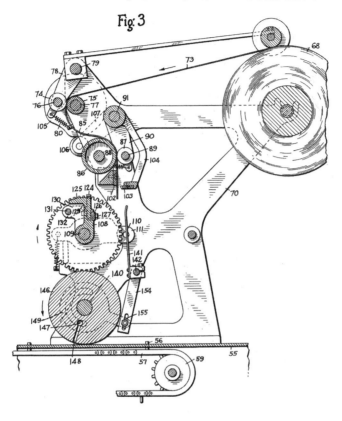

Figure 1 A. Novick, "Making Envelopes and Machine Therefor." Patent, Oct. 13, 1931.

objects, while shifting the meanings of culture, communication, and art objects in their journeys. The journeys of Mail Art marked a particular configuration of geography and social, economic, and cultural relations; they contributed to a remapping of the relation between art and everyday life.

Relays, delays, and . . .

Envelopes are emblematic of a number of the complex objects and practices that concern this book. I am focusing on envelopes here because of this emblematic, even mythical quality, rather than to suggest that they contain

some singular key to art at a distance. Envelopes are material objects that straddle communication and art, that relay between artists and activists, at a distance. And it is distance that gives them their intensity and energy rather than being simply erased by their movement. As containers, envelopes fold inside into outside, public into private. They are an affective and material point of contact—part closing and barrier, part opening—a site at which the public and private fold into one another. They hold out promise and uncertainty. Stuffed full with rich artistic, cultural, emotional, and economic history, envelopes are also part of the everyday that we take for granted—the sort of taking for granted that most art at a distance would disrupt. Envelopes also map distance in ways that reflect and create media discourse and individual subjectivities, according to Bernhardt Siegert's *Relays: Literature as an Epoch of the Postal System.* Siegert, sharing Friedrich Kittler's attention to the material basis of the media, made his study of literature and communication "from the perspective of postal strategies."[2]

Relays details how at first the postal system produced the individual, whose soul, with its "'irresistible desire to communicate oneself'" was the "origin" of letters.[3] According to Siegert, in its next epoch, the postal system became tied up with biopolitics and policing:

Generally speaking, the will to monopolize the means of discourse processing was one of the phenomena called forth by a particular innovation near the end of the sixteenth century. That innovation, after which the postal system began to exist only in the form of bio-politics, marked the beginning of the modern period itself in terms of information economy: the invention of postage. . . . After the linkage between state power and the behavior of the population had been established in matters of postage, the postal system could be understood only as a subsystem within such a network of relations. It therefore became obvious that the postal system was an institution of the police. . . . The goal of the postal system was to ensnare people in discourse.[4]

Siegert argues that the most recent, and final, postal epoch was the "economy of the medium."[5] The ground of the postal system was no longer external, be it individual or state; but instead the postal system became a closed system of communication in which the intentions of sender and receiver are irrelevant: "These differences were integrated into a general model of communication by Claude Shannon so that he might disregard both data sources and

destinations—such as humans who transmit messages and other humans who understand them—as factors in the mathematical theory of communication."[6]

According to Siegert, it was the standard penny postal system that initiated and stamped its signature on this final postal epoch, on Shannon, and on communication. This was because the system operated for all possible letters, not just those that had actually been written.[7] This penny postal system in turn relayed a change to the character of distance. Distance had been at the heart of the letter when it was distance that had determined the costs of posting (through a complex systems of rates that were based on locations and miles).[8] The penny postage stamp, on the other hand, delivered an "eradication of all the territorial markers and individual names that once had defined the exchange of letters, the removal of the world from the postal system (and the elimination of its distances)."[9] The prepayment represented by the penny postage stamp, along with its requisite prior standardization of the data, meant that a media rationality began to pervade the culture. As Siegert argues, this meant that people, bodies, discourses, and numbers became data—before the electric age.

If the penny postage stamp could be seen to initiate, as well as symbolize, this change, it is not surprising that stamps have attracted so much attention among Fluxus and Mail Artists, as a number of the essays that follow allude to. Yet was distance so fully eradicated from penny-posted mail as Siegert intimates? Do changes at the interface of technology and culture ever happen so abruptly and totally? I would suggest that the distance aspect of mail still endured and was, indeed an intimate provocation to artists. Mail continued to operate at a junction between fascination with distance, which called forth its communication, and the irrelevancy of distance, which it helped to produce. It was contradictions and disjunctions like this that helped fuel the interest of Mail Artists, along with other distance artists.

So although the technologies of penny post may have fundamentally altered the specificities of the geographical distances that envelopes travelled, I am suggesting that paradoxically geographical distance still mattered, both on its own and in its articulation with an emotional and temporal distance. Media technologies like the penny-posted envelope constantly dissolved distance, but in so doing, in bringing distance forward, they simultaneously reasserted distance (as it waits and needs to be dissolved). Although many might imply, from McLuhan to Virilio, that speed eliminates or implodes time and space, what distance art suggests is a paradoxical relation among

speed, time, space, and art. If we remember that in German the word for *delivery* also means *blockage*,[10] we are alerted to the emotional temporality of waiting, as the key mode of the envelope. The envelope's moments of waiting and unreliability, which are as essential as those of on-time delivery, are also amplified by affection. It is no surprise, then, that Jacques Derrida's extended love letter (*The Post Card*) is obsessed with the question of an undelivered letter. Nor is it unexpected that "we" never receive an answer from Derrida's correspondent at all. No closure in these envelopes, no unity of sender and receiver in the economy of waiting. It has often been suggested that the logic of distance artworks like Mail Art is a gift logic; however, they might better be thought of as gifts that inherently do not arrive, gifts for which one always waits. Indeed, for Derrida, the *envoi,* the sending, is always the gift of sending, which recalls Heidegger's destining, attending to, awaiting.[11]

Envelopes can also be understood as a point of relay, a point of social and economic and technical connection and communication, but one that is not transparent and smooth: "The relay is not only the nexus of power in the economies of transport and circulation but also potentially the least secure point in the entire communications system."[12] Derrida, still pondering that envelope that went awry, wrote,

To post is to send by "counting" with a halt, a relay, or a suspensive delay, the place of a mailman, the possibility of going astray and of forgetting (not of repression, which is a moment of keeping, but of forgetting). . . . [A]s soon as there is, there is *différance* . . . and there is postal maneuvering, relays, delay, anticipation, destination, telecommunicating network, the possibility, and therefore the fatal necessity of going astray, etc.[13]

The phone, too, would be such a relay point, in the electronic realm, a point of connection and transfer, and also a possible site of e/motional blockage: the call that is not answered, the static on the line.[14] For Derrida, what animated both phone calls and letters was "noncommunication and misunderstanding," along with or perhaps because of chance and luck.[15] As it turns out, communication artists and activists were on the same line; they were enticed and frustrated by these very same things. And although delay, waiting, and noise—as well as chance and luck—had been integral to postal communication, their particular inflection with electromagnetic communica-

tion would take distance artists to new adventures, now on the boundaries of immateriality. For many, immateriality would become a crucial concern and desire, even if one they could not yet technically satisfy. No doubt the impossibility of technical satisfaction fueled artistic adventures with immaterial—to some, even magical—media. As Avital Ronell noted, there was an important connection between magic, media, and technology. In *The Telephone Book*, for example, she points to the sense(s) of magic in the history of the invention of the telephone, with its ghosts in the ether, its static and noise, and its indeterminacy.[17] And whereas on the one hand, these qualities led nineteenth-century science to separate itself from the magic of technology,[18] on the other hand, twentieth-century artists' engagement was incited by static, noise, and delay.

Siegert also notes that in the "final postal epoch," the "economy of the medium," noise was important. In information theory, for example, information itself was understood as inseparable from noise—as an inevitable and foundational part of communication:

In the noise on the channels or in the crosstalk of the networks, communication is founded and founders. . . . [C]ommunication is the presence of a Third, the presence of a parasite, as the French translation of "noise" signifies, which could be an enemy or death (loss of information, thermodynamic disintegration). Just as a roll of the dice never eliminates chance, a signal never can eliminate noise.[19]

It should be remembered that it was this noisy, even paradoxical, quality that would fascinate the distance artists who worked with information, rather than the clean, fast, transparent information that we would come to know on the information superhighway of the nineties.

Troubling media technologies . . .

I'll turn to Siegert for a final time to discuss pulse code modulation (PCM), which was developed at Bell Labs in the United States during World War II and then achieved practical importance in the late 1960s with transistors.[20] PCM is one of the many technologies important in communication and media that had their origins in the military. The fact that the state and the military play a crucial role in the invention and development of the Internet has by now become an established, though still difficult, truism. And it was no less troubling and paradoxical for the distance artists and activists in this

volume that the state and military played a similar role in the media technologies that were their medium.

PCM, an important transitional technology, works digitally to transmit analog data using binary signals. Before PCM, geographical distance was significant in electronic communication because in "conventional electrical systems of transmission, the distance of transmission still had played an extremely important part, since the noise produced by relays was cumulative"; PCM, like penny postage, according to Siegert, "negated space."[21] And perhaps it was this moment, the dying of transmissional distance, that made distance so palpable and so desirable for artists and activists. This is again the paradox of distance in distance art of this period: While on the brink of losing its geographical significance, distance became all the more emotionally significant.

A troubling relation between technology and culture is, of course, not limited to media technologies, which need to be understood in their broader context. The projects and authors in this volume understand technology in varying ways, so it is not appropriate to impose a singular definition or theory here, or to engage with the more intricate philosophical questions concerning technology. I will offer, instead, a few broad observations that hopefully apply for all the varying approaches in the chapters that follow. Technology embodies social relations, including cultural, aesthetic, economic, and political relations. These relations construct technology, affecting its shape and content and power. What is possible in technology depends on the particular cultural imagination and individual subjectivities, while in turn cultural imagination and individual subjectivity are produced by these technologies. Further, technology itself can have an imaginary aspect, inciting metaphor, affect, and discourse. Technology can thus be a major cultural signifier, as it was for modernism and "the future" in the twentieth century. These cultural and "imaginary" significations of technology in turn inflect everyday and artistic experiences of technology.

Technology thus always/already perpetuates the relations that construct it. And when people use, interact with, or connect with technology, it is not some culturally neutral act. Rather they are engaging with "embodied" social relations, and this engagement in turn (re)constructs their subjectivity. This intricate and intimate articulation of culture and technology, the impossibility of a neutral or transparent sense of media technologies, was implicit and explicit in distance art and activism. And, it must be emphasized,

it was this, rather than technology per se, which was of prime concern to the projects and authors in this book.

The past of the future . . .

Moments of significant technological change affected art and politics in the twentieth century well before the period of distance art/activism that this volume addresses. These played out differently in different national and local contexts, so it is impossible to make a generalization that encompasses all the contexts that contributors address in the chapters of this book. I will choose one example, both because it was a precursor to distance art and activism and because it unfolded so differently in different contexts.

Futurism, as is well known, was fascinated with technology, and indeed, technological change was crucial in the disruptions that gave birth to its various incarnations. As the diverse local histories of Futurism suggest, technological change did not have its radical effects in some universal way: politics, economics, aesthetics, and sex and gender issues played out very differently. Thus, in a revolutionary moment, in Italy and Russia, technological change inspired avant-garde and groundbreaking artistic energy; but in the fascist context this energy was nostalgically recuperated to exalt the aesthetics of death and destruction.

In the early years of the Soviet Union, on the one hand, Futurist artists and poets, like Vladimir Mayakovsky, played a significant role in the "network" of agitprop trains and boats that took radical performance and publication, filmmaking and film screening, across vast geographic, aesthetic, cultural, and class distances.[22] On the other hand, as capitalism and religion regained their foothold in Italy, the Futurist excitement, noise, and anarchy gave way to Fascist media recuperations, such as with radio and amplification. The latter media technologies gave Fascism a voice: loud, masculine, and intimate (in penetration), omnipresent and exhorting. This quality of voice made it easier to hold together contradictory ideologies (such as violent and revolutionary change along with disciplined order and national unity; nostalgia for the past and avant-garde radical change; capitalist development with antibourgeois sentiments).[23]

As the chapters in this volume indicate, the local contexts for technological change in the second half of the twentieth century were also varied. In many places in the "West," it was another era of "the future," as proclaimed through industrial developments and scientific and technological change.

The promise of the future was so pervasive in everyday life that avant-garde "Futurism" was overtaken by the everyday commodifications and achievements of a capitalist "future." For many of the projects discussed in this book, these commodifications provided a crucial impetus to their work, in a way that inextricably folded art into activism.

Questioning communication, activism, and art . . .

I'll turn now to some of the particular questions shared by this book's projects, beginning with the key terms of communication, activism, and art. One of the distances that most of these projects proclaimed was from fine art, some going as far as to merge life and art, others to abandon art. This was a direct challenge to fine art and its institutional discourse. In this challenge, there were precursors to these precursors, such as Dada, which raised many of the same concerns and advanced many of the same methods and techniques as some of these distance artists. At issue were not just fine arts debates, however, but also their interlacing with economic issues and political structures. Many artists were concerned more with challenging the institutions not (just) of art, but of communication, from the mail system, to publishing, to radio and television.

This challenge to the institutions of communication was a nodal point of connection between artists and activists and for this book. It is one of the points at which the approach of even the most actively political projects discussed in subsequent chapters is better understood as artist/activist or activist/artist rather than just activist. It is for this reason that in this introduction, I move among the terms *artist, activist,* and *artist/activist.* A crucial concern for all was always to play with or trouble the "communication" medium in which they worked. It should be remembered, too, that to be involved with communicating for artistic concerns, to play with communications technologies and bureaucracies, as artists or artist/activists in various new groupings and configurations is very different from operating within information industries. The artists, even the most activist of them, were not seeking some transparent version of communication. Artists working with and using communication media and networks brought with them an awareness of their medium. And although the information age was then in its early days and information was already a direct concern for some, these artists were not turning on some electric light of pure information as a "medium without a message."[24]

It was in 1964 with *Understanding Media* that McLuhan produced his breathless and breathtaking analysis of the cultural and emotional climate of the media and worked to alert the general public to the ways that different media configured the senses as the source of their effects. Meanwhile, distance artists had already begun producing work with the media, sometimes with interest in the senses, often with a conceptualist approach, and usually with broader social, and cultural concerns. In his seminal text *Networked Art,* Saper analyzed these concerns and these works as sociopoetic, in that "the social situations . . . function as part" of the work, as, indeed, the "canvas."[25] He discussed, for instance, "the resistance of assemblings to the levelling power of mechanical and electronic reproduction, even as they make use of these mechanisms."[26] Sociopoetic works were, according to Saper, interactions among publication and distribution systems, communities of participants and poetic artisanal works. They challenged origin and originality in a way that of course upset the art marketplace and social world. This also meant inherent unresolved conflicts.[27] Sociopoetic approaches to the "object" were shaped at a moment at which the media, as art's media, both threatened to impose a universality yet also promised new artistic and political possibilities that activists, artists, and artist/activists felt impelled to explore.

The art "object," with its aura and individualism, was thus again entering a tension with media, now exacerbated by the sameness and universality of electronic communication's data. Dick Higgins un/categorized as "intermedia" those works that were open, tentative, and challenging to a medium— those that were located "in the field between the general area of art media and those of life media."[28] Distance art that was primarily concerned with real objects and everyday life commented and problematized rather than re-presented (unlike Pop), according to Higgins's schema:[29] "the focus has come off the individual and his identity . . . [and] off the emphasis on new means of perception. . . . It came to be, instead, on the object qua object . . . the process as process, accepting reality as a found object, enfolding it by the edges, so to speak, without trying to distort it (artistically or otherwise)."[30] Thrown into a new world by art at a distance, the object was often now also edged to the limens of materiality and immateriality. This strange liminal existence was parallel to Higgins's intermedia, which were not about the fixities of medium specificity but were "between media."[31]

Betweenness is a useful concept also for thinking about the relation of distance art to questions of communication. The idea of communication was

obviously a major issue for distance artists, though to varying degrees depending in part on their activist bent. Nonetheless it would be a mistake to assume that it was ever necessarily straightforward. As Douglas Davis said, "I don't believe in communication I believe in the great adventure of attempting communication, especially over great distances."[32] Part of this adventure was the engagement with technology itself. With the technology as their canvas, distance artists operated between or outside the form and content divisions that McLuhan, for instance, saw as misunderstanding the everyday media.

The context for this remediation of the art object was the wider political, cultural, and artistic moment of the late 1960s, 1970s and 1980s, a moment that some have claimed as the beginning of postmodernism in the West and others as the reassertion of an other avant-garde modernism, founded in Dada and Futurism and othered by the hegemony of formalist and transcendental modernism.[33] In particular, Conceptual Art or conceptualism was an important artistic context for distance art/activism, as a number of the essays in this volume discuss. Without entering here debates about art movements of the period, and without delineating the important national and local differences and specificities, what is important for this collection is the putting into question of the object.[34] This was in part a rejection of the art object as commodity in the official art world and market. In the United States, this rejection was a political belief in "the ability of a 'dematerialization of the art object' to subvert the commodity status and political uses to which successful American art had been subjected," as Lucy Lippard later reflected.[35] Meanwhile, "[I]n Europe in the climate of '68 the critique of the Abstractionist object was identified with the Marxist critique of fetishism, or with the Situationist critique of spectacle," according to Charles Harrison of Art & Language.[36] As Henry Sayre says of American avant-garde art since 1970—in a comment applicable to many distance art/activist projects—it is "always in process, always engaged . . . undecidable. Its meanings are explosive, ricocheting and fragmenting throughout the audience. The work becomes a situation, full of suggestive potentialities, rather than a self-contained whole, determined and final."[37] The object in distance art/activist projects was, in this sense, re-jected rather than rejected: put into a productive tension of disappearing more than made finally to disappear. Some might link this tendency in the postwar art world largely with Antonin Artaud and the Artaudian primacy of the "jet (sub-ject, ob-ject, pro-ject etc.),"

as does Edward Scheer, for instance. Following Derrida, who d(e)rives the Artaudian jet from "the drive itself . . . the force of the drive . . . the compulsion and the expulsion . . . the force before the form," Scheer finds at the core of the jet "a rejet (reject/rejection) which never stops disturbing the frames of the aesthetic."[38] The effect of the re-jection of objects was an assertion of art's historicity and indeterminacy.

The authors in this volume collectively suggest just such an undecidability that mitigates against a need to re/categorize objects and media or to resolve the tensions among communication, activism, and art. And significantly, collectively is the way many of the distance art projects themselves spoke. Collaboration and networks were crucial, sometimes as articulations of activism, sometimes as an art practice, and usually as an indeterminate interplay of both. The collaboration and networking were not just a means but, again, a medium or canvas.[39]

Performing collaborations . . .

Performance, one of the collaborative strategies of rethinking the object, enacted art's contingency, multiplicity, and polyvocality—what Derrida calls "undecidability"—to indicate "the condition of conflict and contradiction which presents no possible 'solution' or resolution."[40] With performance the work was located in the audience. Again this strategy was not limited to distance art but was influenced, especially in the United States, by the collaborations and intermedia of John Cage, Robert Rauschenberg, and Merce Cunningham, and at a distance, by Futurism and Dada, Bauhaus, and Surrealism.[41] As always, it must be remembered that movements and approaches such as these were inflected by local contexts, as the chapters in this volume elaborate.

Another point of undecidability for many was the issue of amateur/professional, which necessarily arose in many collaborative and iconoclastic undertakings, even though it was not necessarily central for all.[42] Higgins reflected on it as "amateurism" rather than "amateurishness."[43] In one sense this is better understood through performativity, more than through performance, which played a part in most of these projects, whether they focused on performance per se or not. Performativity meant a self-conscious awareness of mutually produced meanings, meanings that arose in the moment of performing connection—in the making and the sending and receiving. These meanings were not those sanctioned by art markets, capitalism, and

the academy; indeed, they disrupted all of these. They were not fixed, they were fluid, in flux. In the twilight of the hegemony of formalist modernism and abstractionism, they are a foreshadowing, perhaps an ushering in of the unsettling of truth effects and the centered individual that came to the fore with the "other" modernism of postmodernism. Peformativity is also a reminder of the body, another of postmodernism's "discoveries." The distance that defined these projects did not reject the body as we might now imagine; indeed, for some, engaging with art, body, and distance was a motivation to their work. Although it may have been more foregrounded for some projects, those overtly concerned with performance, it was never far away in others.

Performativity thus signals a particular, and directly or indirectly ethical/political, relationship to "audience." In terms of the audience, the concept/relationship shifted from recipient to particular participant and player, and interaction was a primary part of the work. Another distance, that between art and the spectator, was thus troubled. The audience was now a key relay point rather than an end point, keeping the work in play, in flux for its makers as well as its audience. For Higgins, "our spectators, our co-conspirators"[44] would fill in the artists' "exemplative work," which became a "blank structure" and "model".[45] This approach to the role of the spectator in making the work often played itself out as part of an arbitrary and chance-driven process.[46] Attunement to arbitrariness and chance were, then, key characteristics of much of the work discussed in this book. For the artists, these qualities of their process operated in tension with any universalizing tendencies of the media they worked in.

The promise or threat of universalizing tendencies raises another ghostly specter, that of Marshall McLuhan. Whether artists directly engaged with McLuhan or not, his ideas (that "cool" or low-res media and puns, for instance, invited participation) were a part of the same microclimate of media concerns that were engaging distance artists. The broader questions about McLuhan's analysis—strangely both aphoristic and sweeping, both prescient and of its time—are beyond my scope here; nevertheless, it is certainly true that McLuhan himself quickly became a mythical figure, and his figure of the global village was widely known.

The global village was not the only or even the main "spiritual" force around for distance artists. The influence of "the East" had been significant throughout modernism, and Buddhism certainly was important for many artists. For example, even if indirectly, through Cage and others, Bud-

dhism's focus on the moment (the "continuous present," as Gertrude Stein would have it) and on the process are striking.[47] This is very different, however, from the apocalyptic or utopian drive, which operated for some other artists. My point here is not to assert Buddhism or anything else as the spiritual basis for distance artists, or even to say that all had a spiritual basis or concern. Rather I would simply note that where spiritual concerns did operate, it was more in a deep, constructive way, rather than as an analysis or afterthought.

But a spiritual reading ought not to be taken too seriously lest it close off the playful, conceptual and open qualities of these works. In the spirit of Dada, it was performativity that frequently inf(l)ected the works, in/determining them as playfully serious and parodically truthful. Perhaps a way to focus not on their truth or "meaning," but on how they worked, would be to think of these works as Deleuzian assemblages—of artists, technologies, objects, audiences. Such assemblages were not found and static but were the consequence of a practice—provisional, temporary, and made—at a distance.

At a Distance is . . .

As editors, Annmarie Chandler and I will preface each of the parts of this book with a brief description of its contents, so I'll conclude here first with a reprise of the book's collective aims and significance and then with a general indication of the book's structure. This volume presents a multidisciplinary approach to the precursors of Internet art and activism. No single discipline or discourse can "explain" these works, which themselves delighted in crossing boundaries and borders and playing in/between media. The volume is also multicultural, as befits the projects of distance art/activism. Our choice of projects for inclusion in the book has been in some ways arbitrary, again as befits the field itself. In a field so rich and diverse, we have chosen not representative types, but rather examples of distance art and activism, in Giorgio Agamben's sense of the "example," which "escapes the antimony of the universal and the particular."[48] We hope that they work in a way that Agamben calls "whatever," that is, with a "[s]ingularity . . . freed from the false dilemma that obliges knowledge to choose between the ineffability of the individual and the intelligiblity of the universal."[49]

As editors we have attempted not to provide some elusive proportional representation, but rather to offer both a sense of the geographic spread of distance art and the ways that local contexts shaped the work of even those

artists/activists who were engaged with international movements. One of the energizing forces for distance art was in fact this geographic and cultural spread, even though cultural difference was not always then (as it is not now) recognized in its very depths.

We use the figure of distance art/activism to focus on the way both art and activism were inevitably, if differently, implicated in all the projects discussed in the volume, whether in the foreground or the background. By addressing this relationship between art and activism, the authors here, artists, artists/activists, and cultural theorists alike, make a significant contribution to our understandings of both art and activism, as well as to the culture of the second half of the twentieth century. They also contribute to a rethinking of distance itself, reminding us of its multiplicity and potentialities. The "same" distance that excites the imagination might also disturb the emotions. Distance, which for some was experienced as geographically extensive, was for others performatively or demographically intensive.

This collection of essays also foregrounds the way that, in varying mixes, the projects discussed in it were shaped by social relations, networks, cultural strategies, economic and political concerns, and conceptual and aesthetic considerations. One of the things that makes these projects, and this book, so important, we would argue, is that they refute all singular determinisms, whether they be economic, political, or aesthetic, while still engaging with these forces. So too, notably, do they refute technological determinism, without denying the importance of engagement with technology. Thus this collection foregrounds the ways that thinking, practice, and art/technological experimentation fueled an explosion of art/activist networked activity.

Significant, too, is the approach to experimentation that animates these projects and the writing about them. In an era in which much of the earlier twentieth century's artistic and social experimentation had been co-opted, these artists/activists continually and playfully evaded the clutches of capitalism's recuperations. Many paid a price for this, at the time and in history, which rewarded their inventiveness and indeterminacy by forgetting them. Whereas some, like Fluxus, have recently returned to prominence, many others remain strangely obscure in an era supposedly fascinated by immateriality, virtuality, and telepresence. This volume is not, however, motivated by some crusading concern to right and rewrite history but rather aims to keep in play, to reopen for question, these twentieth century art/activist

projects, as offering practices and understandings of vital concern for the twenty-first century.

The book approaches the projects through three parts. As many of the projects discussed and mentioned reappear throughout the book, we have appended a timeline for ease of cross-referencing. Since the projects in this volume are so varied, we have organized the parts not around the projects, but around the relations of the authors to the projects they discuss. Part I is written at the greatest distance from the projects themselves. The chapters here provide historically and critically informed perspectives, each with a different emphasis. Although these chapters necessarily have a historic dimension and reference various artists and projects, the aim is to raise and explore issues, concepts, and arguments, rather than detail specific projects. The first three chapters in this part of the volume singularly and collectively provide an overview both of specific works and of their broader aesthetic, cultural, and social contexts. For those new to the experimental art and politics of this period, these chapters provide the necessary contextualizing. The remaining chapters contribute to this contextualizing, but with focuses on one or more specific projects, artists, or activities. In all cases, however, the approach in this part of the book is from the point of view of a cultural critic or historian rather than an involved artist (though some of the authors are artists and have been involved in some of the projects). The authors draw out and foreground the issues as they see them and develop their own critical arguments about those issues.

The chapters in part II approach their subjects more intimately, written as they are by or with people who were involved in the projects discussed. Although the chapters in this part of the volume are in a sense more a documenting and revisiting of the projects, some authors do also discuss critical issues where they were foregrounded by the artists involved in the projects. The writing styles in this part of the book are more informal than in the previous, including first-hand anecdotes and archival material. In tune with the book's subject and the character of the projects under discussion, some of these chapters were written collaboratively or in networked fashion. Although this part of the volume could not possibly fully discuss all distance artists/activists, it does offer, we hope, a broad sense of the diversity of media and modes at work. The groundbreaking work discussed here also provides new and invaluable material for scholars and artists alike.

Part III returns to the voice of cultural criticism with a rethinking of networks, a key figure that appears throughout the book's first two parts but is foregrounded here for political, aesthetic, (cross-) cultural, and economic analysis. The histories of networks with which these chapters engage are not intended to frame or reframe the book's understandings. Rather, we hope that they help put history itself in question, reminding us that history too is subject to the way culture overdetermines memory. In our own brief conclusion, we return to the issues of what happened to the memory of the projects discussed in the volume and their era. We also open there some questions about the new as well as some new questions. This final contribution as editors emerges from our own engagements with the following chapters and offers a homage to the openness that we see as the overwhelming energy of the projects that this book presents.

Notes

I would like to acknowledge a fellowship at the Society for the Humanities, Cornell University, 1999/2000, where I began this research. I would also like to acknowledge provocative and fruitful discussions with colleagues, particularly Timothy Murray, John Ricco, and Mark Seltzer, at Cornell University (1999–2000), and Ross Gibson and my coeditor, Annmarie Chandler, at University of Technology, Sydney. I am also grateful to Maria Miranda for her generous and insightful engagements with the ideas and material in this chapter.

1. Craig J. Saper, *Networked Art* (Minneapolis and London: University of Minnesota Press, 2001), passim; see esp. chap. 1.

2. Bernhard Siegert, *Relays: Literature as an Epoch of the Postal System,* trans. Kevin Repp (Stanford, Calif.: Stanford University Press, 1999), 2.

3. Ibid., 61.

4. Ibid., 54–55.

5. Ibid., 108.

6. Ibid., 109.

7. Ibid.

8. Ibid., 103–104.

9. Ibid.

10. Ibid., 267 n. 2.

11. Jacques Derrida, *The Post Card: From Socrates to Freud and Beyond,* trans. Alan Bass (Chicago: University of Chicago Press, 1987), 64–65. Thanks to John Ricco for alerting me to the Blanchotian waiting at the heart of Mail Art and e-mail.

12. Klaus Beyrer, quoted in Siegert, *Relays,* 11.

13. Derrida, *Post Card,* 65–66.

14. Avital Ronell, *The Telephone Book: Technology, Schizophrenia, Electric Speech* (Lincoln: University of Nebraska Press, 1989). Ronell's telephone book (a seminal text) answers the noisy calls of telephony very fully, so I will not rehearse her arguments here. (For a further discussion of Ronell, see my "E/motional Machines: Esprit de corps," in *Conference Proceedings for Affective Encounters: Rethinking Embodiment in Feminist Media Studies,* ed. Anu Koivunen and Susanna Paasonen, University of Turku, School of Art, Literature and Music Series A, No. 49 Media Studies (Turku, Finland: University of Turku, 2001), available at <http://www.utu.fi/hum/mediatutkimus/affective/proceedings.html>

15. Gregory L. Ulmer, *Applied Grammatology: Post(e)-pedagogy from Jacques Derrida to Joseph Beuys* (Baltimore: Johns Hopkins University Press, 1985), 143–145.

16. Marshall McLuhan, *Understanding Media: The Extensions of Man* (Cambridge, Mass., and London: MIT Press, 1999), 20.

17. "The telephone grew out of a mysterious coupling of art and occult: what we can call *techné*'s sideshow"—in a relay of uncanny contaminations, as Ronell explored in *The Telephone Book,* 366.

18. Ibid., 366–367. What this means for those distance artists today who are setting out on their adventure with science in the front seat is an open question for another place.

19. Siegert, *Relays,* 250–251. In "Communication in the Presence of Noise" (1940), Shannon asserted, "The optimal code requires an indefinite delay in transmitting the

message. . . . The absolutely intelligible is at the same time the absolutely empty" (quoted in Siegert, *Relays,* 255). One of the key theorists to relate information, noise, and parasites remains Michel Serres, *Genesis,* trans. Geneviève James and James Nielson (Ann Arbor: University of Michigan Press, 1955); see, e.g., 57–60: See also his *Hermes: Literature, Science, Philosophy,* ed. Josue V. Harari and David F. Bell (Baltimore: Johns Hopkins University Press, 1982), 73–83.

20. Siegert, *Relays,* 258–260. PCM was used to digitize data from any analog media, by sampling at the transmitter end, quantizing, transmitting digitally, and then reconverting to analog at the receiver end.

21. Ibid., 261–262.

22. It is noteworthy that Mayakovsky's famous ROSTA (Rossiyskoye Telegrafnoye Agenstvo [Russian Telegraph Agency]) posters were based visually on Russian futurist painting styles and thematically on "telegrams, war communiqués, newspapers, manifestoes and speeches"—archetypical of "modern" communications networks of the nineteenth and twentieth centuries. See Roberta Reeder, "The Interrelationship of Codes in Maiakovskii's ROSTA Posters," *Soviet Union/Union Sovietique* 7, parts 1–2 (1980): 28–52, esp. 28–29, 33.

23. See, e.g., Alice Yaeger Kaplan, *Reproductions of Banality: Fascism, Literature and French Intellectual Life* (Minneapolis: University of Minnesota Press, 1986), esp. chaps. 1 and 4.

24. McLuhan, *Understanding Media,* 8.

25. Saper, *Networked Art,* 5, 151.

26. Ibid., 149.

27. Ibid., see, e.g., 12, 31, 134.

28. Dick Higgins, *A Dialectic of Centuries: Notes towards a Theory of the New Arts* (New York: Printed Editions, 1978), 14; see also 28.

29. Ibid., 13.

30. Ibid., 8.

31. Ibid., 12.

32. Quoted in Tilman Baumgärtel, "Net Art: On the History of Artistic Work with Telecommunications Media," in *net_condition_art and global media,* ed. Peter Weibel and Timothy Druckrey (Cambridge, Mass.: MIT Press, and Karlsruhe, Germany: ZKM Center for Art and Media, 2001), 155.

33. See, e.g., Henry M. Sayre, *The Object of Performance: The American Avant-Garde since 1970* (Chicago and London: University of Chicago Press, 1989), xii, where Sayre discusses the "modernism that was defined and developed by Clement Greenberg from the late thirties into the early sixties." See also Charles Harrison, *Essays on Art & Language* (Cambridge, Mass.: MIT Press, 2001), esp. chap. 1.

34. For a discussion of this development, see, e.g., Sayre, *Object of Performance,* "Introduction." Sayre notes that as early as 1966, Harold Rosenberg published a collection of essays, *The Anxious Object* (2). On the "side" of hegemonic Greenbergian modernism was Michael Fried's influential "Art and Objecthood" (*Artforum* 5, June 1967), which advocated formalist "presentness" of self-sufficient object, immanentist aesthetics (6–9).

35. Quoted in Sayre, *Object of Performance,* 15.

36. Harrison, *Essays on Art & Language,* 47.

37. Sayre, *Object of Performance,* 7.

38. Edward Scheer, "Sketches of the Jet: Artaud's Abreaction of the System of Fine Arts," in *100 Years of Cruelty: Essays on Artaud,* ed. Edward Scheer (Sydney: Power Publications and Artspace, 2000), esp. 64–65.

39. Saper, *Networked Art,* 115.

40. Sayre, *Object of Performance,* xiii.

41. Ibid., xiv, 9, and chap. 3.

42. Samuel Weber's discussion of ancient Greek theatocracy—the rule of the audience—is interesting here. Weber relates noise, wandering, mixing of genres, and a breaking down of a sense of propriety—all familiar in distance art—to artist groups (in this case musicians) comprised "neither of amateurs nor of professionals." Samuel

Weber, "Displacing the Body: The Question of Digital Democracy," available at <http://waste.informatik.hu-berlin.de/mtg/archiv/weber.htm>, 2–4 (accessed September 1, 2002).

43. As quoted in chapter 5 of this volume.

44. Higgins, *Dialectic of Centuries,* 49.

45. Ibid., 24, 78, 156–166.

46. Ibid., e.g., 26.

47. See, for instance, David T. Doris, "Zen Vaudeville: A Medi(t)ation in the Margins of Fluxus," in *The Fluxus Reader,* ed. Ken Friedman (West Sussex, England: Academy, 1998), 91–135.

48. Giorgio Agamben, *The Coming Community,* trans. Michael Hardt (Minneapolis: University of Minnesota Press, 1993), 9.

49. Ibid., 1.

Critical Perspectives on Distance Art/Activist Practices

This part of the volume provides critical frameworks for understanding distance art and activist projects. The authors approach their material from the point of view of cultural theorists or historians rather than involved artists (although, as pointed out in the volume's introduction, some of the authors are artists and were involved in some of the projects). As well as providing valuable contextualizing overviews, the authors here also discuss particular mediated experiments, cultural strategies, and aesthetic issues.

Before turning to ways these chapters develop the book's themes, we need to stress how varied the projects' local contexts were. For example, while Stalinism was weighing upon Eastern Europe and erasing radical and experimental histories, in Western countries it was capitalist commodification that was running rampant in the art world. And even though the sixties' counterculture and radical politics ricocheted and relayed well beyond the United States and Western Europe, for instance, they too played out differently in various local contexts. Thus an important understanding that emerges from these chapters, which deal with projects from around the world, is not just the difference in ideas and practices in different situations but also the way that the "same" practices and ideas often had quite different articulations in their particular contexts.

One of the differences among the local contexts of the projects discussed was the character of their technological development. However, it is striking that technology was not the defining factor in the art/activist practices, either in initiating them or in determining their outcomes. Indeed, the very idea of networked art and activism was in play well before the technical possibilities of the 1970s and 1980s. As Johanna Drucker discusses in chapter 1, in her in-depth framing of the aesthetics of new media art just before and

during that period, it was not always necessary to *have* the technology to play with the ideas. And some of the important very early precursors explored technology not through technology itself, but through concept and metaphor (as we return to in part III, with María Fernández's discussion of the *estridentistas*). The chapters here stress that it is more fruitful to attend to human/technology *cultural* relations rather than to imagine technology as simply a self-generated technical preoccupation.

In their local contexts and through their own practices, most of the artists/activists in the 1960s and 1970s were engaged in artistic and theoretical discussions about dematerialization and conceptual approaches to art. Drucker elaborates on the way that traditional object-based and formalist aesthetics in the fine arts were being questioned, with a new emphasis on communication, processes of production, and networks of exchange. She questions, though, the "myth" of the immaterial object. Tilman Baumgärtel, John Held, Jr., and Owen Smith address (in chapters 2, 4, and 5, respectively) the significance of process over objects as an idea that engaged most artists and activists. For instance, the Fluxus community and philosophy (in its "institutional phase," discussed in chapter 4), and the Mail Artists (whose exhibitions chapter 5 explores) turned the distribution process itself into part of their communal art practice. They thus made distance a space of movement, circulation, connection, collaboration and network. As Reinhard Braun argues in his discussion in chapter 3 of Austrian telecommunications artists, what were important in this space were the social and cultural relationships and practices, rather than the object that circulated in that space.

When artists eschewed a finished, autonomous product to engage in "interventionist and participative practices" (74), they were, in Braun's view,

doing something fundamentally different and transgressive: They were creating an "artistic project as a transactional space, as an intervention space, as a cooperative process and temporal construct" (75). They were transforming culture and politics as much as aesthetics. Focusing on the work of Richard Kriesche, Gottfried Bechtold, and Robert Adrian X, Braun analyzes how art in, with, and among media operates as a hybrid practice, as hinges and interfaces for intervention in overall cultural mechanisms. Thus video, television, and film worked for these artists as "ensembles of cultural techniques" (74), composed of elements not just from media art or technology, but also from science and politics.

Both Braun and Baumgärtel describe projects that set up experimental spaces of writing as a new form of communication. Baumgärtel focuses in chapter 2 on projects that were engaged with the concepts and practices of immateriality. But for him, as for Braun, these conceptual projects were not (just) about art and technology so much as social and cultural engagements. Though the projects Braun and Baumgärtel describe differ from those of Fluxus, say, they do share the *performative* emphasis on collectivism, collaboration, and participation.

Related to the figure of dematerialization and the questioning of the object for many artists was a rethinking of corporeality. According to Baumgärtel, the "telematic age," instantiated by the discovery of electromagnetic waves in the late nineteenth century, reconfigured space (and time) and ushered in a new form of communication in which the body and object no longer traveled. Through a number of historic examples, including the exhibition Les Immatériaux (1985), which was cocurated by the French philosopher

Jean-François Lyotard, Baumgärtel explores the concept of dematerialized communication and the way it was addressed by artists using communication media and networks. Les Immatériaux, like many of the projects in this part of the volume, highlights the way that artists and theorists were challenging the gallery environment to incorporate works in which art exists, as Baumgärtel notes, "exclusively within . . . telecommunication spaces" (62). The philosophical issues of immaterial materials and their new sensibility (typical of what Lyotard had understood as the "postmodern condition") framed the exhibition. According to Baumgärtel, Les Immatériaux, which has been strangely ignored by history, was significant in the way it touched on art, philosophy, computerization, automation, microelectronics, and, of course, telecommunication.

In other projects, too, such as N.E. Thing Company, Baumgärtel addresses the way that "information" was alluring through its very ideaness and ephemeralness. For works such as these and others addressed in this part of the volume, the challenge to corporeality was itself somewhat immaterial, not necessarily a "loss" of the body, but the gain of "pseudo-identities and -entities" (67). It engaged artists, activists, and others to play with the space between, the space that makes up the distance, and the space in which dematerialization occurs. And there was a sense of energy, what Braun calls "euphoria," that came from working in a space which is "neither empty nor . . . determined," connective, transactional, and circulatory (81).

A more ironic or humorous engagement characterized the works of Fluxus and Mail Artists. For them, crossing the physical boundaries of space was part of crossing artistic, conceptual, and cultural boundaries. Held and

Smith argue in their chapters that (infinite) play, parody, and humor were central to the way Mail Art and Fluxus breached all those boundaries. "The first decades of Mail Art extolled an unfettered art of play, invention and surprise," according to Held (94). This was not (just) a theoretical attitude but was integral to the iconoclastic and innovative cultural strategies of both these "movements." So too was performativity, which in Fluxus, as Smith examines in chapter 5, also manifested in actual performances. Fluxus performed its rejection of the object by a play with the object's disposability. But although Fluxus is famous for its intermedia approach and rejection of media distinctions, Smith emphasizes the connection between this intermedia play and "network mentality." What mattered to Fluxus, he contends, was the "connections and spaces between media and/or categories" (127).

The transformative power of art—for artists themselves, for the nature of the work of art, and for audiences—was another key concern for both artists and activists, even though, again, they did not share a singular notion of art and politics (or, for that matter, of transformation). Drucker traces social and cultural transformation as an idea at the basis of a wide range of "prophetic announcements" about technology, art, and media from the 1960s and 1970s. There was also fascination, she notes, with "transformations produced by the movement of information through a system of interconnected electronic and computational devices" (42). Further, the transformative power for art itself was enacted for many through new, interactive relations with their audiences. In an important sense, as Drucker suggests, the concern with interactivity, as a new technological and communication strategy, was more broadly framed by the different understandings and practices in relation to social re-

lationships. For Fluxus, too, according to Smith, art's important transformative power lay in the way it was a participatory social act. Smith also shows how artists explored the transformative interconnections among collectivity, art, creative production, and networks. As Braun too argues, what is important is the way each medium transforms experience. Thus distance art/activism is about the process of transformation rather than the end result of transformation. It is, Braun foregrounds, about "radical transformations of everyday and familiar cultural relationships and problems" (76).

Emphasis on activities based on participation in social performative contexts challenged both methods of creating and experiencing art and modes of social engagement and creative praxis as well, according to Smith's reading of Fluxus. Smith argues that Fluxus is best understood as an attitude and as a "network of ideas around which a varied group of artists have collaborated" (119), a "community . . . rather than an art historical movement" (119). For Fluxus social relationships extended beyond audiences to fellow artists and curators. Held similarly maps the new sense of community among Mail Artists and the ways this inflected curatorial expectations and practices. Challenging the tyrannies of the gallery system in the name of democracy, for instance, they demanded exhibitions without "curatorial censorship."

Networking was thus a conscious strategy and philosophy for these artists and activists. For a number of them, the network was not just a means, but also their primary *medium* (as Chris Brown and John Bischoff also address in relation to computer music in part III). Furthermore, networking took on a particular poignancy and urgency for artists in contexts of state political oppression (which Simone Osthoff and Stephen Perkins emphasize in later

parts). In part III of the volume, we foreground networks with contributions that return to many of the issues and practices raised in part I.

From their various perspectives and through specific case studies, the authors in part I of this volume share a number of critical and theoretical concerns about precursors to the Internet: How was distance, as extensive space, being reconfigured and reconfiguring social and cultural relations? What were the relations between material and immaterial "objects," processes, and bodies? How were dominant approaches to art and media addressed and challenged by the hybridity, experimentation, and conceptualism of distance artists? How was interactivity being formed and morphed in particular projects? How did networking shape the imaginary and practical concerns of artists and activists? And, finally, in what ways did cultural, political, and social relations shape the practices of distance art and activism?

Interactive, Algorithmic, Networked:
Aesthetics of New Media Art

Johanna Drucker

Long before the technical infrastructure could support their projects, artists had conceived imaginative uses of digital telecommunications at the interstices of creative studio and technology laboratory. Artists, always quick to envision the potential of new media, had been thinking about new forms of dynamic, real-time interaction for decades before the World Wide Web took off in the 1990s. Artist-and-engineer collaborations had fueled cutting-edge experimental research throughout the 1960s and 1970s, and some of the conceptual thinking in their work led to development of Internet technology, rather than being brought about by it.

Labyrinth, an interactive catalog created by Ted Nelson and Ned Woodman for Jack Burnham's Software exhibition at the Jewish Museum in 1970, is a perfect example of work that was conceptually poised to take advantage of technical developments.[1] An early hypertext system, *Labyrinth* allowed participants to browse, gather information about the exhibit, then print out an individually profiled search record, following the mazelike intuitive pathways suggested by its title. These dynamic properties embodied the "assumption of perpetual change and reuse" that underlay Nelson's vision of then-still-embryonic Web software, *Xanadu.*[2] Both projects made use of an associative linking process that had been envisioned in a 1945 essay by Vannevar Bush, "As We May Think," now perceived as a prescient anticipation of the Internet.[3] Bush's essay could also be seen, in its own right, as a well-envisioned, integrative tool for intellectual work, one spawned by the demands of information management at midcentury. Because Nelson and Woodman's *Labyrinth* was displayed in the art museum context of Burnham's exhibit, it could lay claim to aesthetic credentials as well as to technological visionary status.[4] But was it art? Was it engineering? Did this matter? The intellectual parameters of the piece escaped disciplinary boundaries, asserting principles as much aesthetic as technical. Conceptually, such a work embodies the crucial elements that come to be core components of even the earliest networked art discussed in this volume: interactivity and algorithmic programmability of information encoded in binary form. What are the aesthetic contexts in which such work arises? How does digital work come to be art?[5]

The terms *new media* and *digital technology* became current in the context of the "information society" of the 1960s.[6] A number of concrete events and specific works heralded the arrival of an "art by computers" sensibility within the technical community while in a fine art context, artists generated

their own connections among computers, aesthetics, and other innovative technologies. Shared concerns about the changing status of art objects and practices wove across a number of mainstream art movements in this period, and digital art, narrowly defined, found common intellectual cause with many aesthetic positions. Critical themes came into focus. Discussions of art and technology, postformalism, and conceptualism each contributed elements of a specifically electronic, computational, or digital aesthetic. Theoretical writings came from cybernetics, science fiction, information sciences, and fine arts, to name just the major tributaries of the interdisciplinary stream that swelled the emerging critical discourse of new media, a field loosely defined to include digitally based works as well as experimental uses of analog production, recording, and projection devices. Hybrid forms quickly blurred boundaries of practice and vocabulary. Programmable capabilities were often pressed into service to structure production or presentation of analog materials, and digital works (based on binary code) were sometimes created with limited dependence on electronic or other multimedia effects in spite of their programmed manipulations.

By the late 1970s, the technological capabilities for realizing dynamic works that synthesized real-time participation from disparate locations would be on the horizon. In 1977, Kit Galloway and Sherrie Rabinowitz performed a live collaboration between dancers in Maryland and California, merged in a virtual on-screen space.[7] By the end of the 1990s, networked, interactive, and programmed projects would be almost commonplace, but imagining that such projects were the ultimate destiny of the conceptual experiments of earlier decades misses the point. Artistic activity engaged with technology in a synthesis of imaginative vision, not toward a fixed teleological outcome. As technological developments have stabilized, the experimental features of earlier works have become harder to appreciate for the contributions they made at the time. In *Imagologies,* Mark Taylor and Esa Saarinen offered a detailed chronicle of a 1994 piece requiring elaborate hookups and institutional coordination to facilitate what was in essence an artists' conference call in video-phone. This now seems as mundane as dialing a telephone or sending a fax.[8] What *Labyrinth* foretold and *Xanadu* imagined may have come to pass, but just as aesthetic imagination has yet to engage with the full potential of the technology, so technological developments have yet to fully realize some of the visions of artists working decades ago.

Art in the Information Society

By the end of the 1960s, a critical mass of digital media art had been produced in various settings and contexts, enough to merit exhibition in mainstream venues in the United States and Europe, with smaller-scale activities elsewhere.[9] Developments in various technical, engineering-oriented fields provided new possibilities for artists to make works that employed various interactive devices, feedback mechanisms, programmed or programmable features, robotic elements, and kinetic and telematic components.[10] Individual desktop capabilities were still more than a decade away from market readiness. But fantasies of a networked lifestyle and of a world infused with smart devices, intelligent machines, and futuristic possibilities were rapidly creating the cultural receptivity that would help pave the way for systematic integration of computerized activity into the social and cultural life of the late twentieth century, especially in first-world contexts.[11]

Marshall McLuhan and Buckminster Fuller made prophetic pronouncements. Their publications in the 1960s proclaimed the new age of global interconnectivity and technological solutions in rhetoric much quoted and misquoted in the mass media.[12] From radically different perspectives, John Kenneth Galbraith and Daniel Bell described the new economic impact of information, pointing out the implications of a technocracy in which power resided with an elite of data managers.[13] Pundits from across the political spectrum of mainstream and counterculture positions paid attention to the transformative force of new technology in every area of communication, production, and education in private, public, and government sectors.

The utopian rhetoric of transformation that accompanied these activities was charged with hyperbolic claims of a high order.[14] Such enthusiasm was rampant among writers in the arts, for whom electronic media heralded a new age. In an example typical of this attitude, Gene Youngblood wrote in the preface of his 1970 publication *Expanded Cinema,* "We are witnessing a metamorphosis in the nature of life on earth." The book focused on experiments in video, cinema, and intermedia, and Youngblood's optimistic tone weaves throughout a text in which he "examines image-making technologies that promise to extend man's communicative capacities beyond his most extravagant visions."[15] Fine artists saw innovative possibilities for the arts. Some felt that creative activity should lead the way for envisioning the future in all areas of contemporary life. Others, anxious about the cultural

status of fine art, worried that they might be left behind if excluded from the loops that capitalized research in new media.[16] From the late 1950s through the pumped-up decade of the 1960s, a veritable frenzy of activity seemed to break with every remaining trace of traditional artistic practice. By the 1970s, electronic and digital media were conspicuous elements of a new visual arts landscape.

Each area of fine art was receptive to new media to differing degrees. In video and performance, electronic instruments and devices met little resistance. These were fluid areas of activity, not legacy bound, and reaching to innovation didn't require overcoming entrenched attitudes. Video gained acceptance as an art medium relatively rapidly (compared to the century-long struggle of photography), and it was electronic from the outset, even as an analog medium.[17] In the 1960s, music, performance, and installation work made use of sensor devices and interactive elements.[18] Where new media could be kept discrete as a novelty, it quickly found a niche. When comfortably limited by well-defined boundaries, new media gave fine art a contemporary style and techno-glamour that made it seem contemporary with the pop culture of the 1960s and disco tempo of the 1970s. The counterculture sensibility promoting independent alternatives to the monopolized control of mass media also provided an impetus for art committed to intervention in telecommunications. Technologizing art and aestheticizing technology were complementary impulses at the time.

Extensions of new media into the traditional studio practices of photography, painting, and sculpture were difficult in advance of the desktop capabilities that became widespread in the early 1980s. Specialized training and access to computer equipment in an institutional setting were required. Artists like John Whitney at IBM, some of the now renowned Bell Labs members such as Ken Knowlton or Leon Harmon, and other computer scientists who dabbled in image making, like Melvin Prueitt, could generate image output through computational means.[19] But the tightly controlled decorum of printmaking protocol, fine art photography, painting, and object-based sculpture made these fields highly resistant to the incorporation of digital tools.[20] Process-based or procedural work in material media might be compared to the activity of programming, but the function of this analogy was to unify practices at a conceptual level, not a technical one. Legitimation of technological means of production seemed to undermine the craft status of fine art. A vague sense that one was "cheating" by producing a print with

a laser printer or iris jet persisted into the 1990s. Subsets of traditional studio disciplines—holographic photography, computer-generated poetry, and computer-driven sculpture—were carefully circumscribed as the separate province of technophiles.[21] If anything, the effect was to entrench the traditional disciplines in a reactive conservatism out of keeping with the more widespread transformations occurring across the field of art activity.

Earlier twentieth-century flirtations with mass-culture imagery, industrial production modes, and broader distribution networks had made inroads into the premises on which the fine art object was conceived and executed. But those premises were being challenged anew at the levels of imagery, production, and distribution in the 1960s and 1970s. Pop art not only celebrated the iconography of mass media, it made use of commercial production means such as silk screen and photomechanical transfer. Minimalist artists had their work fabricated in machine shops by industry professionals. Mail art, artists' books, performance-based Fluxus art, and site-specific sculptural work shifted to venues outside the gallery and museum settings, emphasizing alternative sites and modes of distribution.[22] Feminist artists recuperated craft traditions and handmade work, along with highly personal imagery. Artists across a spectrum of ethnic backgrounds brought a range of cultural legacies into the visual vocabulary of fine art. And activist art focused on collective projects, public relations, staged events, and other interventionary strategies in the period when civil rights, Vietnam War protests, and other issue-driven agendas claimed aesthetic support. Older methods of art making, traditional in format and site, were no longer adequate to the tasks perceived to be at hand. Traditional categories of imagery, production, and distribution had indeed all broken open.

But even more profoundly, the very conception of the structure and experience of works of art seemed poised for change. Not only were new materials and media to be engaged, extending modern art's fascination with mass culture, but a serious rethinking of the very idea of "art" appeared on the edge of radical transformation. This shift is clearly evident in the rhetoric of Alan Kaprow, the author and instigator of Happenings, in the writings of artists central to the Fluxus movement, such as George Maciunas and George Brecht, or in the influential teachings of Joseph Beuys.[23] Situationism, the 1960s outgrowth of political and aesthetic exchanges among Guy Debord, CoBrA [Copenhagen, Brussels, and Amsterdam] artists like Asger Jorn, Pierre Corneille, and Lettrists Maurice Lemaitre and Isidore Isou stressed the

importance of circumstances and contexts.[24] Experience-based rather than object-based work sprang up in one location after another. Yves Klein's "zones" of "immaterial pictorial sensibility" (works of art constituted by contractual relationships, rather than objects, as a challenge to ideas of ownership and property), embodied in his exhibition of the *Void* and in other performances between 1958 and 1963, provides a manifesto for an aesthetic practice in which traditional objects have no place.[25]

Scattered throughout the United States, Europe, and Japan and other locations, antiformalist impulses were not part of any single movement. Taken in sum, these antiformalist activities amount to an overwhelming mood of transformation. The work of art was being replaced by a discourse about the idea and premise of art. These fertile conditions produced rapidly morphing fruit in the 1960s and 1970s, much of which set in place those intellectual and aesthetic ideas on which contemporary digital art still operates.

Art, Computers, and Computational approaches

The concepts of interactivity, algorithmic processes, and networked conditions were not fully distilled as principles of digital art until more recently, but their broad outlines were already apparent by the 1970s. During the 1960s, the institutional sites of defense-funded university and industry research labs often served as primary incubators for digital-media art.[26] The capitalization of new technology concentrated access far from traditional studios or galleries or even art schools. Lines between art and nonart can't be easily drawn for such work, but critical discussion of new media art was more the province of artists and their critics than of engineers. Artists understood aesthetics as a cultural discourse with a history, and new media art had a very specific stake in introducing the conceptual parameters that electronic and digital technology brought to the fore. Engineers seemed aesthetically naive by contrast, happily generating artifacts they found pleasing. If it was visual, they called it art, usually with only the vaguest sense of connection to the history of that field. But the contributions that came out of these laboratory and research environments laid substantive intellectual foundations relevant to the larger context of digital art. Data visualization and visual modeling of complex processes drove technical research whose by-products became the tools of the next generation of artists and designers. Similarly, the military and defense sectors' need for environments in which to train personnel in a cost-effective way created projects like flight simulators, later caught up by

the entertainment and gaming industries. Tools being developed in industry research frequently found conceptual realization in aesthetic activity in which the ideas of "programmability" and "interactivity" were explored in creative projects. Sol Lewitt's famous statement "The idea is a machine that makes art" was meant as a response to the by-then-caricatured image of art making as the sign of emotional or spiritual struggle that had become such an exaggerated trope in the heyday of abstract expressionist painting.[27] The systems-based approach to process-based works could be linked to computational methods by analogy, rather than through common technological resources.[28]

Artists whose work was influenced by the conceptual frameworks of new media in the 1960s and 1970s began to look back at traditional work and see it differently—they began to see even conventional artistic practices in terms of data and software or other metaphors of information processing. The two principles essential to electronic and computational work—algorithmic production (through rule-bound procedures) and interactivity (the contingent, systems-dependent, and participant-determined identity of a work)—came to be recognized as a fundamental part of traditional art practice. Thus computational and digital approaches made explicit the understandings that had long been implicit in art production. The same can be said of networking capabilities understood metaphorically and technologically. In metaphoric terms, the value of an aesthetic artifact depends on the systems of exchange in which it circulates. In technical terms, networking indicates the specific potential of cybernetic and electronic systems to use feedback relations, systems of control, abstraction of information, and manipulation. Networked fine art depends on communications technology and exploits the possibilities of abstracting material objects into data that can be migrated through electronic circuitry and transistors to be morphed through processing units and programs. Networking implies social and cultural systems, just as interactivity does, and the work of the Computer Technique Group (CTG) provides an example of the specific capacity of digital media.

Short-lived, ambitious, and highly imaginative, the CTG was a group of artists and engineers based in Japan in the 1960s. Among the works the group created in their few years of operation was *Automatic Painting Machine No. 1,* exhibited in 1969.[29] Painting machines have a longer history, but CTG's complicated device was timely and trendy. Input came from a delimited physical space that it called (in keeping with the fashion of the day) the

"Happening Zone." Microphones and photocells served as primary input sources for sound and light, and additional input came from paper punch tape and manual programming devices using push buttons. As a dancer performed in the zone, her movement was transformed in real time into binary information, processed through a controller, and output through a painting device that moved four spray nozzles on x- and y-axes over a canvas surface. What is remarkable about this work, among other factors, is that it manipulates information as symbolic form. Rather than using a step-by-step procedure to make a shape by directing the actions of a mechanical output device, as in the case of earlier "programmed" art, CTG grasped the potential of the computer to abstract data from any mode of input, any medium, and produce an output that was formally unrelated to that input. The representation of the input as binary, digital information within the controller made the medium of input and that of output independent of one another. Because the information was stored symbolically, it was device independent. Aesthetic manipulation could take place through a series of steps and processes that operated on a symbol set, not on a medium-based artifact. In the case of this specific work, both the input and the output were grounded in real-time performance of a type common in the 1960s Happenings and Fluxus movements. Even the aesthetic principles of *Automatic Painting Machine No. 1,* with its gestural, abstract brush strokes and nonrepresentational imagery, were derived from fine art, though its implementation device depended on computer science and engineering.

Is this also a networked production? In some sense, no. On the most obvious level, the work simply appears to be a digital-mechanical device for art making. True, *Automatic Painting Machine No. 1* also depended on live performance and a set of exchanges for which it was a nodal center, a site of momentary interconnections. And the piece enacted a sequence of transformations produced by the movement of information through a system of interconnected electronic and computational devices. In a technical sense, this is a networked piece: All the components are hooked up through electrical conduits that exchange signals and data. But the telecommunications system of which it is a part is spatially limited and relatively contained. So little social infrastructure is involved that the work is actually less networked than the mail art pieces that circulated through official postal routes and distribution modes. Networking suggests relation to and dependence on a system of human relations, and artworks that were fully networked were still a step

away in technical and aesthetic terms. But works influenced by information processing helped prepare receptive ground at the intersection of new technology and aesthetic sensibility.

The notions of algorithmic, interactive, and networked art evidently took shape in diverse works, some of which were directly related to electronic media, and others quite remote from its technological development. All of this activity occurred in relation to the popular perception that computers and electronic media were revolutionizing every aspect of contemporary life.[30] The exhibition of early computer art projects resulted in their becoming an element in the popular imagination.[31]

Tensions between the tradition of individual creative subjectivity and technologically grounded art in the 1960s and early 1970s provide a foundation for describing another important distinction: that between object-centered things and perceptually based concepts of a work as an experience. The technological emphasis of electronic art brings the participant into the work as a crucial part of the equation. When an artwork is conceived of as a set of conditions for perception, rather than as a discrete, bounded object, then the role of the participant is closer to that played in a quantum experiment. The viewer intervenes in a field of probabilities, and the work is determined in that process, for that instant and situation.[32] Jack Burnham makes this distinction by contrasting George Rickey's sculpture (which, with its beautifully balanced, independently moving arms, is a formal work in which kinetic effects merely rearrange the static elements) with Robert Breer's *Self-Propelled Styrofoam Floats.* The latter work transformed itself over time, continually rearranging its elements in response to viewer participation.[33] Burnham recognized that information technology was fundamentally distinct from mechanical technology by virtue of its dependence on widespread distribution and processing systems that serve to connect human beings with one another as well as with "machines."

Burnham's sensibility was given amplification in the exhibition he curated in 1970 for the Jewish Museum. Software opened in the same year as Kynaston McShine's Information exhibit at the Museum of Modern Art in New York and reflected Burnham's interest in systems and processes.[34] Two years earlier, in his 1968 essay "Systems Esthetics," Burnham had made a case for a paradigm shift (he invoked Thomas Kuhn's work explicitly in the essay) from modern to postformal work on the grounds that the materially bounded object was obsolete as an aesthetic category, having been replaced

by a concept of sculptural practice grounded in relationships.[35] Burnham's 1970 exhibition was technically ambitious. The fact that the artworks it included didn't always work served to reinforce the overarching theme of the exhibition: that artworks were constituted in a dynamic exchange, not as static artifacts. With his emphasis on interactive work and communicative dialogue, Burnham suggested that "software" was an analogy for new art making in general and that the artist's role was to create "programmatic situations," not objects.[36]

Burnham understood the art context in which he was situating his discussion, and he drew on work of the 1960s like that of Les Levine and Robert Breer. These artists created situations or provided the instructions to viewers to make works; they did not produce objects with bounded, static form. Levine's *Live Wires* "processed" viewers by giving them a low-voltage shock. Inspired by examples of participant-activated, sensor-driven works, Burnham clustered his arguments around the term *postformalism.* Process-oriented work seemed analogous to software, and software was the appealing, "brainy" aspect of technology.

By contrast, the very title of McShine's Information exhibition suggests his administrative, bureaucratically located sensibility. No doubt the technocratic tone of Information was meant to cultivate a particular audience for the exhibition. McShine used his title metaphorically. Under its rubric much conceptual art was exhibited. Many, in fact most, of the works were low tech, made with relatively simple means that suggested the organizational processes of information management (files and documents), rather than technological processes or devices. The bureaucratic administration of knowledge, whether computational, digital, or analog, was a prevalent theme of these works. The abstraction of data from process supposedly paralleled the separation of material from the idea in a work of conceptual art. Such a broad concept of information was generalizable to Robert Morris's index cards, Joseph Kosuth and Lawrence Weiner's language-based work, and many photograph-dependent works such as Douglas Huebler's identity project pieces.

Art conceived at the intersection of these sensibilities supposedly did not have to be embodied in an object. It certainly need not bear traces of hand making, nor reveal an emotional content grounded in individual experience. It could make use of any kind of mechanical or electronic process or equipment and need not result in any permanent or stable work. It could be

brought into existence entirely through documentation or a performative action and might in fact have no other existence outside the perceived effects of these instruments. Described in this way, electronic and information art finds support for many of its conspicuous features within a host of practices, rather than being seen as anomalous or marginal. Information art is still not, however, the central or most potent aesthetic force of the period. All the other movements touched on earlier in the chapter—pop, minimalism, Happenings, conceptualism, Fluxus, performance art, and so on—have well-defined outlines in the critical landscape of the 1960s. Information art does not overwhelm or supersede them, nor do its concerns subsume these other activities under a broader category. But the appearance of this fledgling sensibility does connect aesthetic and cultural domains through common interests.

Art and Technology

In the formative years art of digital media art, aesthetic debates ranged broadly. Discussions touched on relations between art and technology, the articulation of postformalism or "objectless" art, and links with conceptualism. Intersections between technology and art had their own extensive lineage in modern works and their many obvious and not-so-obvious ideological subtexts.

A glimpse at a scattering of major works by different early-twentieth-century figures gives an idea of this: Marcel Duchamp's various "bachelor machines," grinders, and procedural "operations," Francis Picabia's mecanomorphs, and Nicolas Pevsner and Naum Gabo's kinetic sculptures all raise questions about the aestheticization of mechanical forms or processes. Machine forms provided a set of figures through which various cultural commentaries could be embodied, from the neurasthenic ennui and exhaustion caused by modern life to playful and derisive suggestions of alienation or brutalizing effects. Metaphoric associations with machine forms or machine processes were only one track of art and technology intersections. The concerns of Russian Constructivist and Productivist artists and Bauhaus engagement with industrial methods, as well as the number of transformations of the technologies of art production and materials (photographic printing, sculptural processes, paint and pigments, etc.) provide many points of significant purchase in these evolving arguments.[37]

Lurking not very far beneath the surface of formal and technical concerns with machine art is another compelling subtheme that became highly charged by computer-generated work: Does the use of mechanical processes necessarily call artistic subjectivity into question? If so, to what extent and on what terms? Machine parts in a human-produced sculpture often call attention to the absence of touch, effacement of traces of the human hand or of artisanal object making. Max Bill, a scientist/artist who took his inspiration from mathematics, wrote in the early 1950s that he was intent on an art process that was put into motion by the setting of limits in a "radical attempt to dispense with all individualistic, stylistic expression."[38] Bill's attitude indicates that he is placing more importance on the initiation of a work than on its realization in an artisanal object. This idea—that human creativity brings a work about, rather than being embodied in its material—was crucial to the notion of a generative aesthetics, such as that invoked by another important figure with an interdisciplinary background that interwove artistic and technological training: Max Bense. Posing an implicit challenge to the idea of inspired authorship, Bense suggests that the use of algorithms to make works explicitly demonstrates the intersection of creativity and programming.[39]

Generative aesthetics created new fears. Digital mediation seemed more extreme than that of early technologies such as the photographic apparatus—it seemed both more remote by virtue of its higher degree of abstraction and more threatening because of its potential autonomy. A rhetoric of the "posthuman" condition has another significant point of origin in the cybernetic theories of Norbert Wiener.[40] Originally conceived as a means of designing weapons and intelligence systems with feedback capabilities that would obviate human error in battle situations, cybernetics inherently drives a wedge between technology and humanity. Even creating simulations of artist-independent or authorless works refocuses the issue of social context for art production in human-to-human communication and exchange while raising questions about the "humanity" of computer-based work.

Clearly not all intersections of art and technology were inherently anti-humanistic, even in works with an obvious machine aesthetic. The lyricism of Jean Tinguely's mechanical works sometimes has a touching anthropomorphism, as do some of Nam June Paik's early robotic sculptures. Works like James Seawright's responsive kinetic *Watcher* (1965–1966) that used robotic elements to mimic behaviors, rather than to imitate forms, focused on the expectations of interactive experience rather than on attributions of sen-

tience to the object or of subjective expression to the artist.[41] Long before cyborg theory had its vogue in the 1990s, the possible integration of human and computational capabilities had been given a certain measure of aesthetic credibility. Alan Turing, in his work on intelligent systems, made the suggestion that a genuine capability for intellectual advancement in programmed environments would depend on making mistakes. Errors, random effects, unexpected and unpredictable elements remain the sign of a romantic individualism—or, alternately, of a nonhuman, chance-dominated world—linking creativity and fallibility through an image of stochastic accident and expressive power.

Postformalism and Conceptualism

The aesthetic considerations that arise in regard to artworks inspired by information processing are fed by other "objectless" art activities, particularly those in Happenings, Performances, and Fluxus art. In spite of its relation to all the conspicuous gadgetry that clutters the landscape at the intersection of art and technology, information art also draws on the equally powerful influences of an aesthetic disposition toward "art without objects."[42] Fluxus performances stressed the use of instructions, often in the form of cards or lists prescribing activities to be performed.[43] Many of these were particularly, emphatically banal. A typical Fluxus work might ask a participant to get in the car, turn on all the lights, use the wipers and radio, blow the horn, turn everything off, and get out of the car again. Attention to the aesthetic potential of ordinary life was a crucial element of Fluxus aesthetics in such works, though the performance-based aspect of these events links them to real-time, event-driven Happenings. In both, the emphasis is on participation: the active making of a work, or the less active witnessing of an event. No objects remain and no artifacts are produced except incidentally. Later re-creations of some of the props for Happenings, or their exhibition, or their repacking for consumption (Flux Boxes and mail order items) were not generally part of the original impulse in these works.[44] But the intersubjective conditions of perception, the networked community of participants whose interactions are the core of the event, are absolutely essential.

The event-driven, collaborative, and participatory character of these mainstream 1960s and early 1970s movements, such as Happenings and Fluxus, had a counterpart in the process-oriented work of conceptual sculpture and site-specific earth works. Though these are produced without

audience participation, they are works whose identity can't be situated in a single object but must be read across a number of locations or instances. As objects they are dispersed and fragmentary and must be reconstituted through a conceptual process. Robert Smithson's nonsite sculptures, comprised of photographs, physical residues, maps, and drawings as well as (largely ephemeral) constructions on remote sites, provide an instance of another kind of work that relies on viewer cognition for its completion. The Art by Telephone exhibit curated by the Chicago Museum of Contemporary Art's director, Jan van der Mark, in the late 1960s, in which all the pieces were the result of instructions given over the telephone, provides another vivid example.[45] Relevant additions to these examples would make an extensive list.[46] Interpersonal exchanges of viewer/participants and artist/participants is constitutive of this work, which has very little form beyond its social forms.

The critical vocabulary of postformalism is sprinkled with terms and phrases that call attention to this change from object-based to process-oriented work. The earlier-twentieth-century notion of the "languages of art," for instance, was replaced by reference to "systems." "Processes" became more significant than mere "objects." And the vocabulary of "operations" or "procedures" appears in work with and without technological components, as if the linguistic phraseology of a technological mode were the new lingua franca of conception and production. An overall emphasis on dynamic manipulation of knowledge (again, "the idea is a machine that makes art") replaces the long-standing legacy of "resistance in material" as the condition for a work's coming into being in form.

The term *postformalism* permeates the work of Jack Burnham, but the concepts it references are broadly sustained in the wider rhetoric that surrounds conceptualism.[47] Tensions between art and technology call the identity of creative authorship into being, and postformal practices emphasized objectless art that is context dependent. But conceptual art established a working distinction between an idea and its realization in material that can be mapped onto the dynamic relations of software and data—at least metaphorically. Dematerialization and conceptualization put a new emphasis on process and communication.[48] Systems of exchange and processes of production, mentioned earlier in the chapter, became associated with metaphors of data flow and information processing in critical rhetoric at the time, even when not put into practice in specific works. Haacke's *Visitors' Profile* is one of the few

conceptual pieces in the early 1960s to make such an explicit connection. In most instances, the comparison is superficial and somewhat simplistic, as when Burnham suggests that Donald Judd's early 1960s "list" of instructions for production of a work had a structural resemblance to "list structures" of programming languages used in artificial-intelligence research. Clearly information had cachet. As Benjamin Buchloh has argued in his discussions of conceptualism, the managerial aesthetic of conceptualism in fact aligned very nicely with "bureaucratic," "instrumental," and "administrative" aspects of this emerging culture.[49]

The ideological effects of this alignment are consequential. The dematerialization that is aestheticized in conceptual art is made familiar through exhibition and display. If "information" is what art is made of, then it must be a substantive and valuable entity. Even if works of art that drew explicitly on either concepts or instruments created for new media technology represented only a tiny percentage of the aesthetic output in the 1960s and 1970s, the presence of such work within an art context is highly significant. The familiarizing and legitimating effects of art are one of its major cultural functions. Bringing glamour and credibility to information by associating it with fine art, these experimental pieces forged a potent symbol of new media for the demographic group comprising viewers of art in museum and gallery contexts. Perversely, however, the myth of information as immaterial grew alongside this increased visibility.

Information is no more "dematerialized" than "ideas," which are always perceived through material instantiation. But the myth of electronic art as "immaterial" has been doggedly persistent, with the most peculiar denial of the complex material conditions of production of any and every digital artifact. Information continues to be conceived of as ethereal files that race like simulacral figures through the wires and airwaves of electronic media, rather than as the complex production of elaborately material technology.

In retrospect we can see many obvious links between the idea-based or procedural approaches to conceptual art of the 1960s and the cluster of artistic and creative practices that began to emerge in digital media in the same decade. The far-reaching impact of conceptual art is now well understood as a self-conscious recognition of the relation of ideas and materials in art. The same force can't be attributed to information technology as a major influence in the visual arts over the last quarter of a century. Even in this first decade of the new millennium, it could be argued, the presence of new technology

has been more quickly adapted as a mechanical tool, output device, and production medium than as an influence on the critical or theoretical foundation of artistic practice. Artists are more likely to use digital capabilities for production than to reconceive their work in terms of data structures or procedural methods or according to other models of abstraction and manipulation specific to an information-based approach. These methods of thinking through artistic practice have their outstanding exemplars, as we've seen, but the systematic and broad-based adoption of such methods will come as part of a maturation cycle in new media criticism and pedagogy.

Though many mainstays of conceptual art practice have become widespread, certain key concepts central to conceptualism really had little direct application to digital media art. For instance, the crucial linchpin of conceptualism is the operative distinction between idea and material realization, with its implied temporal sequence of conception to execution. Though this notion is clearly applicable in principle to digital art, its execution quickly becomes problematic. The strict requirements of formal logic and computational method are more stringent than those that govern the general use of a concept like *information* within art practice. While the term *information* may have provided an important and suggestive link between conceptual art and digital media, computational capabilities in programmed and networked environments have their own particular exigencies far from the galleries and museum venues and displays. An important contribution to cultural perception had been gained by the slippage between artistic uses of information and the coming of an information-based sector in economic and cultural affairs, but the long-term potential of digital technology as a transformative agent in aesthetic realms was still to be realized.

Specifically Cybernetic Sensibility

Throughout the 1960s gadgets and electronic devices showed up in art installations and performances. Electronic media, as much as digital means, became a new material component of many art projects.

Signal processing, the manipulation of the processing of data or current (depending on whether the device was digital or electronic) in a machine, provided a new vocabulary of outputs. New sounds, optical forms, and visual effects could be produced through such means.[50] Material manipulation of electronic and digital outputs through recirculation or recoding, as in the case of the use of input from one medium (e.g., music) to produce a different

output (such as light or color effects), provides another fundamental method of production that is specific to the digital environment. Work in robotics, particularly that which allows either autonomous operation of a mechanico-electronic device, or that which depends on remote connectivity through radio or phone or other signal, has extended the possibilities of sculpture beyond the kineticism of mechanical devices. Telecommunications and other forms of highly mediated subjectivity permit human interaction coordinated across time and space in collaborative projects of an ephemeral and performative nature, as well as for production of works with more concrete outcomes. The development of work on the basis of combinatoric, permutational, or other set-theory manipulations, another fundamental feature of the mathematical basis of programming, gave rise to computer-generated poetry, music, and, to a lesser degree, visual artworks. These computational composition strategies moved beyond the mere recombination of modular items in accord with sets of rules into more complex natural-language, expert-system, and artificial-intelligence activities, with higher-level programming capabilities borrowed from cognitive science and complexity theory.

But the use of these materials in itself didn't systematically engage the specific characteristics of digital media. If digital media art had offered only "special effects" and experiential novelties, it wouldn't have provoked critical rethinking about the foundations on which art could be defined as a category of cultural practice—or on which a work could be understood as an ontological object. The qualities of interactive, algorithmic, and networked art that came into focus in the 1960s were developed in the critical writings of Roy Ascott, Max Bense, Gene Youngblood, Herbert Franke, and Melvin Prueitt, along with others already mentioned. Even when largely descriptive (rather than theoretical) in character, these writings helped define the discourse of a specific cybernetic sensibility.[51]

Ascott's 1966 thesis on the cybernetic vision in the arts, "Behaviourist Art and the Cybernetic Vision," begins with the premise that interactive art must free itself from the modernist ideal of the "perfect object."[52] Like John Cage, Ascott proposes that artworks be responsive to the viewer, rather than fixed and static. But unlike Burnham's category of "postformal" art, Ascott's is derived from firsthand involvement with computers and new technology.[53] As a consequence, Ascott is in a position to take Cage's premise into the realm of computer-based art, suggesting that the "spirit of cybernetics" offers the most effective means for achieving a two-way exchange between an

artwork and its audience. As in the shift from classical to quantum physics, the change is in the premises according to which phenomena are conceived.

Ascott stressed the human context in which works were produced, making a strong case for the performative and networked aspects of new media work. Though skilled in the computational techniques necessary for creation of digital work, he was as intent on pointing out the social conditions that arose from consideration of new methods as he was in creating artifacts. Ascott's work finds a counterpoint in Jack Burnham's 1969 essay "Aesthetics of Intelligent Systems," which addresses broader cultural implications of the pervasive presence of computational methods in society, noting the attention-focusing capability of fine art.[54] Ascott had been interested in the behavioral aspects of cybernetic technology, the use of feedback loops as a model of intellectual process, and the use of schematic analysis and diagrams as means of abstracting systems-based procedures into formal structures. The emphasis he placed on dynamic interactions stressed the human participant as an active component of information systems. Interactivity, as mentioned earlier, wasn't being conceived of as a simple menu of options for outcomes, but in the social relationships that produced meaningful experience.

As the desktop environment has become a regular part of the quotidian landscape and as the Internet has evolved into the World Wide Web, the familiarity of computers as basic tools of studio production has inured us to the novelty of their presence in the artist's studio. But the effects of the intersection of computational capabilities and fine art practice also cause us to think differently about traditional art practices. Can we still think of an artwork as a static and autonomous object? Don't the interactive properties of computationally based work demonstrate to some extent that any art object is created as the outcome of a set of conditions? A work always functions provocatively, drawing forth from artist and then viewer a whole host of responses and reactions. An art object functions as a relay, a switching device among people whose exchanged conceptions are passed from one to another like signals bouncing off a way station. Even if a work is substantive in itself, it is never bounded, finished, or self-identical, because it always functions as a node in a set of interconnected relations. This concept of interactivity is fundamental to our understanding of a work of art in this sense, whether it is generated through computational methods, from electronic media, or from a piece of Carrera marble.

Likewise, the algorithmic condition of computationally generated work is merely the case that demonstrates a general condition. Works of art, be they literature, music, visual, or performance pieces, are instances of rule sets. They manifest the possibilities of the conditions for their production; they instantiate one out of a set of possibilities defined by rules and procedures, instructions and logical sequences of operations. The complexity of these systems is such that they are invisible, but the algorithmic condition of expressive forms is revealed by the recognition of the procedural basis of programmed work in new digital media.

Finally, the networked condition in which digital and electronic art exists shows the fully embedded circumstances in which any form of human expression or representation circulates. The relational and contingent condition of networking depends on the fact of constant movement and exchange through which value is generated. The circulation of any and every bit of information through the systems of meaning production gives it social and cultural currency. These are the actual conditions for the creation of the meaning and value of any work of art in ideological and aesthetic terms. No work of art exists in autonomous isolation, no work is without operational premises, and no work is self-identical or self-defined. These principles came into focus as digital media art, in its variety of technological experiments, formal and conceptual innovations, brought the fundamental aesthetic premises of art making into a renewed condition of self-conscious awareness. Our understanding of fine art has been forever and profoundly changed as a result.

Notes

1. Howard Rheingold, *Tools for Thought* (Cambridge, Mass.: MIT Press, 2000, originally published by Simon and Schuster/Prentice Hall, 1985), 296–319.

2. See <http://xanadu.com/xuhistory.html> and <http://www.iath.virginia.edu/elab/hf10155.thm> for information on the early history of *Xanadu*. Details are sketchy; (one suspects Nelson of a certain amount of historical invention, but he dates his original idea to the early 1960s. One of the great mythic projects, *Xanadu* is the still-unrealized project for a way of working and thinking in electronic document space that would take advantage of the linking and versioning capabilities unique to new media.

3. Vannevar Bush, "As We May Think," in *Computer Media and Communication,* ed. Paul A. Mayer (Oxford: Oxford University Press, 1999), 23–36.

4. See Edward A. Shanken, "The House That Jack Built," *Leonardo Electronic Almanac* 6, no. 10 (1998); available at <http://www.artextra.com> and <http://mitpress.mit.edu/e-journals/LEA/ARTICLES/jack.html>, for a more developed discussion of this exhibition.

5. The term *digital* always refers to media that make use of encoded information in the form of bits. Generally, these are electric or electronic, but binary code can exist outside an electronic environment. Likewise, the terms *electric* and *electronic* refer to art using electric current and art using some form of transistor that, again, may or may not be digital. The phrase *new media* is technologically imprecise and generally refers to a heterogeneous field of electronic tools, some of which are analog, some digital, and some hybrids of the two. The contemporary development of these technologies and their integration in a relatively short time span in the decades of the mid-twentieth century tends to conflate the terms. The significance of their difference resides in the specific conceptual premises that can be brought to bear in the production and manipulation of information in abstract form in digital work. Electric and electronic instruments can be intervened in with little mediation, whereas the encoded condition of information in binary form introduces another layer of mediation into the structure of any activity using digital devices.

6. See Sandra Braman, "Art in the Information Economy," *Canadian Journal of Communication* 21 (1996): 179–196, for discussion of art and cultural capital conceived in terms of information.

7. Frank Popper, *Art of the Electronic Age* (New York: Thames and Hudson, 1993).

8. Mark C. Taylor and Esa Saarinen, *Imagologies* (New York: Routledge, 1994).

9. The Digital Art Museum director is Wolfgang Leiser. Digital Art Museum timeline for digital art, available at <http://www.dam.org/history/index.htm>, lists exhibitions at various sites in the 1960s.

10. Jasia Reichardt, *The Computer in Art* (London: Studio Vista, 1971); but see also work on the history of computing such as Pamela McCorduck, *Machines Who Think: A Personal Inquiry into the History and Prospects of Artificial Intelligence* (San Francisco: W. H. Freeman, 1979); Daniel Crevier, *AI: The Tumultuous History of the Search for*

Artificial Intelligence (New York: Basic Books, 1993); Martin Campbell-Kelly and William Aspray, *Computer: A History of the Information Machine* (New York: Basic Books, 1996); and Howard Rheingold's various volumes, to name just a few introductory works.

11. Many imaginative and popular sources could be cited here from science fiction (Philip K. Dick, Rudy Rucker, Arthur Clarke, Isaac Asimov), television series such as *The Jetsons* and *Lost in Space,* or the writings of "futurologists" such as Buckminster Fuller, and a bit later, Alvin Toffler.

12. Richard Buckminster Fuller, *Utopia or Oblivion: The Prospects for Humanity* (London: Allen Lane, 1970); and *Education Automation: Freeing the Scholar to Return to His Studies* (Carbondale: Southern Illinois University Press and London: Feffer and Simons Inc., 1962); Marshall McLuhan, *Understanding Media: The Extensions of Man* (New York: McGraw-Hill, 1964), and Marshall McLuhan and Quentin Fiore, coordinated by Jerome Agel, *War and Peace in the Global Village: An Inventory of Some of the Current Spastic Situations That Could Be Eliminated* (New York: McGraw-Hill, 1968), and a host of other titles by these authors responsible for introducing concepts like "spaceship earth" into popular vocabulary.

13. John Kenneth Galbraith, *The New Industrial State* (Boston: Houghton Mifflin, 1967). Daniel Bell, *The Coming of Post-Industrial Society: A Venture in Social Forecasting* (New York: Basic Books, 1973).

14. Claims made for radical innovation or novelty effects achieved through technical means often ring hollow on closer examination. Special effects often conceal prosaic aesthetic attitudes. Holography has struggled long and hard to overcome the burden of technology that constrains its image values. The contents of the works produced by Ken Knowlton at Bell Labs are shockingly dull images of gulls aloft or a telephone on the table or a female nude rendered in symbol set (this last is actually the funniest of the group). The opposite is also true, of course: that what passes for "technological sophistication" in an art context would be baby-step activity in an engineering environment. Interdisciplinary intersections produce their own useful intellectual provocations, however inadequate their outcomes might be in a disciplinary frame.

15. Gene Youngblood, *Expanded Cinema* (New York: Dutton, 1970), 45, 41.

16. Attitudes that continue in educational institutions today. Art is rarely given "research" status.

17. John Handhardt, *Video Culture* (Rochester, N.Y.: Peregrine Smith with Visual Studies Workshop, 1986), provides a critical assessment of this phase.

18. Popper, *Art of the Electronic Age,* and David Dunn, ed., *Pioneers of Electronic Art* (Santa Fe: Ars Electronica and The Vasulkas, 1992).

19. Whitney, Digital Art Museum timeline for digital art, and Melvin Prueitt, *Art and the Computer* (New York: McGraw-Hill, 1984).

20. This remains true even at the time of this writing. Studio programs with traditional "area" focus boundaries often remain wedded to their legacy protocols. The fine arts graduate program in photography at Yale is a perfect example of such resistance, as is the painting program at SUNY–Purchase.

21. See articles in *Leonardo* in the early 1990s for some idea of this separate realm of activity.

22. Craig J. Saper, *Networked Art* (Minneapolis: University of Minnesota Press, 2001).

23. Jon Hendricks, *Fluxus Codex,* with an introduction by Robert Pincus-Witten (Detroit: Gilbert and Lila Silverman Fluxus Collection in association with H. N. Abrams, New York, 1988).

24. Elizabeth Sussman, *On the Passage of a Few People through a Rather Brief Moment in Time: The Situationist International, 1957–1972* (Boston: MIT Press and Institute of Contemporary Art, 1989); Alan Kaprow, *Essays on the Blurring of Art and Life* (Berkeley: University of California Press, 1993); and Robert Morgan, *Conceptual Art* (Jefferson, N.C.: McFarland, 1994).

25. Pierre Restany, *Yves Klein* (New York: Abrams, 1982).

26. See Rheingold, *Tools for Thought,* and Fred Moody, *The Visionary Position* (New York: Times Business, 1999).

27. Sol Lewitt, "Paragraphs on Conceptual Art," *Artforum* 5, no. 10 (June 1967): 79–83.

28. See Frances Colpitt, *Minimal Art: The Critical Perspective* (Seattle: University of Washington Press, 1990), for discussion of procedural work; see also *Sol Lewitt: drawings 1958–1992* (The Hague: Haags Gemeentemuseum, 1992), exhibition catalogue.

29. Reichardt, *The Computer in Art,* 86–87. Reichardt's similarly conceived anthology, *Cybernetics, Art and Ideas,* published a year later in 1971, includes Max Bense's "Generative Aesthetics" and Abraham Moles's "Art and Cybernetics in the Supermarket" (Greenwich, Conn.: NY Graphics Society). The point-by-point discussion of instrumental applications of computational method to creative activity in these essays exemplifies Reichardt's editorial point of view. For another important early experiment, see Lloyd Sumner, *Computer Art and Human Response* (Charlottesville, Va.: Paul B. Victorius, 1968).

30. Neil Spiller, ed., *Cyber_Reader* (New York: Routledge, 2002).

31. See Digital Art Museum timeline, for more details <http://www.dam.org/artists/phase1.htm>. The first exhibition listed is in 1959 at the Museum fur Angewandte Kunst in Vienna, with numerous other sites in the 1960s, many technical academies or more venues catering to a specialized, niche audience. The significance of the 1968 and 1970s exhibitions is their centrality within art world contexts. Also see Popper, *Art of the Electronic Age.*

32. Edward Shanken notes that Burnham was influenced by "The House That Jack Built," Shanken's reading of Heinz von Foerster's *Observing Systems.* See Shanken, "The House That Jack Built."

33. Jack Burnham, "Systems Esthetics," in *Artforum* magazine, vol. 7, no. 1 (September 1968), 30–35, 22; see also his extended discussions in *Beyond Modern Sculpture: The Effects of Science and Technology on the Sculpture of This Century* (New York: George Braziller; London: Allen Lane/Penguin Press, 1968).

34. Edward Shanken has produced several papers about Burnham's work in this context, though Shanken is more convinced than I am about the alignments of conceptual art and information technology, since I see conceptual art's presence as far more influential in the art realm than info tech has been, and for different reasons than those that account for the pervasive presence of digital media in the broader culture. See Shanken's online publications: <http://www.duke.edu/~giftwrap/>.

35. Burnham, *Great Western Salt Works* (New York: George Braziller, 1970).

36. Jack Burnham, "Notes on Art and Information Processing," in *Software Information Technology: Its New Meaning for Art,* ed. (New York: Jewish Museum, 1970), 10–14. Catalog of the "Software" exhibition curated by Burnham at the Jewish Museum in Brooklyn, NY (16 September–8 November 1970).

37. Caroline Jones, *The Machine in the Studio* (Chicago: University of Chicago Press, 1996).

38. Quoted by Jack Burnham, from a quotation in Tomas Maldonado, *Max Bill* (Buenos Aires: ENV, 1955), on the back cover of Burnham's *Beyond Modern Sculpture.*

39. Max Bense, "Towards a Generative Aesthetics," in *Cybernetics, Art, and Ideas,* ed. Jasia Reichardt (Greenwich, Conn.: New York Graphics Society, 1971); see also Herbert Franke and Hörst S. Helbig, "Generative Mathematics: Mathematically Described and Calculated Visual Art," in *The Visual Mind,* ed. Michele Emmer (Cambridge, Mass.: MIT Press, 1993), 101–112.

40. N. Katherine Hayles, *How We Became Post-Human* (Chicago: University of Chicago Press, 1999).

41. Eduardo Kac, "Foundation and Development of Robotic Art," *Art Journal* 56, no. 3 (1997): 60–67.

42. See Johanna Drucker, "Collaboration without Objects," *Art Journal* 52, no. 4 (1993): 51–58.

43. *Fluxus Codex.*

44. Exceptions could be cited, such as Claes Oldenburg's *Store with his Ray Gun* pieces, which were original elements of the work, not later reconstructions.

45. Burnham, "Systems Esthetics."

46. Not all performance-based work was postformal or conceptual, and certainly much of it was almost perversely insistent on material conditions. The use of artists' bodies in endurance works demonstrated a perverse extreme in which supposed dematerializations almost beg to be contradicted through intervention. Gina Pane comes to mind, or even Yoko Ono and Chris Burden. This belongs to another discussion, except for the fact that the "bodies" of viewer and artist are so frequently overlooked as locations for the artistic experience that is brought to attention by a postformalist aesthetic.

47. Burnham, *Beyond Modern Sculpture.*

48. Lucy Lippard, *Six Years: The Dematerialization of Art* (New York: Praeger, 1973).

49. Benjamin Buchloh, "From the Aesthetic of Administration to Institutional Critique," in *L'art conceptuel,* ed. Suzanne Pagé (Paris: Musée d'Art Moderne de la Ville de Paris, 1989), 41–53.

50. Dunn, *Pioneers of Electronic Art;* and Popper, *Art of the Electronic Age.*

51. Herbert Franke, *Computer Graphics* (London: Phaidon, 1971); and Prueitt, *Art and the Computer.*

52. Roy Ascott, "Behaviourist Art and the Cybernetic Vision," *Cybernetica: Review of the International Association for Cybernetics* X, no. 1 (1967): 25–56, 37.

53. Ascott had spent a year at the Massachusetts Institute of Technology working with time-sharing capabilities of mainframes in 1968–1969 with Gyorgy Kepes. See Edward Shanken's "Is There Love in a Telematic Embrace?" <http://mitpress2.mit .edu/e-journals/Leonardo/isast/articles/shanken.html>, for a more complete discussion of Ascott, and also Shanken's "The House That Jack Built" for a good discussion of the contrast between Burnham and Ascott.

54. Jack Burnham, "Aesthetics of Intelligent Systems," in *On the Future of Art,* ed. E. F. Fry (New York: Viking, 1970), 95–122.

2

Immaterial Material: Physicality, Corporality, and Dematerialization in Telecommunication Artworks

Tilman Baumgärtel

The last 150 years have been a period of intense dematerialization. New media and telecommunication technologies such as the telephone, radio, television, and on-line networks such as the Internet have dramatically changed our sense of time and space. The increased speed of machine-supported movement with trains, cars, and planes adds to this new sense of space. Although the distances between various different places remain objectively the same, the increased speed with which we are able to cross the territory in between has created a new perception of these spaces.

With telecommunication media, this modernist experience has become even more elementary. With new media such as the telegraph, telephone, and Internet, the body itself plays no role at all anymore in the communication of a message from one point to another. Whereas trains, cars, or planes still move bodies and material goods from one location to another, with telegraph or telephone it became possible for the first time to move messages without any material aspect at all. The discovery of electromagnetic waves in the late nineteenth century by Heinrich Hertz marks the great divide between the material and the telematic age, which is characterized by the split between message and sender, between signal and body. After that discovery, it was no longer the body or a material object that had to travel to communicate information, but rather it was invisible and immaterial waves transporting signals from one point to another, from station to station.[1] These technical advances created a space, or rather, nonspace, that was previously beyond the imagination: a (non)place in which time and space collapsed into one another and which was accessible potentially from everywhere, by everybody, and at all times.

This development has been further radicalized by the introduction and dissemination of computers and computer networks such as the Internet. Here the signals have been broken down into the smallest imaginable elements, zeros and ones that not only can be transported over long distances in an instant, but also can be processed, channeled, filtered, searched, and revised. The immaterial data traveling over these networks not only move information from one place to another, they can also manipulate processes in the physical world, be they Web cams, automated teller machines, or Internet-controlled telerobots.

These new means of telecommunication punch "a hole in space"—not coincidentally the title of one of the first telecommunication art pieces, a television-satellite link between Los Angeles and New York by Kit Galloway

and Sherrie Rabinowitz, who operated under the name Mobile Image.[2] *Hole-in-Space* is only one of many art projects that try to come to terms with the new "space" that has developed "within" the telecommunication network space. Created in 1980, it belonged to the first wave of artworks that employed communication satellites for artistic purposes and is one of the earliest and conceptually most interesting examples of the artistic use of an electronic telecommunication network. The piece is part of the ongoing attempt to use these new, immaterial networks for the creation of art. Be it the telephone, the fax machine, the bulletin board systems of the 1980s and early 1990s, today's Internet—every new telecommunications medium has been tried out as a tool by artists. One of the most important aspects of the telecommunication networks that these artists examined was the immateriality of the media they worked with. Just as was the case with video art— but to an even more extreme extent—the telecommunication media were intangible and without physical presence, a quality that was frequently addressed by the works that were realized for these media.

This chapter concerns itself with the historic exhibition Les Immatériaux, which took place at the Centre Pompidou in Paris in 1985 and addressed the issue of immateriality, and the concepts about the *immateriel* developed by its cocurator, the French philosopher Jean-François Lyotard. I will examine how Les Immatériaux attempted to grapple with the difficult task of showing something that was by definition "immaterial" and therefore almost impossible to present in a traditional exhibition. This topic has been an important issue in the art that exists exclusively within new telecommunication spaces and that, because of its very immateriality, has presented numerous problems for galleries and exhibitions that wanted to show these works. The press release for Les Immatériaux talked of a "nonexhibition," because many of the phenomena that were presented were hardly visible or not visible at all, therefore difficult to show in an exhibition: "The subject of the show itself calls the traditional methods of representation of an exhibition into question, the tradition of the salon of the 18th century and the gallery."[3]

Les Immatériaux was troubled by some of the same problems that haunt every show that tries to incorporate projects that have been created for telecommunication networks. Although the show chose some very different approaches to exhibiting "immaterial materials," its subject matter was very similar to that of many arts projects that use telecommunication media, es-

pecially the Internet. In particular, very early Net art projects from the mid-1990s showed a strong sensitivity to the issue of immateriality and its artistic consequences. It almost seems as if the earlier in the short history of Net art these pieces were created, the more conscious they were of the special qualities that the medium they worked with entailed. Some of these works will be the subject of the second part of this chapter.

Les Immatériaux was a landmark in the development of a discourse on the postmodern society. It not only promoted Lyotard's philosophy but also played an important part in the Central European debate on the shifts in society, technology, and labor that went on in the 1980s in the writings of thinkers such as Jean Baudrillard, Paul Virilio, and Friedrich Kittler, among others.[4] Many of the topics the show touched upon were also addressed in the telecommunication and Internet art that appeared in the 1990s, mainly out of Europe. In some cases, it is even possible to show that a number of telecommunication and Internet artists and theorists either saw the show or at least had significant information about it. However, many more of the activists of the telecommunication and Net art period of the 1990s did not see the show or even know about it, yet they dealt with some of the same subjects; so it appears that Les Immatériaux dug up, almost instinctively, ideas that were about to surface in the arts in the following years.

Les Immatériaux was an original exhibition that touched on a number of topics from very different fields and disciplines, including art and philosophy, automation and microelectronics, telecommunication and computerization. "It is important for philosophers to deal with subjects, that are none of their business," Lyotard pointed out in an interview. "It is not our intention to sum up the new technologies in this exhibition (in part, because they make any kind of encyclopaedic knowledge impossible) or to explain how they work. All it attempts is to discover and raise a sensibility that is specific to Post-Modernism, and we assume that it exists already. This new sensitivity is still hidden, though, and not conscious of itself."[5]

The show was to highlight the technologies that were prerequisites to what Lyotard had called "la condition postmoderne" in one of his best-known books.[6] Modern telecommunications technologies were among the most prominent examples of these technologies that the show put forward, and Lyotard frequently stressed that these technologies transcended matter and corporeality. In an interview on the show, Lyotard added:

The term "immaterial" refers to a somewhat daring neologism. It merely expresses that today—and this has been carried through in all areas—material can't be seen as something that, like an object, is set against a subject. Scientific analyses of matter show that it is nothing more than an energy state, i.e., a connection of elements which, for their own part, are not understandable and are determined by the structures which each have only a locally limited validity. . . . The increasing mutual penetration of matter and spirit which is equally clear in the use of word processing systems is now felt in the classic problem of the unity of body and soul shifts.[7]

And in a conversation with Jacques Derrida, he added that Les Immatériaux "designate a structure, in which there is no room anymore for the traditional difference between intellect and matter."[8]

As a synopsis of the postmodern information and service society, Les Immatériaux not only put a great emphasis on the influence that the new methods of on-line communication might have on our life, it even included an on-line conference with a number of philosophers and journalists, conducted during the show on Minitel, the state-sponsored French on-line system.[9] The conference participants included Daniel Buren, Michel Butor, and approximately twenty other French intellectuals. Lyotard commented: "The experiment seems to me to be especially interesting in terms of how all the times of writing are changing: the time of inspiration, the time of re-reading one's own text, the time where one has the text in front of oneself, the time to check with other texts. And in relation to time this experiment has to be examined."[10]

This on-line conference was an early attempt in collaborative writing, networked discourse, and moderated on-line debate that both precedes and resembles the many similar projects that have taken place on the Net since. Mailing lists such as nettime, re:code, Rohrpost, and Spectre, as well as the many discussion projects that take place on-line for a limited time, have since taken up and popularized this concept. Both the show in general and the on-line writing in particular exerted a strong influence on the development of a discourse on on-line media and of a network-specific art.[11] For example, German artist and hypertext researcher Heiko Idensen points out Les Immatériaux and the possibility of a sophisticated intellectual on-line communication that he encountered at this show as one of the major reasons that he wanted to get involved with computer networks as an artist and critic.[12]

Les Immatériaux incorporated some works by artists that from a contemporary point of view can be considered to be groundbreaking for artistic practices on the Internet and with other telecommunication media: some conceptual artists and some preconceptual minimalists such as Joseph Kosuth, Dan Flavin, Giovanni Anselmo, Robert Ryman, and Robert Barry. Marcel Duchamp, who has frequently talked about his concept of an "anti-retinal" art, was also included. So the show presented some of the most prominent conceptual artists, whom Lucy Lippard wrote about in her book *Six Years,* as well as the art she referred to in the book's famous introduction as "dematerialized": "Conceptual art, for me, means work in which the idea is paramount and the material form is secondary, lightweight, ephemeral, cheap, unpretentious and/or 'dematerialized.'"[13]

This, of course, would also be a good definition of some of the Net art of the following years. Much of the art that was presented at Les Immatériaux was a direct predecessor of telecommunications and Internet art, which is also not only dematerialized, but also unpretentious, ephemeral and (an aspect that is often overlooked) mainly cheap to produce. These qualities are an important source for some of the motifs that appear quite frequently in early Net art pieces: references to physical space and the body, so-called gateway projects that try to connect the virtual space of the Net with the "real world," and projects that address human identity and its trappings in an on-line environment.

Les Immatériaux was structured into a number of sections that had titles such as "Peintre sans corps," "Tout les copies," "Memoires artificielles," "Homme invisible," or "Théâtre du non-corps." Each of these section titles would make perfect sense as chapter titles in an imaginary study on motifs in Net art, because all of the topics they represent are addressed in early Net art pieces, and none of them would have any significance if it weren't for the immateriality of on-line media. The absence of the body, the ease with which endless copies of a digital "original" can be produced, faked memories, and the vanishing of identity and body are all topics of telecommunication and Net art for a good reason: They play upon distinctive qualities of the very media that are used for telecommunication. Digital and communication media have produced a number of recurring motifs, and these motifs mirror the technical infrastructure of telecommunication network architecture.

Some prime examples of early telecommunication art were the projects that the Canadian N.E. Thing Company, Ltd., produced in the late 1960s

and early 1970s. A newspaper article described one of the company's concepts for the use of the international telex system as follows:

So one can imagine the telex at General Motors sounding a sprightly prelude of bell ringing, followed by the N.E. Thing Co. logo ("the world's only telexable logo"), then the admonition: "DON'T LOOK AT THIS UNLESS YOU ARE READY FOR ANYTHING," followed by an invitation to consult the N.E. Thing Co. on "IMAGINATION . . . THE G.N.G. . . . GROSS NATIONAL GOOD . . . IDEAS . . . ANYTHING," at their offices in Vancouver or Ottawa.[14]

Needless to say, the N.E. Thing (pronounced "anything") Company, Ltd. (NETCO) wasn't a proper company that was offering its services to a blue-chip company like General Motors. It was instead an art project by Canadian artists Iain and Ingrid Baxter. Long before the short period of "business art" in the eighties and nineties, the couple marketed themselves as a company that provided "art services" to the art market. Connected to the conceptual art movement of the late sixties, when such art was still called "idea or information art" by many critics, the Baxters registered N.E. Thing as a company in 1969. Its provincial incorporation lists the expressed objects:

i. To produce sensitivity information:

ii. To provide a consultation and evaluation service with respect to things:

iii. To produce, manufacture, import, export, buy, sell, and otherwise deal in things of all kinds.[15]

N.E. Thing's "business activities" earned the Baxters not only an invitation to a number of major international exhibitions of conceptual art but also a membership in the Vancouver Board of Trade. In a show at the National Gallery of Canada in Ottawa, they set up an office as their headquarters in the museum and published their corporate archive in *The N.E. Thing Co. Ltd. Book*.[16] But most importantly in the context of this chapter, they, along with Hans Haacke and his installation *News* (1969), were among the first artists to use the telex for artistic purposes. In the context of their ironic inhabitation of commercial and bureaucratic institutions, this makes them the forerunners of the many attempts to establish fake institutions and companies within (electronic networks) by artists such as etoy, Stuart Rosenberg, IRWIN, Heath Bunting, and Rachel Baker.

The telex was a perfect medium for establishing a "virtual identity" for a pseudocompany such as N.E. Thing. In the dematerialized territory of electronic communication, it gave the company respectability. Unlike the Internet, the telex network was difficult to access and available only at high prices that mostly companies could afford; individuals were rare among the customers of the telex companies because of the prohibitively high costs. N.E. Thing was sponsored by a communications company for its experiments. When Iain Baxter talked to a reporter from the *Vancouver Sun* describing his fascination with the telex, he almost sounded like early Net art enthusiasts: "It's an open channel. No one can stop the telex from working because it's a twenty-four-hour-a-day communication hookup. As soon as you dial the number you are really into that office and then, depending on the personality of the people and their attitudes and so on, well it's up to them what happens. . . . I'd like to find out what the machine can do, what are the processes inside it that can provide new ways of looking at our total environment."[17]

N.E. Thing used the telex not only to establish its "virtual identity," but also to send instructions to remote galleries and museums about how to set up its pieces:

In the Company's interpretation of McLuhan, communications media were used to an advantage by sending telex and telecopier messages from geographic, political and economic peripheries, creating what Ingrid [Baxter] called an aesthetic of distance—a means through which the Company could traverse time and space, inserting its presence in territories that it would otherwise be excluded from. . . . Furthermore, communication works were also a cheap, easy, quick and portable means of artistic demonstration which allowed for an infiltration of national and international corporate and artistic systems that traverse geo-political boundaries.[18]

Creating pseudo-identities and -entities on the Net has been an important subject for on-line artists ever since.

With the telex system as with the Internet, the data were by definition "everywhere and nowhere" at the same time, because transmission of the data took place in a telecommunications network. The data "materialize" only when accessed from a telex machine somewhere (or anywhere) else. This "space" is characterized by dematerialization. Without any physical existence and physical distances, it plays no significant role on the Net. When N.E. Thing used the telex system, it did not only operate in this environment,

it reflected in its work the very qualities of this nonspace. Like the Net artists of the 1990s, N.E. Thing created a number of installations and on-line pieces that dealt precisely with the problematic question of location and space in an on-line environment and that often attempt to make the exchange of digital data on the Net physical again.

When Rosalind Krauss wrote her seminal essay "Video: The Aesthetics of Narcissism"[19] in 1976, she observed how a particular formal quality of the then-new medium video became a subject of the works of many video artists. The fact that video is able to record and transmit at the same time, producing instant feedback, led to a huge number of works by artists such as Richard Serra, Nancy Holt, Vito Acconci, and Joan Jonas that dealt with the possibility of turning the human body into the central instrument and subject matter for this recording. "The body is therefore as it were centered between two machines, that are like the opening and the closing of a parenthesis. The first of these is the camera; the second is the monitor, which reprojects the performer's image with the immediacy of a mirror,"[20] Krauss wrote and identified this phenomenon in the works of a number of video artists.

Similar mechanisms are at work in projects that were created for the Internet and other telecommunication media. Whereas one of video's capacities is the possibility of recording and transmitting, in the case of on-line media, the "material" of telecommunication and Net art is exclusively immaterial data and "immatériaux," to use Lyotard's term. The most successful on-line projects are native to their medium, because they make use of the specific formal qualities of that medium and turn those qualities into subject matters of their work. The pseudo-entities and companies, the relationship between real territory and corporeal cyberspace, the correlation between human and "data body" are central topics to Net and telecommunication art, because they also deal with one of the most significant properties of Net and telecommunication media. By "semiotizing" the phenomena of the real world, the Net opens up very specific gaps for artistic intervention. Although fakes and works that deal with the contradictions between the physical and real and the virtual and immaterial are not limited to Net art but have been dealt with in other, more traditional art forms, in the environment of the Internet and its technical structures, they have an even greater relevance.

As quoted earlier in the chapter, Lyotard said in an interview that Les Immatériaux "attempts . . . to discover and raise a sensibility that is specific to Post-Modernism, and we assume that it exists already. This new sensitivity

is still hidden, though, and not conscious of itself." Telecommunication and Net art works try to express this "new sensitivity." They make us conscious of the immaterial phenomena that have developed within telecommunication technologies. They don't do it with a theoretical approach, they do it by actually engaging with these "immatériaux," by taking these new conditions, with which we have grown familiar so very quickly, to an extreme in order to create an opportunity to experience them again and make them unfamiliar again.

Notes

1. See also Peter Weibel, "Techno-Transformation and Terminale Identität," in *Telematik–NetzModerneNavigatoren,* ed. Jeannot Simmen (Cologne: Buchhandlung Walter König, 2002), 8–15.

2. Frank Popper, *Art of the Electronic Age* (London: Thames and Hudson, 1993), 136–138.

3. From the reprint of the press release in Jean François Lyotard et al., *Immaterialität und Postmoderne* (Berlin: Merve, 1985), 11–12. Translation of all German sources by the author.

4. Probably because of language constraints, the show seems to have had much less of an impact in the English-speaking Anglo-Saxon world. However, a very thorough discussion of the philosophical implications of Les Immatériaux is Anthony Hudek, "Museum Tremens of the Mausoleum without Walls: Working through Les Immatériaux at the Centre Pompidou in 1985" (M.A. thesis, Courtauld Institute, London, 2001).

5. Lyotard et al., *Immaterialität und Postmoderne,* 33.

6. Jean-François Lyotard, *La condition postmoderne* (Paris: Les Editions de Minuit, 1979).

7. Lyotard et al., *Immaterialität und Postmoderne,* 22.

8. Ibid., 23–24.

9. Ibid., 26.

10. Lyotard et al., *Immaterialität und Postmoderne,* 56.

11. For an extended discussion of the early history of these artistic telecommunication experiments before Internet art, see Tilman Baumgärtel, "Net Art: On the History of Artistic Work with Telecommunications Media," in *net_condition: art and global media,* ed. Peter Weibel and Timothy Druckrey (Cambridge, Mass.: MIT Press, 2000), 152–162.

12. See interview with Heiko Idensen in Tilman Baumgärtel, *net.art—Materialien zur Netzkunst* (Nuremberg, Germany: Verlag für moderne Kunst, 1999), 46–54.

13. Lucy Lippard, *Six Years: The Dematerialization of the Art Object from 1966 to 1972* (Berkeley: University of California Press, 1973), vii.

14. Joan Lowndes, "'Easel' is a Telex," in *You Are Now in the Middle of a N.E. Thing Landscape: Works by Iain and Ingrid Baxter 1965–1971,* ed. Nancy Shaw and William Wood (Vancouver: University of British Columbia, Fine Arts Gallery, 1993), 48–49, 48.

15. William Wood, "Capital and Subsidiary. The N.E. Thing Co. and the Revision of Conceptual Art," in *You Are Now in the Middle of a N.E. Thing Landscape: Works by Iain and Ingrid Baxter 1965–1971,* ed. Nancy Shaw and William Wood (Vancouver: University of British Columbia, Fine Arts Gallery, 1993), 11–21, 12.

16. *The N.E. Thing Co. Ltd. Book* (Vancouver and Basel: NETCO and the Kunsthalle Basel, 1978), unpaginated.

17. Vancouver Sun, January 9, 1970. Cited in Joan Lowndes, "'Easel' is a Telex," in ed. Nancy Shaw and William Wood, *You Are Now in the Middle of a N.E. Thing Landscape. Works by Iain and Ingrid Baxter 1965–1971* (Vancouver: University of British Columbia, Fine Arts Gallery, 1993), 48.

18. Nancy Shaw, "Siting the Banal," in ed. Nancy Shaw and William Wood, *Works by Iain and Ingrid Baxter* (Vancouver: University of British Columbia, Arts Gallery, 1993), 25–41, 32–34.

19. Rosalind Krauss, "Video: The Aesthetics of Narcissism," in ed. Gregory Battcock, *New Artists Video* (New York: Dutton, 1987), 43–64. Reprinted from *October* 1, no. 1 (Spring 1976).

20. Ibid., 45.

3

From Representation to Networks: Interplays of Visualities, Apparatuses, Discourses, Territories, and Bodies

Reinhard Braun

Translated by Cecilia White

In 1972 Gottfried Bechtold created the multiple *Media Suitcase* (which was exhibited at Documenta 5 in Kassel)—a collection of various media available at the time, ranging from photography and slides through to Super-8 film and a reel-to-reel videotape. The videotape included in the collection was blank. The whole *Media Suitcase* was for sale; it was intended to be an archive in itself, with the blank open reel video tape to be recorded by the buyers. What they filmed, according to Bechtold's instructions, was then part of the *Media Suitcase,* as an archive initiated by the artist and completed by the buyers. Bechtold did issue one clear instruction: the camera had to be aimed at the video recorder during filming in order to document the medium itself. However, *Media Suitcase* was not simply an assemblage of media formats. Nor was it merely an offer to purchasers to participate in content production. It was first and foremost a collection of cultural technologies.

From photography through to video technology, the differences among them notwithstanding, a universal genealogy of the (visual) capture and assimilation of realities becomes apparent. Within this genealogy, discovering, cataloging, representing, ordering, and discoursing are all processes that technical media use as cultural tools. But media should never be understood only through their superficial characteristics or merely as interfaces: Certain ideas of reality, society, and subject are always encoded in them. "Every medium shapes human interaction in that, like a metaphor, it transforms experiences. Media work like metaphors insofar as they pre-construct the world we perceive."[1] Up until and including video technology, there was a centralized organization of space and visualities, which Foucault explains as surveillance and discipline. It was through this working of surveillance and discipline that technically reproduced visual objectification and commodification operated, as did the hegemonic control of the means of cultural representation: "Representation is the manner in which we can make some form of sense of the world so that it serves our own interests. It's a political process and it holds the power to produce within itself meaning for the world at large as well as for its own surroundings. . . . Representation is understood as a location for power plays."[2]

Thus Bechtold's *Media Suitcase* represents more than one hundred years of the politics of visualities as the politics of power, which dictates that reality is a picture of the world. Techniques of representation appear within this as technological ideologies of transparence: "'visuality' is due to community and epistemological conditions which make it possible—in other words, the

relationship between power and knowledge."[3] Thus, *Media Suitcase* pursues "an exploration of technology, which doesn't double the world, but rather changes the world."[4] And this exploration is not just artistic. It is deeply political: "Everything on TV is reality. But reality is being in possession of a blank screen. And that possession of a screen is called engaging with reality. However this also means being involved in the relationships of power."[5]

During the 1960s and 1970s, the practice of media art in Austria was characterized by a "critical commentary on a media-conditioned population. It was a questioning of the manner in which 'reality' was being presented by the media."[6] In no way did this media-based transmission of "reality" facilitate some utopia of democratized and pluralized cultural productions of meaning. Nor did the critical implementation of minority discourse and the beginnings of revision of hegemonic forms of politics of visualities refer to the question of the meaning of images. Instead it had to do with the question of their construction and circulation. The media-technical, social-ecological, and political structures of image making were highly debated issues (cf. projects like *Epistemic Videotechnology*" [1974] by Peter Weibel; *Adjuncted Dislocations II* [1978] by Valie Export; and *Video Installation* [1972], by Gottfried Becthold).

"A picture's space, a film's location, is the marker of what is real, symbolic and imaginary. In Expanded Cinema the cinema system was broken up into its individual components, deconstructed, strewn around and then reconfigured. It was shifted within visual meaning and then reassembled. Expanded Cinema is the forerunner of electric cinema, of virtual reality."[7] Expanding artistic practice has nothing to do with an expansion of the concept of art. Instead it relates to the working through of strategic descriptive associations in which media like video, television, and film are not characterized primarily as aesthetic visual carriers, but as ensembles of cultural techniques whose elements also stem from the fields of technology, science, art, and politics. Because of this, video, television, and film are simultaneously material to be examined, and the method of examination, the media art practice, is a form of intervention into and within media-based perception. These interventionist and participative practices oppose the idea of an artwork as a complete and fixed form, and in so doing *refer to* other practices that transgressed their artistic context, such as Fluxus, performance art, and conceptual art.

This openness, this lack of completion, is one of the fundamental shifts in a conceptual approach, whereby the conditions of institutional frameworks

are revised and the potential for participation is created. What is then conceivable is the artistic project as a transactional space, as an intervention space, as a cooperative process and temporal construct. What Roy Ascott wrote on early network projects also seems to relate to earlier projects within the framework of video art or Expanded Cinema (projects like *inside-outside* [1973] by Richard Kriesche and *Facing a Family* [1973] by Valie Export): "The work is never in a state of completion, how could it be so? . . . It subverts the idea of individual ownership of the works of imagination."[8]

The transition from representation and object to the possibilities of transactional space, the reorganization of process, and the openness of interpretation create notions of conceptual spaces. However, these conceptual spaces can no longer be mapped by physical coordinates. Instead their elements and meanings are organized within an open, uncompleted, relational system. Spaces emerge beyond physical spaces, the elements of which are no longer tied to their character as a carrier of representation. "My work has no particular place, or the place is unknown."[9] The shift from object to process (deconstruction, intervention, reconstruction, reception) is not a purely technically driven one, from item to information. Rather it is a cultural shift in general, located, therefore, also in the arena of change within artistic practice.

Within the framework of conceptual art, projects were made as antiobjects, as renunciation of the specially made object. These projects (including, for example, the work of Dan Graham and Douglas Huebler) rejected an assimilation of existing object-based work and media forms and ultimately called into question the autonomy of art and artwork in general. The basis for this internal questioning was created not only by the split of concept from execution, but also by the differentiation between the relationships of presentation and reception: that which is exhibited or demonstrated is oftentimes a reflection about the work itself or about the use of signs or media within the work. The recipients are not so much addressees of projects; rather, they are reconstructors of the various references and contexts.

Also in the area of Mail Art from the 1960s onward, projects have been realized that had nothing to do with the circulating objects as aesthetic manifestations. They had to do, instead, with the circuitry of ideas and information, the circulation of concepts, and the construction of an (art) community. "This other art is something small, that can be carried around in a bag, sent on a postcard, captured on a videotape, can be driven to, found during a stroll or painted on a wall."[10] The uncoupling of the work from specific contexts

and from the context of the work itself makes its mobilization possible and facilitates transfers and transgressions, which are important not as an art theme, but as its process and form.

Between July 1, 1969, and July 1994 Douglas Huebler created *Duration Piece No. 13*. One hundred one-dollar notes were circulated, accompanied by a letter saying that anyone sending the note back to Huebler would receive $1,000 in return. What could possibly be identified as the material, space, or work of art in this case? How can a separation of the work be formulated beyond its arbitrary temporal fixation? Who emerges through all of this as the producer? Who decides the "form" of the work? Because of artists', like Huebler's, strategies in dealing with these questions and because of the way they provided—so to speak—new answers, art is effectively released from the discourse of production in the narrower sense. Art remains in the background as a would-be strategy, as a way of describing and justifying. Huebler defined art as a "system of documentation," a system that is becoming more and more, according to Jean-Louis Comolli, a "system of cooperation" within the framework of change from a culture "driven by representation"[11] to a culture driven by networked operations. "Just as the camera has come to symbolize the entirety of photographic and cinematic process, the computer has come to symbolize the entire spectrum of networks, systems, and devices."[12]

A panorama of connected machines (with the computer as its paradigmatic object)—and all the transformed processes of perception, communication, and understanding that are associated with this panorama of connected machines—is already anticipated in these early protomedia- and media-art projects of the 1960s and 1970s. These projects are less concerned with dismantling the borders of art and much more interested in interventions and radical transformations of everyday and familiar cultural relationships and problems (and the panorama of connected machines would become part of these everyday and familiar cultural relationships and problems). That is, both the media projects and the conceptual art projects try to occupy specific functional places within the frameworks of cultural processes. "The functional place is a process, an operation which transports between places, a mapping . . . of discursive branches together with the bodies which move within them. . . . It is an information-oriented place, an overlapping of texts, photography and video recordings, physical places and objects. . . . It is a temporary concern, a movement, a chain of meaning, without any spe-

cial focus."[13] The transactional spaces of art are thus strongly discursive rather than spatially constructed.

Art practices like video art, Expanded Cinema, Fluxus, Conceptual Art, and Mail Art engage contexts that lay beyond the otherwise-mapped institutional frameworks of art. They intervene in everyday cultural relationships, the outcomes of daily life, the relationships between those outcomes, the shifts of information and objects within society, the material world, and lastly, the sphere of information making and the technical media. Artistic practices are locked into cultural systems, where they (temporarily) "occupy" or stage certain operations. They produce constellations of time and space that are removed from representation and can be reconstructed only through process. Spaces evolve within these projects long before a connection to culture via information technologies in a narrow sense, before the predominance of the computer (in the shape of the personal computer). These spaces are different from the space of art, different from distinct public spheres. They are spaces that find completion only in the recipient's imagination or that can be manufactured in or by the activities of participants. "This new art is collaborative and interactive. It ends the unidirectional state so characteristic of traditional literature and art. Its elements are text, sound, picture and virtual touch which is based on force-feedback. These elements are not part of a fixed order of things; they are signs of movement."[14]

In this way interface, perception, communication, immateriality, diversification, simultaneity, and so on are not a priori technical terms: A network of artistic or general sociocultural practices is not a priori a network of guidelines, protocols, and programs.[15] It is becoming much clearer that they have to do with a transformation "which newly defines the practices of our symbolic transacting and thereby our understanding of reality."[16]

Robert Adrian X said, "At the same time I was doing all those 'Modern Art' pieces—at the beginning of the eighties—I began with communications works. I was already thinking about how to deal with the dematerialization of art and art practice into communications networks. There's no product at the end. The whole thing is about communications, about exchange of ideas, about opening up a space, operating in it, then closing it again—this is what happens when you turn your computer on or off or connect to the Internet."[17] The conference "The Fifth Network" was staged in Toronto in 1978 and transmitted via local cable TV. It was where Robert

Adrian X met Bill Bartlett, who introduced him to slow-scan TV experiments on the Canadian West Coast. At that time Bartlett was operating the "Open Space" with other artists in Victoria, British Columbia, and he organized the PacRim Slow-Scan Project in 1979, supported by the Vancouver Art Gallery. Later that year, for Computer Culture 79 in Toronto, he created the Computer Communications Conference "Interplay," in which Robert Adrian X, Richard Kriesche, Heidi Grundmann, and Gottfried Bach, participated from Vienna. A studio at Austrian TV was set up as a temporary project center, and incoming and outgoing news was read live on the radio program transmission *Art Today* (*Kunst Heute*).

On February 16, 1980, a conference, "Artists' Use of Telecommunications," was run within the framework of the exhibition project Video Made in Austria in the Museum of the 20th Century in Vienna and involving the San Francisco Museum of Modern Art. This conference was one of the first crystallizing points of this "new" art practice in Austria. Besides Robert Adrian X, other participants from Vienna included Ernst Caramelle, Valie Export, Richard Kriesche, Helmut Mark, and Peter Weibel. The conference, organized by Bill Bartlett and Carl Loeffler of artcom, brought together participants in Vienna, Tokyo, Vancouver, Hawaii, New York, Boston, and San Francisco using the IP Sharp APL Timesharing Network and either a worldwide teleconference linkup or a live two-way video connection (slow-scan TV) and Audiolink (in the United States). Ideas and projects were presented, discussed, and designed around the topic of telecommunications technology in art. It was the first time that slow-scan TV pictures had ever been transmitted from Austria.

The Artists' Electronic Exchange Program (ARTEX) was incorporated into the commercial IP Sharp network in 1980–1981. It was one of the first mail programs worldwide that was put into place and used by artists. ARTEX, which remained in existence until 1990–1991, made it possible for a group of writers to use these new methods of production to engage in distributed authorship. At the same time ARTEX created a new form of communications-oriented cooperation; and as a first, it provided an experimental "space" within the context of artistic practices. ARTEX, like other communications networks such as FidoNet in the 1980s, is also an example of the development of a specific community in and through the Net, which leads to new concepts about the foundations of artistic organizations and types of

cooperation and ultimately to new concepts about social engagement itself. In the context of an artist's use of telecommunications, the main concern is not just about art and technology. The focus is on the analysis of new cultural interfaces, on designs of future behavioral and transactional potential in electronic meeting spaces. The electronic agora, in which everyone is connected to one another, and the associated democratic postulation of potential equality via nonhierarchical and widespread authorship are illusory utopias. Their illusory nature stems from the fact that all the early networks are primarily occupied by economic- or militarily-oriented interest groups, the huge success of the World Wide Web notwithstanding. Nevertheless, projects that are not subordinate to economic and military concerns have been developed and are still being developed, even if they are not planned as permanent interventions. These projects create a space for nonhierarchical communication and production and are meaningful because the space they create enables an important new cultural mapping and establishes media relationships in a different way. Artistic communicative practices create and experiment with a type of transaction that is neither normative nor instrumental. Instead this type of transaction cuts across discourses that exclude, border off, discipline, and guard. These are the very discourses that signpost the everyday in technology today with its proprietary softwares and the limitations of commercial network providers. On the other hand, in the context of artistic creation of communication environments, presence, representation, participation, and the construction of publics are changing fundamentally. This means that a "Utopia of networks, electronic reception and a post-territorial society is possible . . . a Utopia whose materialism remains ephemeral, a Utopia which removes itself from spacial organization and whose current moment is determined by its participation instead of by its chance physical location."[18]

The most important and encompassing telecommunications project of the 1980s was definitely "The World in 24 Hours" (*Die Welt in 24 Stunden*), conceived and organized by Robert Adrian X in the context of Ars Electronica in 1982. The project linked artists in sixteen cities on three continents with one another for twenty-four hours, from noon on September 27 until noon on September 28, 1982. "The goal of the 'World in 24 Hours' was to follow the midday sun right around the Earth, thereby creating a kind of telematic world map."[19] During this time the *Confer* program of ARTBOX

was used as both the coordinating platform and a medium for the artistic projects themselves. Differences between the process and the product or between the creative medium and its presentation no longer made any sense.

At noon local time (or as near to it as possible), each of the participating artists or artists' groups was telephoned from Linz, Austria, to enable the exchange of prepared works, improvisations, and information in the media available at the time. Using the three telephone lines in Linz available for the project, it was possible to send or receive three types of media simultaneously. Each contact lasted approximately one hour: half an hour in each direction. Using *Confer*, participants were linked with each other for the entire twenty-four hours. The results of those contacts were presented in the foyer of the Upper Austrian State Studio of Radio Austria, where the entire project was brought together.

Contributions to "The World in 24 Hours" included *Ten Wings* by Roy Ascott, *The Customer Is Always Right* by Tom Klinkowstein, and *Late Times Extra* by David Garcia. Slow-scan television, fax, and sound transmission were also used, and special projects or works were developed for those media. Peggy Smith, Derek Dowden, and Nancy Peterson in Toronto worked on *Signal Breakdown—Semaphore Piece* and used every available channel in parallel for the project. The Gekko group in Pittsburgh created *Gekko's Window* via slow-scan TV and *Confer*, and numerous fax messages were sent from Frankfurt and Vienna to Linz.

Both the way "The World in 24 Hours" worked and its consequences indicate that projects like it were not conceptualized from the outset to create particular objects or "artworks," via fax for instance, although these were what reached the public. Rather they were conceived to produce and drive dialogic exchanges and relationships: that is, to construct particular media-focused relationships among participants and to produce communicative events. In a certain sense the constellation of the project itself presented the actual "work." Although no defined and enclosed rooms of artwork came into being as a result of the project, special applications and presentations did develop: configurations that always stood in a larger systemic relationship, thereby reproducing a worldwide connection that was installed by media.

By breaking down borders between process and product, communication and production, local input and transmission, and so on, projects of this nature remove the possibility of fully defining the territory these borders previously encompassed; and, of course, they remove any possibility of defining

that territory solely as a territory of art. "The World in 24 Hours" showed that a "network" cannot be understood as groundbreaking technology where something happens or does not happen (like a bureaucratic office, empty at night). Rather, the network arises only in its active utilization as a transactional space—"when you turn off or on your computer"—a transactional space whose existence is determined by engagement rather than by what happens to be its physical location. At the same time as the (related) utopias of a "global community" are being oversubscribed, over and over again, various other manifestations of collaborations of individuals and media are also now coming into view. These collaborations have existed since the early 1980s, working on projects that defied description at the time, because of the discourse of art, society, and politics current at the time. It may be that the euphoria that accompanies the potential spaces and transactional capabilities of network technologies is provoked by this idea of a space that is neither empty nor completely determined. A similar debate about the role played by media-based networks of transactional spaces in the context of current society's future development shows, however, that while the year 1982 is technologically far behind where we are now, media or culture theory from that period must nevertheless be recognized as still valid.

In the context of Laboratoria Ubiqua (curated by Roy Ascott, Tom Sherman, and Tommaso Trini), which was part of the "art and science" focus of the 1986 Venice Biennale, Roy Ascott planned "Planetary Network," a worldwide computer network–slow-scan TV project with participants from Venice, Vienna, Alaska, Sydney, Honolulu, Vancouver, Los Angeles, San Francisco, Chicago, Toronto, Pittsburgh, Atlanta, Boston, Bristol, Paris, and Milan. Within this framework Robert Adrian X organized an international network for slow-scan TV and computer conferences for the project on the basis of two months of free access to the IP Sharp network. During a live event, slow-scan pictures and faxes were exchanged worldwide, and texts were sent via the medium of ARTEX. The fax group was organized and coordinated by Maria Grazia Mattei with the MIDA group of artists from Milan. A Minitel connection with France was arranged by Don Forresta and coordinated by Jacques Elie in Venice. Finally an Austrian BTX installation was organized and coordinated by Zelko Wiener in Venice (BTX, short for *Bildschirmtext,* the Austrian version of videotext, was like the very successful Minitel system in France. Although the Austrian Postal Service provided access in all of their shops, BTX completely failed to become a communication

system in Austria.) Carl Loeffler was the person responsible for establishing a gateway to Compuserve in the accompanying conference. A vigorous exchange resulted, including an intense and controversial discussion about possible future scenarios under the banner of electronic media, the development of technology, and the role of the artist within this development. Regarding the results of "Planetary Network," Roy Ascott wrote that

the stream of creative data which has eventuated via the interaction of artists around the world could be understood in the same way by the whole world. In that sense Venice was no longer privileged. The network resulted in the destabilization of the Gallery-Museum-System in so far as it broadened the scope and possibly the nature of individual creativity. In that sense a whole stream of interactive communications media were activated—electronic mail, computer conferences, videotext, slow scan TV—as well as the exchange of computer pictures. On top of that the laboratorium used interfaces served by videodiscs, digital sound, paint systems and cybernetic response structures and environments.[20]

In 1992 and 1993 Robert Adrian X and Gerfried Stocker led the annual program of the Steiermark Culture Initiative using the title "ZERO—The Art of Being Everywhere" and focusing on metaphors of travel, transmission, transfer, and transition. "This program seeks to address the problem of the end of the industrial millennium and the apparent collapse of the Utopian dreams of the 20th century."[21] In the context of "ZERO," a long list of projects by artists, composers, and writers were undertaken. Taking up the idea of ARTEX (but using completely altered contextual requirements), the first goal of "ZERO" was the establishment of ZEROnet as a bulletin board system. ZEROnet worked with the FidoNet protocol (still widely used at that time) and controlled entry to other nets (like the Dutch Artnet) through gateways. "Because the most conspicuous aspect of the new culture which will be dominant by the year 2000 is the new communications technology and its peculiar characteristics of shrinking the way we experience time and space, this project is planned to take place at the intersections of—and points of access to—the networks of communication and transportation."[22]

"ZERO" followed a decidedly new media cultural geography via a technical network connection among various cultural spaces: "a Utopia of networks, electronic reception methods and a post-territorial society."[23] Are we as cultural objects only just blips in the media bundle, as this new media

geography (or better, topology) not only keeps information and the economy revolving but also creates new styles of interface between real geographic, social, and cultural space and nonreal media mechanistic space? "[T]he borders between subject, if not the body, and the rest of the world are being radically formed anew by the mediation of technology."[24]

ZEROnet therefore has conceptual concerns similar to those of ARTEX and other Net community projects, user groups, and conference groups (such as Communitree 1978, although on-line only for a few months; user groups in "The Well" (Whole Earth 'Lectronic Links) from 1985 onwards; the BBS "//BIONIC" from 1989 onward; up to "The Thing" from 1990) as well as projects based on hypertext and MUDS (Multi-User Dungeons). These concerns include surrounding technologization of culture; questions about the possibilities of reorganizing objects, material, space, producer, and recipient; and interest in and yet simultaneous skepticism toward the central project of modern times, namely, turning materials into information and then in turn understanding and organizing this information once more as materials (above all, as products). Accompanying that was an equally skeptical interest in the effects of synchronization and simultaneity and the resulting fundamental consequences for such things as public and local cultural contexts. "The culture of media is virtual history," writes Robert Adrian X.[25] Those words do not simply reflect the simultaneity of various stories and representations within the context of a media creation and a horizon of actualization. Instead they also encompass a growing transience, situational change, and dependence on context for decisions, statements, opinions, and recognition in general.

The space that projects like "The World in 24 Hours," "Planetary Network," and "ZERO" construct is both technological and sociocultural. It is as much a communications space as a cultural one. It is not just about the technological ability to negotiate. The information that circulates in this space is culturally coded and aligns primarily with social subjects rather than with machines or apparatuses. It is less concerned with the configuration of ascertainable spaces (virtual reality) but much more with the configuration of social relationships on the basis of manifest connectivity. These apparatus-based interfaces are also interfaces for the translatability of language and cultural codes within the contexts of media environments. They move within the framework of a dichotomy between subject and technology and often provide a critique to a utopia that would "separat[e] the information

contents of life from its material foundation."[26] Particularly, on-line projects derived from bulletin board systems address the problems of translation of local cultural codes and the problems of (artistic) projects that install a potentially global system of exchange and communication. This is because the on-line projects (such as "The Thing," [Vienna 1992]) are rooted in local cultural contexts that cannot be assumed to be known somewhere else in detail. The genealogy of these experimental and essentially temporary telecommunications or network projects also includes works like *CHIP-RADIO* (1992), *REALTIME* (1993) and "Horizontal Radio" (created in 1995 at Ars Electronica). Experimental telecommunications or network projects continue this specific form of engaging with and questioning of media culture into the 1990s, as the World Wide Web parades victoriously by. However, the transformation of network technology into forms of everyday cultural practices must not be allowed to trick us into thinking that the fundamental related questions about the technologization of culture have in any way been resolved.

The project of media-oriented art is incomplete and irregularly developing and can only be outlined here in its basics. It should be stated again that media-oriented art is not interesting primarily as a formation of new artworks. It is by far more interesting to consider how far the contexts of works allow themselves to be reconstructed. "Art changes from the producer of sense to the arranger of operations."[27] This approach to art thus follows no single hegemonic trajectory. Instead it is marked by breaks, discontinuities, folds, dissimultaneity, and sprinklings. "Non-linear principles of form are indeed the measure of a culture, which is accustomed to fragmentation and montage. Knowledge as sampling, experience as purposeful, communication as proof of transaction, hyper, access on demand: these are a few concepts of the technoculture of 'nomadic madness.'"[28] The overlapping and interfacing of phenomena as well as the breaks and transgressions between apparatus/media and semantic and sociocultural systems appear as the essential departure points that could be identified as a central concept in the current context of network-oriented and telecommunicative artistic media practice. In this way they also may be regarded as a theoretical motif: "The task of artistic practice is not the creating of unbroken unity but rather the opening of breaks and the unfolding of diversity, a practice which one works on, which Guattari called 'heterogeneses.'"[29] Such artistic practice operates as a formation of hybrid strategies on the borders between technology, art,

and society. It also creates new borders for itself that run within this cultural system. A fundamentally new perspective on artistic media practices has thus developed since the first video projects analyzed and worked with culture's technical and technological nature: "It concerns the model, which unceasingly rises and collapses, and the process, which unceasingly continues on, is interrupted and then is picked up again."[30]

Notes

Translation by Cecilia White, with translations in end notes by the author. The editors wish to thank August Black for his assistance.

1. Norbert Bolz, *Theorie der neuen Medien* (Munich: Raben Verlag, 1990).

2. John Fiske, *Lesarten des Populären* (Vienna: Turia + Kant, 2000); previous edition, *Reading the Popular* (Boston: Unwin Hyman, 1989).

3. Tom Holert, "Gelenkte Visualität," in *Imagineering: Visuelle Kultur und Politik der Sichtbarkeit,* ed. Tom Holert (Cologne, Germany: Oktagon, 2000), 20.

4. Peter Weibel, "erweitertes kino (auszüge)," in *Protokolle 2/1982: Peter Weibel: Mediendichtung,* ed. Otto Breicha (Vienna: Jugend und Volk, 1982), 97.

5. Richard Kriesche, "1. Video und TV, 2. Post-Video," in *Video End,* ed. pool (Graz, Austria: pool, 1973), 73.

6. Nicoletta Torcelli, *Video Kunst Zeit: Von Acconci bis Viola* (Weimar, Germany: Verlag und Datenbank für Geisteswissenschaften, 1996), 21.

7. Valie Export, "Mediale Anagramme: Ein Gedanken- und Bildervortrag. Frühe Arbeiten," in *White Cube/Black Box,* ed. Sabine Breitwieser (Vienna: Generali Foundation, 1996), 99–127, 119.

8. Roy Ascott, "Das Gesamtdatenwerk," *Kunstforum International,* no. 103 (1989): 100–109, 104.

9. Robert Barry, quoted in Klaus Honnef, *Concept Art* (Cologne, Germany: Dumont, 1971), 35.

10. Robert Adrian X, in *Kunst Mikrokunst Makrokunst,* ed. Peter Hoffmann and Robert Adrian X (Graz/Zagreb: Galerije Grada Zagreb, 1981), 33.

11. Jean-Louis Comolli, "Machines of the Visible," in *Electronic Culture: Technology and Visual Representation,* ed. Timothy Druckrey (New York: Aperture, 1996), 108–117, 108.

12. Bill Nichols, "The Work of Culture in the Age of Cybernetic Systems," in *Electronic Culture: Technology and Visual Representation,* ed. Timothy Druckrey (New York: Aperture, 1996), 121–143, 121.

13. Miwon Kwon, "Ein Ort nach dem anderen," in *OK. Ortsbezug: Konstruktion oder Prozess?* ed. Hedwig Saxenhuber and Georg Schöllhammer (Vienna: Edition Selene, 1998), 17–39, 25.

14. Eduardo Kac, "Aspekte einer Ästhetik der Telekommunikation," in *ZERO: The Art of Being Everywhere,* ed. Steirische Kulturinitiative (Graz: Steirische Kulturinitiative, 1993), 24–92, 70.

15. Cf. Heiko Idensen/Matthias Krohn, "Kunst-Netzwerke: Ideen als Objekte," in *Digitaler Schein. Ästhetik der elektronischen Medien,* ed. Florian Rötzer (Frankfurt am Main: Suhrkamp Verlag, 1991), 371–396.

16. Mike Sandbothe, "Interaktivität: Hypertextualität-Transversalität. Eine medienphilosophische Analyse des Internet," in *Mythos Internet,* ed. Stefan Münker and Alexander Rosler (Frankfurt Am Main: Suhrkamp, 1997), 56–82, 57.

17. Robert Adrian X, unpublished interview with the author, 2000.

18. Timothy Druckrey, "Das Schicksal der Vernunft im globalen Netzwerk: Teleologie, Telegrafie, Telefon, Television, Teleästhetik," in *Mythos Information: Welcome to the Wired World,* ed. Karl Gerbel and Peter Weibel (Vienna: Springer, 1995), 151–163, 152.

19. Robert Adrian X, "Kunst und Telekommunikation 1979–1986: Die Pionierzeit," springer—Hefte für Gegenwartskunst 1, no. 1 (1995): 10–11, 10.

20. Roy Ascott, "Das Gesamtdatenwerk," *Kunstforum International,* no. 103 (1989): 100–109, 104.

Reinhard Braun

21. Robert Adrian X, "ZERO: The Art of Being Everywhere," from the Concept Paper of 1991, published later in *ZERO: The Art of Being Everywhere,* ed. Steirische Kulturinitiative (Graz: Steirische Kulturinitiative, 1993), 24–92, 70.

22. *Ibid.*

23. Timothy Druckrey, "Das Schicksal der Vernunft im globalen Netzwerk: Teleologie, Telegrafie, Telefon, Television, Teleästhetik," in *Mythos Information: Welcome to the Wired World,* ed. Karl Gerbel and Peter Weibel (Vienna: Springer, 1995), 151–163, 152.

24. Allucquère Roseanne Stone, "Würde sich der wirkliche Körper bitte erheben?" in *Kunstforum International,* no. 133 (1996): 68–83, 77.

25. Robert Adrian X, "Green Light" in *ZEITGLEICH,* ed. TRANSIT (Vienna: TRANSIT, 1994), 172.

26. Simon Penny, "Körperwissen, digitale Prothesen und kognitive Diversität," *Kunstforum International 132: Die Zukunft des Körpers,* no. I (1996): 51–157, 151.

27. Hans Ulrich Reck, "Entgrenzung und Vermischung. Hybridkultur als Kunst der Philosophie," in *Hybridkultur: Medien Netze Künste,* ed. Irmela Schneider and Christian W. Thomsen (Cologne: Wienand, 1997), 91–117, 103.

28. Timothy Druckrey, "Illusionen der Simulation," in *Illusion und Simulation. Begegnung mit der Realität,* ed. Stefan Iglhaut u. A. (Bonn: Cantz, 1995), 138–157, 156.

29. Andreas Broeckmann, "Medienökologie und Ästhetik der Heterogenese," in *Netzkritik. Materialien zur Internet-Debatte,* ed. Nettime (Berlin: Edition ID-Archiv, 1997), 194.

30. Gilles Deleuze and Félix Guattari, *Tausend Plateaus. Kapitalismus und Schizophrenie* (Berlin: Merve Verlag, 1992), 35.

4

The Mail Art Exhibition: Personal Worlds to Cultural Strategies

John Held, Jr.

Cross-Cultural Communication

Before the Internet, Mail Artists were communicating across vanishing borders, establishing contact with an international network of cultural workers, helping to pave the information highway. Overcoming such barriers as language and political ideology, Mail Art participants found common ground in novel means of distributing art and ideas. This open system of communication, established through the postal service and other forms of marginal communication by a small coterie of "advance scouts," intuited the emergence of a new mass medium that would deliver cross-cultural information and creativity on a massive scale.

Fluxus artist Robert Filliou wrote in the 1960s of an "Eternal Network," envisioning a coterie of friends and artists participating in an ongoing open exchange of art and ideas.[1] His concept was quickly adopted by a circle of correspondents, anticipating the aspirations of the Internet generation some twenty-five years hence.[2] This "network" was formed and developed through the postal service. Mail as an artistic medium had brushed against previous twentieth-century avant-garde movements, such as futurism, Zaum, Dada, nouveau realism, the Situationist International, Gutai, and Fluxus. The postal system was used for interpersonal communication, for promotion of the artists' ideas with a wider audience, and as a new medium of artistic exchange.[3]

The Italian futurists mailed metal postcards and were early proponents of "visual poetry."[4] Russian Zaumists were incorporating rubber stamps into their books and "zines" as early as 1912.[5] Kurt Schwitters and Marcel Duchamp were also using rubber stamps, exploring various conceptual facets of the postal medium by the end of the decade.[6] Yves Klein's smallest painting was a monochrome postage stamp of IKB (International Klein Blue) surreptitiously canceled on a postcard.[7] Fluxus artist Robert Watts printed his first artist postage stamp sheet in 1962.[8] The Japanese Gutai group depended on its publications to bridge the geographical distance linking it to Western centers of contemporary art.[9]

Ray Johnson and the New York Correspondence School

The title of "father of Mail Art," however, must go to the American artist Ray Johnson. Born in Detroit, Michigan, in 1927, Johnson insisted that his postal activities began in 1943, and there are letters to his childhood friend Arthur Secunda substantiating the claim.[10] By the end of the decade, Johnson was attending Black Mountain College, the most advanced center of

American art at the time. While there, Johnson studied with Joseph Albers, became friendly with John Cage, Merce Cunningham, Robert Rauschenberg, and numerous others who were to make a substantial impact on post–abstract expressionist art.[11] By 1955, Johnson had given up painting to pursue a career in graphic design and had put together a mailing list of some two hundred art world and popular-culture figures, to whom he began sending moticos, cutouts on black paper resembling modern hieroglyphics.[12] Correspondent Ed Plunkett termed Johnson's activities "The New York Correspondence School" in 1962:

Before 1962–63, there was no specific term for mail art. I began calling it the New York Correspondence School of this reason: Abstract Expressionism or Action Painting was then often referred to as "The New York School" so I merely inserted "Correspondence" into the term. This name caught on, despite the fact that Ray chose to spell it "correspondance" and chose to kill it in 1973 with a letter to the obituary column of the "New York Times"—a dead letter. But the term and the concept have persisted and expanded, first to the West Coast and to Canada, and finally internationally and intercontinentally.[13]

Ray Johnson's New York Correspondance School (Johnson changed the *e* to an *a* to stress the performative aspect of the activity) proved an able distribution system for Filliou's emerging Eternal Network to promenade through the postal system. Mailings were affordable, reached everywhere, and could be used for either promotion or anonymity. They could convey mystery, blending the separation of art and life. Before the Internet, the postal system was the standard economical means of interpersonal communication with an international audience. Artists took advantage of its reach in establishing an international community.

In a preface to an interview with Johnson, Henry Martin explained:

To me, Ray Johnson's Correspondence School seems simply an attempt to establish as many significantly human relationships with as many individual people as possible. All of the relationships of which the School is made are *personal* relationships: relationships with a tendency towards *intimacy* relationships where true experiences are truly shared and where what makes an experience true is its real participation in a secret libidinal charge.

And the relationships that the artist values so highly are something he attempts to pass on to others. The classical exhortation in a Ray Johnson mailing is "please send to . . ." Person A will receive an object or an image and be asked to pass it on person B, and the image will probably be appropriate to these two different people in two entirely different ways, or in terms of two entirely different chains of association. It thus becomes a kind of totem that can connect them, and whatever latent relationship may possibly exist between person A and person B becomes a little less latent and a little more real.

It's the beginning of an uncommon sense of community, and this sense of community grows as persons A and B send something back through Ray to each other, or through each other back to Ray. And then the game itself will swell through Ray's addition of still other images and person C and D and E. . . .

Configurations of possible relationship will always be constantly shifting, but the more they shift, the more the very fact of such possibilities will itself grow solid. It's a game that's played with a good deal of levity and wit, but it also has an air of deadly seriousness. This fluid web of interrelationships can be felt as the very stuff of which psychic life is made, and it hovers as though in a void. Ray is a kind of image of the demiurge, always making something out of nothing, substance out of possibility.[14]

"Sub-Cultures and Their Specific Means of Diffusion"

One of the first books concerned with Mail Art, Hervé Fischer's *Art and Marginal Communication,* detailed the reasons for the growth of the postal underground:

The mass-media diffuse only a limited part of the cultural production of a society. They leave in the fringe of what is rightly or wrongly called mass-culture a whole range of expression that the mediators of the large public consider too new or too specialized. . . . I will deal with sub-cultures and their specific means of diffusion: the marginal media. . . . These latter often experience the necessity to invent their own means of communication, in order to assert their own existence which is denied to them by the radio, the television and the established press, all of which ignore them.[15]

In a section of his preface, "Mail Art, Art at a Distance," Fischer states that the arching reach of the mass media "favored the progressive blooming of a marginal, international sub-group of scattered artists. They have established a dense network of marginal communications. It is primarily the international

post office network, that have served this sub-group, in as much as it favors frequent contact in spite of distances between artists scattered through the industrial world."[16]

Johnson's New York Correspondance School included artists, art world insiders, icons of popular culture, casual friends, and others accrued by chance. Many found their way into the lists Johnson composed for his New York Correspondance School meetings. Art critic Arthur C. Danto noted that

most of the Correspondance School members are fairly obscure (as were, for that matter, most members of Fluxus). . . . The Correspondance School was a network of individuals who were artists by virtue of playing the game. Some of them were . . . "initiates" by virtue of sharing—or at least appreciating—Johnson's sense of humor: a readiness to respond to a certain kind of joke or pun, visual or verbal; to take trivial things as monumentally important; and to profess a fan's dedication to certain borderline celebrities.[17]

Open Space for Cultural Experimentation

Perhaps the first to link the postal activity of Johnson and the "networking" concept of Filliou were the Canadian art groups Western Front, Image Bank, and General Idea. In an interview with Mail Artist Mark Bloch, AA Bronson, one-third of the membership of General Idea, declared:

I think it—let's call it the "electronic revolution"—[was] already in progress without there being an electronic technology in place. So, the whole idea of networking on very horizontal rather than vertical structures. . . . It's much more about free-form networking that operates in a very organic sort of way. So the correspondence art was very much like an illustration of that. It's like the Internet . . . it's exactly like the Internet in its structure and in the way it happened and the way it changed and shifted all the time.

It was appearing with a small group of people who were, in a way, more conceptually advanced. It was just part of their nature. And it's really now that it's appearing in the culture at large. Buckminster Fuller always talked about a 25 year lag between something being invented and something appearing in the culture at large and that's sort of how correspondence was. It was something for just a few people and now in the form of the Internet, it's just sort of everyday activity for everyone.[18]

The "organic" nature of the growth of Mail Art parallels the rise of zine culture. In *Notes from Underground: Zines and the Politics of Alternative Culture,* author Stephen Duncombe traces his interest in zines to

a true culture of resistance . . . a novel form of communication and creation that burst with an angry idealism. A medium that spoke for a marginal, yet vibrant culture, that along with others might invest the tired script of progressive politics with meaning and excitement for a new generation. . . . Their way of seeing and doing was not borrowed from a book, nor was it carefully cross-referenced and cited; rather it was, if you'll forgive the word, organic. It was a vernacular radicalism, an indigenous strain of utopian thought.[19]

Duncombe concludes that, like Mail Art, zines provide an open space for cultural experimentation:

In the shadows of the dominant culture, zines and underground culture mark out a *free space:* a space within which to imagine and experiment with new and idealistic ways of thinking, communicating, and being. Underground ideals such as an authentic and instrumental life provide—albeit in inchoate form—a challenge to modern society. And underground culture creates a space in which to experiment with novel forms of social production and organization. Practices such as nonalienated cultural production and nonspatial community of "the network" are perhaps indicators of the directions in which a future society could go, or utopian ideals after which to strive.[20]

"A Fluxus Masterpiece"

Perhaps the foremost theoretician of Mail Art, the late Ulises Carrión, wrote in his essay "Personal Worlds or Cultural Strategies?" that "Mail Art shifts the focus from what is traditionally called 'art' to the wider concept of 'culture.' And this shift is what makes Mail Art truly contemporary. In opposition to 'personal worlds,' Mail Art emphasizes cultural strategies."[21]

Carrión saw no distinction between the use of the mail and other media in the creation of those cultural strategies. Fax and emerging personal-computing technologies, introduced in the 1980s, gained immediate acceptance by the Mail Art community, which was fixated not on the postal exchange, but rather on the aesthetics and distribution of communication:

The Post Office provides the artist with a distribution network but it doesn't define the work. The Post Office is not an essential element of the work and it could be replaced by other transportation systems. . . . At first sight, compared to telephones or televisions, the Postal System seems rather slow, unsafe, complicated, awkward, inefficient, uncontrollable. But these imperfections leave space for play, for invention, for surprise, those qualities that mail artists have been exploiting for quite a number of years now.[22]

The first decades of Mail Art extolled an unfettered art of play, invention, and surprise. From 1943 until 1962, largely under Johnson's tutelage, Mail Art was an unbridled innocent, unaware and unconcerned of a potential future. In 1962, when Plunkett named Johnson's activity the New York Correspondence School, participants in the fledgling medium began to develop an awareness of their actions. Concurrently, Fluxus began to congeal, with various artists marking their own postal terrain. Foremost among these Mail Art activities was the Yam Festival, coordinated by George Brecht and Robert Watts, a series of events scattered around the New York metropolitan area in 1962 and 1963. Watts described the Yam Festival as a "loose format that would make it possible to combine or include an ever expanding universe of events." The Yam Festival Delivery Event announced that "R. Watts and or G. Brecht will assemble a work and arrange delivery to you or an addressee of your choice."[23] Both Johnson and Fluxus took Mail Art to new levels in the sixties, gaining new adherents through an alternative stance that resonated with the counterculture tenor of the times. "The Correspondance School is a Fluxus masterpiece, if that makes any sense," wrote Danto.[24]

"Evaporations by Ray Johnson"

By the 1970s, the foundation for the Eternal Network was set, and Mail Art was taking on all the trappings of a new artistic movement. Soon, "networkers" were using Mail Art not as collateral activity (as previous avantgardes had done), but as an intrinsic part of their creative expression. Johnson curated The New York Correspondance School, an exhibit at the Whitney Museum of Art, in 1970. In 1972, *Rolling Stone,* the influential American music magazine, published Thomas Albright's two-part essay, "Correspondence Art" and "New Art School: Correspondence," drawing adherents from a new politically, socially, and culturally engaged generation. *FILE* magazine, edited by General Idea (1971–1989), helped spread Fil-

liou's Eternal-Network concept worldwide. The Fluxshoe exhibition (1972), curated by David Mayor in various venues through Great Britain, meshed the previous generation (Fluxus, the New York Correspondance School) with those newly drawn to the field.

As early as 1968, Johnson had written of his desire to mount an exhibition showcasing the New York Correspondance School. Writing to Michael Morris of the Image Bank in Vancouver, British Columbia, Johnson stated, "I wanted this year to have a N.Y. C.S. Show but nobody knew how to organize it or what to say so I thought I would do all the work myself and organize the show as I wanted it to be seen. . . . My own gallery is pretty cool about the whole thing I think because they have quite a bunch of framed Ray Johnsons to sell. I am not exactly terribly popular with the general public. I seem to be liked by the select few."[25]

When Johnson's friend and participant in the New York Correspondance School Joseph Raffael (a.k.a. Joseph Raffaelle) moved to Sacramento to assume a position at California State University, Johnson was afforded the opportunity to put his plan into practice. The Last Correspondance Show was held April 7–30, 1969, at the art gallery of California State University, Sacramento.[26] Johnson, in the course of explaining his views on art history to Henry Martin, ruminated on this early exhibition:

Like one of the first mail art shows was in Sacramento when I went out there to lecture. . . . I specified that I had to be under a pink light and I had a text that I wrote and this was one of the beginnings of all these performances and lectures and exhibits, and then I say to my friend Toby Spiselman, "Like, what year was that?" It's as though people imagine that the importance of that is because it was done in that particular year since it was only a year or so later that people everywhere in universities and colleges began getting this idea that you simply write out a lot of letters to people and you get all this stuff and you exhibit it in a gallery, which is what I did at the Whitney Museum, which was in 1970, which I think was in 1970.[27]

Johnson proposed an exhibition, to be co-organized by Marcia Tucker, a curator at the Whitney Museum of American Art, that would include everything sent to the museum in response to an invitation that Johnson sent to correspondents (figure 4.1). The exhibit was displayed from September 20 to October 6, 1970, under the title Ray Johnson: New York Correspondance School. Tucker, later the founder and director of The New Museum in New

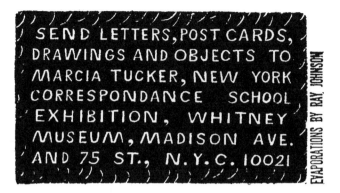

new york correspondance school exhibition

Figure 4.1 "New York Correspondance School Exhibition," Ray Johnson and Marcia Tucker, curators. Whitney Museum of American Art, New York, New York. September 2–October 6, 1970. (4 pages). Offset. 7″ × 7″. Photo: Mike Dickau (Sacramento, California).

York, was savvy enough to understand Johnson's concept. Years later, she would write: "In New York there's the art 'world' and the art 'community.' In general, in other parts of the country, there's just the art community. The art world is something I'm not too interested in. I don't feel as though I share in its values. But I do feel I'm part of the art community."[28]

The invitation to the exhibition read, "Send letters, postcards, drawings and objects to Marcia Tucker, New York Correspondance School Exhibition, Whitney Museum, Madison Ave. and 75 St., N.Y.C. 10021." Along the right-hand border was rubber stamped, "Evaporations by Ray Johnson."[29] Johnson seemed to suggest that the exhibition was to be a momentary glimpse into a transitory realm, flowing like a river and as difficult to capture.

The exhibition elicited skeptical reactions from the mainstream press. *Vogue* labeled it "nutsy." Kasha Linville, writing in *Artforum,* noted the contradiction of capturing "a living thing in flight, to pin it down and make a

museum display of it."[30] Hilton Kramer remarked, "What you and I might deem fit for a wastebasket, the Whitney Museum of American Art judges worthy of its exhibition space."[31]

Years later, the merits of exhibiting Mail Art were still being debated. Danto, reviewing a Johnson retrospective, continued to question the wisdom of exhibiting "a living thing in flight": "But its countless scraps and scribbles merely express its spirit, which can hardly be put on view in a vitrine. Spinoza made a distinction between 'natura naturata' and 'natura naturans'—between the world as a system of objects and the world as a system of process."[32]

Despite critical concern, the 1970 Whitney exhibition proved a turning point in the development of Mail Art. Sharla Sava summed up the importance of the exhibition:

The exhibition, because it was displayed in a prominent and publicly sanctioned institution of art, marked a crucial turning point both in terms of Johnson's own practice and in terms of the status correspondence art acquired within the avant-garde. Through this inaugural display the defiant stance of mail art joined rank with many other contemporaneous practices in an adamant rejection of the conventional art object. Dissimilar in its intentions, however, from the other art experiments, the exhibition of the NYCS at the Whitney posited an exuberant and idealist reconciliation between the opposing realities of system and structure. The institutional display of the NYCS inaugurated in 1970 at the Whitney was a remarkable attempt to reconcile a private living system of communication with the vast and anonymous structures that govern the wider social world, and, as such, it merits further consideration.[33]

Johnson seemed conflicted about the exhibition as well, and for many years distributed a mailing with the message "Dear Whitney Museum, i [sic] hate you. Love, Ray Johnson."[34] He was never to organize another Mail Art show, although he did participate in those of others.

Emerging History of Mail Art

From the Whitney exhibition onward, Mail Art assumed both a private and public face, with Johnson no longer at the helm to guide its course. It was during this period that the term *Mail Art* was conceived.[35] The medium took on a life of its own, often bowing to Johnson for tone and inspiration but growing too large for his immediate attention. Now everyone had a mailing list. The interested newcomer had only to browse the participant listing of

an exhibition catalog to find the names and addresses of several hundred contributors from twenty to thirty countries. Catalogs began to elicit essays from active participants, providing the reader with an introduction to the emerging history of Mail Art.[36]

Publications such as West German Dada expert Klaus Groh's *International Artistic Cooperation Infos* began disseminating information on Mail Art shows, projects, and meetings. Groh wrote that "mail productions or creativities by mail are more open, more democratic than all artistic productions ever before. Mail art is open for everyone. Mail art can be used by everyone. Mail art can be brought to everyone and every institution in any part of the wide world."[37]

Exhibition catalogs and other Mail Art publications were predominantly photocopied and stapled, in the manner of contemporary zines. But Mail Artists were as creative in their publishing activities as they were in formulating the structure of the Mail Art show. Assemblings, *Commonpress,* and *Smile* are innovative publication projects, rivaling the Mail Art show as a channel of unedited communication, providing free spaces for the dissemination of open expression.[38]

"During the 1970s," wrote Mike Crane in *Correspondence Art: Source Book for the Network of International Postal Art Activity,*

... the visibility of mail art increased through exhibitions and publications across the spectrum of art showcases worldwide, from major international to national and regional museums, universities, community or commercial galleries to apartments and post office lobbies. ... The existence of so many exhibitions, simultaneously and non-stop, is a force that has changed mail art. The mail art show is a creature unto itself. Now it is possible to maintain a busy mail art career by responding to show invitations and never engaging in a direct, interpersonal exchange.[39]

Distrustful of the Art World

The reasons for the explosion of Mail Art and accompanying exhibitions are numerous and not without historical precedent. One need only reference Marcel Duchamp, like Johnson an artist widely admired throughout the network. Duchamp had grown distrustful of the art world, including the supposed avant-gardism of a sympathetic cubist faction headed by Albert Gleizes and Jean Metzinger. He had submitted *Nude Descending a Staircase, No. 2* to the 1912 Paris Salon des Indépendants, whose organizers found the

work too provocative for their "reasonable Cubism." Duchamp said nothing and went to fetch back the painting. "It was a real turning point in my life," he declared at a later point.[40]

But Duchamp's hopes for a democratic exhibition policy were not completely dashed. He accepted a position overseeing the hanging committee for the Society of Independent Artists, which was planning a major New York exhibition in 1917. Exhibition submissions were open to any American or European artist paying the society's five-dollar annual dues and a one-dollar initiation fee, with a policy of "no jury, no prizes," a forerunner (minus the fee) of contemporary mail art etiquette.

Duchamp installed the exhibition by hanging the artists alphabetically, beginning with the letter *R*, which was drawn out of a hat. This method of installation proved too much for the exhibition leadership. John Quinn, one of the country's earliest champions and collectors of modern art, who had donated his services as legal council to the society, declared the Duchampian installation "democracy run riot."[41]

A Nonjuried Exhibition with Broad International Participation

Stressing cooperation, not competition, the structure of the Mail Art show brought Duchamp's vision of democratic display to fruition. Johnson's New York Correspondance School Whitney exhibition opened the floodgates to a number of similar exhibitions. In 1971, a Mail Art component was part of the VII Biennale de Paris, curated by Jean-Marc Poinsot. Fluxus artist Ken Friedman organized Omaha Flow Systems, at the Joslyn Art Museum in Omaha, Nebraska, in 1972. Mail Art historian Géza Perneczky writes that "the Omaha Flow was the event where the dam really burst, since it was the first show where anyone was free to contribute."[42]

The following year, Davi Det Hompson organized An International Cyclopedia of Plans and Occurrences at Virginia Commonwealth University in Richmond. "None of this would have been possible without the information networks of several organizations; Fluxus West, New York Correspondence School, Image Bank and particularly the International Artist's Co-op. These systems are proving that there is an alternative to the exclusive and judgmental methods of traditional gallery/museum exhibitions," Hompson wrote in the introduction to the exhibition catalog.[43]

Hompson went on to explain the difficulties of staging a nonjuried exhibition with broad international participation:

Exhibited in the corridors and stairwells of the three-story Anderson Gallery, the thousands of items arranged by country, covered the walls from floor to ceiling. A small library of pamphlets and books were available to be read and stacks of printed material, posters, matchbooks and booklets were given away. . . . However, CYCLO-PEDIA was not without problems, and if you are considering a similar undertaking I have a few observations. Since no limitations or specific forms were imposed in the announcement, contributions ranged in size from postage stamps to bedsheets, in numbers up to 100 page sequences. Finding ways to arrange and attach all of this to the walls was a difficult job and once attached still allowed many items to be damaged or stolen.[44]

Exhibition Documentation

Johnson's Whitney exhibition was documented in a four-page brochure that included a brief essay by William S. Wilson ("Drop a Line") and a list of the 106 participants. Omaha Flow Systems remained undocumented. Fluxshoe, an important show in 1972 that brought together the Fluxus generation with the emerging Eternal Network of Mail Artists, was accompanied by a catalog, and a later addendum, that reproduced works and provided biographical information on the contributors and a bibliography of relevant books and periodicals. The catalog for An International Cyclopedia of Plans and Occurrences listed the names and addresses of contributors, examples of submitted work, and, as previously noted, an introduction by the organizer.

Catalogs became important components of the exhibition structure. Since work was sent to Mail Art exhibition organizers free, and the vast majority of participants were hampered in attending the shows they entered by impediments of geographic distance, catalogs became a standard form of reciprocation. For an inventory of my personal collection of Mail Art exhibition documentation prepared for the Getty Research Library in 2001, I compiled a listing of 1,192 items (catalogs, participant lists, posters, and postcards) from fifty-four countries documenting exhibitions from 1970 through 2002.[45]

Mike Crane wrote that

after 1973 there was a continual influx of participants as well as a search for more alternatives in exhibiting, publishing, and exchanging information about mail art. During this time the growth of correspondence art was horizontal rather than vertical, that is, more, rather than different, work and events appeared. Certain message

types incorporating collage, rubber stamps, and xeroxes appeared regularly, forming a mail art style.

By 1976 the existence of an international network was confirmed. Exhibitions and publications increased in number so substantially that by the end of the 1970's these forms seemed to rival, if not surpass, individual mailings as the focus of mail art.[46]

Mail Art Considerations

This proliferation of Mail Art shows led to controversy within the medium when it became apparent that certain curators were issuing exhibition invitations for work never displayed or documented. In 1980, Lon Spiegelman and Mario Lara, two California Mail Artists, issued a manifesto of Mail Art "considerations":

While the eternal-mailart network has no formal rules, it is growing at such a rate that certain "considerations" must be given to the conduct of those individuals hosting mailart exhibitions if the system is to grow in a positive way.

Beyond the dictates of basic human nature, focusing on politeness, mailart shows are a two-way street of communication. We, as practicing mailartists, feel that the following "considerations" should form the foundation of any show that calls itself a "mailart show."

(1) No fee (2) No jury (3) No returns (4) All works received will be exhibited, (5) A complete catalog will be sent free of charge to all participants. (Hopefully the catalog will be more than just a list of names.)

If for whatever reasons a mailart show curator cannot fulfill these "considerations," then he/she should return, without cost to the contributing artists, all mailings received. As this new art phenomenon emerges and develops, it is our wish to offer clarity.

"Mailart is not objects going through the mail, but artists establishing direct contact with other artists, sharing ideas and experiences, all over the world."

It's time to strengthen this vital alternative avenue of self-expression because we no longer feel that the present-day art structure is concerned with the artist as a sensitive individual, trying to develop within an ever increasing and complex cultural milieu. Art today is concerned with valuable objects and status. Mailart is concerned with communication. Art is magic, magic is fun, art is fun.

Whereas in the past, we mail artists would send works to mailart shows merely because they were listed as such, we no longer find it acceptable to submit material to shows that do not deal—up front—with these "considerations."

Mailart is still the art of "no rules." Only the "considerations" of basic human politeness prevail. It must be remembered that a mailart show curator receives one of the world's finest collections of art "free" and we feel that the host "owes" something to those individual threads who compose the final piece. Also, curators get to keep the artist's work and should get something in return for their energy/time. Without them there would be no show.[47]

Mail Artists have gone to great lengths to sustain the open structure of the medium's exhibitions. In declaring the existence of an eternal network, Robert Filliou stated that

In practical terms, in order to make artists, first, realize they are part of a network, and therefore, may as well refrain from their tiresome spirit of competition, we intend, when we do perform, to advertise other artists' performances together with our own. But this is not enough. The artist must realize also that his is part of a wider network, la Fete Permanente going on around him all the time in all parts of the World.[48]

"An Important Turning Point in This Particular Art History"
The existence of the Eternal Network brings a measure of responsibility to those adhering to its creed. The vitality of the network is not the products produced within it, or its function as breeding ground for emerging artists, but in the maintenance of its open structure. In documenting a period of controversy within Mail Art, Chuck Welch has written:

Mail Art has been in existence for over thirty years as an alternative, multi-lateral art form based on principles of free exchange and international access to all people regardless of nationality, race or creed. Little has been written about strategic issues which ultimately will point the direction that Mail Art will follow. Indeed, some controversial issues, if not confronted by Mail Artists themselves, could threaten the existence of Mail Art as a democratic based forum existing outside of traditional art systems.[49]

In specific, Welch was referring to the controversy surrounding the 1984 exhibition Mail Art Then and Now, held at Franklin Furnace, New York. Curated by Ronny Cohen, who had authored the article "Please Mr. Postman Look and See . . . Is There a Work of Art in Your Bag for Me?" for the December 1981 issue of *ARTnews,* the exhibition proved a turning point in

Mail Art history. In the article, Cohen had called Mail Art "the liveliest and most exciting communications game—and the best artgiveaway—in town, whether your town is New York City or Los Angeles."[50]

However, Cohen was soon to learn that "the best artgiveaway" was not without its price. Upon attending the opening of the exhibition, New York Mail Artist Carlo Pittore noticed that not all of the works sent to the show were on display. Soon after, Pittore drafted "An Open Letter to Dr. Ronny Cohen," taking the curator to task for her curatorial censorship:

Your invitation stated that **all** materials would be exhibited. As you know, this is a sacrosanct mail art concept—the primary aspect of mail art exhibitions—and that is **everything** contributed to a mail art exhibition is to be exhibited. **No rejections** is synonymous with mail art, especially as the work is given and not returned, and you have arbitrarily decided to reject and edit. That you have decided to disregard this concept marks you as no friend to mail art, or to mail artists, and denies perhaps the most unique and appealing feature of this universal movement.[51]

A storm of protest commenced. Lon Spiegelman edited a special issue of *Umbrella* (March 1984) devoted to the controversy, which had spilled over to a series of contemporaneous panel discussions, sponsored by Artists Talk on Art at the Wooster Gallery in New York. Cohen, who had been previously designated to moderate the panel, was asked by the panelists to relinquish her position for having been "insensitive to the fundamentals of the global network."[52]

Panel member John P. Jacobs later wrote of Cohen's dismissal as moderator that

Perhaps we were too naive. Certainly, following Dr. Cohen's response, which claimed that we must conform to a real world if we wished to get anywhere, and which had the feeling of a teacher rapping a bad child on the knuckles with her rod, we became ruder than necessary. It was, however, our goal to carry our beliefs into action, to speak loudly and plainly, as a group and for the group. It was our goal to draw the fine line. If such action is too idealistic, too far from the real world, then let the likes of Ronny Cohen abandon us to our idealism. It is the glory, the power and the importance of our idealism, that we no longer rely on the real world for our daily bread, that makes international mail art as significant a movement as it is. If the real world cannot accept and work with our idealism, then in the future that world should avoid

us. We were born to survive. At any rate, I think that in the long run, this will prove an important turning point in this particular art history, And I think, too, that the excitement, communication and energy that it has stimulated will be positive. It appears that many are involved in the process of attempting to define who we are, and what it is that we're trying to do. It appeared that our goal on the panels was to make the first steps in this attempt. Instead we seem to have produced the energy, both positive and negative, for others to take that step themselves. In time, I think the positive results will begin to surface.[53]

The cover of the "Special Exclusive Mailart Edition" of *Umbrella,* illustrated by artist "Harry Bates" (a.k.a. Al Ackerman), portrayed a postman holding up an envelope reading "Let's Get Mailart out of the Classroom and Back in the Gutter." As a result, Cohen, at one time the medium's most prominent supporter, was flushed from the scene. Mail Art also paid a price, with no major institution in New York having staged a significant Mail Art show since that time, excluding the Ray Johnson retrospective held at the Whitney Museum of American Art in January–March 1999, which included a Mail Art show component in tribute to the artist.

Mail Art Exhibitions and Exhibiting Artistamps, 1985–1995

Despite this, Mail Art exhibitions have flourished. One hundred forty-nine shows were mounted in 1985, according to the information supplied in *International Artist Cooperation: Mail Art Show, 1970–1985.*[54] This was an increase in exhibitions that continued unabated into the 1990s, as did the variety of venues, with exhibitions expanding to previously barren areas of involvement, including China, Taiwan, Ghana, the Soviet Union, and Yugoslavia (figure 4.2).

For instance, in 1990, Cuban artist Pedro Juan Gutiérrez curated the exhibition Interart Box Number: Project Mail Art in Havana. During a 1995 visit with the artist, he inscribed the catalog to me with the words, "This is the catalogue of the first exhibition of Mail Art in Cuba. Was a small show for a week in the garage of a house in Miramar District in 1990. I worked during five years collecting the pieces. I believe it is an historical and unknown show." In 1995, another Mail Art show was held in Havana. Unlike the previous show curated by Gutiérrez in the garage of his home, the 1995 exhibition was installed in El Museo Nacional Palacio de Bellas Artes, the most

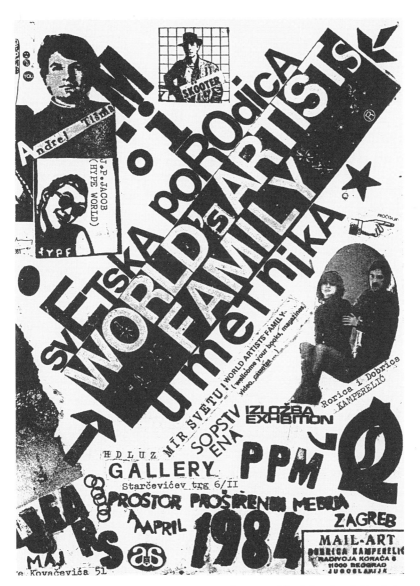

Figure 4.2 "World's Artists Family," Dobrica Kamperalic, curator. Hdluz Gallery, Zagreb, Yugoslavia, April 1984. (8 pages). Photocopy. 9" × 6½". Photo: Mike Dickau (Sacramento, California).

prestigious museum of fine arts in the country. The exhibition attracted seven hundred participants from forty-five countries. It is one of the few instances of an exhibition of Mail Art held in a national museum of fine arts.

Whereas institutions of cultural stature have been reluctant to install Mail Art shows, the postal museums of several countries have done so with great success. Indeed, a postal museum seems a natural arena for the presentation of Mail Art. For example, three active Swiss Mail Artists, H. R. Fricker, Günther Ruch, and M. Vançi Stirnemann, collaborated with the Swiss PTT Museum in Bern, Switzerland, on the 1994 exhibition Mail-Art: Netzwerk der Künstler. Work for the exhibition was drawn from the archives of the three artists, but also included an opening day fax project, open to the network. The catalog for the exhibition included a "Petite Encyclopédie du Mail Art et du Networking," which included definitions and descriptions of networking, Mail Art shows, congresses, archives, postcards, envelopes, artistamps, rubber stamps, copy art, performances, magazines, audio, and computers.

The following year, the Musée Postal in Brussels, Belgium, held a similar exhibition, Mail-Art Memorabilia, drawn from the substantial archive of Belgian Mail Artist Guy Bleus. The display of postcards, artistamps, catalogs, envelopes, audio art, badges, invitations, posters, objects, photographs, and books provided museum viewers with an excellent overview of the field. The show, like many others held in larger venues, drew on established collections as well as works submitted by open invitation.

Whereas the previously mentioned Mail Art shows have provided opportunities for the public to witness the full range of Mail Art, exhibitions have also been held showcasing specific genres of the medium, including artist postage stamps (figure 4.3), rubber stamp art, photocopy art, fax art, visual poetry, artists' books, zines, stickers, and badges (figure 4.4). Exhibitions of artist postage stamps (termed *artistamps* by the late Canadian Mail Artist Michael Bidner) have been especially popular. The first such exhibition, Artists' Stamps and Stamp Images, was organized by James Felter at Simon Fraser University in Burnaby, British Columbia, in 1974. The exhibition featured approximately three thousand stamps and stamp images by thirty-five artists and seven artists' groups from nine countries. Documenting the "first wave" of artistamp production, the exhibition featured works by Fluxus artist Robert Watts, New York Correspondance School participant May Wilson, psychedelic poster artist Robert Fried, and Donald Evans.

ARTISTS' POSTAGE STAMPS FROM THE INTERNATIONAL MAIL ART NETWORK

Figure 4.3 "Faux Post: Artists' Postage Stamps from the International Mail Art Network," John Held, Jr., curator. Bush Barn Art Center, Salem, Oregon, June 2–28, 1995. (4 pages) Offset. 8½″ × 8¼″. Photo: Mike Dickau (Sacramento, California).

A culmination of several decades' worth of activity in the artistamp field was the exhibition Timbres d'Artistes, installed at the Musée de la Poste in Paris from September 14, 1993, through January 20, 1994. Curated by the museum's director, Marie-Claude Le Floch Vellay, with the assistance of French Mail Artist Jean-Noël Laszlo, the exhibition brought the full power of this important genre to the fore, with over fifty full-color artistamp sheets reproduced in the accompanying catalog, prefaced by critic Pierre Restany.

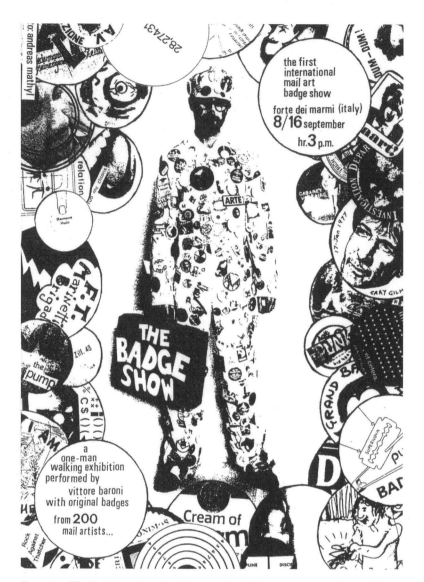

Figure 4.4 "The First International Mail Art Badge Show," Vittore Baroni, curator. Forte dei Marmi,
Italy, September 8–16, 1980. (6 pages). Photocopy. 12" × 8½". Photo: Mike Dickau
(Sacramento, California).

Virtual Exhibitions and Mail Art Congresses

Although the heyday of Mail Art shows may not yet be at an end, the advent of the Internet has wrought profound changes in the administration of their practice. The basics remain: conceptualizing a specific theme, issuance of invitations to participate (within the framework of the "considerations" of no fee, jury, or return of work), logging in entries to the show, display of the works, and documentation to contributors. All this can now be done over the Internet, rather than through the postal service. Contributors to these virtual shows easily send attachments over the Internet, bypassing the postal system as delivery mechanism.

Mail Art purists, who decry the drift from paper to digital formatting, may be dismayed at the absence of a paper catalog at the expense of electronic documentation. Mail Art, however, has always thrived in an environment of economical frugality, and the Internet has replaced the postal service as the cheapest form of interpersonal communication. The Internet also has the advantage of speed, lessening the lead time in mounting exhibitions. Web sites documenting Mail Art shows can display photographs of exhibition openings the same day as the actual occurrence.

Mail Artists who grasp the notion of "art as communication" will not dwell on the past. They recognize that a new medium has risen to extend the concepts fermented through the postal service. In 1986, Mail Artists convened over eighty international face-to-face meetings in a series of Decentralized World-wide Mail-Art Congresses, celebrating and examining the meaning of Mail Art. By 1992, the landscape had changed. Mail Artists reached out to others interested in various forms of long-distance artistic communication, including the field of telematics, in a series of Decentralized World-Wide Networker Congresses.

In the booklet *Networker Congress Statements,* used to publicize the concept, art critic Robert Morgan challenged Mail Artists to move beyond "style" to new ways of communication:

The art world is a small ensemble of followers who believe in the hegemony of style—that old modernist hangover. Styles deplete meaning and therefore should have nothing to do with what mail artists call the "network." But mail artists are too often jealous of the art world and want to remain separate. This is a problem. Like a ghetto, the art world remains the macrocosmic projection of what the network wants to be. The network, in essence, should remain the underground aspect of the art

world. The network is about direct visual/verbal access. That is the basis for establishing a new order of communicating ideas.[55]

Italian Mail Artist Piermario Ciani responded to Morgan's challenge, reiterating the same network philosophy put forth by Ulises Carrión a decade before:

The networker goes from one side of the globe to the other, creating his works in collaboration with others, and he doesn't mind if his voyages are real or virtual, as today he can activate networks for exchanges without leaving his desk, transmitting his works via fax, modem or other media, and the major limits are those imposed by the institutions who, with few exceptions, are still proposing white walls with hanging pictures. . . . In the post-industrial society where we live, the planet is constantly criss-crossed by millions of informations interconnected in many different networks and it is in this scenery that the networker acts, becoming in fact the interpreter of his own time.[56]

The Network Remains Eternal

Mail Art and the strategies constructed over a thirty-year period have proven adaptable to the new electronic technologies. Mail Art is not an endangered species flailing in the Internet surf. The network remains eternal. Filliou's concept is being delivered to a new generation of alternative cultural workers through constantly improved means of communication:

The rapid movement and the instantaneous, often fortuitous encounters along the computer highway are a stimulating experience, similar in many ways to the no less exciting sensation felt from the 1960s onwards by the growing number of people who have taken part in the activities of a global network that is certainly much more modest in terms of the technologies employed (envelopes and stamps), but no less astonishing in its results: the "eternal network," to use the term coined by the artist and sociologist Robert Filliou, of Mail Art.[57]

Mail Art remains a viable communication path among artists of different cultures, but with the rise of more sophisticated and economical technologies, its crucial moment may have passed. Networking, the cultural workers' ability to communicate in various media appropriate to the situation, a legacy imparted by a generation of Mail Artists, has become a vital strategy in the present artistic climate.

Notes

1. Robert Filliou, *Teaching and Learning as Performing Arts* (Cologne, Germany: Verlag Gebr., 1970), 205.

2. Robert Filliou, "Research on the Eternal Network," *FILE* (September 1973): 7.

3. John Held, Jr., "From Dada to DIY: The History of Alternative Art Culture in the 20th Century," *Factsheet 5,* no. 63 (1998): 10–12.

4. Giovanni Lista, *L'art postal futuriste* (Paris: Editions Jean-Michel Place, 1979).

5. Joanne Greenspun, ed., *The Russian Avant-Garde Book, 1910–1934* (New York: Museum of Modern Art, 2002).

6. John Held, Jr., *L'arte del timbro/Rubber Stamp Art* (Bertiolo, Italy: AAA Edizioni, 1999).

7. Sidra Stich, *Yves Klein* (Stuttgart: Cantz, 1994).

8. John Held, Jr., *Robert Watts: Artistamps/1961–1986* (San Francisco: Stamp Art Gallery, 1996).

9. Alexandra Munroe, *Japanese Art after 1945: Scream against the Sky* (New York: Abrams, 1994), 84.

10. Matthew Rose, "Collage by Arthur Secunda," *Lightworks,* no. 22 (1995–2000): 5.

11. William S. Wison, *Black Mountain College Dossiers No. 4: Ray Johnson* (Black Mountain, N.C.: Black Mountain College Museum and Art Center, 1997).

12. John Wilcox, "The Village Square," *Village Voice,* October 26, 1955, p. 3.

13. Edward M. Plunkett, "Send Letters, Postcards, Drawings, and Objects . . . The New York Correspondence School," *Art Journal* (Spring 1977): 234.

14. Henry Martin, "An Interview with Ray Johnson: Should an Eyelash Last Forever?" *Lotta Poetica,* (February 1984): 7.

15. Hervé Fischer, *Art et communication marginale: Tampons d'artistes* (Paris: Balland, 1974), 19.

16. Ibid., 24.

17. Arthur C. Danto, "Correspondance School Art," *Nation,* March 29, 1999, p. 32.

18. Mark Bloch, "Communities Collages: Mail Art and the Internet," *New Observations* (Summer 2000): 6.

19. Stephen Duncombe, *Notes from Underground: Zines and the Politics of Alternative Culture* (London: Verso, 1997), 3.

20. Ibid., 195–196.

21. Ulises Carrión, "Personal Worlds or Cultural Strategies?" in *Second Thoughts* (Amsterdam: Void, 1980), 51.

22. Ibid., 54.

23. Joan Marter, ed., *Off Limits: Rutgers University and the Avant Garde, 1957–1963* (Newark, N.J.: Newark Museum, 1999), 42.

24. Danto, "Correspondance School Art," 34.

25. Scott Watson, ed., *Ray Johnson: How Sad I Am Today. . .* (Vancouver: Morris and Helen Belkin Art Gallery, 1999), 44.

26. Muffet Jones, "Selected Biographical Chronology and Exhibition History," in *Ray Johnson: Correspondences,* ed. Donna De Salvo and Catherine Gudis (Paris and New York: Flammarion, 1999), 206.

27. Henry Martin, "Interview with Ray Johnson," 14–15.

28. Sharla Sava, "Ray Johnson's New York Correspondence School: The Fine Art of Communication," in *Ray Johnson: Correspondences* (Paris: Flammarion, 1999), 131.

29. Ibid., 122.

30. Quoted in ibid., 122.

31. Quoted in ibid., 126.

32. Danto, "Correspondance School Art," 34.

33. Sava, "Ray Johnson's New York Correspondence School," 121.

34. Ibid., 134.

35. John Held, Jr., "Networking: The Origin of Terminology," in *Eternal Network: A Mail Art Anthology,* ed. Chuck Welch (Calgary, Alberta: University of Calgary Press, 1995), 19.

36. Of special note is the catalog *Mantua Mail 1978,* edited by Romano Peli and Michaela Varsari, for the exhibition at the Assessorato Cultura Comune di Mantova in Mantova, Italy, September 21–October 21, 1978. In addition to reproducing works sent in for the show and the names and addresses of contributors, the catalog included essays by active practitioners in the field such as Ken Friedman, Mike Crane, Hervé Fischer, G. J. De Rook, and Bill Gaglione. The design and content of the catalog set a high standard for subsequent publications in the field.

37. Klaus Groh, "Mail Art and the New Dada," in *Correspondence Art: Source Book for the Network of International Postal Art Activity,* ed. Michael Crane and Mary Stoflet (San Francisco: Contemporary Arts Press, 1984), 75.

38. For an overview of Mail Art publications, see Géza Perneczky, *The Magazine Network: The Trends of Alternative Art in the Light of Their Periodicals, 1968–1988* (Cologne, Germany: Soft Geometry, 1993).

39. Michael Crane, "Exhibitions and Publications," in *Correspondence Art: Source Book for the Network of International Postal Art Activity,* ed. Michael Crane and Mary Stoflet (San Francisco: Contemporary Arts Press, 1984), 301, 312.

40. Calvin Tomkins, *Duchamp: A Biography* (New York: Holt, 1996), 83.

41. Ibid., 180.

42. Perneczky, *Magazine Network,* 51.

43. Davi Det Hompson, "To Each Contributor and Friend," in *An International Cyclopedia of Plans and Occurrences* (Richmond: Virginia Commonwealth University, [March 15–April 10] 1973). Unpaginated exhibition catalog.

44. Ibid.

45. John Held, Jr., *Mail Art Exhibition Documentation, 1970–2001: An Annotated Inventory of Catalogs, Participant Lists, Posters and Announcements* (San Francisco: Modern Realism Archives, 2001).

46. Mike Crane, "The Spread of Correspondence Art," in *Correspondence Art: Source Book for the Network of International Postal Art Activity,* ed. Michael Crane and Mary Stoflet (San Francisco: Contemporary Arts Press, 1984), 195.

47. Chuck Welch, *Networking Currents: Contemporary Mail Art Subjects and Issues* (Boston: Sandbar Willow, 1986), 109.

48. Held, "Networking," 20.

49. Welch, *Networking Currents,* 1.

50. Ronny Cohen, "Please Mr. Postman Look and See . . . Is There a Work of Art in Your Bag for Me?" *ARTnews* (December 1981): 68.

51. Carlo Pittore, "An Open Letter to Dr. Ronny Cohen," *Umbrella* (March 1984): 38.

52. Ibid., 36.

53. Ibid., 46.

54. John Held, Jr., *International Artist Cooperation: Mail Art Shows, 1970–1985* (Dallas: Dallas Public Library, 1986).

55. Aggressive School of Cultural Workers, Iowa Chapter, *Networker Congress Statements* (Iowa City: Drawing Legion, 1992).

56. Ibid.

57. Vittore Baroni, "It's a Net, Net, Net, Net, Net World (Long Mix)," in *Vanished Paths: Crisis of Representation and Destruction in the Arts from the 1950s to the End of the Century,* ed. and coordinator Emanuela Belloni (Milan: Charta, 2000), 265.

Fluxus Praxis:
An Exploration of Connections,
Creativity, and Community

Owen F. Smith

In 2002, Fluxus celebrated its fortieth anniversary. Throughout its history Fluxus has been composed of an international group of artists, musicians, poets, and others who participated and continue to participate in the varied activities associated with the Fluxus rubric. Through their work and activities, these artists have actualized a network-based paradigm of creative engagement. In these four decades Fluxus artists have continually explored the interconnections among collectivity, art, creative production, and distribution. From festivals of new music and event-based performances to the development and production of artists' publications, multiples, and films to the exploration of collaborative performances and the development of co-op housing, Fluxus has stressed activities based on participation in social performative frameworks. Fluxus offered insightful and creative engagements that challenged and continue to challenge the methods of creating and experiencing art as well as modes of social engagement and creative praxis. In the last several years Fluxus has received increasing historical and critical attention, and there are now several good texts that present a general consideration of Fluxus.[1] This chapter will therefore not cover all of the directions and forms explored under the Fluxus rubric, but rather is a more focused consideration of some specific key aspects, namely, performativity, process, play, networked culture, and communal artistic praxis (figure 5.1).

There seems to be an ongoing argument over who and what is or was Fluxus. On the Fluxlist <http://www.fluxlist.org>, an online discussion group devoted to things Fluxus and beyond, discussion on this topic has taken place numerous times. In both the content of the debate and in the form it is taking, with its rants and flames, it is essentially the same argument as has been going on for the last forty years in Fluxus. Many of the correspondences among Fluxus artists themselves and with others centers on the issue of participation in Fluxus and who is and isn't Fluxus. There are many reasons why the debate is still ongoing, but what I would like to suggest here in the context of a prehistory of the Internet is that the debate still rages about Fluxus because of its very nature. In early 1963 George Maciunas wrote to Dick Higgins that "Fluxus is a 'collective' & should not be associated with any particular fluxus individual. In other words flux tends to de-individualize individuals."[2] Higgins himself addressed this issue, writing to Jeff Berner in 1966:

Let's us say no more of Fluxus than you have said: you are right. Doing the thing counts. I regard myself as a Fluxus person, and Fluxus as a movement which serves

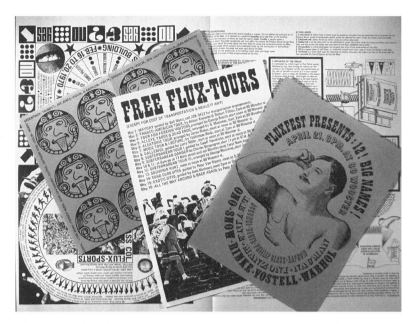

Figure 5.1 A small selection of performance and event posters. From the author's collection.

as a good handle for a lot of things to be dealt with. Anything that helps the move-ment helps anyone in it. Anything that only helps the organization or that hurts any of the people involved, that's what we have to be aware of. . . . As I said in my letter to GM [George Maciunas], I would continue to send him the best people I could find because the movement and, ultimately, the general collective spirit transcend the importance of anything that an individual might do, for or against the objective in-terests of the movement.[3]

What this statement indicates is both a reason for the continued debates around Fluxus and a key aspect of its very nature: Fluxus is a group of indi-viduals who constitute an entity, or maybe better yet, a community, called Fluxus. This community is simultaneously the product of its constitutive members but ultimately is more than any one individual or individuals. Fluxus membership is very fluid and has changed significantly over the last forty years as artists have joined and then left and then joined the group again. In this pattern of participation, what has remained constant is a com-munity called Fluxus and the underlying ideas or attitude around which it is constituted. Thus Fluxus exists not in a traditional way of specific mem-

bers who define and determine a group, but as a network of ideas around which a varied group of artists have collaborated. It is this core aspect of a philosophical or conceptual frame in Fluxus that is fundamental in recognizing Fluxus as a community and a philosophy rather than an art historical movement.

Fluxus as an attitude can be said to have existed prior to the group's formation. The creation of Fluxus, although it was not necessarily coherent or logical, was self-conscious and intentional. In the middle and late 1950s, a number of artists, musicians, and writers began to create work that rejected traditional cultural practices in an attempt to formulate a new art, music, or poetry. These artists were located throughout the Americas, Europe, and Asia, and centers began to form in each of these geographic regions, but many of the artists did not know of each other or have a means of sharing their ideas and work, particularly on an international scale. In partial response to this situation, Maciunas and Higgins began in 1961 to develop plans for a magazine called *Fluxus*. For this reason it can be stated that Fluxus was, from its very beginnings, thought of as a means of information exchange and not as an art style or movement. In fact Fluxus began not as a group of artists, but as a response to a perceived need for a distribution mechanism for their work, and to expose a wider range of people to the "good things being done," as Higgins described it.[4] The desire to publish such a magazine was connected to three fundamental concerns: establishing an information resource by gathering together an international collection of new work, creating a network for interchange among artists, and exposing the work of these artists to one another as well as to a broad audience. The initial stimulus for this project was in part an extension of the anthology of artists' works that had been put together by La Monte Young in late 1960 and early 1961, which was later published as a book titled *An Anthology*.[5] As a result of Young's work, it had become clear to Higgins and Maciunas that there was an important international and vital body of work that was largely unknown or unrecognized. Higgins and Maciunas began to gather artists' names and their work as part of the formulation of the magazine. They contacted artists who in turn contacted others and thus began to formulate a network of artists who shared many but not all concerns. Although Higgins and Maciunas's stated aim was the publication of a magazine, the real significance of their efforts was the initial formation of an international network of artists, writers, and musicians working in post-Cageian forms of experimental music and art (figure

Figure 5.2 An image of the monogram cards created by Maciunas as a representation of individuals in the international Fluxus network. From the author's collection.

5.2). In 1967 Higgins described the situation surrounding Fluxus and its formation as follows:

In the early 1960's there were few performance possibilities and even fewer publications open to this very world wide interest. . . . For me the arts depend upon, for their liveliness, the interaction between the digestion of the past and the digestion of the present. Terrible, the connotations of the gastric word, but I mean it metaphysically. You cannot abstract or separate formal and semantic meanings or experiments. Fluxus began as a rostrum to be used for the new arts. Maciunas, Mac Low, Corner and I began by publishing event work which we did not like (or trying to

publish them), so long as they seemed to relate to this interaction. The "flux" of the name "fluxus" refers to this interaction.[6]

The first public presentations under the name *Fluxus* were not, however, as a magazine, but as a series of performance festivals. In 1961 Maciunas traveled to Germany to take a job as a designer with the U.S. Army. While in Europe in 1961 and 1962, working with Higgins and several other artists in Europe, he continued to develop plans for publications that were now called *Fluxus Yearbooks* and alternatively *Fluxus Yearboxes*. In a letter to the pop artist Claes Oldenburg, Higgins explained Maciunas's plans for publications:

When I heard from him [Maciunas] again he was in the money, had a stable in the little air-force city of Wiesbaden in southern Germany, had bought a printing press, and had decided (wisely) that the only way [to see] any of the stuff he wanted to see in print would be to print it and distribute appropriately. He knows how, since he spent the last seven years in graphics offices in publishing and magazine houses. The format, he decided, would be to make a periodical to exist in boxes, the periodical to be called "fluxus" to be issued quarterly in runs of 1000, with another 200 "luxus fluxuses"—tentative name for the special issue—to contain originals, unprintable matter, unmanufacturables, film strips, photos, newspapers, etc. Each issue will be broken up arbitrarily into nations and geographical regions. The first issue is to be American and is to be published in English, French and German. Then comes French, then German, then eastern European, etc. The material he likes is the experimental and "lively."[7]

The core formation of Fluxus in the early 1960s also reflected a more specific and focused attitude about art and culture. This concept of Fluxus as a network of interrelated concepts and ideas has been expressed by a number of the artists associated with Fluxus. The most specific attempts to discern the Fluxus attitude are to be found in the writings of Higgins and Ken Friedman, both of whom have proposed lists of "qualities" that are present in Fluxus works and events. Higgins proposed that this list would consist of nine points: internationalism, experimentalism, intermedia, minimalism or concentration, an attempted resolution of the art/life dichotomy, implicativeness, play or gags, ephemerality, and specificity.[8] Friedman proposed a slightly different list of twelve criteria: globalism, unity of art and life, intermedia, experimentalism, chance, playfulness, simplicity, implicativeness,

exemplativism, specificity, presence in time, and musicality.[9] Although this attitudinal development was the most significant aspect of the European and American Fluxus performances from 1962 to 1964, another outcome was that Fluxus began to take on an identity as a group. Some people even began to think of it as a movement and began calling it Neo-Dada because of its seeming rejection of traditional forms of music and art and its celebration of cultural confrontation, transience, and nonhierarchal forms of cultural production (art making). This dual existence of Fluxus, as a group with a historical identity and as an attitude that underlies and shapes a Fluxus idea, has proven to be problematic, in that many have mistaken specific activities of individuals or groups of individuals as the core of Fluxus work rather than a manifestation of the potential of Fluxus. This definitional quandary is not just some artifact of the debates around Fluxus's history, but an aspect of its very nature. Although Fluxus's nature can be traced to the works and artists associated with it, these are not the exclusive determinants of Fluxus, but rather the residue and artifacts of its existence. More central to Fluxus is its nature as an attitude toward art, life, and culture. Thus to recognize this aspect of Fluxus, that is, Fluxus as an attitude and not a movement, allows us to return to its core of ideas. In doing so we can see a primary emphasis on participation and collectivism in Fluxus that forms a fundamental commitment to what we would now call a network mentality. Central to this are two interconnected aspects for Fluxus: first, the primacy of the event (or act), with a correlated concern for participation, and second, a centrality of information exchange, modeling, and education. Higgins was referring to such aspects of a new mentality when he wrote "An Exemplativist Manifesto." Although the whole essay is worthy of consideration, two short paragraphs are most relevant here:

Our arts . . . seem always to involve some aspect of performance—we enact, we do, we perform or commit aesthetic acts. We commit an act of education when we teach or when we present our live manifestations. Even our most static works are the result of such acts and, thus, have a performance aspect. . . . The action of the artist . . . is always sensed in the work and so the work can never be a fixity. Like life itself, our works are impure—always the centers of emanations of experience.

Such works can not be ends in themselves. Instead they always participate in the ongoing process of sharing an experience. Among the criteria for evaluating such works must always be the efficiency and force of their suggestion and proposal. Since

this process stresses not the single realization as the work, but the dialectic between any single realization and its alternatives, for in many exemplative works the method and format of the notation are far more crucial then in the works of the cognitive past.[10]

Of the multitude of directions and ideas that Fluxus has explored, the most significant one is that it models a way of being creative that offers a communal, participatory, and open-ended alternative to the traditional forms and functions of art making. Fluxus works and performances often emphasize collectivity and collaboration rather than the traditional art practices of individuality and exclusivity. Higgins characterized the value that he felt Fluxus had as follows:

I do not believe in amateurishness: that isn't what it is all about. But in amateurism, is simplicity. An art (by which I also mean non-art, if you prefer, so long as it is aesthetic in some way) on which one cannot hang a cycle of professional crafts and dependence. An art which by its very nature denies its perpetrators their daily bread, which must therefore come from somewhere else. Such an art must be given, in the sense that experience is shared: it cannot be placed in the market place and in this way it differs profoundly from the Fluxus-derived "movements" of earth-works or media-hype forms of concept art. Much of that work I enjoy—I even love . . . I must reject, not because it isn't officially Fluxus, but because it isn't free. It's just so many hat racks for careers to be hung onto. When the name of the artist determines the market value of a work and not its meaning in our lives—beware![11]

By rejecting both the romanticized frames of art as visionary and transcendent and the modernist notions of art as professional and exclusionary praxis, Fluxus returns to a simpler engagement open to all. Art becomes not a way to become famous, a carrier, or even a way to make a living, but something more important. In this way art becomes a social act, because of its participatory nature, and transformative as well, because of this very same inclusionary stance. Although this open, often seemingly uncritical and playful aspect of Fluxus is sometimes dismissed as insignificant or lacking a serious motivation, it is of fundamental import for a collective, collaborative, and global-based mentality.

After a number of group performances or concerts in New York and Europe, Fluxus went through a period of significant change.[12] A number of the initial participants left the group in 1964 because of tensions that had

developed concerning, among other things, differing opinions about Fluxus activism and its potential political aims. These differences came to a head with a picket of the performance of Karlheinz Stockhausen's *Originale* in August 1964.[13] This picket was planned as an extension of Fluxus's growing critique of traditional cultural politics but instead highlighted the strong differences that existed among many of its participants. Some, such as Nam June Paik and Higgins, felt that Stockhausen warranted serious consideration as a fellow avant-gardist and others, such as Maciunas and Henry Flynt, felt that Stockhausen was reflective of a European old-guard attitude of cultural superiority. About this and the general change in participation in Fluxus, Maciunas wrote to Higgins that

the date of Summer 1964 was set by yourself not me when you said . . . that you quit Fluxus, not only you, but in your own words "everybody." So, all I did was take your word for a fact and assumed everybody quit, except that is people who later denied this assumption. That is how Phil Corner, Alison, Ben Patterson & Paik got themselves in company with yourself (& for a while Bob Watts). . . . Kosugi did a classic double cross a year ago. Tomas quit himself. Henry Flynt quit himself, Jackson quit himself.[14]

The consequence of these changes was that a new focus in Fluxus activities emerged. Although some performances were presented, performance was no longer such a primary focus of the group's activities, which shifted to the production and distribution of publications and multiples. This shift was not a rejection of the earlier event-based performance work or festivals, but a return to the initial impetus for Fluxus's formation (figure 5.3) In the period from the mid-1960s through the mid-1970s a number of new artists joined the group, including Ken Friedman, Larry Miller, and Paul Sharits. Although extensive plans had been developed for publications in the first period of Fluxus, and several works—such as George Brecht's *Water Yam,* a collection of event scores that were published as loose cards in a box, and the collective publication *Review Preview,* a collection of documentary photos, scores, and works for sale printed on a long scroll of glossy paper—were produced, it was not until after 1964 that the majority of Fluxus works were in actuality published. Among the great variety of projects completed in this period were a large number of works by individual artists, such as Ben Vautier's *Mystery Food,* which consisted of commercial canned goods from which the

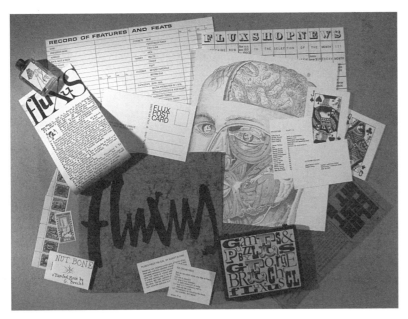

Figure 5.3 A selection of various Fluxus publications, including flyers, stamps, multiples, and other printed materials. From the author's collection.

original label had been removed and replaced with a new Fluxus label; a variety of works by George Brecht under the name *Games and Puzzles* that included, among others, a marble and instructions to "roll up hill"; a series of explorations on the form of chess by Mieko (Chieko) Shiomi titled *Fluxchess;* Bob Watts's *Fluxstamps,* some of the first artist stamps and numerous others; eleven issues of a Fluxus newspaper titled *V TRE;* a collection of Fluxus works and publications such as those listed above that were contained in a briefcase called *FLUXKIT;* a series of short films by Sharits, Yoko Ono, Higgins, and others that were jointly published and presented as a film series titled *FLUXFILMS;* and the anthology publications *FLUXUS 1* and *FLUX YEARBOX 2,* which were the eventual result of Maciunas and Higgins's original plans for collective Fluxus publications.[15]

Although the production of the variety and forms of Fluxus publications, films, and multiples is of general significance, it is two other aspects of this work that have a particular relevance for a prehistory of the Internet: first, the exploration of new and combined forms of media, or more specifically, intermedia; and second, the attempt to develop a new global distribution

network for the works themselves. Fluxus not only attacked the existing cultural forms and systems but also attempted to create an alternative distribution system for both Fluxus works and Fluxus ideas. Fluxus works were created as anticommodities. They were made using low-end mechanical processes, such as offset printing, and from mass-produced materials, such as the plastic boxes that many Fluxus works were packaged in or consisted of, and/or they used materials that were disposable or had no value, such as the used water in Vautier's *Dirty Water* or the scraps of paper in Friedman's *Flux Clippings.* The works were made inexpensively and sold at quite modest prices, and although this aspect was never fully realized, they were intended to be made in large number and thus disposable. The works often included aspects of their own self-destruction in that they called for some form of viewer participation or alteration, such as Ben Patterson's *Instruction No. 2,* which included a bar of soap and instructions to "wash your face." Fluxus used mass-produced materials, forms, and mechanisms as a medium. Rather than rejecting these aspects as not appropriate for art production given their noncraft value or nonaesthetic qualities, they celebrated them as both aesthetic and nonart.

From the very beginning Fluxus refused to see the creative arena as clearly or rigidly segmented into various arts. Thus, even though individual works may and do vary in degree of emphasis toward one art or another, they are also what Higgins has called "intermedial."[16] One of the most significant acts of Fluxus is to see all works as literary, musical, visual, and performative rather than just as one of these forms or another. This challenge to our traditional separation of media into types is connected to a larger cultural shift in Fluxus: from a text-based to a visual, or field-oriented, culture. Much has been written about Fluxus and its intermedial emphases; however, what I would like to suggest here is another result of the interconnections between Fluxus and intermedia, and that is a network mentality. As the focus of work in Fluxus shifts from product to process and from producer to a shared interaction among artist, performers, and audience, the result is a self-perpetuating process that emphasizes the totality of materials and participants, even though either or both may and do change. The resultant focus, based in a self-critical investigation of media, rejects media distinctions and posits a focus or core of activities that exists in the spaces between media (i.e., intermedia). As Higgins indicates, intermedia is a hallmark of a new type of work:

I would like to suggest that the use of intermedia is more or less universal throughout the fine arts, since continuity rather than categorization is the hallmark of our new mentality. There are parallels to the Happening in Music, for example in the work of Philip Corner and John Cage, who explore the intermedia between music and philosophy, or Joe Jones, whose self-playing musical instruments fall into the intermedium of music and sculpture [and t]he constructed poems of Emmett Williams and Robert Filliou certainly constitute an intermedium between poetry and sculpture.[17]

It is the connections and spaces between media and/or categories, such as the "space," between say, poetry and painting, sculpture and theater, or music and dance, that takes precedence in the intermedial activities of Fluxus. In addition to the work itself one can, as Higgins has suggested, see a more general new mentality:

We have no fear of becoming: our thought processes are meditations . . . in the sense that they are liberated processes of thought and feeling, as opposed to directed ones. We are quite readily capable of experiencing these as emptiness and beyond concrete conceptibility. All this adds up to a new mentality, at least for the western world.[18]

Such stress on liberated processes of thought and feeling can be seen in the shifting associations of activities, objects, and people allied with Fluxus. They are present in the decentralized community and social networks that result from this very same interactivity, but they are part of the larger lack of interest in Fluxus in concrete aims and specific limits to perception and understanding.

The general Fluxus attitude seeks to open up the possibilities of life and art as a consequence of direct participation, a partnership process that emphasizes the power of play, the affirmation of engagement, and the value of creation without predetermined, definitive characteristics or goals. In Fluxus works, whether they are performances or multiples or other publications, there is an end product, performance, or object, but the real significance of the works is how they model the processes of intermedial thinking, processes in which the aim of the work is at least in part to establish multiple possibilities containing patterns of both presence and absence that create both an ambiguity of meaning and its opposite as well. Such a cognitive

intermedium can be seen in the nature of many Fluxus works, such as James Riddle's *Flux ESP Kit,* Friedman's *Flux Corsage* or Brecht's *Games and Puzzles.* These and many other Fluxus works manipulate or play off of the model of interaction in games. What Fluxus picks up on from games is not just the immediacy of humor, but a more general importance of play as a kind of model for open-ended discourse that stresses relations rather than a linear production and communication of discrete pieces of information. In this form, play is important for Fluxus because it stresses participation and breaks down the normal physical and conceptual barriers between the spectator and the work. This kind of play is also most evident in Fluxus as an attitude more than a reference to a form or a particular game structure. For the Fluxus worldview, play has no specific beginning, middle, or end and no spatial or numerical boundaries. This kind of play is thus most aptly described as infinite play. It is one of the primary operative modes of cognitive intermedia, and it has a significance that is transformative rather than formative. Because infinite play is expansive, a primary motivation is the perpetuation of the play of ideas and associations. The Fluxus worldview places no great significance on conceptual or physical boundaries other than those that are internally defined in relation to the recognition of associations and difference. This is not to say that there are no boundaries, materials, or objects in Fluxus, but that they are less important and ultimately inconsequential in the processes of change and creation of possibilities. It is this aspect of Fluxus that puts thought into play and creates the potential for a cognitive intermedium. In Fluxus modes of play, what is created is not so much a thing or a specific frame for play, but a space for cognition: simply put, a space to think more than act is established. At the same time such processes of play are aimed at not allowing the engagement to become predetermined or fixed, in the sense that they are not enacted for some specific utilitarian end, such as solving a problem. In fact many Fluxus works that take the form of games or kits are unusable in a traditional, goal-oriented way. One version of Brecht's *Games and Puzzles* contains a shell and puzzling instructions that read, "Arrange the beads in such a way that the word CUAL never appears"; another version contains several beads or marbles with the following instructions: "Arrange the beads so that they are the same. Arrange the beads so that they are different." Thus these and other similar Fluxus works are intended to play with our expectations and our cognitive faculties, rather than be played in any traditional way. They create cognitive space by leveraging

our expectations of traditional finite games against our reality of experience, creating more questions than answers. How is one to either start or end the process of play? How can one carry out such instructions—are they senseless? How is one to understand language—is it the basis for meaning? Is there a means of measuring successful participation? These and other such questions engendered by Fluxus-type works thus not only are at the heart of the work but *are* the work in a more fundamental way than the physical materials from which they were constructed.

Many Fluxus works, performances, and interactions emphasize the process of meaning making as part of the work. Ben Patterson's *Questionnaire* is a small card printed with the following—"please answer this question carefully. Yes () No ()"—and Eric Andersen's *Opus 13* reads, "do and/or don't do something universally." These works and others like them offer us a possible closure, answer, or end and then reverse or counter that possibility through their forms, materials, or implications, thereby highlighting the continuous deconstruction of established meanings and the projection of new possibilities as a basic pattern of our means of understanding and making sense of the world. Alison Knowles's *Giveaway Construction* instructs us to "find something you like in the street and give it away," and Emmett Williams's *Gift of Tongues* instructs us to "sing meaningfully in a language made up on the spot." Such instructions are not intended to be actualized as a means to achieve an end or the work itself but are intended to be understood and perceived as part of the act of knowing and thinking. These works, as events in life, are formed through self-perpetuating processes of construction and deconstruction, and Fluxus works seek to model a way of thinking and acting in a fluid world of signifieds and signifiers. Takehisa Kosugi's *Theater Music* instructs us to "keep walking intently," and Nam June Paik's *Zen for Film* is a clear loop of 16 mm film. The processes and interactions in all of these Fluxus works are central to the act in Fluxus as part of a unified process of teaching and learning, or as Higgins puts it, a "movement away from negativity and fear and guilt of our parents, and into new alliances and less alienated relationships—by means of the arts as media for exchange. Our involvement . . . in such an exchange involves a new dialectic which we then project into our whole aesthetic experience—we must learn in order to teach, we must teach in order to learn."[19]

The relational nature of meaning production is evident in many Fluxus works that stress the notion of differing situations and varying potential

interpretations. The meaning evident through Fluxus events and objects shifts and changes because they require personal participation in the work or experience. As a result, Fluxus works are not based on the source of original artistic conception, or solely on the artist's intent, but occur in the mental realm of the viewer/participants or in the shared cognitive space that Marcel Duchamp labeled the "art coefficient."[20] The exploration of an interactive and shared development occurrence in Fluxus works is significant and forms the basis of a type of experience we now call hypermedia. Although hypermedia is often thought of as a specific form found in electronic and digital formats that supports linking graphics, sound, and video elements in addition to text elements, it is fundamentally not limited to a type of media. Hypermedia is based on three concepts: a prioritization of interaction, an interest in multivariant readings or experiences, and the use of a form that has built-in demands for responses by the participants. These very same concepts are at the core of Fluxus works and the experiences they seek to generate. Although Fluxus is not technologically hypermedia based, it is hypermedial in conceptual aims and even in the intermedial forms used. Fluxus works must be experienced, and central to this experience is participation. The score to Lee Heflin's event piece *Ice Trick* instructs that "a one pound piece of ice [be circulated] among members of the audience while playing a recording of fire sounds or while having a real fire on stage. The piece ends when the block of ice has melted."[21] In this and in many other Fluxus works, the audience and the performers are no longer separated; they instead become participant/users. The results of such interactions among the users, the performance, and the works are intentionally varied and variable, for this is the core of the flux in Fluxus. In the interactive process of creation that occurs among the artist, the work, and the audience, we are not held less accountable but more so, or as Brecht states in his *Event Score* of 1966, "Arrange or discover an event. Score and then realize it": We are ultimately responsible for the work and our experiences in or of it.[22] Friedman's "globalism," in his twelve core ideas of Fluxus, refers to a similar set of conceptual nodes.[23] Although for Friedman, globalism has other aspects as well, it nonetheless contains as key principles an awareness of connectedness, an exchange of information, and a participatory approach to art and culture.

Fluxus publications and multiples were initially made available not through traditional art venues such as museums and galleries but were distributed through alternative distribution mechanisms such as bookstores,

small shops, or directly through the mail. In these processes Fluxus appropriated the materials and forms of commercialized production and distribution to create and distribute noncommercial publications and multiples. A number of different Fluxshops were set up in the United States, France, and the Netherlands. In addition to these shops, which it must be noted were of limited success, several Flux Mail-Order Warehouses were established that were directly aimed at establishing a new means for distributing works and publications without those works themselves seeming to become profound, exclusive, or valuable as a commodity. In 1978, Paik elaborated on the significance of Fluxus as a distribution mechanism that he felt went beyond Marxist parameters:

Marx gave much thought about the dialectics of the production and the production medium. He had thought rather simply that if workers (producers) OWNED the production's medium, everything would be fine. He did not give creative room to the DISTRIBUTION system. The problem of the art world in the '60s and '70s is that although the artist owns the production's medium, such as paint or brush, even sometimes a printing press, they are excluded from the highly centralized DISTRIBUTION system of the art world.

George Maciunas' Genius is the early detection of this post-Marxistic situation and he tried to seize not only the production's medium but also the DISTRIBUTION SYSTEM of the art world.[24]

Fluxus's involvement in the distribution system as a means and mechanism for art is, as Paik points out, significant, but even more important is the recognition of systems of exchange as a communal practice and as art forms themselves. This recognition, coupled with a lack of interest in traditional differentiations between high and low culture, art and nonart, and preservation and destruction, is an aspect of Fluxus that has become part of network culture and can be traced from Fluxus through mail art and other artists' collaborations in the 1970s and into the culture of the World Wide Web in the 1990s. This form of cultural practice, which recognizes the potential of the systems themselves as art (and as a community), is simultaneously a use (or misuse, by traditional practices) of the system of production and distribution and a critique of that same system. Additionally, Fluxus uses the forms of publications not just for information distribution or the presentation of publicity, but as a networking form and an extension of, or

in some cases a replacement for, the group. In the mid- and late 1970s and throughout the 1980s, Fluxus becomes, more than anything else, a network of associations and contacts. This aspect of Fluxus is not really new, however; it was just more evident given the diminishment of the movement's performance activities and publications in this period. As early as 1963, Brecht recognized this global network as a central aspect of Fluxus:

It has been evident to me for some time now that, even beyond the value of individual works right now, there is a more important change taking place in the nature of the actions we find it nourishing to undertake. . . . (or say: "the nature of the acts we find being taken.") So I am very pleased to see FLUXUS taking form (as in your newsletter) as a sort of (center of activity) or (focus of action). . . . GLOBAL ASPECT: FLUXUS seems to be an anational, rather then an international, phenomenon, a network of active points all equidistant from the center. These points can proliferate, new points arise, at any place on earth where there is life. . . . I think we should stop thinking that only "cultured" individuals lie within our reach. . . . I would be interested in knowing generally, how large the FLUXUS system is, and how you envision its makeup.[25]

As envisioned by Brecht, Fluxus is not so important as a thing or a quantifiable entity, such as an art movement, but as a conceptual approach, a worldview, and a cognitive space that allows for a shifting group to collaborate in creating a world together. Understanding this, it becomes clear that Fluxus is more of a virtual space than it is a particular art historical group with a finite set of geographic and chronological parameters.

The works and the distribution forms become intertwined in Fluxus as they both are subsumed into a new exchange value for the works. Although Fluxus publications and multiples were sold, they were sold only to cover the cost of production. The real aim of this system was the distribution of ideas more than products or objects.

No matter how it may seem, given the divergent nature of the works, all the periods of Fluxus activities share a basic attitude about art, culture, and life that is a key factor in the Fluxus project. Fluxus is fundamentally a rejection of the status quo's parameters of and for art as distinct from life. In his 1965 manifesto *ART-FLUXUS ART-AMUSEMENT,* Maciunas attacked what art had become:

Art must appear to be complex, pretentious, profound, serious, intellectual, in-spired, skillful, significant, theatrical, it must appear to be valuable as a commodity so as to provide the artist with an income.

To raise its value (artist's income and patron's profit), art is made to appear rare, limited in quantity and therefore obtainable and accessible only to the social elite and institutions.[26]

Rejecting the object-centered, exclusive, and commercially driven nature of art that Maciunas described, Fluxus seeks to return art to a communicative function and a dispersed practice, an activity and a way of thinking that is open to all. An objective of Fluxus—and this is inherent in its communal, performative, and participatory aspects—is the elimination of art as a spe-cial activity. In a letter to Tomas Schmit, Maciunas wrote:

Fluxus is not an abstraction to do on leisure hours—it is the very non-fine-art work you do (or will eventually do). The best Fluxus "composition" is a most non personal, "ready-made" one like Brecht's "Exit"—it does not require any of us to perform it since it happens daily without any "special" performance of it. Thus our festivals will elim-inate themselves (and our need to participate) when they become total readymades (like Brecht's exit). Same applies to publications & other transitional activities.[27]

The Brecht work to which Maciunas is referring is an event score titled *Word Event,* the score for which is simply the word "Exit." The work was often pre-sented by someone writing "Exit" on a blackboard and performed by the audience as they left the performance space after a concert, but it was also intended to be "performed" any time one exited a space or location. It was, as many events are, an act drawn from life and presented as a simple activity that we perform constantly without realizing, and thus the score aims, to borrow a phrase from John Cage, to wake us up to the excellent lives we are living.

In Fluxus one can see a glimmer of an information economy: not what our economy of information has become, in the commodification and sale of information, but a desire to create a network for interactions between con-stituents. What Fluxus models is a system, however flawed, that seeks a judi-cious use or management of the intellectual resources of its community. Further, this process of information exchange within this economy was pro-jected as shifting; all could, or at least would eventually, participate as both

producers and consumers. Such an information economy seeks to use these very same resources in an efficient manner to perpetuate the community itself, not through protectionist practices, but through the spread of its ideas, with (as many Fluxus artists have commented) the aim that eventually such traditional economic distinctions as consumers and suppliers and artists and viewers would be eliminated as unnecessary. All Fluxus works, whether they be performances, publications, or multiples, are intended to be used and passed on as the viewer/participant comes to understand the work and even become a participant in the network. This model is based on a new social praxis that is shared and participatory. Art becomes not an object for contemplation or consumption, but a network, not, however, in the media or technological sense, but rather as a cognitive space and a communal structure.

Works such as Knowles's *Performance Piece #8* (1965) play off of the understanding that it is only through our own limited view of difference and its workings, from within the operation of language, culture, philosophy, and so on, that we gain any glimpse of cognitive and linguistic operations at all. The score for *Performance Piece #8* is as follows:

Divide a variety of objects into two groups. Each group is labeled "everything." These groups may include several people. There is a third division of the stage empty of objects labeled "nothing." Each of the objects is "something." One performer combines and activates the objects as follows for any duration of time:

1. something with everything

2. something with nothing

3. something with something

4. everything with everything

5. everything with nothing

6. nothing with nothing[28]

This piece is thus to be not understood as a series of fixed points, but as a conditionally determined territory, filled with contradictions and the potential for them. The work proposes a new type of participatory existence: not a delimited, static one that dominates our older concepts of understanding, but one that is network based and shifting as the participatory nodes shift in and out of the network. Thus both the network and Knowles's work exist, or they

have a core, but their boundaries and the means by which the participants operate are in a constant state of flux. Such open-ended pieces (as most Fluxus works are) are not intended to create a new media or center but instead seek to get us to reconsider the world itself with all of its vagueness, dislocations, and potentialities. The Fluxus investigation of the world is a simple insistence on experience as an interaction between participants and object, performance, poem, or work that seeks to minimize the potential cessation of play. The rejection of categorical distinctions and evaluative hierarchies in Fluxus is entirely related to an awareness of, and emphasis on, the lack of a non-context-bound center, that is, medium, whether it be physical or cognitive. This emphasis on the relations between the constituent aspects and a parallel absence of a singular or dominant conceptual medium, is explored in Fluxus as part of an attempt to extend potential conceptual domains and the play of signification infinitely into what can be called cognitive intermedia. The free or open play of meaning dominates the work as a hyperlink in the network of Fluxus ideas and works. The viewer is asked to become a formative participant in the creation of multiple meanings, to act and play by substituting one signifier for another. In this process the physicality of the work or the bounds of its materiality become irrelevant as single aspects and instead become part of a networked whole. Because of these shifts, the play of signification in Fluxus can no longer be called to a halt or grounded, because it is only through the presence of a center, or medium, that the play of substitutions can be arrested. The lesson of this kind of infinite play, as embodied in Fluxus, is that the process of ever-changing substitutions is an aspect of network creativity and an act of life.

What the modes of critical thinking found in Fluxus offer to art is parallel to what the open-source code movement offers to computer programming: the tools by which a previously exclusionary practice, whether it be the programming of code or the creation of art, and means of production not only become available to all but grow and remain vital through the work and ideas of many varied participants. In many Fluxus works the stress on participation, performance, and interaction is a means of accentuating the connectedness of all human activities, even those labeled as art. All aspects of Fluxus include elements that work against the traditional relationship in art of the passivity of the viewer and the domination of the object. What is modeled in the work, activities, and interactions of the Fluxus group is a communal praxis aimed at the creation of a network based hyper- and intermedia.

Even though much of Fluxus existed prior to the age of the computer, the Internet, the World Wide Web, hypermedia, and hypertext, Fluxus's activities and attitudes present many of the most important realizations of network culture, many of which we are now only rediscovering.

Notes

1. For more information on Fluxus, see Hannah Higgins, *Fluxus Experience* (Berkeley: University of California Press, 2002); Owen Smith, *Fluxus: The History of an Attitude* (San Diego, CA: San Diego State University Press, 1998); Ken Friedman, ed., *The Fluxus Reader* (New York: Academy Editions, 1998); Elizabeth Armstrong, ed., *In the Sprit of Fluxus* (Minneapolis: Walker Arts Center, 1993).

2. George Maciunas, to Dick Higgins, letter, [early 1963], Collection Archiv Sohm, Staatsgalerie, Stuttgart, Germany.

3. Dick Higgins to Jeff Berner, letter, September 13, 1966, Collection Archiv Sohm, Staatsgalerie, Stuttgart, Germany.

4. Dick Higgins to George Maciunas, letter, [Spring 1962], Collection Archiv Sohm, Staatsgalerie, Stuttgart, Germany.

5. For more information on these developments, see Jackson Mac Low, "Wie George Maciunas die New Yorker Avantgarde Kennenlernte," in *1962 Wiesbanden 1982*, ed. Rene Block (Wiesbaden, Germany: Harlekin Art, and Berlin: Berlinner Kunstlerprogramm des DAAD, 1983), 110–126.

6. Dick Higgins to Tjeena Deelstra, letter, March 13, 1967, Collection Archiv Sohm, Staatsgalerie, Stuttgart, Germany.

7. Dick Higgins to Claes Oldenburg, letter, June 26, 1962, Collection Archiv Sohm, Staatsgalerie Stuttgart, Germany.

8. Dick Higgins, "Fluxus: Theory and Reception," in *The Fluxus Reader*, ed. Ken Friedman (London: Academy Editions, 1998), 224.

9. Ken Friedman, "Fluxus and Company," *Lund Art Press* 1, no. 4 (1990): 292–296.

10. Dick Higgins, "An Exemplativist Manifesto," in *A Dialectic of Centuries: Notes towards a Theory of the New Arts* (New York: Printed Editions, 1978), 158, 159.

11. Dick Higgins to George Maciunas, letter, November 19, 1974, Collection Archiv Sohm, Staatsgalerie, Stuttgart, Germany.

12. For more information on these performances and other activities, see Smith, *Fluxus,* 165–203.

13. For more on this see Hannah Higgins, "Fluxus Fortuna," in *The Fluxus Reader,* ed. Ken Friedman (London: Academy Editions, 1998), 32–36.

14. George Maciunas to Dick Higgins, letter, [Fall 1966], Collection Archiv Sohm, Staatsgalerie, Stuttgart, Germany.

15. For more information on Fluxus publishing activities, see Simon Anderson, "Fluxus, Fusion, and Fluxshoe: The 1970s," 22–30, and Owen Smith, "Developing a Fluxible Forum: Early Performance and Publishing," 3-21, both published in *The Fluxus Reader,* ed. Ken Friedman (London: Academy Editions, 1998).

16. Dick Higgins, "Intermedia," *Something Else Newsletter* 1, no. 1 (1966): 1.

17. Higgins, *A Dialectic of Centuries,* 16.

18. Ibid., 162.

19. Ibid., 163.

20. Marcel Duchamp, "The Creative Act" (lecture given in Houston, April 1957), printed in *ArtNews* 56, no. 4 (Summer 1957); 28–29.

21. Lee Heflin, *Ice Trick,* n.d., n.p.; score in the author's collection.

22. George Brecht, *Event Score,* 1966, n.p.; score in the author's collection.

23. Friedman, "Fluxus and Company," 244–247.

24. Nam June Paik, "George Maciunas and Fluxus," *Flash Art,* nos. 84–85 (1978): 48.

25. George Brecht to George Maciunas, letter, [early 1963?], Maciunas's personal microfilms no. 1/109, Collection Archiv Sohm, Staatsgalerie, Stuttgart, Germany.

26. George Maciunas, *ART-FLUXUS ART-AMUSEMENT* (New York: Fluxus, 1965), unpaginated.

27. George Maciunas to Thomas Schmit, letter, [1963?], Collection Archiv Sohm, Staatsgalerie, Stuttgart, Germany.

28. Alison Knowles, Performance Piece #8, 1965. This score is reproduced in *The Fluxus Performance Workbook,* ed. Ken Friedman, published as special issue no. 9, *El Djarida Magazine* (1990), p. 35.

Artists/Activists Re-view
Their Projects

The ideas, passions, and forces driving selected projects are explored in this part of the volume. From varying perspectives, each of the contributors engages with the challenges that faced artists and activists as they worked with and against distance in their practices. Some contributors map their own artistic journeys and rewrite their own singular histories. Others choose to write in styles that reflect the collaborative, networked quality of their work: Sherrie Rabinowitz and Kit Galloway discuss their work with Annmarie Chandler in chapter 6; Anna Freud Banana dialogues with Craig Saper in chapter 11; Simone Osthoff works closely in chapter 12 with Eduardo Kac and Paulo Bruscky; and Tetsuo Kogawa's contribution in chapter 8 is woven together from an e-mail interview with the volume's editors. What emerges from the rich archival material in the following chapters, which includes histories/stories, descriptions, documents, and images, is the inventiveness and energy of engaging with communications media as art/activist mediums as they defi(n)ed distance.

Many of the projects discussed in this part of the book involved a direct or indirect reengagement and reshaping of earlier art traditions that used parody, collage, and chance. For example, in a reengagement with Dada, Mail Artist Banana worked through parody. As she and Saper discuss in chapter 11, parody performed as an analytic tool and a form of practice for her. More indirectly, there was the "wacky" approach of the collage group Negativland to social commentary. As Don Joyce describes in chapter 7, the group didn't experience any tension between aiming for something "sounding good" and letting the random loose and experiencing the joys of coincidence: "Whatever happened just happened" (186). Or as writer and sometime assembling artist

Melody Sumner Carnahan says in chapter 10, "It's about playing around and seeing what happens" (239).

Fluxus and mail art approaches played out in ways that were inflected by local situations, such as the politically repressive environment that Bruscky worked in during the early 1970s in Brazil. As Osthoff discusses in chapter 12, Bruscky's work responded to that political climate, pushing national, geographic, political, and artistic boundaries. In ways that were experimental and playful, political and conceptual, performative and curatorial, Bruscky made works and happenings with sound, fax, mail systems, photocopiers, film, and video. His "eruptions" into public space, typical of Fluxus and mail art, were a "fusion of art and life" (262).

Chance, again not "new" in its appeal to artists, was reinvigorated as a significant value and mode of practice for distance artists/activists. For example, as he reveals in chapter 13, Roy Ascott's commitment to chance in/determined his *I Ching* project (within Robert Adrian X's "The World in 24 Hours," discussed by Reinhard Braun in chapter 3). And Carnahan's story in chapter 10 also reveals how her practice embodied chance, which fascinates her, as she fell into and upon distance art. In a sense Carnahan made her own personal discovery of assembling art, motivated initially by "simply trying to keep the mailbox stuffed with oddball things to facilitate getting out of bed in the morning" (231). She and her husband, Michael Sumner, made a form, listing the years 1970–1979, with a blank line for each year, and gave or sent it for completion to friends, relatives, and strangers, as well as artists, writers, politicians, and other people they admired—from Carnahan's own family members to John Cage. For Andrew Garton, too, in the "isolation" of

Australia, correspondence in his mailbox similarly became a source of inspiration and material for his early cut-up "assembling" musical compositions, as he discusses in chapter 14.

It was to a certain extent the alternative milieux in which artists like Ascott and Carnahan found themselves that provoked unexpected and exciting connections. Carnahan identifies the positively chaotic, iconoclastic, and enflamed atmosphere of the late 1970s in California in which nihilism, futurism, and existentialism supplemented the 1960s influences of Dada and surrealism. For Ascott, his existing interest in psychic systems resonated with the San Francisco Bay Area world of the paranormal and esoteric, a milieu that helped develop what would become his understanding of consciousness as a field of enquiry as well as connecting him with a world of computer conferencing. In a similar countercultural context, Banana took a different turn: After a psychodrama workshop experience at Esalen (home of the archetypal and controversial "California" alternative, psychedelic lifestyle of the late 1960s), she "went Bananas, first figuratively and later literally" (250). This experience gave a new, performative direction to her work. When she came upon mail art somewhat by chance (of course), Banana found there a network of poetic and political "therapy." Saper suggests in chapter 11 that like Wilhelm Reich's, Banana's work involves her performative freeing up of personal energies that reverberated through to "free up the communal energies available in systems and networks" (252). Furthermore, as Saper draws out, its *networked* quality shaped Banana's work in a very particular way as the analyst, and in a sense the analysis, "diffus[ed] and fade[d] . . . in networks of people and meanings" (248).

Social networks and creative collaborations were significant and pleasurable aspects of practice for many of the contributors to and subjects of this part of the volume; for others they were crucial. As they were for Eastern European assembling artists (whom Stephen Perkins discusses in Part III), the networks of both mail art and Fluxus were artistically and personally enabling for Bruscky in the 1970s. Osthoff discusses in chapter 12 the way that these networks provided Bruscky with an "alternative venue for art making, participating in shared networks of ideas and gestures of resistance that linked national and international artists" (262). Through these Fluxus and Mail Art networks and approaches (though with serious consequences for himself, including several jail terms), Osthoff tells us, Bruscky was able to make important experimental performances and interventions that explored processes of "circulation, reproduction and distribution" (262).

The power of the arts to engage with the community in the creation of alternative communication contexts is raised by the work of telecommunication artists Galloway and Rabinowitz, as they discuss with Chandler in chapter 6. Their aesthetic inquiries traverse troubled borders between art, activism, habitual social behavior and technological invention. From a different angle, Jesse Drew's activist/artist work was also focused on the community, as part of a scene that used media for political purposes. As he reveals in chapter 9, for Paper Tiger TV, Deep Dish TV, and the Gulf Crisis TV Project, the network was about people-to-people communication and empowering democracy, as well as the politics of access to communication technologies and the power to "create your own media." Although Drew writes and works mainly from a political perspective, it is striking that his work in

this area brought him into contact with fellow artists as well as with activists and that for him as an activist/artist, questions of the medium were never transparent. Similarly, Garton, working in what he calls the collaborative "theater of activism" (299), engaged in his own practice and with fellow artists/activists across music, performance, writing, and public media, "integrating both . . . artistic and political interests" (299), as he reveals in chapter 14.

Just as Garton's Toy Satellite was an attempt to break the one-way transmission broadcast model and work more locally, Kogawa first engaged with mini-FM's low-power radio transmission for similar reasons. As he reveals in chapter 8, Kogawa came to mini-FM as a grassroots "free-radio" medium that "could be independently controlled by nonprofessional ordinary citizens" (192) as well as respond to Japanese state control of media on one hand, and youth culture's isolation and political and cultural decline on the other. Mini-FM, with its one-kilometer radius transmission, was a low-tech apparatus that configured distance in an intensive rather than extensive way. It worked well in high-density urban Japan. Informed by Merleau Ponty's phenomenology, William Burroughs' cut-up method, and Félix Guattari's *La revolution moleculaire,* among other philosophical and artistic influences, Kogawa's mini-FM was part of a "minor" politics. And his early broadcasts worked like a magnet, attracting listeners to the "stations" and multiplying stations rapidly.

Confrontation with the commercial broadcast model and its impact on artists and audiences was also important for Negativland, as Joyce elaborates in chapter 7. As a forgotten medium, radio says Joyce, offers the "very best

kind of place to attempt art" (184). Working with radio as an art medium in itself, rather than a transparent broadcaster of other art, Negativland members collaborated not just with one another but with those who called in to their live radio show, *Over the Edge.* A collage style of collaboration and radio making, *Over the Edge* involved live reworking of multiple sources, including found sound/media, music, and a sort of "public access to our ongoing mix via telephone" (184). In his mini-FM practice, Kogawa similarly worked with radio as medium, focusing increasingly over time on its art and performative capabilities. He came to see it as "radio without an audience" (203) a performance that could "deconstruct the conventional function of radio" (203). Kogawa developed mini-FM as performance art that worked with the "microunit of the medium" (207).

Radio and sound are places and acoustic spaces where new and old technologies could provoke and promote each other as well as playing across physical spaces. Heidi Grundmann of *KUNSTRADIO* in Austria, for example, tells in chapter 15 of early events involving radio with computers, data gloves, sensors, violins—as well as with musicians, artists, engineers, producers, and so on. She describes how *CHIP-RADIO* participants at one location "played" instruments at another location—instruments that seemed "played as if touched by the hands of ghosts" (320). Telematic simultaneity and the circulation of sound across distance in this event did not deny distance so much as make what the art historian Romana Froeis, quoted by Grundmann, terms the "processes in the electronic space" between the two, "physically and psychologically perceptible." (320).

It is clear throughout this part of the book that although all the contributors and subjects were consciously and critically engaged with the question of their relations with technology as artists/activists, not all shared the same approach. Whereas some were wary, others were utopian. Ascott, although well aware that the "direct link" between the technology he explored and "big business and the military" could be "darkly problematic" (287), nonetheless believed that an artistic telematics would be fundamentally different and indeed "could provide the means for enlightened artistic and poetic alternatives" (287). Telematics for him was, indeed, essentially utopianism: "to be both here and elsewhere at one and the same time" (288). For the postmodernist Ascott, this resonated with Derrida's *différance,* endlessly deferring meaning from any finality. It made telematics a working medium, particularly for *La Plissure du Texte: A Planetary Fairytale,* a play on/with Roland Barthes's *Le plaisir du texte.* This was the expression of his idea of artist as "context maker"—in this case, in a globally distributed textual interplay.

A desire to experiment with the potential of human communications, interactive technologies, and the creation of telecollaborative environments inspired Galloway and Rabinowitz's *Satellite Arts (The Image as Place)* project. Rather than an ode to massive technology, it was an assertion of and quest for the reinvigoration of the human imagination in modeling large-scale, real-time, interactive environments. Dancers at opposite ends of the U.S. continent collaborated, improvised, performed, and "discovered" together, in a mixture of real and virtual spaces/places. Galloway and Rabinowitz's *Hole-in-Space,* while continuing a concern for spontaneity, set up a "social situation with no rules" (166), giving New Yorkers and (Los) An-

gelinos a telematic window on and to one another. Another project by the pair, *Electronic Cafe-84*, which operated for seven weeks during the 1984 Olympic Games in Los Angeles, acknowledged the importance of including informal and culturally diverse human-to-human connectivity in the design of collaborative multimedia networking environments.

Dialogical and process-based (rather than object based) approaches were typical of early telematic works using video. As discussed by Osthoff in chapter 12, these approaches were characteristic of Kac's work, for example, when he shifted from art based in the body to immaterial art, first holographic art and then videotexts, while still in Brazil. The confluence of personal computers and the global electronic network was the context of Kac's shift into works with telecommunications, networks, and telepresence. As Osthoff explains, his goal in making this shift was to explore "the interactive, improvisational quality of both personal and public telecommunications media simultaneously, integrating the apparently antagonist media into a single process" (273). Rather than focusing on distance as space, Kac's telepresence art emphasized the *temporal* dimension of distance and *real* time more than real space.

Many distance artists/activists were thus challenging conventions of the production of art that separated "object" from distribution, makers from curators, artists from activists. In the early 80s, Paper Tiger Television involved artists, activists, and academics who worked with a low-tech aesthetic for aesthetic, political, and economic reasons. Hand-delivering videos to public-access stations, they challenged the distribution modes of broadcast network TV with their sneakernet. Deep Dish TV, as Drew details in chapter 9, took

these challenges further with a more interactive two-way video network. Out of this energy and these networks, in the face of the events of the (first) Gulf War, came the Gulf Crisis TV Project in 1990, which again involved artists and activists and other intellectuals. Even though collectivity was fraught with debates concerning professional versus "funkier, home video-cam aesthetic" (221) and what audience to aim at, nonetheless, a remarkably extensive and effective national and international network was rapidly established.

Networks are, of course, a key issue for most of artists in this part of the book, and all raise issues of networks' social and cultural aspects, which will be foregrounded in Part III. It is striking that what we understand by the term *networks* is also fundamentally extended by the artists/activists who write for this part of the volume. Garton, for example, tells of a time when a pre-Internet "service provider" like Pegasus in Australia was a place for live on-line poetry readings and a live election night text feed. And it was a base for internationally networked events such as "FIERCE/InterRave, a multi-faceted party, performance, and symposium, and what could be described in current terms as a precursor to today's Net-casts, a text-cast with about forty participants representing the Net-connected world in 1933" (305). Through this networked party, they raised money to purchase modems for nongovernmental organizations in Southeast Asia.

Early distance art/activist projects sought to disrupt the conventions and assumptions associated with transparent or instrumental notions of communication and distribution. Distributional art/activism, including setting up networks of distribution, was important beyond electronic arts. In an era in

which zines were flourishing, Fluxus and assembling artists were exploring all manner of alternative distribution as part of the very *process* of their art making. In the 1970s, Banana's mail art publication *VILE,* for example, included discussions, (illustrated) letters, and addresses for networking, as well as mail art and visual poems.

Besides distribution, a crucial issue at the juncture of "democracy" and networked communications, for collage artists in particular, was, as it is today, copyright. The possibility of "recontextualizing" found media became a major issue with consumer copying technology such as cassette recorders, VCRs, and photocopiers, as Joyce explains in chapter 7. Joyce discusses one of the earliest confrontations between copyright law and media collage and its negative effect on art practice, especially sonic art. His Negativland example also raises the issue of the complexity of a collage that was "made out of preexisting material but constituting a wholly new work in itself, as all collages do" (182).

While most projects explored in this part of the volume operated outside of or beside mainstream media, not all did. For those that did not, different institutional settings affected the possibilities for distance art and activism, and distance artists'/activists' relation to technology also inflected and was inflected by their everyday working relations. Having worked collaboratively in the area of radio as the producer of *KUNSTRADIO,* Grundmann, for example, points in chapter 15 to the enabling, mainly institutional context of Austrian support and access that fostered innovative work in and through radio art. And in turn, the way that artists, technicians, and media experts collaborated within institutions shifted the culture in those institutions. In

Austria, this cultural and institutional context intersected with the culture of earlier activities of electronic artists, such as those addressed by Braun in chapter 3. This networking between both generations of distance artists was a significant animator and shaper of the (Austrian-based and/or Austrian-connected) radio art work that Grundmann describes.

Both within and outside institutional settings, it was not, as Drew asserts in chapter 9, technology that was the center of media art/activist work, but social relationships and collective activity. Technical and media expertise coalesced with artistic practices for many. As numerous contributors to this part including Grundmann foreground, even the most experimental projects, bringing together a number of different technologies, were not driven by technology or uncritical of it. Within a trajectory of intermedia (rather than convergence) and of constant "remediation between older and new media" projects displayed a stunning "hybridity of networks and mass media, of bodies and machines" (331).

The ways that bodies were implicated with machines in distance art/activism was torsioned by philosophical and aesthetic and media concerns as much as technical factors. The tension between emotional and physical distance plays out for Kogawa, for example, in the distance of the media artist's body. Distance in media is thus not defined by conventional space and time, according to Kogawa, and Chris Brown and John Bischoff return in part III to this sense of distance as performatively rather than physically or communicatively configured—intensive rather than extensive. Kogawa's "radio parties" were more performance art gestures than a means of communication. His practice became more and more micro, closing in from the walk-

ing distance of mini-FM to a hand-waving distance: distance configured by the performer's body. In the face of an era of "global communication," Kogawa's response, politically and artistically, was "to rethink our more micro and local area of space and time . . . [and] insist on a microscopic approach, in order to find the diverse differences in the shrinking but increasingly dense distance" (209).

Finally, we would note that in contributing to this volume, a number of authors confront the difficulty of documenting work that is often inherently ephemeral. Indeed, when one of the pleasures and impetuses of the work is this very ephemerality, there can sometimes be, at this writing distance, a provocative lack of documentation and archives to work with. Further, as participants in the projects that they discuss, the authors face the complication of writing about their own and collaborators' ideas, motivations, and practices. Although the distance of time does not necessarily make this challenge any easier, the challenge creates an enlivening and enriching tension in these stories of distance artists/activists.

6

Animating the Social: Mobile Image/Kit Galloway and Sherrie Rabinowitz

Annmarie Chandler

In 1999, Kit Galloway and Sherrie Rabinowitz (Mobile Image) received Guggenheim fellowships for their lifelong contribution to the arts. Their headquarters, studio, and home, Electronic Café International in Santa Monica, California, operating weekly from 1987 to 2000 and working with over forty international affiliates, allowed hundreds of artists, performers, researchers, and people from community organizations to explore, with them, the creation of new ways of being in the world and being interconnected in emergent electronic and digital environments. Their full trajectory of work encompasses creative and cross-cultural explorations utilizing satellite communication systems, teleconferencing technologies, video phones, and early contemporary computer networking systems, including Web casting and work with Virtual Reality Modeling Language (VRML) and 3D multiuser environments.[1]

This chapter investigates Galloway and Rabinowitz's seminal projects, *Satellite Arts (The Image as Place)* (1977), *Hole-in-Space, A Satellite Communication Sculpture* (1980), and *Electronic Café-84* (1984). It incorporates themes developed by the artists as Mobile Image and covered in Gene Youngblood's earlier critiques.[2] What follows is a reflection and conversation with the artists on a journey through their archives (through interviews conducted in 2002 and 2003) to further explore the social, aesthetic, and technological motivations that underscored this work.

A New Trajectory, a New Context, a New Scale, a New Practitioner: The Avantpreneurs

Teaming up in 1975, Galloway and Rabinowitz united their backgrounds in the media arts with their talents in engineering, architecture, theater, and environmental design to form their visions of how alternative telecommunication contexts might develop and the role of the arts in shaping and humanizing technological environments. Their work was to become an unremitting aesthetic quest for imagining "a much larger scale of creativity," in the "new world information order," a quest that acted in direct opposition and intervention in the "lifeless" communicative possibilities they saw emerging in the scientific, academic, fine arts, and media communication environments of the 1970s and 1980s.[3]

From the start, Galloway and Rabinowitz's core desire lay in experimenting with the real-time, interactive potential and quality of human communications in technological environments. Their body of work pursued the

idea of a globally distributed "electronic commons," intolerant of network latency, that would allow geographically dispersed participants to convene and co-occupy an instantaneously composited virtual space as if in the same virtual place.

Sherrie: We were too close to our vision, so it's always been hard to put the idea into simple language that paints a picture so that people can "see" what we saw in their minds eye. That's why we tried to dissect the whole idea and attempted to manifest and prove various aspects as individual projects. One should consider and look at the body of our work as an effort to describe and test our ideas of how all this could come together. The set of ideas were expressed in *Satellite Arts, Hole-in-Space,* and *Electronic Cafe-84.* The first step we put forward was the larger contextual idea of the global immersive composited image space. We chose to frame it as "a performance space with no geographical boundaries." As far as we could tell this idea had for decades been hidden from the imaginations of a multitude of disciplines including the arts and artists, and tomorrowland futurists. We were too impatient to wait any longer—too impatient to wait ten or twenty years for computer-simulated approximations of this idea.

Galloway and Rabinowitz's earliest influences can be traced back to the playful and imaginative calls to real-time interactivity in the 1950s television genres, in TV programs for children like *Winky Dink and You*[4] and the composite image space explored by Ernie Kovacs[5] and Steve Allen.[6] Kovacs would do improvisations and comedy by superimposing his live studio image onto film clips and interact with the film characters, and Allen did improvised comedy by superimposing his live studio image over live coverage of unsuspecting pedestrians outside the TV studio. These forms had earlier precursors in a large but mostly forgotten body of popular culture from the late nineteenth century through the mid-twentieth century, imagining the future world of interactive visual communications, inspired by the development of the telegraph, telephone, radio, and formative sound and image technologies, ideas also developed in early and contemporary science fiction genres. *Electronic Cafe*'s extensive collection of illustrations, texts and memorabilia of what the French call "works of anticipation" reveals that social and cultural insights for "convergence" were well underway during this period.[7]

Later influences on Galloway and Rabinowitz included the dawn of the space age and events associated with the space race and cold war: the launch of the Sputnik satellite in 1957, television and other media coverage of the Kennedy assassination,[8] the reinterpretation of the mass media by McLuhan, and political interventions associated with media activism. There were thus accumulative effects that shaped both their expectations and their attitudes about the role of the artist in a technological society.

Kit: With what seemed as a perfectly reasonable set of expectations, we proceeded with an agenda that would pursue the idea of at least approximating, as a series of concepts and aesthetic inquiries, a manifestation of telecollaborative environments that would make it possible for geographically dispersed publics, intimate couples, and communities to convene together in real time in the same electronic space. While these expectations and desires seemed reasonable to us, they were nevertheless delinquent in the real world that was allegedly entrepreneurial—there were no industrial parks, theme parks, or facilities in the world to experience these ideas as a technological possibility. We thus developed a series of projects that addressed a wide variety experiences, convergence of technologies, and social/cultural configurations. Our vision, or rather sets of desires, were then and remain today independent of any technology because technology was then and remains today inadequate.

Our research confirmed an almost total disinterest if not incompetence by the arts community in relation to modeling compelling implications of interactive telecommunications technologies and telecollaborative environments. Artists and the stewardship within the arts community seemed to be blindsided by obsessions with genres suitable for the context of traditional broadcast and cinematic storytelling. Efforts to secure cable access and aspirations to have video art tapes and installations broadcast seemed to underestimate the intrinsic qualities of visionary telecommunications environments that had been articulated as utopian and dystopian expectations for over a half century.

For Galloway and Rabinowitz more interesting public communication environments were emerging outside and independently of these spheres:

Kit: Probably the most used community networks were CB radio, international short-wave and ham radio networks, cultural and telecom networks

that were vastly more cultivated, purposeful and accomplished than that popularized for a short while by the CB radio craze, i.e., *Smokey and the Bandit* movies. You had this other subculture of techno engineers and ex-military and civil service types that developed a culture and technical competence and dexterity and called that ham radio culture. They were building their own context, operating within a free preserve set aside for low bandwidth with spin-off networks. There was a model, there was a whole global committed population that had technological competence to not only be end users; they had the competence to develop the technology. To us it wasn't an art problem, it was a problem of human creativity, human creativity animating the technology.

In our minds the role of the artist in societies increasingly dependent on technologically mediated realities required something far more than the collective efforts of media art or telecom art manifestations targeted towards the insular and subjective confines of an art gallery. A new vision, a new practice and new practitioners were required that would no longer presume to subordinate aspirations towards utility and creating approximations and working models for socially sustainable alternatives to the status quo, in preference to continuing to use technology to create unique consumable artifacts of transcendent beauty.

A new aesthetic transcendent of the art world schema and intrinsic to the implications of a potential global revolution in telecommunications was sorely missing. Not only was a fresh start needed, but, like all attempts to reinvent the role of the artist, a new practice and a new trajectory was needed that was both larger and more inclusive than the collective expressions framed by that which was celebrated and perceived as relevant within the context and stewardship of the established art world and its practices.

Satellite Arts (The Image as Place)

When the National Aeronautics and Space Administration (NASA) announced in 1977 that it was accepting proposals from nonprofit organizations for experiments involving its U.S.-Canadian satellite, *Satellite Arts* (*The Image as Place*), Galloway and Rabinowitz's first investigation and aesthetic research project, found support for realization. The Corporation for Public Broadcasting and the National Endowment for the Arts funded the work (figure 6.1).

Figure 6.1 "Kit and Sherrie, *Satellite Arts*, 1977." Kit Galloway (left) and Sherrie Rabinowitz (right) go over the score and storyboards used by the performers and collaborators that made up the crew for the 1977 Satellite Arts project A Space with no Geographical Boundaries.© 1977–2003 Galloway/Rabinowitz.

Sherrie: We were interested in observing the creative potential of satellite communications. There was power there not being manifest. So it was the aesthetics and the power that was it.

Kit: NASA was losing funding from Congress and was facing the prospect that they would no longer be a publicly funded R & D [research and development] wing of the developing telecommunications satellite industries. So, NASA turned to nonprofit organizations for sympathy and public support. They even began to respond to the demands from some public sectors for the idea of a public-service satellite that would give a dividend back to taxpayers by saving nonprofit public-service organizations millions of dollars a year by wiring around the telephone monopoly. This was the situation that opened up NASA to accepting proposals for public service, educational, telemedicine,

and creative applications of satellite technology. This is what got us to pack our bags and move back to the U.S.

We weren't goo-goo, ga-ga about satellites. We realized what was needed was a network that was intolerant of latency but that wasn't going to happen, (it) didn't exist, but with satellites we could model the ideas. Satellite was the only way to move moving images across oceans to create a model for the global-scale image as place. We determined that after testing this less-than-desirable solution, we would come to understand viscerally and kinetically the limitations imposed by the latency and apply that knowledge towards developing a list of scenarios for future work.

In many ways *Satellite Arts* was the most demanding and challenging of all of Galloway and Rabinowitz's work. In 1977, artists were experimenting with composited imagery, and some were experimenting with satellite communications for conferencing and broadcasting events. But this project had no precedent as a telecommunications form for interactive, composite image work for performance, in what the artists now refer to as prehistoric cyberspace. *Satellite Arts* linked dancers three thousand miles apart, from outdoor locations on the East and West Coasts of the United States, in this performance space "with no geographical boundaries." Taking a year to develop with NASA, the live transmissions that lasted four days were beset with technical disruptions and disappointments when NASA's infrastructure regularly went down. However, *Satellite Arts* was still able to act as the intended prototype to test a number of creative and social approaches to the combination of real-time and virtual communications.

Although dance had often been employed for experimental video art, in this experiment dance was not so much about content but was rather an appropriate tool for investigating this terrain.

Sherrie: We've always worked with scored improvisation, and drawings were part of the scores before this. This is something the theorists didn't understand because they're always informed by asynchronous communications and text-based environments. We need to credit Ann Halprin and her husband, Lawrence Halprin, who was an architect and he wrote a book called *RSVP,*[9] which was about improvisation. We read it and it was so cool—they had a methodology that answered some of the needs for the *Satellite Arts* project. We knew it had to be about spontaneity and improvisation. We knew

we needed scenarios and scores and there it was, so we used that as a model. We knew how we wanted to start at A and to get from A to B to C, but how you got from A to B was about relating to each other.

Kit: We also need to make a reference to improvisational jazz as an attribute. While jazz and real-time improvisational collaboration has fallen out of fashion, like so many valid forms of human expression tend to do over time, it does not diminish or antiquate either the skill sets or the necessity for such forms of human expression. Command over our instruments of networked telecollaborative cocreation is so important that it is our opinion that such dexterity even subordinates crafted and artistically refined performances, narratives, and storytelling. These instruments or the technological webs and networks we swim in together can not only accommodate improvisational creativity; they awaken and inspire it to swell up from the innate human desire to connect with the other(s). Yet institutionalized and academic precepts about what is to be celebrated as art and achievement is stuck in controlling time and the frame rather than accommodating improvisational mastery of complex systems in "real time," and thus escaping the frame as well as the business of authentication offered for consumption by the gallery space.

Sherrie: We didn't want to work with any dance veterans or people with experience with video. We wanted fresh, unopiniated dancers. Through Ann Halprin we discovered a young troop calling themselves Mobilus. The group had grown out of the Ann Halprin training. So they came to us and we introduced them to our concepts for the image place and live video and our thinking and they introduced us to their dance and so it went.

To prepare the dancers, the artists workshopped collaborations that allowed the human dynamics to take control of the space. The approach was process oriented rather than "prescribed," with the artists using their own illustrations and storyboards as "visual metaphors" to guide and stimulate ideas and interactions. The scored improvisation provided a vehicle through which to allow maximum freedom to explore new ways of seeing, listening, feeling, moving, and coming together in the *creation* of the new space. Sessions were also held in closed-circuit video spaces to familiarize the dancers with the video medium and its capability.

The project had a visual form or template for establishing the separate locations in California and Maryland as a split screen, which would then dissolve

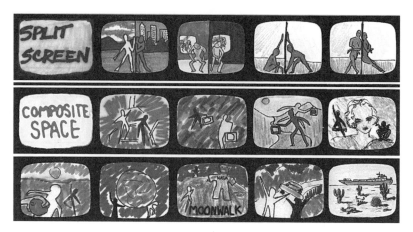

Figure 6.2 "Galloway and Rabinowitz storyboards created for *Satellite Arts,* 1977." Sampling of the Galloway and Rabinowitz storyboards depicting some of the scored improvisational inquiries into the image as place. The "split-screen scores" in the top row represented the conventional dividing line that had always separated remote participants during long-distance televisual encounters. Galloway and Rabinowitz's mission was to destroy this conceptual encumbrance and break through to a shared composited image space and urge that it become co-occupied by the widest possible diversity of people, places, and things. The "composite space scores" depict various scored improvisational tasks to be performed during the short four days of the 1977 *Satellite Arts* project, sponsored by NASA, the National Endowment for the Arts, and the Corporation for Public Broadcasting. With a team of media arts collaborators and the Mobilus dancers, Galloway and Rabinowitz used these and other real-time telecollaborative scenarios and applied dance as a "mode of investigation" to approximate and examine for the first time the potentials and limitations of a new "performance space with no geographical boundaries." © 1977–2003 Galloway/Rabinowitz.

into an entirely new third and shared location for four performers. The split screen, however, acted as more than a visual metaphor representing distance. It was also a device delineating "video spaces" and "remote locations" and therefore something the artists set out to deliberately destroy. The split screen was thus an "architecture" designed and scored "to be torn down, torn down in order to enter and convene together in, what was up until that time, an unexplored territory (figure 6.2)."[10]

The communications environment, however, presented the dancers with a number of unique challenges in connecting with one another and creating their performance. The perimeters of both outdoor and remote locations were bordered with monitors that allowed them to see the composite landscape and their virtual encounters. The satellite delays, seen as reflections or visual echoes in one of the scored examples in the dancer's movements, had to be integrated and made sense of. The delays also slowed the dancers' sense of timing, so that navigating the space produced sensations of heaviness in

what the artists refer to as "thin space" and "thick time." The dancers' perception of touch migrated to the virtual realm, and if their images touched one another on screen, both dancers "felt" it. The experience of being together with "the other" in the virtual environment also felt different when different imaging techniques were employed. The "key," for example, produced defined boundaries within the composite for performing one's interactions with someone else's "solid replica," whereas the "mix/dissolve" effect, which is softer and blended images together, prompted more sensual interactions and was, according to the artists' aesthetic criteria, always a superior choice, in the case of video technology, for providing intimate and compelling encounters in a composited image space.

The archival segments reveal sequences of clarity, recognition, and ease with "being in the place" as the dancers, who are otherwise three thousand miles apart, perform duets, create compositions with one another, and interact with their electronic, lens-captured representations and those of their remote partners. These moments are mixed with those showing people working hard to make contact with one another as to well as to understand and respond to a range of introduced and changing audiovisual stimuli. Collaboration, it was discovered, meant, figuratively, "a whole daisy chain of people holding hands" to make all of the subcomponents and elements come together, from the dancers to the camera and control room crew, with everyone getting in focus with the dynamics taking place.

Kit: Our language going into this was the performances were tests and the tests were performances. (*Commenting to me, watching the archival recordings*) What you're watching is people learning. What you're watching is the discovery process. She's discovering [herself on the screen], then the camera people start discovering, the keying people start discovering, and there are moments where they are all creatively playing together. Gene Youngblood points to the nontrivial attributes of what he calls the process of "the creative conversation," the process through discourse, which leads to the discovery and understanding of the points of view and meanings of the other person. This is a creative and constructive act of collaboration. Once we agree and have come to understand each other, we then proceed with the trivial process of communication.

What we got was sort of our first drafts, first drafts over a series of four days—with one day down time. We were able to spend enough time to acculturate in the space—to approximate the underlining goal of attaining a

feel for creating a real-time improvisational creation. *We have attempted to make this a signature quality of our work.* All of our projects tried within the limits of our financial viability to exist within the rawness of the real world long enough to yield some semblance of our aspiration for real-time virtuosity for ourselves, the participants, and/or the publics that became captured within the web of new context we cast.

The 1977 *Satellite Arts* project incorporated image processing, wireless acquisition of physiological data, and as a result of using geosynchronous satellites to test and evaluate the only existing technological context for manifesting a global real-time immersive visual environment, we addressed what would turn out to be the issues of network latency from that time forward.

Because the *Satellite Arts* project was a close collaboration with NASA, it yielded discourse with people within NASA and DARPA [the Defense Advanced Research Projects Agency] that were deeply invested into the practical and indispensable aspects of text-based messaging and communications. Nevertheless, beyond the fact that text-based networking was incidental in facilitating coordination much as it has done through the late eighties and nineties, it offered us little as a compelling alternative to our aspirations for a broadband environment. As for proficiency with a keyboard, we considered ourselves and the social contexts we were envisioning as apart from type talking and the statistical reality and skill sets that required keyboard proficiency in the real-time social domain. Later, when computer bulletin boards revealed the context and celebrated attributes of disembodied role playing for keyboard-proficient participants, we were happy for them, but still unaffected. Without regret, we did not find text-based or a keyboard-based interface into a networked world compelling enough alone to subordinate our total vision for a telecollaborative and immersive space.

Sherrie: Our artwork is about social spaces that accommodate the physical reality and the virtual. A major theme is mixing the real and the virtual—those two things. You are more involved and invested in the presence of that image which is an extension of you. You are in your mind mapping a virtual person next to you and your relationship together. What was very important to us was facial recognition and a combination between the verbal, the virtual reality of the context and lens-captured reality, and that meant that people had to take responsibility for the event, for their image and who they were as they were represented by lens and camera captured imagery . . . and

that's what we were invested in, both facial recognition and the quality of presence.

This exploration of "being" and inhabiting virtual environments was made over a decade before philosophers would again become invested in concepts of "place" as distinct from the time/space/pace discourse dominating emergent communication technologies. More interestingly, *Satellite Arts* incorporated most of the elements now being argued as integral for the formation of identity in unexplored and uninhabited landscapes and for the act of implacement to occur. The social inquiry necessary for establishing "where I am, how I am together with others, and who we will become together" was stimulated through interactions between the real (the "here") and the virtual (the "there"). Scored improvisation allowed the fullest exploration of the "collusion of landscape and body when human beings venture beyond the confines of familiar territory."[11] The sensorial displacements and adjustments to the environment and the dancers' experiences of kinesthesia are now becoming recognized as ways of "being" in environments in which common methods of orientation are disrupted or in which one's perceptions "drift between regions."[12] The integration of sensory stimuli with observational assessments as a means of navigation has precedents in earlier cultures. Edward Casey, addressing not virtual space but the Pacific Ocean, cites examples of skills learned by the Puluwatan Micronesians and Islanders, who combined assessments of the night sky and distant horizons with their experience of the feel of the roll and pitch of their canoe on the waves to navigate toward what were otherwise regarded as "unknowable" destinations.[13]

Hole-in-Space, A Public Communication Sculpture

By 1980 Mobile Image had decided it was time to take some experiments to the streets.

Sherrie: We wanted people to discover a *Hole-in-Space.*

Kit: We wanted to create people encountering this space and see, what was their behavior? What would they do? How would they react? See we're interested in the human dynamics and the quality of the communications. We were looking at new ways to culturally animate these new ways of being in the world and new models had to be invented. And we didn't want a spectacle.

Hole-in-Space, A Public Communication Sculpture is probably the Mobile Image work people are most familiar with, for two reasons: Selected footage was edited and distributed as an award-winning documentary, making it widely accessible outside the event, and the material itself is captivating and very entertaining regardless of the stage of technological development of an audience. Galloway and Rabinowitz stress, however, that curatorial focus on this project alone as "emblematic of their work" strongly misrepresents the significance of their trajectory in cyberarts history; highlighting it as an isolated project, without examining it in the context of their other aesthetic inquiries with composited image space and the social and technical dimensions required for *Electronic Cafe-84,* camouflages the paradigm they were developing regarding an anticipatory, "globally distributed electronic commons." It also camouflages their confrontation of the status quo for hijacking the social imagination from exploring these potentials for real-time, multimedia telecollaboration.

In *Hole-in-Space,* live satellite communications were used over three days to link unsuspecting publics in Los Angeles and New York. Screens erected in windows at a department store in Los Angeles's Century City and the Lincoln Center in New York created a networked space in which people in each city could encounter and converse with one another (figure 6.3). Life-sized images of the other group were relayed to each group on the screens. However, no composited imagery or self-view monitors were used this time, as the idea was to bring people together to create an environment in which people "could invest their energy in whatever they were doing in the social space" without the visibility or distraction of technology. Facial recognition and eye contact were again important aspects, as well as an absence of signs and advertising, and the lack of any explanation of what was going on; if anything was to occur at all, it had to be spontaneous.

These requirements for spontaneity and presence involved many months of preparation, as suitable sites and satellite sponsorship needed to be located and negotiated. Lighting and sound were also an issue. The necessity of preserving "natural" lighting conditions at the locations and also of allowing people to see each other was achieved by using military cameras that were able to "see in the dark" and pick up ambient as well as infrared boosted light on people in front of the windows. Satellite audio delays and echoes had to be treated and carefully and continually balanced to keep the exchanges as clean and direct as possible. Youngblood discusses the need to understand

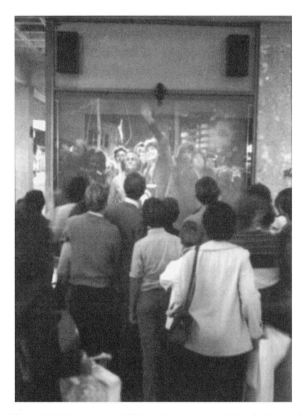

Figure 6.3 "Views of *Hole-in-Space,* 1980." View of the window installation for *Hole-in Space* (1980) facing the public sidewalks in front of The Broadway, a department store in Century City (a city within the larger Los Angeles megalopolis). © 1994–2003 Galloway/Rabinowitz.

the importance of both *scale* and *control of context* in relation to the work, in which the intention was to reconcile "discontinuities of scale . . . by collapsing large scale phenomena into human-scaled environments, expressions and possibilities."[14]

Kit: We wanted it to feel like you were encountering somebody on the sidewalk, that they weren't "in" a thing. We wanted a day of discovery, a second day of further sort of development to get into more sophisticated levels of interaction, of where are you, who are you, and we were going to look and see how people behaved, did they mimic TV or was it like a cocktail party, a little bit of this, a little bit of that.

Developed as a "social situation with no rules" and operating for between two and three hours every evening (New York time), the event unfolded very much as the artists foreshadowed. On the first evening, people going home from work or going about their business have their attention captured by the life-size images of other people appearing in the windows. The archival footage shows groups starting to form in both places trying to figure out where the images are coming from and what's going on, and at the same time some people initiate short greetings across the link to get to know the other crowd. The environment starts to warm up quickly as people start clapping, shouting and waving at each other, while some individuals exchange personal details about themselves and their jobs to strangers in each city, much to everyone else's amusement. Everyone is having fun and sharing exchanges they would otherwise feel inhibited about in public spaces.

By the second evening, word's gone around informally that something interesting is going on at the windows in both cities. Still without any mediated explanation of what is happening or why, people who have been there the previous day and brought friends along take their own initiative to describe, to others, the connection between Los Angeles and New York and to integrate strangers into the experience. The opportunity for reunions is irresistible, and a number of people turn up purposefully to meet relatives or friends they haven't seen for years. By the third day, this has become a frenzied activity, as the event also attracts press coverage and very large crowds arrive seeking out relatives and acquaintances "on the other side." The meets and greets are interspersed with impromptu solos or duets by people who feel like entertaining everyone with their talents. At one point someone suggests playing "charades by satellite" and groups of strangers at both sites pool their talents to collaborate on scenarios while everyone else urges them on.

In the verité interviews conducted during the event at each site, the sense of excitement about the space is palpable. People realize they're sharing and shaping a new communication experience, and some comment, "It could have been done years ago."

Sherrie: One of the things that people enjoyed was seeing other people meeting and seeing other people be intimate with their relatives. They really enjoyed that. People were seeing the commonality of "us." Nobody cared whether it was art or not.

Kit: You know in the art world and academia there was this thing about distributed authorship, loss of the author and things like that—and "that's what *Hole-in-Space was.*" We didn't think of that, but we created a context and we stepped away, and then they completed the work. We created situations that allowed people to own this with their imaginations where they could encounter it, sort of rock it for a while. At least for a period of time we triggered or instilled that kind of behavior, that kind of dynamic.

Electronic Cafe-84

These rituals of hospitality and place were further explored in Galloway and Rabinowitz's third and final model for a "resocialization" environment, *Electronic Cafe-84.* The year 1984 was the year the Olympics came to Los Angeles. It was also the year the first Macintosh was released and the year people were reminded of the Orwellian, antiutopian vision of a totalitarian communication order. As a response to this prophecy and with uncanny insight into the adverse social potentials of a gestating digital information society, Mobile Image designed a project to create a model for "a place where a globally networked culture might emerge that would enable consumers of information to evolve into the architects of services that served their interests rather than the interests of Microsoft."[15] These objectives formed a summons, to action in the 1984 Manifesto for the project, a challenge to artists, cultural gatekeepers, and corporate communications power brokers, that "WE MUST CREATE AT THE SAME SCALE AS WE CAN DESTROY. . . . That the counterforce to the scale of destruction is the scale of communication, and that our legacy or epitaph will be determined in many ways by our ability to creatively employ informal, multi-media, multi-cultural, conversational, telecommunications and information technologies."[16]

Like *Hole-in-Space, Electronic Cafe-84* was envisaged as an electronic community commons, this time utilizing emergent computer networking technologies. The project, commissioned by the Los Angeles Museum of Contemporary Art as an official event of the Olympic Arts Festival, constructed a seven-week shared network among five family-owned restaurants in the Korean, Hispanic, African, and beach communities of the less glamorous regions of Celebrity City, areas that would otherwise remain untouched by the Olympics. Rabinowitz commented on the project in a 1984 televised interview:

We've designed this communication system to associate as many communication systems as possible, and it tends to emulate a real café, a café in the sense that you can walk into a café and at one table people are having a serious conversation, at another table people are flirting, somebody else is just watching what's going on, somebody else is writing poetry, somebody else is drawing something. All those things take place simultaneously, at the same time, and they're hosted gracefully by the café. So in trying to define what we wanted the communications system to be, we wanted to create a communications system that allowed for that same kind of breadth of communication.[17]

Galloway acted as systems integrator in the achievement of the design of the network in a period when no such network acted as a model for associating systems capabilities with the habits, cultures, and human interactions significant to a selected environment. Most people in the public context of computer use in 1984 were just coming to terms with their word-processing softwares; small minorities of specialists were using early e-mail formats and, if familiar with academic-research contexts, text-based formations of the Internet. There were no public Internet cafes and fortunately, according to the artists, no Starbucks cafes either.

The *Electronic Cafe-84* network integrated a number of capabilities from existing and hybrid technologies into a simultaneous multimedia, data-archiving, and real-time communication system for the purposes of cafe dynamics. The network included slow-scan, phone link video systems; a telewriter electronic writing tablet; computer terminals and keyboards; hardcopy printers; and video screens.

Kit: That was the design parameter, a multimedia, telecollaborative network that would provide the basic human requirements for moving ideas between people even if they didn't speak the same language, built on the existing dial-up Internet network.

The drawing tablet we chose because of its capability. You could draw on paper. It was French made. So these pieces existed and they had their applications in the world for telestrating or things like that. We actually had to build the genlock to be able to make those tablets work with the video so that people could add a tape and draw on video. So we solved a lot of technical problems to take these different cats-and-dogs pieces of technology and make it possible for them to work together as an integrated system or to be

used independently—we tried to present it as sort of a guest you know—this is a cafe and this is going on in the cafe—that took a year.

During the six months the system was being designed, key members of the communities associated with the cafes were involved with preparation for the event. Revolving artists-in-residence and artist/systems operators were trained from within the communities for each *Electronic Cafe* site. Mostly, however, the interactions were intended to be self-organized and discovered by groups and individuals from the communities, as in *Hole-in-Space.* The artists prepared a technology "menu" for each café, which acted as a diagram and storyboard for the setup and systems and for stimulating ideas on what people might do with the technology. Audio and video conferencing was possible, and the audio conferencing became popular for poetry events, in which a guest poet from one of the communities might drop in and then be linked to the other cafes on the network for an exchange. The video conferencing was mainly used if people wanted to meet, show off their children, or introduce others across the network. Performances could be broadcast via audio and video. Photo novellas[18] proved a very popular way of communicating. Text, telecollaborative drawings, still video images, and telewriter-annotated video images could also be stored on an optical-disc recorder to create a community memory in the first demonstration of a public storage-and-retrieval pictorial archive.

Ana Coria (community facilitator on the project): A lot of people from Central America over in the Boil Heights would input, people who were totally separated from their culture, some who'd been tortured and what not, lost people, they put in poems about people they loved and photographs and the community—it was basically the community image.

I would say at least from my perspective the electronic writing tablet was probably the most accessible and the most fun part of it for people because of the linguistic issues. People who didn't have a Chinese keyboard could write their language. So it had a lot of uses and then you could integrate photography, images from the video cam. People could capture still video images of people and then people at another café could then draw in text balloons and thought bubbles with the telewriter, so people would be putting words in Reagan's mouth and stuff like that you know. Yeah it was really fun.

Kit: People began to wallpaper the places with all the printouts of images, written text, and drawings—so that became the panorama, histogram, the catalog of the kind of textures and possibilities that was possible. Gang members in East L.A.—they had their own wall, "this'll be our wall—you don't put your stuff on our wall!" and gangs were showing all their secret handshakes to gang members in other parts of the city.

Sherrie: The screen was not the focus, it was one of the elements—when you walked into the café, you know, you got your food and you looked at the walls and the art.

Kit: There were a number of ways to sort of absorb this—by observation, by looking at what was a gallery, which was in effect a sort of a storyboard of what had transpired, which also told that community story and also revealed the "others" out there. There was also the catalog or the menu of possibilities, like the restaurant menu—you can do this—I can see you—you can do that—you watch and you look—there's people there to help you. In addition to the artists-in-residence and artist/systems operators, all the cafes, as we predicted, had a population of nine- and twelve-year-old boys that soon became self-trained system experts right away for anyone wanting assistance, explanations, encouragement.

The artists recall that by the end of the first week there was both a community of users and a community of enthusiasts and that the places had become the most active cultural centers in the communities, outside the churches. Over the seven-week period in which the cafes operated, and within the context of both regular café visits and curiosity-motivated attendance from the broader population attending the Olympics, people had engaged in zillions of spontaneous interactions, as well as working out their own ways of dealing with sensitivity to cultural differences or stereotypes (figure 6.4).

Onward

Kit: As for the potentials and validity of methodology we used in the mid-seventies, frankly, what we did over a quarter century ago remains to be rediscovered and reaffirmed, as soon as those in the arts with Internet2 capabilities become bored with watching local performers interacting with displays simply presenting remote participants.

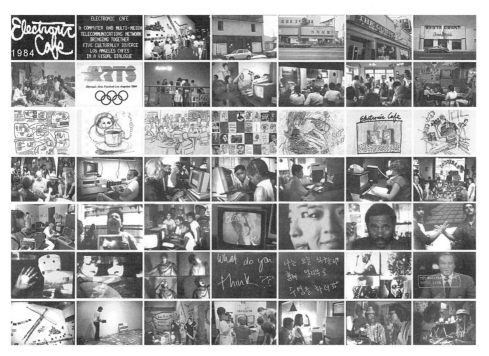

Figure 6.4 "*Electronic Cafe-1984* Mosaic." The *Electronic Cafe* Network was about integration: integrating community, art, technology, multimedia telecommunications, and cross-cultural communications. © 1994–2003 Galloway/Rabinowitz.

Our vision for an immersive social space was "realistic" in its representation rather than those approximated by text-based mediation, computer or video games, and now-abandoned devices such as goggles or VR [virtual reality] eye phones. Our visions for public spaces and networked public venues were democratic, dynamic, and accessible, more political and prompted and facilitated by community participation—totally different than what Internet cafés have come to be.

It's interesting to think that the Internet has become such a large bubble of context that it is improbable that anyone can operate outside of that context. Thus it may be impossible to create a new context. Alas, we are all now content creators for the *über alles* context of all time. The age of the avantpreneurs is over. We now return to an age of the entrepreneur. And so it's back to business as usual, and artists line up to have their art without walls credentialed by traditional art venues.

Galloway and Rabinowitz have recently "retired" to develop their archiving projects. However, from 1984 to 2002, their seminal work acted as a foundation for creating globally networked cultural and community centers, operating under principles extending from this earlier work: (1) employing a multitude of disciplines, (2) using the performing arts as modes of investigating the competence to achieve, sustain, invent, and approximate new ways of being in the world, and (3) creating a new context so that new forms and content can emerge. The Electronic Cafe (Community Access for Everyone) International headquarters in Santa Monica utilized a "multimedia collaborative network" for over eighteen years, accommodating a hybrid and transforming mix of low- and high-end technologies, an enterprise largely supported by Galloway and Rabinowitz's own convictions and energies as well as by "fiends, sponsors and friends in corporate places."

Countries like Australia and Canada adopted national community access policies and funding schemes in their media, arts, and telecommunications spheres throughout the 1970 to mid-1980s, and consequently, at least for a short period, an expectation for social integration existed in the national consciousness. Galloway and Rabinowitz's work, however, was troubling to a powerful social reality in which "celebrities dance" in the thin veils of civility between a demographic and marketable identity abridged to the lonely "grid of one."[19] Their emphasis, therefore, on inclusiveness, cultural diversity, and interdisciplinarity in their inspirational telecommunication art represents a heroic quest in animating an intervening social paradigm for the development of emergent electronic and digital communication environments.

Notes

1. See the trajectory of work from 1977 to 1998 on the artists' Web site, Electronic Café International, at <http://www.ecafe.com>.

2. Gene Youngblood, "Virtual Space: The Electronic Environments of Mobile Image," *International Synergy Journal* (Los Angeles) 1, no. 1 (1986): 9–20; "Virtual Space: The Electronic Environments of Mobile Image," in *Ars Electronica: Facing the Future (A Survey of Two Decades),* ed. Timothy Druckrey (Cambridge, Mass.: MIT Press, 1987), 360–365; "Defining the Image as Place," *High Performance* (Los Angeles), no. 32 (1987): 52–59.

3. "The Challenge: We Must Create at the Same Scale as We Can Destroy" (manifesto for the original Electronic Cafe) (1984), available at <http://www.ecafe.com>.

4. Harry Prichett and Edwin Brit Wyckoff, creators, *Winky Dink and You,* produced by Marvel Screen Enterprises, Inc. (original version televised 1953). This was the first interactive animated TV program in which the "You" part of the title referred to the child viewer, who was called to the "magic window" to help the adventuring Winky and his dog Woofer flee from trouble. The interactivity was achieved by placing a thin sheet of acetate over the TV screen and using crayons to draw ropes, bridges, and other props to assist Winky's escapes.

5. Ernie Kovacs, a U.S. television comedian (1950–1962), pioneered the use of special-effects photography, including superimposition, in TV comedy.

6. Steve Allen starred in the critically acclaimed NBC series *The Steve Allen Show* (1956–1976).

7. Late-nineteenth-century forecasters of "distance vision" include the artist George du Maurier with his cartoon in *Punch* (1879) predicting "Edison's telephonoscope," in which a British couple teleconference from their lounge room via a cinema screen link with their family playing tennis in Ceylon. The French artist and writer Albert Robida drafted designs for a multilingual audiovisual network for ballet and opera (1883), and the Australian inventor Henry Sutton designed an apparatus called "telephany," the first theoretically conceived TV, to link citizens in the mining town Ballarat with the Melbourne Cup horse race.

8. During the broadcast coverage of the Kennedy assassination (1963), the three television stations suspended their regular programming and all commercial advertising for an unprecedented four days to offer continuous live coverage of the event, providing an insight that the technologies could be used to bring people together.

9. L. Halprin, *The RSVP Cycles, Creative Processes in the Human Environment* (New York: Doubleday Canada, 1969).

10. Description of the purpose of the split screen from the artists' Web site and storyboards, available at <http://www.ecafe.com>.

11. Edward Casey, *Getting Back into Place: Toward a Renewed Understanding of the Place World* (Bloomington: Indiana University Press, 1993), 23.

12. Edward Casey, *The Fate of Place: A Philosophical History* (Berkeley: University of California Press, 1997), 304.

13. Casey, *Getting Back into Place,* 28.

14. Youngblood, "Virtual Space," 14.

15. From a description of the purpose of the Electronic Cafe in the original (1984) manifesto for the project, "The Challenge: We Must Create at the Same Scale as We Can Destroy," available at <http://www.ecafe.com>.

16. Ibid.

17. Rabinowitz's comment on the 1984 E Café project comes from an interview by the local ABC network in Los Angeles during the 1984 Olympics.

18. The photo novella is a way of communicating in which images are used to initiate a dialogue for expressing how people feel about themselves and issues affecting their community.

19. George W. S. Trow, "Collapsing Dominant," in *Within the Context of No Context,* 21–57 (New York: Atlantic Monthly Press, 1981).

7

An Unsuspected Future
in Broadcasting:
Negativland

Don Joyce

My background and history are in fine art. I was a painter who then graduated to sculptural electronic light works, but by the late 1970s I was clean out of good ideas, disliked the culturally isolated elitism of the museum/art gallery scene, and had more or less stopped working on visual art of any kind. In the midst of this void, having always loved and listened to music and music radio since childhood, I became a volunteer disc jockey at the noncommercial Pacifica Network station KPFA-FM in Berkeley, California, purely for the fun of it. I routinely played an eclectic mix of all kinds of music from different genres and eras, including comedy and spoken word: nothing very unusual for noncommercial radio, though I sometimes tried to be funny or creative with records by combining related themes in sets, or by slip-starting the Doors' "When The Music's Over" where the big long scream is just to be scary. In 1981, through someone who liked my show, I met Negativland, a group of young, self-taught audio collage makers who were manufacturing their own records of their own home-made music, household sounds, and noises they made or collected. I invited them up to my radio show which was called *Over the Edge,* and the show finally began to live up to its name.

The members of Negativland brought a lot of audio-generating equipment into the broadcast studio—keyboards, guitars, portable tape players, toy noisemakers, odd pieces of metal to bang, and their own mixers—and we proceeded to mix music and sounds together live on the air, also making use of all the regular studio playback equipment in simultaneous and overlapping ways. It was all new to me. My first exposure to vinyl "scratching" was literal when, in 1981, someone slowly pushed the needle across the surface of a record from outside edge to label with the volume turned way up. It was a revelation to me to see anything so "abstract" being done to a live radio transmission. I had never thought of such a thing myself, though I had sometimes suspected the medium of radio could *be* art, rather than always just being *about* art or using art that was created elsewhere in other media as its content. This kind of live, spontaneous, multisource mixing may seem like a common enough possibility now, but it wasn't common in 1981 radio. Well, what could I do? I invited them back to perform on the show every week, I joined the group, and *Over the Edge* has been a live-mix radio collage from Negativland ever since (figure 7.1).

From the beginning of our late-night, on-air collaborations, we carelessly and willfully broke all the rules of normal radio procedures. We overlapped records or played just two seconds of one in just the right place and switched

Figure 7.1 "Negativland: A big place." Some of the members of Negativland. Photo: Negativland.
© 1983 Seeland. Used by permission.

Don Joyce

to another. We set up reel-to-reel tape machines to create endless loops of our broadcast within our broadcast or use them for extreme echo. We would be mysteriously remote and never speak on mike, or we would rant as "characters" with on-air phone callers, never letting on who we really were or what was really happening. The ear-opening curiosity of "no-host broadcasting" was immediately attractive to us as an expectation avoidance device. We would sometimes spend the entire night on some topic or theme, intermixing related source material in various mutilated or fragmented ways to create a continuous sense of "subject." From the beginning, we would mix spoken dialogue, often captured from popular media, over various music by us or others, which has remained a Negativland "style" of collage music throughout many of our records as well. There were always attempts at serious social referencing, but I suppose our total aesthetic might be better characterized as "wacky," and humor has always been a big part of it. We were serious about not letting anyone take it seriously and often tended toward the realm of pranksters more than "artists." We wrote phony commercials and used scripts to create fictional radio "features." We liked hoaxes, sendups, spoofs, and rearranging "found sound" from the media environment around us to say things it never intended to say (figure 7.2).

We spent a lot of time editing and reediting our ever-growing collections of home-taped and found media: radio, TV, movies, self-help cassettes, talking books, the news, exercise tapes, celebrity interviews, political speeches, live and recorded ham radio communications, commercials, bloopers, sound effects, etc. There was a sense that anything and everything out there that could reach our home tape recorders was "up for grabs" as raw material that might be recycled into something else entirely and spit back out in some new form on our own show or on our records. We knew nothing nor cared anything about copyright law until we got sued for working this way on a record we made in 1991. Media collage, it seems, was more dangerous fun than we thought, and our education in copyright law and its overreaching effect on the art of collage in an age of mass-available reproduction technology began (figure 7.3).

We had released a CD, a single consisting of a variety of tapes that had come our way. At a live show we did, an audience member gave us a notorious underground tape of Casey Kasem, the famous top-40 countdown DJ, which contained outtakes from his prerecorded broadcast in which he was

Figure 7.2 "Negativland: No noise." Photo: Jay Blakesberg and Negativland. © 1986 Seeland. Used by permission.

having all kinds of problems introducing the then-new group U2 to America. His angry and frustrated rants to his engineer were hilarious bloopers full of obscenities, doubly hilarious when you consider the squeaky-clean, sweater-clad image of all-American blandness Kasem had in the media. Since he was talking about U2 in the tape, we decided to add some U2 music, picking the song "I Still Haven't Found What I'm Looking For." (Most of Casey's rants were a barrage of angry questions about how to introduce them: "The letter U and the numeral 2? These guys are from England and who gives a shit!") We then found a bunch of citizens band (CB) radio conversations we had on tape in which a CB "jammer" was annoying the others on the same frequency with all kinds of obscenities and interruptive noises (only one person can speak at a time on a citizen's band), resulting in other users' discussing how to find this guy and his obscenely taunting them to do so. To that we added other tapes talking about obscenities on records ("The Kingston Trio used the word 'Damn' on a record and it was banned"), along with some satanic stuff, comments on the music business, and so on.

We actually only used about thirty seconds of U2's recording in the intro, then switched to a computer software program that allowed us to substitute

Figure 7.3 "Negativland: Helter stupid." Some of the members of Negativland. Photo: Jay Blakesberg and Negativland. © 1989 Seeland. Used by permission.

our own instruments or sounds for the instruments playing any popular melody. So our version of "I Still Haven't Found What I'm Looking For" had breaking glass for drums, kazoos for guitars, us humming the melody, etc. The combined result was both shocking and hilarious, but U2's label, Island Records, was not amused. It sued our label at the time, SST, for copyright infringement amounting to approximately $90,000 in "damages."

Island stopped the release and had all copies destroyed. Once we began to study this issue, we felt we had a clear case of fair use, since the work had a

somewhat editorial point of view about U2, the music business, and so on, as well as being a collage made out of preexisting material but constituting a wholly new work in itself, as all collages do. Unfortunately, as is often the case, going to court against a large corporation to defend this work as fair use was economically out of the question for us or our label, so we settled out of court and were required to pay off the somewhat reduced damages. There's much more to this story, involving our getting sued again by our own label to pay the entire damages ourselves, after our release of a CD/book[1] relating this entire story of criminal music. It happened to be unflattering to SST's role in this, so SST sued us again for copyright infringement because we reprinted one of their public press releases in the book (figure 7.4).

From that point on, we became very interested in the role of copyright law as it was being used by the record business to prevent all unauthorized sampling and appropriation of commercial works, virtually eliminating, for instance, all unauthorized audio collage, which the record companies didn't happen to approve of because of its content slant. This, of course, eliminates an important aspect of musical "free speech" in this new age of easy reproduction in which "quoting" of existing works is proliferating throughout the art of music. Fair use already exists in copyright law to allow for this free-speech function but is unfortunately way behind the times in its extremely narrow legal interpretations, leaving casual music sampling and abstract audio collage out in the cold unless it can pay for its source material and get permission to use it. Often using hundreds of fragmentary sources in a single recording makes paying for them impossible for us as independent fringe artists now running our own little label, and permission becomes an even bigger roadblock, as our work often happens to be critical or unflattering to our sources. The permission aspect constitutes prior restraint on free expression, putting artists' very ability to exercise their right of free expression in the hands of unrelated commercial interests (depending on their approval of our biting satire of them, for instance), and these commercially motivated laws work to prohibit all but the rich and flattering from the modern practice of collage in the art of music.

Copyright as an opportunistic tool of corporate censorship and image control remains a distinctly antiart influence within our culture, discouraging all free appropriation for sonic collage of all kinds (any music that samples is, in fact, a collage), requiring payment and permission to quote or recycle one's own culture in new works. We continue working as we always

Figure 7.4 "Negativland: U2 law suit." Some of the members of Negativland. Photo: Negativland. © 1991 Seeland. Used by permission.

have but have never been sued for doing so again, indicating that the highly selective way these laws are invoked has more to do with the nature of the particular commercial properties involved than any broad principle of preventing reuse in new work. We can and do collage, without anyone's objecting, obscure or out-of-print material that no longer has a viable "market," but a currently rich and famous source will sue faster than a knee jerking. The claim of "economic competition" from such unauthorized collage works is foolish on the face of it when one compares the sources to the sampled works made out of them, which are seldom going to appeal to the same audience at all. But the courts continue to buy this irrelevant line of market control thinking nevertheless, treating every fragmentary reuse in new compositions just the same as counterfeiting an entire work, even though the two activities have nothing in common.

Radio is particularly interesting to me in this context because it is a mass medium completely ignored by copyright restrictions on reuse. Its nature of apparent disposability—passing through real-time airwaves to immediately disappear forever—allows us to use, change, or mutilate anything there, famous or not, with no one paying any attention to it at all. Even the Federal

Communications Commission (FCC) laws for radio that do exist (no re-broadcasting the signal of other stations, no broadcasting personal radio formats like CB or ham, etc.) can routinely be broken for creative purposes without anyone noticing. In a sense, radio is now the forgotten medium in our midst, threat free and without "importance" in any legal or cultural terms, and at this point, virtually unconsidered as an art medium. That's why it's the perfect outlet for artists involved in audio who can find their way into noncommercial stations. It's the last available mass medium in which no one cares very much what you do, which is the very best kind of place to attempt art.

From the beginning, our use of the telephone on radio was intentionally atypical of broadcast phone etiquette then or since. We saw public access to our ongoing mix via telephone as a way for listeners to anonymously contribute to that mix, which doesn't stop when we punch them into it anytime, without warning to them or anyone else. Our motto is "When your phone stops ringing, you're on the air. Don't say hello." We actually don't respond or converse with most callers as "hosts," preferring not to set up the phone access aspect as any kind of content channeling or subject guidance that hosting always manages to imply, and our phones are unscreened and undelayed, which makes simultaneous playing along with the broadcast from the phone possible. No delay is simply necessary for real-time musical phone participation. We recommend that callers wear headphones tuned to KPFA for the actual stereo mix and turn their phone upside down and use it like a microphone. I believe KPFA must be the only station left on the air that allows us to neither screen nor delay on-air calls. Like most "safety" innovations in modern broadcasting, "protecting" the station and the public with screening and delays also means draining any unpredictable or spontaneous art potential right off the airwaves. For safety's sake, art is always the first to go.

With no call screening, we never know what the phone button will present us with, which proves to be dumb or "inappropriate" in plenty of cases, but also unforeseeably interesting in many others. *On the Edge* is nothing at all like talk radio, though we tape that too and sometimes use bits of it in our mixes. We're still subject to FCC dirty-word guidelines and simply hang up on those deadly seven words whenever they occur. Otherwise, the calls, which may include people playing music or tapes or making noises, as well as their rantings, ravings, criticisms, and commentaries, are all treated as just another element in a mix of sonic spontaneity. We can process calls with effects,

and we "edit" them in the same way we edit the whole mix going on around them, hanging up without warning whenever we've had enough—but calling back for more is always an option. We call it "receptacle programming."

Although *Over the Edge* is a little like a musical chat room with no typing, it's not the limited interactive abilities of radio that links us to this now-digitized age of the Internet, but the creative attitude of *Over the Edge,* which has always favored a public-domain approach to the culture around us, and which, it turns out, corresponded well to Internet culture and practices once the Net emerged. *Over the Edge* began during the first peak of the popularization of consumer technology designed for copying media at home: the cassette recorder/dubber, the VCR, Xerox copiers, etc. This was the beginning of copyright holders' losing control over their content's public reuse, which has now evolved into the virtual hysteria of intellectual property owners as they are confronted with the Internet's default user control over all digitized content. But the computer user's attitude that "what reaches my screen is mine" was not born in computers; only much further facilitated by them. This was the view of culture we were using toward all home-available media in 1981. The view is not that of a bootlegger out to profit from counterfeiting or distributing unauthorized material, but a view that sees all material out there as reusable in new work, from creating new perceptions of that material all the way to creating new collages with it in which the material might be hardly recognizable. Transformation or theft? A big difference to consider if you're interested in the progress of art over the last century, which we can now characterize as being noticeably propelled by collage practices in each and every art medium from the beginning of the twentieth century on.

Over the Edge is radio collage, something still occasionally available elsewhere on college radio, but aside from some station ID production, it's a nonformat completely spurned by the commercial multiglomerates that all of commercial radio has now congealed into. The concept of creative uses for any "found sound" we can capture has somewhere forced up the term *recontextualize* as a legally understandable defense against copyright restrictions on reuse in new art. As we now look at the Internet among us, this strikes me as a good term to describe Internet culture too.

What *Over the Edge,* as a radio show, only obscurely hinted at—an electronic environment in which everyone was equally free to be creative with whatever came their way *and* to redistribute it themselves—the Net just

happens to have now institutionalized in an apparently irreversible way for everyone, ready or not. Our approach to appropriation and audio collage was never this hopeful. We always considered ourselves content to be culturally isolated, an acquired taste, and to be called pirates and thieves in order to continue to do what came naturally to us as media artists. But now pirates and thieves are everywhere, because all of culture is up for grabs at the grassroots point of reception. Where *Over the Edge* only pointed at a theoretical cultural public domain amid content still bound up in physical objects in the material world, the Internet put the theory into practice by eliminating the physical object entirely.

The weekly *Over the Edge* audio collage began as a stew of everything and anything, probably including the sound of a kitchen sink, without any regard for centralized content control or even "quality." Whatever happened just happened, and I always saw it as a job of cultivating coincidence in something relatively random while trying to keep it all sounding good. We tend to think of coincidences as rare events in which we notice random correlations, but I believe coincidence is actually a much more common occurrence in human perception once we actually start looking for it. I will often find a great many coincidences in diverse material played "randomly" (sonic similarities in music, subjects or topics that coincide when they come up on separate machines, particular words from two different and unrelated sources that "make sense" when played together, consecutive phrases from two different tapes that appear to comment on each other, etc.). This happens so often and so consistently that I have come to believe that how the mind recognizes coincidences actually has something to do with consciously looking for them to happen, somehow cultivating their increased appearance by being more aware of what *kinds* of diverse material will produce them when randomly mixed together. I never work out any of these little coincidental blessings in advance, they just happen, and it's one of the many little thrills in relatively unplanned mixing that never fails to amaze me.

Our broadcast material on *Over the Edge* has always been from the world around us, including recordings of sounds from our home environments and whatever larger environments we have made for ourselves as a culture, but certainly filled with the "professional" electronic media environment we are surrounded with, too. What we haven't really made for ourselves, somebody made for us. But a real and ever-present environment it nevertheless is, day in and day out! So among other things, we began snatching fragments from the

mass-media stream that was targeted right at us, after all, and began redirecting these fragmentary captured references into larger contexts that compared, contrasted, and transformed their former "meaning" to some degree.

It seems that the general public will always take control of revising the destiny of cultural products that enter its sphere of possession if given the opportunity. With digital technology, it suddenly can, and so it does. But this new opportunity has also evoked a newly awakened awareness of the economics of modern culture and the all-encompassing colonization of the arts by commercial interests that has come to characterize our popular culture as a whole. These commercial interests have actually come to rule what's "important" and what's not in cultural material on the basis of sales alone. Among other things, when that private cultural income threatens to go out the window, some very different sorts of standards for popular "worth" may start to emerge.

As audio artists in the early 1980s, Negativland seems to have been predictive of media-saturated human responses that have now spread and emerged outside the arts to become, among other things, the average kid's approach to the Internet and its content. In the early 1980s, only radio, a pretty-much-ignored mass medium apart from time spent riding in a car, was actually available to most anyone if he or she cared to volunteer, and particularly interesting to us as artists as a medium in which to express our relationship and reaction to the one-way commercial media barrage that had already become our common psychic environment and the inescapable definer of all things important in this culture. When we began to treat a radio station and its listeners to our antics with all this in mind, we were sometimes considered eccentric people doing perplexing things by both listeners and our own station. (Again, it's humor that gets one through such droughts of understanding: As long as one can be funny or amusing with it, everyone takes it more easily as a joke of some kind no matter how seriously perverse one may actually be concerning cultural implications.) Now such once-alternative attitudes toward our commercial media environment are as common as commercials, and even by the time the Internet began to go public in the early 1990s, everyone in or out of art seemed ready to take the whole mass media/communication thing into their own hands on the Net and use it for their own unique, often culturally contrary purposes.

Another interesting connection I see between today's Net user attitudes and our earlier radio attitudes is the aspect of willful anonymity. Just as we

intuitively preferred to disguise ourselves and even our point of origin when broadcasting, this immediately became an often desirable mode for delving into the Internet as a user. In a strange way, the Net makes its participants both more potent as individuals and yet more inclined to be anonymous or pursue role playing. Part of our point in disguising who we were and what we were doing was that we were unrepentant thieves of our own culture for purposes of irony and comment. But beyond whatever threat from copyright owners we may have sensed, anonymity simply fit our very natural approach to using and reusing our own culture anyway. We were treating the whole world as a public domain of source material, because what we reused was certainly being made public, and it was certainly in our domain.

We in Negativland have often said that we consider our kind of appropriation-based work to be a form of self-defense, a way to actually deflect the commercially motivated consumer propaganda assaulting our minds and spirits every day, turn it around, and send it back out with a new and different meaning those who created it originally never intended. We thought that was pretty much an artist's view of creative possibilities in this society, but it now turns out to be much more widespread than that. We now see such attitudes, including many more radical than we ever had, operating everywhere across the Internet and hardly ever being called art. This, and the Net's almost unconscious reliance on collage techniques and processes in everything, makes us feel right at home there. Our problem recently has been how to move anywhere beyond this with collage and media appropriation as artists. What is important to do in this realm now that these former art probe concepts and techniques have become such eagerly accepted mainstream diversions and common user activities for the whole Internet generation, and probably of only casual interest to most of them already? But that's our problem, and one way we pursue it is still outside the legal crosshairs of cultural scrutiny, on the forgotten medium where experimentation is still actually possible to do because no one is paying attention, that old radio over on your shelf.

Over the Edge continues to this day, our broadcast now appearing weekly on the Internet, and I think it continues to represent the same Net-like attitudes, ethics, and etiquette it was an example of before the Internet was turned on. We hope we are an amusing example, encouraging listeners to make out of their world what they would like it to be, to break it down and put it back together to their own taste, to participate in a shared culture

to do this, and to share their own self-determined and unrestricted input anonymously—not for purposes of creating their own self-contained show-case, but to contribute to a whole creative process in progress involving many ideas and inputs common to us all—and certainly to steal as much from us as we may steal from them. In 1981, I made up "Universal Media Netweb" as the name of the fictional, appropriating radio network that presents our *Over the Edge* program. Now I have an actual Internet e-mail address that ends with the made-up word, @webbnet.com, and sometimes I just have to smile at the way art and life play their echo game, imagination turning into reality in no time.

To hear Over the Edge live on the Internet or as an archived stream throughout the week, go to www.negativland.com, under the Over the Edge icon.

Note

1. Our CD/book is called *Fair Use—The Story of the Letter U and the Numeral 2,* available at <www.negativland.com>.

8

Mini-FM:
Performing Microscopic Distance
(An E-Mail Interview with
Tetsuo Kogawa)

Tetsuo Kogawa with Annmarie Chandler

and Norie Neumark

Tetsuo Kogawa introduced free radio to Japan in the early 1980s and helped found many microradio stations (including Radio Polybucket and Radio Home Run) that were part of the "mini-FM" boom in Japan. Mini-FM utilizes micropowered transmitters to create a micro broadcasting and communication context, acting as an alternative to the mass-media, large radio stations and global communications.

Question: You've written a number of articles in English on mini-FM (e.g., in *Radio Rethink* and on the Web <http://anarchy.k2.tku.ac.jp/non-japanese/index.html>) and more in Japanese that have not yet been translated. We're very interested in the mini-FM phenomenon for a number of reasons, including the relationship between art and activism, performance and play, professionalism and "amateurism," distance, communication, networks, and social transformation.

Our first question has to do with the Japanese context for the mini-FM movement, including the post–World War II historical background. Can you discuss the specificities that helped shape the development of mini-FM? For instance, can you talk about government-controlled media in Japan after World War II, in relation, say, to concepts and habits of individualism, nationalism, citizenship, and foreign influence? Can you also address how Japanese youth culture helped shape the development of mini-FM?

Tetsuo: The mini-FM movement was encouraged by a number of Japanese social and cultural factors. As soon as the Allied Forces occupied Japan on August 15, 1945, the CIE (Civil Office of Information and Education), part of the GHQ (General Headquarters), brought all the Japanese mass media under control. The short period of transition just after the war paradoxically created a radical consciousness of freedom from the old system and customs. Ironically enough it was particularly via radio, at least at first, that they tried to educate the Japanese into freedom of speech—that is, in the Western modernist sense of democratic, political and religious "freedom." But even those who were against the U.S. politics did not reject their lifestyle. In 1951 NHK (Nippon Hoso Kyokai–Japan Broadcasting Corporation) started television broadcasting. American pro wrestling fascinated the audience. Electric washing machines, refrigerators, electric vacuum cleaners, Coca-Cola, Kleenex, and blue jeans became widely popular. To say nothing of American movies and pop music.

Several other long-term changes within the mass-media industry structures, the technological environment and social consciousness also prepared the ground for the mini-FM movement. For me individually, there was both my personal intentions and dreams to promote free radio that could be independently controlled by nonprofessional ordinary citizens, as well as the fact that as a college teacher, I had felt a strong need for a medium to bridge the isolated communications context of my seminar students. By this I mean that after the end of the student movements in the late sixties and early seventies, feelings and ideas about sharing with each other and political and cultural collaborations were rapidly declining among students.

The student movements in the late sixties had opposed authoritarianism, first in the schools and then in government and world powers. Influenced largely by the Cultural Revolution in China, and mixed with the impacts of various movements such as the American counterculture, underground theater, French *nouvelle vague* cinema and the Fluxus performances and happenings, the students started their rebellion outside existing parties and political organizations. The New Left student movements had encouraged new types of cultures of solidarity and collaborations among young people, including both those who were activists and those who were apolitical.

Sometimes national solidarity seemed viable but, as the pressure and repression by the police became stronger, separation between groups developed, with struggles over policy and conflicts between the factions. More hard-line or extreme Marxist and Leninist ideologies escalated and some of the groups started to arm. There were executions of the members of Rengo-Sekigun (the Allied Red Army) in the deep mountain area and then heavy gunfights with the police in 1971. These incidents changed the mood drastically and destroyed the dream of a peaceful "revolution." Especially among students who believed in change, the shock was very strong. In this sense, the system used the incidents very cleverly to suppress antiestablishment trends. The mood of radical change quickly disappeared. Distrust among students grew too.

Social-cultural institutions, such as broadcasters and schools, were unable to respond to this situation. The content of radio and television was still fifties-U.S. style and was unable to fulfill the needs of listeners who wanted more diverse programming. I think that Japanese broadcasting was still strongly controlled by the state government and therefore the number of radio/television stations was fewer in comparison to other advanced indus-

trial countries. In the late 1970s there were only two national FM stations. There were local FM stations but their programs were mostly franchised from the national broadcasters.

This was very different from Australia, U.S., Canada and Europe where hundreds of local and community radio stations provided diverse programming on the FM dial. It was quite natural that a feeling of isolation became strong while the mindless enthusiasm for spending money and massive purchasing was escalating. At the same time, the postindustrial or service-oriented era was starting. Commodities were becoming more and more personal, rather than group/family-oriented.

Although Japanese culture was labeled and characterized as having an uncritical *banzai*-collectivity, the Sony Walkman (which appeared on the Japanese market in 1979) allowed people to individualize technologically even without their being explicitly conscious of it:

The pre-war Emperor System replaced the spontaneous, regional and diverse collectivity with a highly artificial homogenous collectivity, what I called *"banzai* collectivity." *Banzai* is a special shout and hand gesture of a person or group who blesses the authority (the State, the Emperor, the employer). When a group shouts *"banzai"* with one voice, their leader shouts it first, and the others follow. *Banzai* collectivity is not spontaneous but manipulated as a cult. This manipulated collectivity was especially organized after the middle of the Meiji era, around 1890, by means of total integration of the educational system, the military system and family life into the Emperor System. . . . Haruni Befu, Yoshio Sugimotto, Ross Mouer and others revealed that such stereotypes of the Japanese as workaholics or "devoting the self to the group" are not spontaneous social patterns but political phenomena, which are largely imposed from above by the authority.[1]

The rapid spread of personal car ownership also changed the homogenous group-oriented tendencies into a kind of individualism. The gradually escalating economy changed the housing situation, too. As the large family disappeared and the percentage of women workers grew, the nuclear family became popular. The number of one-child families was also increasing. This further intensified Japanese individualism. I once named such a peculiar individualism "electronic individualism." Later on, this notion had a popular term, *otaku,* and it spread outside the country.

A commentator on youth popular culture, Akio Nakamori, recognized a new type of youth emerging, where they called each other "*otaku*" instead of "you." They were possessed by a mania for comics, movies, etc. Nakamori started a column, "A Study of '*Otaku,*'" in 1983 in his magazine *Tokyo Otona Club.* Later on, mass-circulated newspapers and television adopted this term. This was the period when personal computers started to become popular and the means for virtual communication rather than face-to-face was becoming interesting and distance cultures began. Movies like *Being There* (1979), *Blade Runner* (1982) and *Videodrome* (1983) were favorites amongst the *otaku.*

This term *otaku* became popular in the English vernacular of popular culture in nineties magazines such as *Wired* where it was used synonymously for *nerd,* emphasizing a monomaniacal interest in computers, TV games, animations, and collecting gadgets. *Otaku* has other meanings, however. *Otaku* in Japanese originally meant "your house." But it could also be understood as a personal pronoun meaning "you" as well. The difference between the common understanding of "you" and *otaku* is that *otaku* has a connotation of slight distance.

Question: Can you talk further about how this *otaku* mentality and the gloomy political situation played a role in your developing interest in electronic art and radio?

Tetsuo: I started experiments using electronic devices in my seminars in April 1980 just after I came back from New York. From the mid-1970s to March 1980 I spent many years in New York as an ACLS (American Council of Learned Societies) fellow to the Department of Sociology at New York University. Maybe this was my idiosyncratic memory of that feverish era and my experience in New York where people of different backgrounds and languages talked, both in a friendly way and aggressively, but my seminar classroom felt too quiet. Although people were kind and wanted to talk to each other, they hesitated to talk directly because they were too reserved ("shy") and sensitive about cutting in on others. This behavior is not abnormal but is actually a part of Japanese culture that I call the "culture of distance."

As far as I was concerned, I had to solve the communication problems of my students; otherwise it was difficult to proceed with discussions in my seminars. This was my challenge to what I had in mind about communication, democracy and medium. At that time, I had already started to experiment with free radio in my own way, strategically utilizing very weak airwaves to

transmit signals. The first system was a remodeled wireless microphone with an adequate antenna added. It was already being used as a popular toy by some children and young people for playing "broadcaster." However, few people considered seriously using such a thing as a working transmitter for FM broadcasting. It wasn't long before I brought the system to my classroom.

After thinking hard about my students' reticence, I brought in a portable tape recorder and used it in my seminar. Each of the students spoke a few words or sentences onto it and passed it to the others. Rather than experiencing the difficulty of person-to-person communication, they could talk to the machine. When everybody finished talking, I replayed the tape. What I did was a kind of reverse of a William S. Burroughs' "cut-up" using the tape recorder instead of paper. When the tape was replayed, they found in otherwise random utterances an unexpected continuity and context that they had not intended but had unconsciously created. It was an expression of an unconscious (unwilled) collective work happening beneath our communication, which made sense to them through Merleau-Ponty's concept of "entrelacs." It also interested them as an area of performance art. This created a virtual and temporal consensus for us to continue further talks and progress to a further level.

Question: This interweaving of philosophical concerns, pedagogical issues, and engagement with electronic devices and art seems to be very important to your work as an artist and teacher. Do you want to add anything further?

Tetsuo: As a person who studied philosophy and was later inspired by the New Left movements, I did not want to "teach" my students. How could I teach? Communication problems are always interrelated. No one-sided solution is possible. I had to start from the beginning. But my early experience helped me to do so. I have to tell you a bit of a long story before going on about radio and education. I grew up as an only child and was accustomed to being alone. During my childhood in Japan (in the forties), one-child families were rare. I had no problem with person-to-person communications in small groups, but to join a group I had to intentionally change myself. Unlike today, rules and customs of homogeneous collectivity ("*banzai*-collectivity") were very strong. It may have been as a response to this situation that I became interested in amateur radio in my early junior high school period. It is difficult to describe how fascinating to me my first success with contact on the air felt. You may recall the beginning scenes of Robert Zemeckis's movie

Contact where young Ellie (Jodie Foster playing the grown-up Ellie) has her first experience of amateur radio communication. However, I soon had to give up this emancipating recreation due to impending preparations for entrance examinations to senior high school and college.

In my late teens, existentialism was the philosophy that justified my "loner" attitude. In Japan, existentialism appealed to intellectuals after the end of the forties and the influence continued until the sixties (up to the explosion of the New Left movement after 1968). Existentialism theoretically refuted collectivism and justified those who were isolated and independent as more "authentic" in their existence. These ideas triggered my decision to enter the Department of Philosophy to study phenomenology. One of the hottest topics in philosophy at the time was solipsism versus collectivism. Every intellectual who was captivated by existentialism had to confront the theoretical difficulty of solipsism. How can 'I' as an isolated existence find a window to the outside and communicate to other 'I's? It was lucky that I studied phenomenology, which relates not only to existentialism but also to more social theories. The late sixties was the period of the "renaissance of phenomenology," where new approaches to Edmund Husserl and advanced phenomenological studies in cultural anthropology and sociology appeared. Merleau-Ponty convincingly overcame the existentialist solipsism by reconsidering the 'I' and the body as not separated; for him 'I' am by nature embodied. 'I' and the other don't meet as essentially separated beings. They are "intertwined," "coexisting," "cofunctioning," in "communion." His notions of "chiasm" and "entrelacs" condense these ideas.[2]

Using Merleau-Ponty to break through my students' nihilism and isolation, as I talked about above, was successful, but I was still working as an "ordinary" schoolteacher, using books. Meanwhile I had also become more involved in the arts and in cultural activism and was looking for a new way of teaching, as a performance artist—as I came to call myself. My New York experience had inspired and nourished me a lot. At the same time, the students' attitudes had changed too. They read less and less. The printed medium wasn't working as an interpersonal communication space. Video, film and graphics interested them instead. That's why I started to use the tape recorder, 8 mm camera and the videotape recorder for communication (rather than as a documenting device). The film of an 8 mm camera runs for three minutes. My students shared this 180 seconds among the group (ten or so) and shot what each person wanted to express for the shared seconds (fif-

teen or so) in the classroom. The following week (film developing required a week) we watched the full film. We were fascinated by the unexpected plot or context or coherence. At worst, it could be considered as an "incomplete" surrealist artwork. Discussing the films, I would bring up Merleau-Ponty and other related theories such as structuralist semiotics and I even circulated relevant printed texts. I found that after such a workshop they were able to read and the print medium interested them again. My workshops using a tape recorder had the same objective. 8 mm film provides an interval while the film is in the lab being developed; during this time the students become a film audience rather than the makers. The tape recorder can replay quickly and is easy to use in intensive segments. First each student talked or created sounds for sixty seconds (record → pause → pass the machine on → record → pause . . .) and then at the end they listened to the ten- to fifteen-minute tape. In the following sessions the talking was reduced to thirty, fifteen, . . . seconds. Over time, they found themselves spontaneously talking not only in monologue but also dialogue. In the end they forgot to use the tape recorder and just began talking to each other. Do you think this is a trick by a machine? Not in my opinion. The medium always has this function of neither just documenting nor simply carrying information but of "intertwining" people and creating interpersonal space. What I would call a "weaving" medium.

Question: We are very interested in the performance side of mini-FM: Could you to talk more about it? Can you discuss whether there was any tension (difficult and/or productive) between performance art and communication goals in mini-FM—an art/activism tension? Also, did groups address each other and the audience as *"otaku,"* and/or were there other direct ways in which the culture of the youth movement shaped the practice of mini-FM?

Tetsuo: The radio movement using low-power transmitters started in 1981 and then boomed in 1983 when many newspapers and magazines and even television stations reported it. The term *Mini-FM* had become popular since, I think, an article in *Asahi* newspaper used this term on May 11, 1983. Before that we used *free radio;* others used *independent radio* or *home-made radio*—there was no single terminology.

I mentioned that the Japanese youth culture of the 80s had a kind of *otaku* culture of distance where people wanted some kind of distance between each other in relation to communication, relationships and behavior. Mini-FM

was an appropriate medium for this culture because it kept such a distance and at the same time enabled them to feel at home when they communicated with others. In my observation, however, those who started mini-FM stations after 1981 had a mixed sensibility of both getting together and of *otaku,* or distance, in a sense. Authentic *otaku* communities were, by the way, actually passive and did not want to organize anything by themselves.

The seminar workshop I ran did not directly lead to mini-FM. Mini-FM had a different motivation—not to do with either education or making people feel at ease. As soon as I came back from New York in April 1980, a couple of my friends and I started to discuss how to start a free-radio movement, such as in Italy where free radio had been and still is flourishing. We were serious about opening an alternative radio station associated with community interests. The main aim was to use the radio medium as a means to deliver information and messages. This is quite different from what I later theorized for mini-FM as a form of cultural catalyst and performance art. At that point, though, it was just ordinary radio in micro size. Micro, because it had very-low-power broadcast, needed no license, and was able to use the massive free space on the FM dial (which was there unused because of the inflexible policy of the Ministry of Post and Telecommunication). It was possible to link every microunit to each other. I have been thinking of a similar idea for today's Wi-Fi hot spots although in analog radio at that time it was very difficult to link a number of transmitters with a consistent sound quality. But the idea was fascinating and we believed in organizing a large-scale model of mini-FM networks to cover a large area.

It was in this period that I brought a set of micro transmitters into my classroom and let my seminar students use it. They were quickly fascinated and some of them started their own station, Radio Polybucket, on the campus. Using this as an example I wrote articles for mass-circulated cultural journals. News about free radio in Europe was also appearing in the major newspapers. People were becoming interested in "new media." Low-cost electronic toys like wireless microphones were also readily available. Within a year, mini-FM exploded way beyond my expectations and even major radio/television stations were interested in it. I learned that even big companies, which had been irritated by the government's inflexible policy on broadcasting, now expected that they could easily open their own radio station using mini-FM. After the end of 1982 many mini-FM stations were established in Tokyo and other big cities. Radio Polybucket was also developed under the

Tetsuo Kogawa with Annmarie Chandler and Norie Neumark

new name of Radio Home Run, which was recognized as the earliest mini-FM station in Japan.

Question: Can you say more about Radio Polybucket and Radio Home Run?

Tetsuo: Radio Polybucket was opened in 1982. The name derived from the plastic (polyethylene) bucket, which is a popular Japanese garbage can. The students imagined this as signifying something hodgepodge and something minor/marginal/negligible. It was also influenced by Guattari's *La revolution moleculaire* and an implicit criticism against "big is beautiful" careerism.

When they graduated, the students started to develop their radio activities at their new station Radio Home Run, located in Shimokitazawa, the most bohemian area in Tokyo. The name is a baseball term but its connotation was to "cross distant borders," because they wished to cross the borders of every obstacle (not only the airwave regulations but also sociocultural difficulties). The station finished in 1996 because the members became too busy with their "main" occupations and some of them moved far away from Tokyo. Soon afterwards we started Net.RadioHomeRun, an Internet radio, and tried to reorganize the members who were separated in different locations in Japan. It still operates every month but the excitement and enthusiasm is over.

Radio Home Run had an almost anarchic policy where nobody controlled it and anyone visiting the station could become a member. As the station used a room of one of the members' apartment, nobody had to pay except for the cost of making the programs. Depending on who took care of the program, the content and way of running it differed. Some of the programs were similar to regular radio but most of them used radio as a catalyst for talking, playing and getting together. The interesting thing was that as the atmosphere livened up during the program, listeners couldn't help coming over to our place. The location was very convenient and in our service area (one-kilometer radius) there were a lot of cafes, bars, and restaurants where young people gathered with their portable radios or Walkmans with FM radio functions. Some people visited, first hesitantly, and then within a week started their own program. Some audience enthusiasts parked their cars nearby to listen. This radio was just like a theater or a club where the audience themselves approached it instead of staying at distance. The whole activity was so diverse that it is difficult to summarize what they did (figure 8.1). While homeless

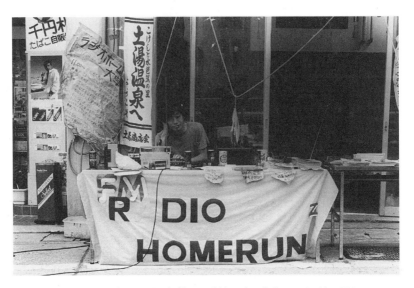

Figure 8.1 Radio Home Run holds a special broadcast in the countryside, 1984.
Photo: Toshiyuki Maeda.

people came along, we were also visited by famous people such as Félix Guattari, Ivan Illich, DeeDee Halleck, and Hank Bull (figures 8.2 and 8.3).

There are many Japanese reviews of Radio Home Run (some in English)—in newspapers, journals and on radio and television. Toshiyuki Maeda, one of the founding members, who is now a professional photographer, has thousands of pictures of what happened at this station. There are sound/video documents too. You can see some of them at my Web site <http:// anarchy.k2.tku.ac.jp/radio/homerun/histryrhr/>.

Question: Can you say a bit more about the response to mini-FM Outside Japan?

Tetsuo: In the eighties there were a number of people outside Japan who really appreciated mini-FM: DeeDee Halleck, Félix Guattari, Ivan Illich and Hank Bull. DeeDee had just started Paper Tiger Television, the first public-access television in New York City, and was interested in mini-FM's free networking and its positive "abusing" of the regulation. Félix Guattari found in mini-FM a kind of "micro revolution." Ivan Illich praised mini-FM's creative use of low-tech and grassroots character. Their evaluations were different but what they shared is that they considered mini-FM to be a medium.

Figure 8.2 Félix Guattari at Radio Home Run, 1985. Photo: Toshiyuki Maeda.

Figure 8.3 Ivan Illich at Radio Home Run, 1986. Photo: Toshiyuki Maeda.

Mini-FM: Performing Microscopic Distance

Hank Bull was a bit different. He was more interested in mini-FM as art. He was one of the pioneers of telecommunication art using telephone, fax, and videophone. Therefore he was interested more in the "noncommunicating" function of mini-FM and associated it with "radio art." In the meantime, radio art had become popular and the first international conference of radio art was held in Dublin in 1990.

The understanding of mini-FM has changed since then. With the earlier "immature" Internet, people were accustomed to a "low" quality of technology and this even produced some artistic aspects of mini-FM. Club culture also supported mini-FM as an art form. In 1993 in the U.S., the microradio movement arose. The leading person was Stephen Dunifer in Berkeley, California. I first met him in 1992 when Jesse Drew of Paper Tiger West organized a radio party for me. I held a workshop to build a one-watt FM transmitter and then we instantly opened a radio station. A lot of activists joined the discussion. Jesse wrote,

The first evening's program ranged from excited talk about the possibilities of pirate radio to tapes of music by local groups to a live clarinet performance by an 11-year-old. . . . As one activist observed, the one-half- to one-mile radius the transmitter covers is about the size of a voting precinct. Neighborhood groups could use these stations to discuss political issues and report on local events not covered by Bay Area and national news shows.[3]

Stephen had been involved in pirate radio but he underestimated such a small power as one watt. It was amazing that in a year or so he started an activity to let people know about a mail order DIY [do-it-yourself] kit to build a transmitter. Meanwhile, his own pirate radio station, Free Radio Berkeley, was fined $20,000 by the FCC [Federal Communications Commission]. This triggered a lot of interest as well as protest by activists who were interested in alternative media and who had been disgusted with the controlled mass media under the "pool system" during the Gulf War. Since 1993 the microradio movement grew in the US. Microradio was not the same as mini-FM because its size, "micro," was larger than "mini." But it is very interesting that in the circumstance where too many radio stations existed and one could own one's own station (if one had the money) people became interested in relatively smaller size of communication.

Question: Getting back to your performance art work with mini-FM and what you write about it, this opens up different ways of thinking about communication and art. Can you talk more about this?

Tetsuo: Being deeply involved in the mini-FM movement, one day I noticed that most of the stations were less aware of the audience but more interested in the sender themselves: They were absorbed in what they were doing on the spot. If they had become anxious about the size of the audience, they would have given up very quickly. They found the audience too small and sometimes nonexistent. But the station worked. It seemed to me that mini-FM was "radio without an audience" (figure 8.4). Later I found the convincing explanation of this phenomenon in Humberto R. Maturana and Francisco J. Varela's criticism of "the metaphor of the tube for communication." They argued that "communication takes place each time there is behavioral coordination in a realm of structural coupling. . . . The phenomenon of communication depends not on what is transmitted, but on what happens to the person who receives it. And this is a very different matter from 'transmitting information.'"[4]

In 1984, there was a monumental event, the Hinoemata Performance Festival, where over fifty performance artists and art critics got together in a mountain venue. This allowed artists from different areas and genres to collaborate with each other and then gave them the chance to show their work in galleries, museums, theaters and public spaces. Performance art suddenly revived after a twenty-year vacuum (from the end of the fifties to the early sixties performance art had been active in Japan only through external movements such as Fluxus). Since I had been already involved in writing about performance art, I was naturally engaged in this trend and even started to show my own performance pieces which used electronics. My career as a performance artist started at this moment. While I was involved in the message-oriented mini-FM movement, I started to experiment with what I had theoretically rethought about mini-FM.

I think, at the time, there were very few who were convinced about the new artistic or even "therapeutic" or social possibilities for mini-FM. A lot of potential did exist, however, for seeing it as more than just a "means of communication." In order to try to deconstruct the conventional function of radio, I tried a sound installation using micro-FM transmitters and radio receivers in a garden, a collaboration with dance performers carrying

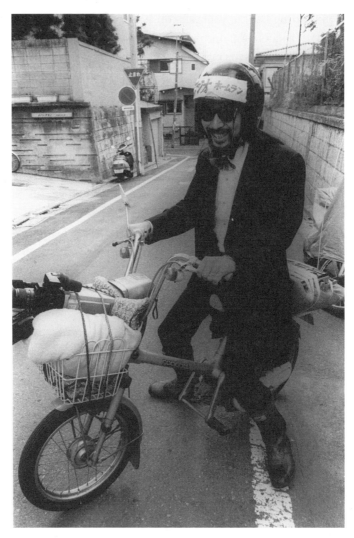

Figure 8.4 Radio Home Run on motorcycle, 1984. Photo: Toshiyuki Maeda.

transmitters to create fade-in/-out sounds on the receivers from their moves. There was also a kind of concert where the audience was in a house with radio sets on the floor and I walked around the house with a transmitter talking and playing tape sounds and so forth. Transmitting at the same frequency by a couple of transmitters was interesting, too. Later I named it "palimpsest art." The technique of "palimpsest" derived from Paolo Hutter of Radio Popolare in Milan in the seventies, which mixed various live sound sources during a program. Even a person who just happened to call in could instantly join the live mix. I tried this method through airwaves jamming. "Radio party," as I called it, is another one of the basic forms of mini-FM as performance art. This usually starts in my workshop, building a microtransmitter by myself (sometimes the participants do the building) and then people get together and begin a party using the completed transmitter to talk, play, eat and drink. In an hour-long radio party people also go for a short "picnics" outside carrying radio receivers.

Question: Have you worked with video or television in the context of your mini-FM or performance projects?

Tetsuo: In the late eighties we tested a microtelevision by a using a small transmitter, which was made of a booster and the RF [radio frequency] modulator of a VCR. The service area was as small as Mini FM but it worked to deliver moving images and sounds to our community areas. However we soon found that the viewers did not want to come to the station but kept watching. Television in particular seems to pin the viewer down to his or her own location. But ten years later when I started streaming radio with moving pictures by *RealVideo,* I found that the low quality of this medium helped motivate the audience to move. Since they were located a long distance from Tokyo, they could not come to the station but eagerly called in or mailed to our location. I suspect more sophisticated video transmission would not enable such a response. As Mitch Kapor said, low bandwidth sometimes has high "emotional bandwidth."

Question: You've mentioned Fluxus. Do you think that your approach was influenced by Fluxus? Did Fluxus have a particular inflection in the Japanese context?

Tetsuo: I like to consider myself as an irresponsible "descendant" of Fluxus. Apart from my activities as a media critic and as an artist, I've been faithful

to my own intuition and idiosyncratic taste. But whenever I was challenged to do something new, I found that Fluxus artists had been involved with something similar conceptually. John Cage (who is beyond Fluxus) did everything. Certainly Fluxus has a particular connection with Japan. And Cage was influenced by Taisetsu Suzuki, the Zen guru. Quite a few Japanese performance artists such as Takehisa Kosugi, Yasunao Tone, Yoko Ono and Ay-O were in the Fluxus network.

Among the various art movements from outside Japan, Fluxus was the one that most appealed to Japanese "avant-garde" artists in the sixties. Since the end of the fifties there had been a constant connection between New York and Tokyo. Yoko Ono was in SoHo and her loft was a hotbed of what later on [1961] George Maciunas called Fluxus. She had a lot of Japanese connections. Her partner at the time was Toshi Ichiyanagi, an artist of "avant-garde music." As Tone repeatedly said, however, the fact was that artists in Japan already had Fluxus ideas before they knew about Fluxus. So I should say that they had shared with Fluxus earlier influences such as existentialism and surrealism.

Actually, Fluxus-type performance art had already started in the late 1950s. Takehisa Kosugi, Chieko Shiomi, Shuko Mizuno, Yasunao Tone and so on eventually organized Group Ongaku in 1960. This was a very influential group not only for experimental music but also for other "avant-garde arts." In 1960 Ushio Shinohara with his companions such as Genpei Akasegawa, Shusaku Arakawa, and Shousaku Kazekura declared themselves to be "Neo-Dada organizers." They experimented with "happenings" as late as in 1958 and many popular magazines and newspapers wrote about this. Sofu Teshigawara, an "avant-garde Ikebana" artist, started the Sogetsu Art Center, the most magnetic art space, and most of experimental artists in this period showed their works there. This center invited Cage and [David] Tudor in 1962. [Cage's] first visit was a sensation. When I went to his "concert" at Tokyo Bunkakaikan-sho Hall, I found many notorious experimental artists I had heard about in various indy media. This event turned out to be the catalytic meeting for those who were involved in contemporary arts. Anyway, I can't summarize this very complicated history here, but let me just say that it's possible to think that many Japanese experimental artists found their "home" in Fluxus.

Question: Can you tell us anything more about your current radio work?

Tetsuo: I am presently more interested in much smaller scales of radio transmission along with sound art experiments. Radio Kinesonus <http://anarchy.k2.tku.ac.jp/kinesonus/> was started exclusively for this. It was after the midnineties that more people became interested in mini-FM as something different from ordinary radio. I argued that in the age of public access via satellite communication, global communication would become somewhat banal; artists should be concerned instead with the microunit of the medium. The Internet has rapidly developed global communication literally and the exchange of data has become too easy. This gives us an opportunity to rethink our more micro and local area of space and time. Radio also allows me to rethink the relationship between art and the body. High technology can substitute equipment for our body elements. Media art, techno-art, and computer art tend to reduce the bodily involvement in an artistic creation. It is because technology has been commonly and bureaucratically used in these directions. However, *technology* has dual aspects: *techne* (techno-) and *logos* (-logy). *Logos* logicizes everything and eventually establishes *logistics.* Our modernist way of life and the military system have become ever closer to each other. *Techne,* however, means hand work. *Ars* (art) is the Latin translation from *techne.* So technology does not have to be only "high tech" but could also work on the scale of hand work and at the distance of human limbs. This is a new area for the electronic arts and perhaps provides an alternative to the present way of life.

As for my own recent work in radio art performance—having used microtransmitter(s) as a catalyst for experimental communication, I have become interested in more minimal transmission of airwaves. While mini-FM's range was walking distance, my present attempts are done within waving-hands distance. By moving my hands over very-low-powered transmitters, I can make my hand movements evident as well as the noise/sounds deriving from the interference that my hands and transmitters create. I am interested here in the relationship between hands and airwaves because I think the hand is the minimum integral part of our body. Immanuel Kant allegedly wrote that "the hand is the outer brain of human being." The brain is also a part of our body and is the most complicated and dense part. So our hands can act for our whole body. In the last couple of years, Kazuo Ono, who was born in 1906 and was one of the most important founders of Butho dance, has been performing using only his hands because he cannot move his other limbs due to paralysis. Leon Theremin invented his famous instrument

and many musicians have used it as a music instrument. Although the Theremin has been used as an instrument to be played, I think this invention is also suggestive about ways to create a new form of radio art using our hands and airwaves.

Question: What you say about radio and art and body is very interesting. Please expand on these ideas.

Tetsuo: The history of Western civilization is a process of substituting technological artifacts for the human body. Performance art is a compensation for the loss of the body. The artist's body is the battlefield between technology and the body. As modern technology has introduced new phases starting from machine technology to electronics to biotechnology, technology has driven the performance artist's body into a "body without organs."

Conscious of Artaud, Deleuze and Guattari took this concept as the matrix of our body. To my mind, the "body without organs" means what our body is and how it is. In the era of machine technology, the performance artist could rely on reconstructing the "living" (bare, naked, aural, and flesh-oriented) body-organ. Machine technology had already invaded the human body from external spaces (the city, architecture and so on). Computer-generated technology, however, has left less room for the performance artist for any "natural" spontaneity of the body. Simulation technology still needs at least a sample of embodiment though. In biotechnology, the change goes to the extreme. Cloning technology checkmates the body itself. It finishes off any optimistic counting on the body's spontaneity. This means the body must now deconstruct itself into a "body without organs." This situation could be interpreted as the realization of the Hegelian idea of "the subject-object identity" where our subjectively "physical" (embodied) and, at the same time, objectively "physical" (disembodied) body ends.

The technology of electromechanical reproduction climaxes in biotechnology where the distance between the original and the reproduction completely disappears. The "natural" body cannot be the criterion of the world any more. Distance exists but does so virtually. This does not mean that distance becomes fake and illusory. Rather, it means that distance does not rely on what is familiar any more. It becomes totally manipulative. So what is distance in media? It is not defined by conventional space and time. Even if virtual, we could experience numerous forms of distance with new technologies.

To put it another way, today's technology is going to remove every distance that defines the human body as well as the objectified body and the physical world. Geographical and spatial distances have been shrinking with global media. Digital technology erases the distance between the original and the reproduction. But I don't think that these trends homogenize everything. We need to change our conventional epistemology and macroscopic approach and we need to differentiate distances, or else everything might seem to be the same. The fact is that global media create "translocal" enclaves of cultures. They are very local as well as going beyond locality. It is difficult to understand such a translocality unless we insist on a microscopic approach, in order to find the diverse differences in the shrinking but increasingly dense distance. Mini-FM would be merely one examples of such a microscopic approach.

Notes

1. Tetsuo Kogawa, "Beyond Electronic Individualism," *Canadian Journal of Political and Social Theory/Revue Canadienne de theorie politique et sociale* 8, no. 3 (Fall 1984): 15.

2. Maurice Merleau-Ponty, *The Visible and the Invisible,* ed. Claude Lefort, trans. Alphonso Lingis (Evanston: Ill.: Northwestern University Press, 1968), 130–155.

3. Jesse Drew, "This is Kxxx: Mission District Radio!" *San Francisco Bay Guardian News* May 13, 1992, 26, no. 32, p. 13.

4. Humberto R. Maturana and Francisco J. Varela, *The Tree of Knowledge,* rev. ed. (Boston: Shambhala, 1992), 196.

From the Gulf War to the Battle of Seattle: Building an International Alternative Media Network

Jesse Drew

In December 1999, fifty thousand environmentalists, social-justice advocates, and labor activists descended on Seattle, Washington, in a determined outpouring of opposition to a meeting of the World Trade Organization. The mass demonstrations and subsequent street clashes caught the mainstream media off guard; these media expressed surprise at not only the large numbers of the protesters, but the extent of organization and global participation evident among them.

Pundits were quick to acknowledge the Internet's role in building the large scale of the Seattle demonstrations. Such a perspective, however, tends to place the technology in the center of the events, ignoring that the technical practices and experiments of independent media activists emerge from social relationships and concerted collective activity. Furthermore, such a perspective ignores the past practices and historical roots that helped to pave the way for new, progressive Internet communications. What kind of interpersonal network structure existed beforehand to accommodate the building of this type of alternative media network? What types of technological infrastructures were used in previous alternative media projects, and how did these projects contribute to contemporary communications practices?

To investigate some of these questions, this chapter looks at the *Gulf Crisis TV (GCTV) Project* and its roots in the Deep Dish TV Network and *Paper Tiger Television.* Most of the source information for the chapter comes from the author's personal involvement in these activities, as well as from discussions with primary participants, archival sources, and published writings. The *GCTV Project* was an alternative video network that sprang up in response to the U.S. war on Iraq in 1990–1991. The organizers of this project were able to effectively create an alternative television system, receiving, editing, and transmitting video images locally and internationally, a few short years before the popularization of the Internet and Web services many take for granted today. The GCTV Project, in its own small way, helped lay the foundation for contemporary Internet-based alternative media networks.

Paper Tiger TV (PTTV) emerged in the early 1980s from the beginnings of a different form of new technological infrastructure, the crisscrossing coaxial lines of cable television. Building from the success of media activists' demand for public-access TV channels from the cable conglomerates, a group of activists, academics, and artists chose to use these newly won television channels to focus on the media themselves. Some of the initiators of and early participants in *Paper Tiger* included Dee Dee Halleck, Diana Agosta,

Pennee Bender, Caryn Rogoff, Shu Lea Chang, Martha Wallner, and Tuli Kupferberg.[1] Fusing artists, activists, and academics, *Paper Tiger TV* released a prolific barrage of half-hour critiques of mainstream media programming, critiques of print media ranging from the *New York Times* and the *Washington Post* to *Seventeen, Cosmopolitan,* and *TV Guide.* Some of these early critics presented by *PTTV* included Herb Schiller, Joan Braderman, Donna Haraway, Harry Magdoff, and Murray Bookchin. Paper Tiger programming appeared on Manhattan cable in 1981, opening with a hand-made, funky, decidedly low-tech look. This low-tech aesthetic was not only the result of a minuscule budget, but a conscious effort to show the public that anyone can make media. This demystification of television technology became a prime aspect of the Paper Tiger style. Most shows opened with the hand-held title cards "Smashing the Myths of the Information Age" and "It's 8:30 PM. Do you know where your brains are?" The full *Paper Tiger TV* manifesto would scroll by, often on a hand-made "cranky," accompanied by some punchy, upbeat music:

PAPER TIGER IS A PUBLIC ACCESS TV SHOW.
IT LOOKS AT THE COMMUNICATIONS INDUSTRY
VIA THE MEDIA IN ALL OF ITS FORMS.

THE POWER OF MASS CULTURE RESTS ON
THE TRUST OF THE PUBLIC
THIS LEGITIMACY IS A PAPER TIGER.

INVESTIGATION INTO THE CORPORATE
STRUCTURES OF THE MEDIA AND CRITICAL
ANALYSIS OF THEIR CONTENT IS ONE WAY
TO DEMYSTIFY THE INFORMATION INDUSTRY.

DEVELOPING A CRITICAL CONSCIOUSNESS
ABOUT THE COMMUNICATIONS INDUSTRY IS A
NECESSARY FIRST STEP TOWARDS DEMOCRATIC
CONTROL OF INFORMATION RESOURCES.[2]

The early Paper Tiger shows were shot "live to tape" with an all-volunteer crew, on a shoestring budget, mostly derived from small arts grants, dona-

tions, and tape sales. With the hope of spreading its electronic message far and wide, the Paper Tiger collective took on the task of dubbing and hand-delivering or mailing copies of Paper Tiger programming to other supporters in other cable systems for playback. The programming could then be seen in various localities throughout the country, including Austin, Texas; San Diego, California; Burlington, Vermont; Providence, Rhode Island; Saint Louis, Missouri; Springfield, Illinois; and Detroit, Michigan.[3] A newly formed Paper Tiger Television (PTTV) section in San Francisco began to help with production and distribution as well. Soon, copies were being run around several dozen public-access stations in different locales, becoming by popular acclaim a form of sneakernet.

As the shoes began to wear thin, *PTTV* began looking for more efficient means of distribution. Modern TV networks rely upon the hovering satellites in geostationary orbit to transmit their programs to a national audience. By the mideighties, there were enough satellite transponders at cheap enough rental fees to allow mere mortals access to the footprint of a satellite. The ethereal distribution plan originally intended to send out *PTTV* programming over satellite dubbed Deep Dish TV, blossomed into a much wider concept (figure 9.1).

By the mideighties, the mass marketing of the home camcorder allowed millions of citizens to have access to video production, essentially eliminating the need for studio equipment or expensive, heavy U-matic camera/deck combinations. Activists and artists worldwide were capturing local stories and struggles, producing homemade tapes that were typically screened to a few friends and wound up sitting on a shelf somewhere. Public-access programming like *Paper Tiger TV* and *Alternative Views* in Austin, Texas, helped popularize the idea of public-access television, encouraging members of the public to play back its productions on local cable access stations. Groups of camcorder enthusiasts and local public-access programmers began to grow in cities and towns across the United States.

At the core of the *PTTV* philosophy is a belief in the importance of people making their own media and rejecting their predetermined role as passive consumers of prefabricated images. Deep Dish TV took on the task of making a more interactive, two-way video network, to the extent that the expense and technological apparatus allowed. Why not contact the homegrown producers, encourage them to send in their tapes, and splice them together into thematically based programs to send back out on the airwaves via satellite?

Figure 9.1 Promo for Deep Dish TV. Image: Deep Dish TV. Screen shot.

These local groups of producers could then download and record the feed from the dish and program the material back into their community public-access timeslots. Therefore, community groups that made a tape on their local housing struggle could sit back and watch with their participants and supporters as their story appeared on their local cable station, alongside similar stories from all over the country. Thus was born Deep Dish Television (DDTV), the first public-access television network. This form of TV, in which consumers were producers as well as consumers, was counterposed against the increasing marketing hype of "advanced," "interactive" TV, which still positions the audience solely as consumers of visual "product."

Deep Dish TV, in collaboration with the Boston Film and Video Foundation, uplinked its first series in 1985–1986. The series was made up of ten one-hour programs, on subjects such as labor, housing, racism, and Central America. It was offered free to public-access organizations and was downlinked by at least 186 stations.[4]

One of the most important results of this project was a booklet that came along with the tapes, an illustrated zine that included contact information for the hundreds of video activists around the United States who participated in the making of the series. The contact addresses were laid out in a mailing-

list template and arranged by zip code, so that the list could be xeroxed directly onto mailing labels that could be attached to envelopes or packages to be distributed via the postal service. A nationwide video network was thus constituted, composed of paper, phone numbers, fax numbers, and satellite feeds. If an artist produced a program in Tucson, Arizona, but her friends and family lived in Albuquerque, New Mexico, she could contact New Mexico participants in the network and ask them to run the show there. Likewise, if someone lived in New York but needed footage or an interview from someone in San Francisco, they could usually find someone to do them the favor and perhaps be asked to reciprocate sometime in the future. This network took root especially as people began to meet in person, often during annual national meetings of the National Federation of Local Cable Programmers (now called the Alliance for Community Media). This important organization formed in 1976 as a way for public-access advocates and programmers to compare notes and strategize collectively.

DDTV produced numerous seasons of programming, with editors volunteering to put the material together in a coherent and curated fashion. After the first season of programming, Deep Dish coordinators proclaimed:

Deep Dish TV has left behind it a network of contacts and open lines of communication between independent producers, community groups, and access centers, between access centers and cable systems operators, and between communities all across the country. An ongoing network could go a long way in combating the large and small problems that have plagued public access: isolation, limited publicity, low esteem, and lack of contact with alternative examples. The response to Deep Dish TV is strong evidence that an independent, decentralized television network can work.[5]

Subsequent programming seasons included programs on Latin America, Asia, cultural politics, AIDS, women's issues, environmentalism, and anti-militarism. After the second season, Deep Dish had confirmed responses from 250 cable access centers that had downlinked and played DDTV programming, potentially reaching over twelve million households in forty-three states, including Alaska.[6] Judging from the mail, the audience also included backyard dish owners, primarily rural viewers without access to cable systems, who were happy to see some noncommercial programming out in the ether. DDTV also opened up its programming schedule to other organizations, uplinking tapes produced by groups such as the United Farm

Figure 9.2 Demonstration against Gulf War, New York City. Image: Gulf Crisis TV Project. Screen shot.

Workers Union, the Amalgamated Clothing and Textile Workers Union, and the International Women's Day Video Festival. In 1990, the network transmitted to a U.S. audience a live speech from Nicaraguan President Daniel Ortega in Managua.

Toward the end of 1990, the specter of war began to loom on the world stage as President George H. W. Bush began threatening Iraq with military retaliation after it moved into the U.S.-allied oil territory of Kuwait. In response to this saber rattling, the ashes of a still-smoldering antiwar movement stirred in many American communities. In city after city, town after town, U.S. activists began to mobilize teach-ins, demonstrations, and acts of civil disobedience to raise unasked questions about U.S. history and responsibility in the Gulf region—questions basically ignored by the major media outlets (figures 9.2 and 9.3). For their part, the mainstream media hosted a parade of military brass, conservative pundits, and oil-friendly business analysts who dominated the press and the airwaves. Deep Dish began discussions with antiwar activists and other concerned citizens about trying to use the camcorder to capture and present the missing side of the debate. Camcorder activists nationwide had been shooting and documenting popular opposition

Figure 9.3 Demonstration against Gulf War, San Francisco. Image: Gulf Crisis TV Project. Screen shot.

to the war drive, scenes absent from the evening news and morning papers. The subservience of the U.S. media to the war plans of the U.S. administration was frightening even to many who still believed in the ultimate objectivity of the "fourth estate." It became apparent to those opposed to the war and to the proliferation of anti-Arab racist fear mongering that something should be done to counter the mass-media subservience to U.S. policy.

The Gulf Crisis TV Project was formed in the fall of 1990 and put out a call for video documentation of local antiwar events, as well as to disseminate interviews with dissident experts and intellectuals ignored by mainstream media (figure 9.4). Also welcomed were artistic and cultural works that critiqued and illuminated what was happening in the Gulf. The first series produced by the project, consisting of four tapes, edited under duress by many volunteers *War, Oil, and Power, Operation Dissidence, Getting Out of the Sand Trap,* and *Bring the Troops Home!* According to Dee Dee Halleck, one of the principal organizers of the project:

The series contained the work of over a hundred producers, from dozens of locations. The work ranged from rallies, to comedians, to guerrilla theater, to intimate

Figure 9.4 Opening graphic from Gulf Crisis TV Project. Image: Gulf Crisis TV Project. Screen shot.

interviews, to didactic charts and history texts. Artists such as Seth Tobocman and Mary Feaster made graphics for the series. Performance artists Paul Zaloom and Papoletto Melendez created performance pieces. Norman Cowie, Joel Katz, Tony Avalos, and Karen Ranucci made short video art pieces. The programs bristle with anger and outrage, but also have humor, music and dramatic moments. They have testimony from such experts as Edward Said, Noam Chomsky, Dessima Williams, Daniel Ellsberg and Grace Paley, and heart-felt testimonies of GI's who were willing to go to jail rather than fight.[7]

The first four half-hour programs were uplinked in January 1991 on the Deep Dish TV Network, to hundreds of local cable stations. A friendly Public Broadcasting System (PBS) station, WYBE in Philadelphia, sponsored an uplink on the PBS satellite, thus making the series available to millions of public-television viewers, including those in New York City and Los Angeles. The programs were also publicly shown to crowds of people hungry to see another side of the story. The tapes played in public venues such as community centers, movie theaters, university teach-ins, and churches. Seeing the audiovisual representation of large antiwar protests in public venues

helped tremendously in building confidence for further mobilization and in dispelling the "spiral of silence" and subsequent apathy and depression that frequently accompanies state-controlled media and propaganda.

As war preparation turned to actual war, as Desert Shield begat Desert Storm, the tightening of the media control grew more intense, as the dailies and large broadcasting networks meekly succumbed to mandatory military censorship of images from the Gulf. Dissenting views were essentially eliminated, and reporting of mass protest was silenced except for rare occasions.

In San Francisco, for example, the site of a demonstration of two hundred thousand people, local media outlets suppressed the extent of the protest, arbitrarily reporting the number as fifteen thousand. One National Public Radio reporter, while preparing her live report from the demonstration, told her editor that there were over one hundred thousand people at one of the protests. She was told by the national news director not to report the numbers and the size of the protest. At one television station, a handful of prowar bikers was juxtaposed with one hundred thousand antiwar protesters in a pathetic attempt at somehow equating the size of the demonstration by the two sides. This disinformation happened consistently. A Japanese news crew from *The Scoop,* a Japanese news program similar to the CBS news program *60 Minutes,* came to San Francisco and produced an entire segment on the willful disinformation propagated by U.S. media on the extent of public protest to the war. There was so much antiwar activity in San Francisco that activists there created their own weekly program called *Finally Got the News.* Chock full of reporting on the mass arrests, bridge takeovers, and large-scale civil disobedience occurring in the San Francisco Bay Area, it helped expose the media's silence and complicity in suppressing the truth about the size of the antiwar backlash. KQED, the local PBS station, which steadfastly refused to run programs with views opposing that of the government, became the target of alternative media activists as well. As critics often point out, the problem with so-called public television in the United States is that it is at the mercy of Congress, which funds much of its infrastructure, as well as beholden to the corporate "underwriting" that pays many of its bills. This often makes PBS broadcasters very reluctant to rock the ideological boat. Antiwar documentarians, determined to be "on" (KQED) at any cost, showed up with a video projector and a sound system and had a public screening on the station's blank outside wall, with the police looking on.

To further enhance distribution, the Gulf Crisis TV tapes were duplicated thousands of times and sold cheaply at events and through the mail. Tape owners were encouraged in turn to duplicate their tapes and pass them on, and thus tapes circulated by the thousands into the hands of friends, family, and coworkers nationwide, becoming in effect an American electronic samizdat. Millions of people ultimately saw these videos, in direct opposition to U.S. policy and the U.S. media whiteout. All these actions added to the wholesale rejection of corporate media and contributed greatly to the desire to build an alternative media infrastructure.

During the war, the informal network of alternative video activists grew to international proportions as the GCTV Project linked to other video collectives around the world. Many of the network contacts came from informal international connections that had accumulated over many years of Paper Tiger production. These connections took on more importance in light of the somber events taking place in the Gulf.

The call went out to the international grassroots video contacts to send footage showing what was happening in their countries. What was the response from other peace movements around the world? Was there international outrage from other countries? What was the perspective from other peoples not subject to U.S. media self-censorship and blind patriotism? Tapes came in from all over the world, and in return tapes went out all over the world in an international exchange of evidence of opposition to U.S. policy in the Gulf. The GCTV Project received protest footage from Taiwan, the Philippines, Spain, Korea, France, and other nations. Programming from the GCTV Project was shown all over the world, including on Channel Four in England, on Vision TV in Canada, and on channels and public venues in France, Japan, and Germany. Some of the tapes were translated into Japanese and showed to groups of community activists and students in Tokyo.

The first series of four Gulf Crisis programs was followed by six more programs: *News World Order, Manufacturing the Enemy, Lines in the Sand, Global Dissent, Just Say No!* and *War on the Home Front.* These tapes were also broadcast on the Deep Dish TV Network and distributed by the growing number of antiwar activists and organizations. The series continued to screen, even after the war wound down. In 1993, the Gulf Crisis TV Project was part of the prestigious Whitney Biennial and later screened at the Berlin Film Festival and many other festivals and venues.

The success of the Gulf Crisis TV Project, fraught as it was with conflicts and tensions, economic difficulty, and technical limitations, illuminates the exciting possibilities unleashed by media activists developing independent media networks that have the possibility of breaking the blockade of ideas erected by today's corporate-owned media. The ability of fax machines and satellite feeds to cross borders was invigorating and exciting for thousands of activists walled in by the corporate stranglehold of CBS, NBC, ABC, and CNN. It is a powerful feeling when people see themselves and what they stand for represented in mass media, on a television set, or on the big screen.

The fact that these media activities were initiated and sustained by an independent collective of media producers is a strong statement, in and of itself, in a field often dominated by egotistical artists and profit-driven corporations. The collective's structure often meant that the production process was rarely smooth, with frequent debate between those arguing for a "professional, broadcast quality look" and those arguing for a funkier, home videocam aesthetic, or between those advocating appealing to an already radical audience and those advocating appealing to a more mainstream audience. Discussion also ensued about whether to bring in younger, though perhaps more inexperienced, people and how to increase the diversity of the collective by reaching out to communities of color. These discussions did not always leave everyone happy and unruffled, particularly as they ensued amidst a frantic work effort, spurred by the perceived U.S. rush to genocide in the Middle East.

Despite these problems, the collective awareness raised by this media project contributed in its own small way to the realization among young activists that corporate media are unable to deliver the truth, and that a movement must have its own media infrastructure. To many anti–Gulf War activists, the link between democratic debate over foreign policy issues and mass media became inseparable. A true democracy is, after all, based upon an informed citizenry, and an informed citizenry was ultimately not desirable for the petrochemical-driven foreign policy in the Gulf region. The Gulf Crisis TV Project helped develop a new way of thinking about media networks and how such networks can contribute to democratic participation.

In hindsight, it is quite remarkable that such an extensive video production network was developed at such a rapid pace, without relying upon many of the Internet and Web tools we take for granted today. The Gulf Crisis TV

Project is testimony to the position that a network is primarily about people-to-people communications, rather than just a patchwork of electronics.

The choice of the word *network* to describe Deep Dish TV was not taken lightly. The buzzword *network* is ubiquitous in today's technological times. Much of society may be connected electronically today, but not much intelligence is expressed with that word *network*. What is left unsaid is that not all networks are created equal.

The notion of a net seems to signify a democratic sharing, an equal distribution of nodes, all connecting to other points, without hierarchy. Few networks are like that. TV broadcast networks are hierarchical, with a central locus, with no feedback, and with no way to communicate among its outer points. This broadcast model has historically dominated the construction of networks. The radio, TV, and cable industries have all promoted this structure. Today, the Internet is under the same pressure to conform to this type of network model. The e-commerce economy, the Holy Grail for many multinational corporations, is searching for a way to force this centralized, broadcast model, profit-enabling structure upon the Internet. The Internet business model is a broadcasting model, with the central hub being distributors of electronic services and entertainment, à la AOL and MSN, among others.

There is also a quaint notion that networks—all networks—are inherently positive entities: that somehow all networks are the electronic equivalent of talking over the neighbor's back fence or dealing with the friendly neighborhood merchant. Networks, however, must be scrutinized for their social impact, and not just their technical achievement. Networks, like other technological creations, are, after all, not simply discovered or invented, but are engineered into existence and put into place by institutions of power. Networks, in particular electronic networks, have existed for over a hundred years. The standard term *network,* at least in the United States, was popularized by CBS, RCA, and the red and blue networks of early commercial broadcasting. The network of telegraph lines strung up around the world at the turn of the last century transformed primitive colonialism into modern imperialism. The United Fruit Company, the inventor of the "banana republic," was one of the earliest builders of AM radio networks, constructed in order to keep their banana plantations and shipping operations humming. Today, advanced computer network technology allows the smooth functioning of global capitalism. Cash register signals flow from the mall, to the corporate

headquarters, to the third-world sweatshops, to the shipping companies and warehouses, and back again. Indeed, not all networks are created equal.

Networks can be hubs, chains, stars, or other configurations. They can also have varying levels of equality and exchange. The desire of Paper Tiger TV, Deep Dish, and the Gulf Crisis TV Project was to develop a truly interactive, participatory network infrastructure that stresses democratic involvement over passive consumerism. It is not enough to be merely consumers of information: Democracy requires active participation as well. The Gulf Crisis TV Project helped to promote an activist vision, and to point out that certain barriers to building such a global, grassroots media network, such as language difference, national borders, different television standards, distance, and time obstacles, can be overcome.

In 1993, Deep Dish TV broadcast a program produced by Paper Tiger TV called *Staking a Claim in Cyberspace.* This program took a critical look at the new developments in the rapidly growing domain of cyberspace and the construction of the information superhighway. While accurately foretelling the rapid corporatization of the Internet, it also raised the emancipatory possibilities of a universal computer media network, in which every port could send and receive information, unfettered by corporate gatekeepers. The establishment of the Independent Media Center in Seattle in 1999 was evidence that these possibilities were indeed realizable.

Notes

Special thanks to Martha Wallner, Dee Dee Halleck, Jeff Perlstein, Carla Leshne, Glenda Drew, and Simone Farkhondeh for their help and comments.

1. For an excellent history of *Paper Tiger,* see Dee Dee Halleck, *Hand Held Visions: The Impossible Possibilities of Community Media* (New York: Fordham University Press, 2002).

2. *Paper Tiger TV Catalog* (New York: Paper Tiger Television, 1997–1998), 2.

3. *Paper Tiger Television Re-presents the Media,* catalog, Ramapo College, Mahwah, New Jersey (1987), 7. Produced by the Art Galleries of Ramapo College.

4. From the *Deep Dish Directory,* a resource guide for grassroots television producers, programmers, activists, and cultural workers, Paper Tiger TV (1986), 10.

5. *Deep Dish Directory,* 14.

6. *Deep Dish Directory,* 4.

7. "Making Outrage Contagious: Chronology of the Gulf Crisis TV Project with Texts and Testimonies," with Dee Dee Halleck, Simone Farkhondeh, Cathy Scott and Marty Lucas, available at <http://www.papertiger.org/index.php?name=outrage>. Web site, a collaboration with Simone Farkhondeh, Cathy Scott and Marty Lucas. NY, in March 1992.

The Form: 1970–1979 and Other Extemporaneous Anomalous Assemblings

Melody Sumner Carnahan

The idea sprang to life out of boredom: 1978, California, a cramped studio in Tan House Apartments at the edge of Palo Alto, a few hundred yards from the Bayshore Freeway. I had just returned from my first trip to Europe visiting the catacombs of culture in London, Paris, Rome, Madrid, Athens, and then Cuenca, Spain, where I decided to devote my life to the art of writing. I was patiently awaiting the news that Mr. Stegner wanted to give me his coveted Wallace E. Stegner Fellowship in Creative Writing at Stanford University. I was planning to be the next Ken Kesey.

I peppered my application with affirmations: "I hope that fiction, when relieved of the necessity to comment on life, may deliver us into a more immediate experiencing of it." And "I want the words to have an inciting mental power, the heat of combination or generation . . . provoking direct sensory, sensual, and emotional activity, as music can do." As it turned out, they weren't much interested in words as dynamite. The not-exactly-form-letter rejecting my application called the work "too experimental." Recently, a New York agent declined to represent my work, describing it in similar terms as "falling between the cracks of commercial, literary, and experimental." She said, however, that she enjoyed "the apparent relishing of each phrase as it's spat out!" Exactly. Which reminds me of the way George Saunders describes his favorite kind of writing: "The sentences are not merely sentences but compressed moments that burst when you read them."[1]

While waiting to hear from Mr. Stegner, I went to the Stanford campus everyday to write. I sat in courtyards, under trees, on benches, in hallways, observing. I wrote pieces there that have since made their way into books and live performance works, CD and DVD recordings, film scores, video and audio works, installations, and radio productions. I now consider that "my time at Stanford" was fruitful, and though the university didn't acknowledge my presence, I learned what I needed to learn from it, and what I needed to work against.

One day, supine on the bed (there was only one chair), I heard, broadcast through the tiny clock radio, what turned out to be my future direction: words set to music in Robert Ashley's opera *Perfect Lives*.[2] Ashley, I soon discovered, was the director of the Center for Contemporary Music at Mills College just across the Bay in Oakland. My husband, Michael Sumner, said, "Why don't you apply to Mills as well . . . just in case this Stanford thing doesn't work out?" I did, and was awarded a full-tuition scholarship and spent the next three and a half years in heaven working with composers and musicians,

making books, and receiving a master of fine arts degree in writing. My work was not only accepted, it was understood, though not so much in the literature department as in the "experimental" Book Arts Program, and at the "experimental" Center for Contemporary Music, where I studied with Ashley, Maggi Payne, Terry Riley, and Laetitia Sonami. I had found my tribe.[3]

Back to Palo Alto and the waiting . . . Tan House Apartments:

She was hoping to catch a glimpse of the person who had emitted the short half-shriek which hadn't sounded like the noises made by the deaf woman next door when she tried to get her husband's attention as he worked on his car, nor had it sounded like the noises made by the girl on their right whose boyfriend sometimes resorted to violence when she had hit him with a heavy skillet or thrown the contents of one of his drawers into the swimming pool.

This fairly autobiographical story I wrote at Tan House was later included in my first collection, *The Time Is Now.*[4] We had few friends in town, contemporary culture was nonexistent in stodgy Palo Alto, and the inhabitants seemed like cockroaches: no sign of them until you weren't looking and then they came out to do something—but what?

It is early summer, evening. A woman pulls out weeds from around the trees in her yard. A man comes out of the house, stands directly behind her in his shorts, black socks, a drink in his hand. She continues pulling weeds without looking up. He walks around, looking down, then kicks a rock off the cement drive. It skips, rolls, and lands in a pile of others that form part of the landscaping. He goes back inside.[5]

I got a job working part-time in the Education Department of the *Wall Street Journal* up on Page Mill Road. I rode my bike there three times a week and for fun at lunch hour lounged on the grounds of nearby SLAC, the Stanford Linear Accelerator Center, which to me was one of the power spots of the world. We didn't have a television, and the pool (though a hit with the occasional out-of-town visitor, who had to sleep, literally, in the closet) was not my thing. One day I got an idea, again lying on the bed.

"Mike!" I said.

"Yes. . . ." My husband turned warily from the desk where he'd been fixing the roller on my Hermes portable . . . *ding // *ding // *ding.

"Can you make me a form? It would list the years 1970 through 1979, each year followed by a blank line. We'll send it out to people and ask them to fill it in. I mean . . . it's so vague, the whole decade. What was it about anyway?"

"H-m-m," he said, not one to jump on board prematurely. Maybe this was just a passing whim ("She has a whim of steel."), or maybe it would turn out to be fun like the "chance" walks we took tossing a coin at each corner to decide which way to go, invoking unknowns.

We were young, ambitious, reckless, and, as I say, bored with suburban Palo Alto. The punk scene was just getting going in San Francisco, also New Wave theater, and New Music performances, but you didn't see a sign of it in Palo Alto. We'd make pilgrimages to San Francisco clubs whenever our 1964 Ford Galaxy cooperated. What do you do night after night: listen to the neighbors fight, take long bike rides, eat another giant chocolate chip cookie? This blandness was not what I expected from California, having at seventeen traveled up Highway 1 to San Francisco with my wildest high school friend who insisted I get "experienced."

A few months earlier, for fun, Mike and I had performed a guerilla art act late one night, anonymously plastering an 8½ by 11-inch Quick-Print poster all over the narcoleptic town: at traffic lights, on parking posts, phone poles, realtor's signs, Stanford's utility boxes, fences, walls, whatever flat surfaces we could find (using actual wheat paste or a staple gun). The poster was one simple icon, a black-on-white silhouette of Edouard Manet's famous "fifer" (figure 10.1). This was Mike's idea. He'd been excited by the walls of weathered posters in European cities. After we'd made the anonymous postings, we'd check out if and how people reacted: they had penciled in words, spray-painted over it, or tried to peel off the harmless, enigmatic image. Why? Someone wrote a letter to the editor at the Stanford paper, asking, "What is it all about?" No one knew. How strange. This was totally interesting to us.

Now we knew firsthand how a benign unexpected action could elicit a response among people who are adjusted to sameness.

"How to make the stupidity of everyday life a visible issue. . . . Everyday I feel I am being: A. cloned, B. knifed, C. embalmed," from *Search and Destroy* magazine, San Francisco, 1978.

Mike proceeded to draw up "the form" using rubdown type, and he added lines at the bottom for signature and date. I handed it out to coworkers at

Figure 10.1 Manet's "fifer" posted in Palo Alto, California, 1978.

the *Wall Street Journal* and people I met around town, to relatives and friends, asking them to "fill it in and give it back to me." Mike then suggested we mail it out to artists, writers, politicians, people we admired, people we didn't know. He looked up addresses at the Stanford library. I typed up a letter to enclose with the blank form:

Dear So-and-So:

This is a form I am sending out to 100 people. I would like you to fill it in anyway you like then send it back. I will be very grateful if you do.

We had no idea, nor did those who received the form, what, if anything, would come of it. We were simply trying to keep the mailbox stuffed with oddball things to facilitate getting out of bed in the morning. The art, the poetry, the personal revelations and honest explanations began pouring in. We enjoyed noticing how the paper had been touched, cut, smudged, re-folded, collaged, or drawn upon. The tenor of the handwriting, what kind of pens or pencils had been used. The boldness, the shyness exposed; fanatically neat people whose practiced words fit perfectly; messy ones who had no loyalty to the lines often spilling over onto the back of the form; the ones holding back, the ones letting go. . . . Objects were sometimes attached to the form: feathers, photographs, a complete set of hand-tied flies in one instance.

Many responses were straightforward and heartbreaking in their sincerity. Deaths, operations, marriages, breakups were the signposts for some. Others were completely political in approach: "Nixon's visit to China." A curious poetry came out of normally quiet, unassuming teachers and businessmen. Visual artists, too, often used words evocatively, whereas published writers were more reticent, perhaps not wanting to give their words away (figure 10.2).

I was moved by my parents' responses. My father's prediction for 1979, "World War III or Depression," and my mother's hopeful "looking forward to fun in van," which seemed to quintessentialize their personality differences.

There is a precedent for this kind of thing in my life: I launched an unending salvo of questions as soon as I could talk. Much later I began "interviewing" informally. I'd come up with a question and write down the responses from various people; I surveyed people in bars, at conferences, trying to catch them off guard: "Would you rather be wrong or boring?" or "What is the source of your beauty?" or "What do you want that you are not getting now?" . . . often the words love or affection came up. Once I made fortune cookies for a friend's birthday party, inserting sentences from my stories. When I asked people what the "fortunes" meant to them, I was surprised how they had made immediate and meaningful associations, similar to the anomalous truths that erupt from the *I Ching* when it is consulted sincerely.

In terms of influences: For several years Mike had been studying the work and ideas of John Cage, beginning with Richard Kostelanetz's documentary monograph on Cage. That book literally fell into his hands at the university

Figure 10.2 Forms filled out by Richard Elmore, Lark Drummonds [Brandt],
Pete McKloskey, and Mollie Favour-Miller, 1978–1979.

1970 - 1979

	WOMEN	WORK PROJECTS	EXPERIENCES @ SIGNIFICANT EMOTIONAL IMPACT	PLACES	COLOR
1970	NONE OF 10 YRS MARTO	ROBERT TRENT JONES COLLECTION (WATER COLOR PAINTINGS)	FIGURING OUT A WAY TO PAINT. TRAVEL, MAKE MONEY ON THE SWING PROJECT.	(marks)	AQUA BLUE
1971	MARTO CHRIS	ROBERT TRENT JONES COLLECTION	REALIZING I WASN'T HAPPY IN MY LIFE @ NINETY HANGING ON AFFAIR/OLD CHAOS	RIVERS (marks)	GREEN
1972	LESLIE JOAN KAREN CHRIS	MORNING BUILDING ELKHORN @ SUN VALLEY	DIVORCE MOVING TO IDAHO BONNIBLE. TOTALLY LEAVING EVERYTHING BEHIND	IOWA IDAHO	BURNT ORANGE
1973	LAURIE	ELKHORN GOODFELLAS HORN BLOWER	ADJUSTING TO LIVING ALONE * WHAT ABOUT LOVE AFFAIR WITH LAURIE	IDAHO	PAYNES GREY
1974	LAURIE	HORN BLOWER ELKHORN MATTRON	TRYING AS TO GET ALONG IN ELKHORN/SUN VALLEY. IT WAS NOT MY KIND OF SPORTS OR TOWN WAS FRUSTRATING	WASHINGTON	YELLOW OCHER
1975	EMILIO, ANN, JOAN, BETTY, DORIS, DAWNA SUZANA ROSE BEVERLY GLENDA LAURIE AGNES LESLIE	WASHINGTON DESIGNS ERICKSONS LANDSCAPE DESIGN	ADJUSTING TO THIS MOVE TO CALIF AND ENDING OF ALONE SCENE @ LAURIE DEVELOPING MY OWN HOME LOVELL ST DEPT.	CALIF	HOOKERS RED
1976	ALICE ALICE ALICE	GATEHOUSE CROWS NEST LA PUEBLE PEOA STUDIO	MEETING DAVID LEARNING TO LOVE ALICE RETURNING TO MY FAMILY IN SO. DAK.	KANSAS SO. DAK	ORANGE ORANGE
1977	ALICE ALICE	SESON RIVER CROWS NEST BUDDENBROOK THE FARM	STARTING MY OWN COMPANY BUYING THE HOUSE @ ALICE CHECKING INTO ALICE BEYOND ENDO ROMANTIC SEASON MOTHERS DEATH	MISSOURI SO. DAK	DAFFODIL YELLOW
1978	ALICE	GOOD GARDEN RODMANS UNION JEAN CUTT ROMANCE SUSAN BREE	DIVORCING WITH ALICE THAT NIGHT ROWING THE GREEN RIVER LEARNING THE DEEP PLEASURES OF LAURIE AND LIVING @ ALICE THE FURTHER DEVELOPMENT OF PEOA	UTAH ARIZONA ORANGE/GREY	TERRA COTTA
1979	ALICE ALICE	LA TOUR NUSAGE CROWS NEST DEER PARK INN			DARK BROWN SO FAR

SIGNATURE _____ (signature) _____

DATE SEPTEMBER 2 1978

I ENJOYED THIS EXERCISE. PLEASE TREAT IT AS SOMETHING VERY PERSONAL

House of Representatives
Washington, D.C. 20515

MEMORANDUM

DEAR MELODY:

PETE IS UNAVAILABLE TO COMPLETE THIS FORM. IF YOU WOULD LIKE, I COULD HAVE ONE OF THE STAFF COMPLETE IT.

REGARDS,

JOHN KOHLER

1979 _____

SIGNATURE _____

DATE _____

C 1970 Cambridge, Brigham's ice creams; Cold winter, Revere Mass; Washington D.C., test Patty August high Boston, Connecticut — lisa + Marie.

B 1971 English High, Hal, Carl + maybe, Harvard Law Review, cold winter, spring along the Charles, Tony Adams, Blue, dope, Rabbit

A 1972 Hal, Chris, Colorado, Hank + Bev, San Francisco, Lester, painting, Rabbit, Tony Adams + the prig wisconshine

A/F 1973 split up, broccoli, Oregon, Kelly, Ann, blues, music; etching, Crossman's Alderman Peters, drugs, Hank, Bev.

1974 Texas Highway, Wisconsin Summer, Broccoli, Jesse Comes home from Hank + Kelly + Uncle Bo, etching, Katonnge Theo Barbara, Drummonds; California X-mas + winberry Creek, Jan

A 1975 Good birds, good energy, maudais + Jesse Kelly, Hunter Cindy, Bev, Mary Anne, Sharee, Orcas Island, photo etching, wine painting, hard soft string! winberry Creek

etc 1976 downhill + teaching ⟩ downhill

etc 1977 This is a very useful form — I have been using it ever since I got it. This FORM

1978 A+ gets a GOOD GRADE A+

+ 1979 "Every cloud has a silver lining" USEFUL FORM # 113

19,745 ↑ 74.5 × 10 = 19,745

SIGNATURE Lark Drummonds

DATE 12/4/78

P.S.— I'll bet you never imagined you'd get this back —

	
1970	117 lbs
1971	110 lbs
1972	115 lbs
1973	120 lbs
1974	122 lbs
1975	115 lbs
1976	118 lbs
1977	132 lbs
1978	122 lbs
1979	120 lbs

SIGNATURE Mollie Jerome Miller

DATE Dec 22, 1979

bookstore in Fort Collins, Colorado, in 1971.[6] By 1978 we had probably heard of Kostelanetz's *Assemblings,* though we hadn't actually seen one. His "assembling" concept was both practical and brilliant. Beginning in the fall of 1972, artists were invited to submit one thousand copies each of an 8½-by 11-inch work (one to four pages completed in any medium that could be reproduced). With no editorial judgment on the part of the editors, the volume would be assembled and bound, thereby circumventing one of a publisher's greatest hurdles—raising the capital for printing costs.[7]

We sent Kostelanetz a form to fill out, which he did, as did Andy Warhol, John Cage, Ed Ruscha, John Baldessari, Ruby Ray, Dick Higgins, Throbbing Gristle, Vito Acconci, and many other admired artists (figure 10.3).

At the same time, mail art was circling the globe. In 1978 we were ignorant of this grassroots venue for art. However, soon after receiving a significant number of completed forms, we were introduced to an "underground" printer/publisher from Union City across the Bay: The Fault Press, named after the fault line that ran through its building.

A partner in the press, Rustie Cook, leafing through a few of the forms we brought to her Thanksgiving dinner, said instantly: "This should be a book." We hadn't thought of that. So far, no one who had filled out a form knew what, if anything, would ever be done with it. And each had no idea what anyone else had done with her or his form, so, for any one person, the moment of confronting the page was pure. The people who completed their forms did so for themselves and kindly sent them back to us as requested. I know now that people will do most anything if you ask them politely, and they seem to feel particularly responsible when filling out a form.

After showing some completed forms to a couple of artists who were visiting, they asked to be part of it. I reluctantly said yes and later regretted it. People who had seen other completed forms approached the page in a self-consciously "arty" manner, trying too hard to be weird, to be unique. Their forms were ultimately not included. The rule stuck: No one who had seen any other completed form could fill out a form. It had to be a fresh experience. The one hundred forms in the book are all from people who had no idea what it was for, or what others had done.

At this point we were initiated into the broader mail art world through Rustie and her Fault Press partner Terrence McMahon (pseudonym Ian Teuty). They had been publishing found and visual poetry, collage assemblages, and twisted fictions in their chapbooks and later punk/Dada publi-

Figure 10.3 Forms filled out by John Baldessari and Genesis P-Orridge, 1978.

cations since 1971. They had recently produced a radical send-up of the ever popular *TV Guide.* For their tenth anniversary, they produced a publication, *The Casual Abuse Issue,* which included a seven-inch, 33⅓ rpm flexi-disk recording from Evatone soundsheets, featuring a punk song titled "Love's Alright," by Fresh. The cover of each copy was an original, and my story "Dear Male Friend" was published in its entirety, along with the words and images of two hundred other contributors from around the world. In the tradition of the times, artists were invited to be part of the publication and the exhibition, and whatever they sent in was mulched into the mix, printed and bound, and the originals were hung on the walls for the party.[8]

Once at Mills, having happily moved out of Palo Alto and on to Lake Shore Avenue in Oakland, I signed up for Kathy Walkup's book arts seminar, "What Is a Book?" From handmade-paper letterpress broadsides to books bound in shower caps, materials and media came together to explore what communication is about and how material forms can bend to lend wider scope to what is said.

The summer before I started at Mills, Rustie Cook and I began printing the book *The Form: 1970–1979* at the Fault Press shop, reproducing the forms people had filled out. Arduous. My first hands-on book production experience. I hadn't imagined the labor and attention required to get the

simplest type and image onto a printed page. These were predesktop computer days, so photographic negatives had to be shot in camera and plates were burned, ink was poured, and the A.B. Dick offset presses churned. The two of us hand-collated the thing: 250 copies of 103 pages spread out around the room. A circumambulative marathon. The whole process took months longer than we had imagined, but when it was done, the Mills College Art Gallery decided that *The Form* originals should be displayed behind glass, so it hosted an exhibition, in March 1980, and the books were available, printed and bound just in time.

This was the first publication from our imprint. The name was born as Mike and I were driving across Nevada in the old Ford Galaxy, the windows rolled down, the heat pushing a hundred, Mike at the wheel, my bare feet up on the dash. Perspiring steadily, I said, "We need a name for our press."

He thought about it for a mile and answered, "How about Burning Books?"

The Form was included in several artists book shows, won a Purchase Award from the Art Institute of Chicago, and the contributors all got copies. It's been out of print since then, and we have just this year gotten around to reprinting it. It still grabs people, even those born after 1979. A novel on each page.

The iconoclastic mind-set of the late seventies/early eighties was anti-establishment to the core, and though it shared some ideological principles with the sixties, the aesthetic was diametrically opposed. Though the do-it-yourself West Coast punk/New Wave movement was keen on the avant-garde art movements Dada and surrealism of the 1910s and 1920s, nihilism, futurism, and existentialism also fueled it. With an almost religious faith in the regenerative powers of chaos, it was a more "positive" version of the London thing, uniquely California grown ("California über alles"). Music, theater, and performance pieces were being created by people who hadn't been trained but got up on stage anyway and used power tools and screams, put their bodies at risk, to extend, bend, or contort the moment at events promoted by word of mouth or cheaply printed flyers, similar to the raves of more recent years.[9] On both sides of the Bay, we'd found thriving scenes expanding and cross-fertilizing exponentially, saying in boldface type "make it, break it, take it, fake it, infiltrate it, *but do something different.*" Billboard alteration was becoming a new sport, anti–everything corporate in a pro-active, tongue-in-cheek way—"terminal fun," to quote the Mutants. Unspoken was the assertion that you don't need the approval of the East Coast

establishment, big L.A. record companies, or grant support from the National Endowment for the Arts to light your fire. *Alere flammam,* "to feed the flame," became the Burning Books motto.

I hosted a four-hour radio program on San Francisco's KPFA for which I had solicited original versions of "Star Dust," written by Hoagy Carmichael in 1929, the most recorded song in history. Home-taped versions from librarians and computer programmers, amateur pianists and toy organ players, electronic-music composers and opera singers were aired alongside recordings by Sarah Vaughan, Willie Nelson, and Hoagy himself. John Bischoff re-recorded his piece inside a tunnel while swinging the microphone around his head. Every version I could get my hands on was played—"waste art, want art."

Around that same time, "New Music bumped into new music."[10] In 1982, composer/performer Barbara Golden (a fellow Mills grad) and I went into serious debt to independently produce a three-night festival of M.U.S.I.C.: Marvelous Unlimited Sounds in Concert. Barbara had earlier presented her thesis concert at Mills, "Home Cooking," which included cameos by other composers and performers, a lot of singing, drinking, listening, and eating, with Barbara as avant-chanteuse and demimondaine. This led to my idea that Barbara should host a New Music/New Wave television program, which evolved or devolved into the concept of a live, three-night extravaganza. We at first had some enthusiastic local backers, but at the last minute they backed out. We'll never do it again, but at least we did it right, and no one died.

M.U.S.I.C. performers ranged from Lou Harrison to Arto Lindsey of DNA, Joan La Barbara to "The Voice of L," Esmerelda, George Lewis, "Blue" Gene Tyranny, and John Giorno, ten to twelve acts per night. Many people donated their time or got paid almost nothing. Composers Maggi Payne and Jay Cloidt performed and also engineered. We found a space in San Francisco, the slightly seedy bordello-flavored theater On Broadway, directly above (and run by the same guy) the infamous punk venue the Mabuhay.

M.U.S.I.C. brought together wildly divergent trends in music and performance. During one of the quietest pieces on Saturday night, a shamanic invocation by Sam Ashley, the heavy-metal band in the venue below was heard much more clearly than Sam. He didn't seem to mind. It was the perfect moment for practicing what John Cage had taught us: Everything is music.

Mike screened his *Throbbing Gristle* film made at the band's Kezar Stadium appearance in 1981. He designed the poster for M.U.S.I.C., and numerous

posters, logos, and cassette/CD covers since for our composer/musician friends, many of whom started their own labels, such as Artifact Recordings, Rastascan Records, and Frog Peak Music.

Everybody could produce and be an event, in the spirit of the happenings of the sixties. An art event was not just a polite white-wine, dress-fine affair, but a passage into a nonordinary sphere. We all had to get out there and do something. As a writer, I was asked to give readings. One time I decided to lip-synch, wearing a bathing cap and graduation gown, to recordings of others reading my words. This was termed "performance poetry," which was fine with me. The next time I led the audience in a "sing-along-with-the-bouncing-ball" piece. Using a slide projector and light pen, the words from Allen Ginsberg's poem "Howl" were sung to the tune of the "Sound of Music" (*I saw . . . the best minds . . . of my gen-er-a-tion. . . .*) Finally, having realized my voice was never going to cut the cake or the mustard, I asked musician and composer friends to take my stories and "do anything they wanted with them." They did, and to my delight have continued to do so for the past eighteen years.[11]

My personal initiation to a type of meeting "at a distance" took place in junior high school back in Denver, Colorado. One day my sister and I found out about "the teen line." It was a sort of primitive chat room. You would dial up a certain always-busy number, and then, in between the busy signal buzzes, you would shout out *buzz*—"Hello!"—*buzz* and some young guy would answer, "Hi!—*buzz*—"What's"—*buzz*—"your"—*buzz*—"name?"—*buzz.* You would tell him your name if you liked his voice, and then he would tell you his. You or he or she would give a phone number (laboriously, one number at a time), which often started a stream of unexpected things, such as meetings at the shopping center or the A&W on Colorado Boulevard. Anybody who called up at any given moment was given equal chance to meet in the same "virtual space," a step beyond the "personals" in a newspaper.

Speaking of phones, "answering machines" functioned as venues for randomly accessible creative expression when they first came out. John Giorno, in 1968, created his New York City Bowery-based *Dial-a-Poem,* which innovated the use of the telephone for mass communications, initiating the Dial-a-Something industry, from Dial-a-Joke to 900-phone-sex numbers.

Patrick Sumner, as part of Burning Books' By-Products, hosted an unusual answering-machine "site" in 1983–1984. Patrick advertised his site with a series of twelve postcards showing an image and phone number only,

which were mailed out, posted, and printed in magazines. Each week a short, specially commissioned audio work could be accessed free; all you had to do was ring up the number and listen. Patrick asked a dozen of us to contribute audio works, including Jon Livingston's *Streetwalker,* Michael Peppe's *Phoney,* and the serialized drama *Three Shots in the Night* by Sheila Davies.

It takes nerve to give. It takes trust to put stuff out there not knowing what will come from it. I'm grateful to the people who filled out those forms for me. Ego let-go and copyright out the window. Or as Woody Vasulka says (quoting Phil Morton), "Copy it right!" Steina is the one who told me, "It's not about who did it first, it's about who did it best." It's about playing around and seeing what happens. No ideologies, no preconceptions. Stirring it up to allow something new to form.[12]

Book artist and typographer Kathleen Burch joined Burning Books after Mike and I had published *The Form* and two letterpress chapbooks. I met Kathleen in Kathy Walkup's book arts classes at Mills. We three have collaborated for many years intermittently, and each of us has produced works on our own. Our first project together was the *Violence Poster* (1981), which featured, along with a graphic image of gangster Bugsy Siegal after he'd been shot in the face, a series of possible actions one might take in response to violence. The poster was prompted by our need to respond to the murder of John Lennon in December 1980. Friends and fellow students helped us put it up around the Berkeley/Oakland area.

The poster engendered antipathy, confusion, praise, inspiration, and finally a reprinting, paid for by Serendipity Books of Berkeley, which had displayed the poster in its windows and got requests for it from Canada and England. Soon after *The Time Is Now* was printed, Kathleen and poet Theresa Whitehill and I "advertised" the book by reciting in unison its 128-word "long title" in elevators, on BART (the Bay Area Rapid Transit) and in bars and cafes on Market Street and Telegraph Avenue.

Several books later . . . 1986: Burning Books, with a lot of support (i.e., personal debt and volunteer labor), produced *The guests go in to supper,* a 384-page anthology featuring the texts, scores, and ideas of seven living American composers who use words in their music: John Cage, Robert Ashley, Yoko Ono, Laurie Anderson, Charles Amirkhanian, Michael Peppe, and K. Atchley. When I called John Cage asking him to be part of the book, he said, "Fine. I have an 8-page manuscript or a 64-page one. Which do you prefer?" We asked for the big one. Later, as we were consulting him about

Figure 10.4 Melody Sumner Carnahan interviewing John Cage for *The guests go in to supper* (Burning Books), New York City, 1985.

some typesetting difficulties, he said, anecdotally, that the Museum of Modern Art had called the day after we did and wanted to publish that same sixty-four-page work, *MUSHROOMS et Variationes*. He told them he had already promised it to us (figure 10.4). Later, he helped us get Yoko Ono to agree to be involved after she had initially said no. She had been his friend for many years; she introduced him to macrobiotics when his rheumatoid arthritis had just about done him in. When we were interviewing her for the book, at the Dakota in New York City, she described how he had persuaded her: They were having dinner, she had just raised the fork to her lips, when he explained that she might want to reconsider being involved in the project. She couldn't say no to him. When we finally got around to paying Cage the first installment of the tiny royalty we had promised him, he sent the check back, with a note saying, "I'm glad you do what you do."

We realized quite early that we probably wouldn't make a living from writing, art, or Burning Books, so we've always had jobs of various kinds. Kathleen, who has worked as a typographer and designer, cofounded the San Francisco Center for the Book in the early 1990s. Mike and I moved to New Mexico in 1989 and have continued making books: In addition to collabo-

rations with composers and performers, I get paid as a writer and editor, and Mike works as a designer for art publishers and art museums. Mike and I have continued producing Burning Books, often with a copublisher, such as *Helen Keller or Arakawa* by Madeline Gins, published with New York's East-West Cultural Studies.

Lately, as Burning Books, we have returned to posters; pamphlets; small inexpensive saddle-stitched books; and comics-style publications. These are cheaply printed on a web press or laser printer, mostly given out free or for an absurdly small price (10 cents) with the Web address at the bottom (burningbooks.org). Recently, Mike initiated the Salvo Series of Educational Pamphlets, with titles like "Shopping for War." Some of the work has made its way into museum installations and Santa Fe's ongoing Window Project, the creation of artist/curator Guy Ambrosino, where artists are given a commercial storefront window to fill for a month. It's a great way to get things out into the world. Things given freely find their way into the hands of those who appreciate them.

Write or create only to please yourself, and please yourself completely. And in so doing, please a few others completely too. Each one may go out the door and become your messenger. But if you try to please everybody, you end up pleasing no one completely. And you have no messengers.

—Gertrude Stein, quoted in *"Who* or *What* Is Burning Books?"* 1991

Notes

1. The quote is from George Saunders, writing about his influences in "Johnny Tremain" (*New Yorker,* January 1, 2001), 125.

2. Episodes of Robert Ashley's *Perfect Lives* were originally released in 1978 on Lovely Music Ltd. (generally referred to as the "yellow record"), with Ashley speaking the words. Later, Lovely released the entire opera on CD and videotape as "opera for television," and it premiered on Great Britain's Channel Four Television in 1984. Burning Books produced the book, *Perfect Lives* (San Francisco: Burning Books, 1991), including the entire libretto and an in-depth interview with Ashley in which he explains how he makes his art. John Cage is quoted on the back cover: "What about the Bible? And the Koran? It doesn't matter: We have *Perfect Lives.*"

3. "What seems to be emerging in 'creative writing' is an academicism based on long-passed models. By completely denying any interest in experiment, or the infusion of avant-garde concerns, creative writing cuts itself (and its students) off from the evolution of Literature." Richard Kostelanetz, "Creative Writing," *Interface Journal* 5 (Spring 1978): 21–22.

4. The original edition of *The Time Is Now* (Oakland, Calif.: Burning Books, 1982) includes eleven of my stories (as Melody Sumner) with tab dividers, spiral binding, and a glossary and index. The book was codesigned with Kathleen Burch (illustrations by Michael Sumner) to encourage rereading and cross-referencing. I handed it out to friends, and one friend passed it along to his friend, C. Carr, a reviewer at the *Village Voice* in New York City. She wrote about the book in a *Voice Literary Supplement* cover feature, calling it "a fast ride with the top down" ("Fractured Feary Tales," *Voice Literary Supplement,* November 1984). The book sold out quickly, and Burning Books reprinted it in 1985. Both early editions are out of print, but the expanded edition with composer collaborations on compact disc was released in 1998 (Lebanon, N.H., and Santa Fe: Frog Peak Music and Burning Books), 47.

5. This excerpt is from a limited edition, letterpress version of *Gravity,* which I hand-printed at Mills College (Oakland, Calif.: Burning Books, 1980, 8). The story was later incorporated into my *13 Stories* (Santa Fe: Burning Books, 1995), 80.

6. From a recent conversation with Michael Sumner (Santa Fe, September 7, 2002):

I came across the book *John Cage,* edited by Richard Kostelanetz [New York: Praeger, 1968], and was excited that Cage's ideas were applicable to any art medium, not just music. Anything he mentioned was something to pursue. He talks about Gertrude Stein, Karlheinz Stockhausen, Morton Feldman, Christian Wolff. He had worked with Jasper Johns and Robert Rauschenberg and, as a visual artist, I was already interested in them. After reading what he had to say about his own work and other events of that period I wanted to know everything.

In 1971, the Contemporary Art History class only brought me up to 1945 and I was more interested in what happened in the next twenty-five years. That monograph on Cage, and his other books, particularly *Silence* and *A Year from Monday,* were for me like clunky hypertext. They set up my mental browser so that when I was "surfing" in bookstores or record shops these key names were highlighted and I pursued them.

Recordings were harder to find than books, but I did purchase *Variations IV* [Cage with David Tudor] in a drugstore selection of discounted records. It was a to-

tal surprise. It cost me fifty cents. Ironically, Cage wrote somewhere that he wasn't interested in recordings and particularly didn't like *that* recording because it was part of a live performance in Los Angeles that went on nonstop for four hours but the recording only included short excerpts. I didn't care if Cage didn't like it and my friends didn't like it, it was incredible for me. A friend of mine in Aspen, Colorado, came across Cage's *Indeterminacy* and gave it to me. I treasure that record.

I also ran across a book about EAT [experiments in art and technology] from the 1970 World's Fair in Osaka, Japan. Here was other evidence of what was happening in technology-based art and experimental performance and the collaboration between visual art, music, dance, and writing. Gradually I started finding more recordings of contemporary composers, including Robert Ashley, Pauline Oliveros, Iannis Xenakis, Alvin Lucier, Joan La Barbara, Morton Subotnick. By searching out the skimpy record bins labeled "electronic" or "twentieth century" or "avant-garde" and taking whatever was there, I became educated.

7. About Kostelanetz's *Assemblings:* "The conveners of this embittered harvest are Richard Kostelanetz, Henry Korn, and Mike Metz, and they have gone about it in an ingenious way, since their contributors were made to supply not, as is conventional, the potential contents of an anthology but its actual contents: '1,000 copies of up to four 8 1/2 in. by 11 in. pages of anything they wanted to include printed at their own expense.' Which leaves the editors, who say they accepted everything they were sent, with nothing more arduous to arrange than the binding of the volume. Straight publishers too might like to try this labor-saving method out on their most adventurous clients; not only would it work out very much cheaper, but provide an extra thrill, too, for the eventual reader, who could enjoy his hero's text exactly as he himself had prepared it for the Xerox machine; immediacy would hardly go farther." (*Times Literary Supplement,* January 21, 1972).

8. "This collection is not a documentation of the Fault's Punk/Dada Mail Art exhibition. It is intended as a collage, or rather a fragment, from the combined efforts of all the participants and friends listed on the contributor's page. DO NOT HOLD THE FAULT ACCOUNTABLE. The distortion and calculated misuse of individual work is the result of my own casual and abusive attitude towards art. Three hundred copies of the issue were printed & assembled during April & May by Terrence McMahon. All attempts to buy or get 'extra' copies will be ignored and any contributor caught trying to sell their copy will be held in contempt. The remaining copies will be distributed free to pedestrians at the Fault's tenth anniversary party. At the party, all the original works will be displayed to the public for a minimum of three hours. Eternally yours, Ian Teuty." From the editorial page of *The Casual Abuse Issue*

(Hayward, Calif.: Fault Press, 1981), one issue of the Fault Publications which took many forms.

9. "Here's a good example of how punk cuts both ways, one thrust reveling in the lifestyle afforded by the dollar Empire, the other rejecting imperialism out of hand. This ambivalence is dynamic; is something battling for our souls? Nostalgia for life among lawn furniture and holidays in the sun, vs. rage at militarist adventures abroad and well-policed conformity at home." Comment from Peter Belsito, Bob Davis, Marian Kester, about a Tuxedo Moon poster, in *STREETART: The Punk Poster in San Francisco, 1977–1981* (Berkeley: Last Gasp, 1981), 124.

10. Charles Shere, "New Music Bumps into New Music," *The Oakland Tribune* (November 28, 1982), H6.

11. "I didn't like the sound of my voice and my first story collection had just been published. Most of my friends were musicians, composers, and performers. One day I got the idea to have THEM put the words to music, so I could avoid having to do readings myself. I handed the book around, saying, 'Do something with the words, any way you like.' To my surprise, they did. And in ways I couldn't have imagined." Introduction to book/CD compilation of *The Time Is Now* (Lebanon, N.H., and Santa Fe: Frog Peak Music and Burning Books, 1998), 2.

12. "Guard the mysteries! Constantly reveal them!" San Francisco poet Lew Welch quoted in Kathleen Burch, *Indicia* (an interactive book and card game) (San Francisco: Burning Books, 1990), 43.

Networked Psychoanalysis: A Dialogue with Anna Freud Banana

Craig Saper

Anna Freud Banana is widely considered a crucial figure in the formation of networked art experiments, especially correspondence art, stamp art, and public-performance art. Her work serves as a model, and direct influence, for art and media activism on the Internet. Her life and career serves as an apt example of how particular countercultural activities, like the therapeutic politics of performance art, led to new forms of art and experimental media networks. The dialogue presented in this chapter took place over one year (from the fall of 2001 through the fall of 2002) using e-mail supplemented with readings from Banana's mail art and other works as well as her readings of my book *Networked Art*. An image of a sheet of her artist stamps appears on the cover of that book, and our dialogue began as a way to correct my omissions and extend the scope of the published book for future projects. As the dialogue developed, it began to focus on the intellectual and artistic biography of Banana herself. We focused the dialogue further for this chapter to examine her biography in terms of precursors to art and activism on the Internet. In doing so, we also highlighted the importance of her artistic and intellectual biography for new models of scholarship, politics, psychoanalysis, and everyday life. In that sense, the dialogue represents an experimental form of research that borrows strategies from Banana's work and biography. The reconstructed interviews in *Conversing with Cage,* by Richard Kostelanetz, epitomize this genre of scholarship.

CS: One can imagine a lineage from Sigmund Freud, who founded the psychoanalysis of the talking cure, with the analyst's quiet leading presence the crucial component, to Anna Freud, who founded the psychoanalysis of language's breakdown dependent on the scandalizing and interrupting analyst discovering the absences of the censorious ego, to Anna Freud Banana. Do you introduce a new psychoanalysis: a psychoanalysis that mobilizes parody as an analytic tool?

AFB: In a 1993 performance, I included the allusion to Anna Freud in my name. I intended the moniker as a joke. In the elaborate parody of a research study called *Proof Positive That Germany Is Going Bananas,* I dressed in a white lab coat embroidered with the seal of the Specific Research Institute of Canada. I investigated the "new German Banana consciousness" including testing gallery goers in seven German cities for "Banana Syndrome," using a "Bananized" version of the MMPI [Minnesota Multiphasic Personality Inventory] and Banana peel test cards.

CS: So, it was a joke limited to one performance piece? It wasn't anything as elaborate as a marker for a networked psychoanalysis of social systems (or more in tune with the specific works you make: sociopoetic systems)?

AFB: Unwittingly, or even unconsciously, the performance brought to light something obvious but unstated before. My life, work, and pseudonym already suggested what you call a networked psychoanalysis of sociopoetic systems.

CS: This analysis seems to depend on the diffusion and fading of the analyst in networks of people and meanings. So, it shares much with its predecessors in terms of the analyst fading, but now examines social situations much like the Frankfurt School did with Freud's work.

AFB: My work on Bananology joined in, and influenced, the webs of groups involved in what you have called "networked art and intimate bureaucracies." Just as Joseph Beuys suggested, in his Fluxus pun-laden performances, a political movement that led to the creation of the Green Party, my parodic performances suggest a networked psychoanalysis. I use the Freud pun on fried-Bananas to suggest an analytic method.

CS: Brilliant! Let's step back from this theoretical conversation and start examining your work as an artist—is that the right word?

AFB: I describe myself as a "conceptualist," and my work includes performances, publications, mail art, artist stamps, and artist trading cards. I have produced *Encyclopedia Bananica, Banana Rag, Artistamp News,* and *VILE* magazine. To artists and art historians, my work has three distinct and overlapping territories: performance art beginning with Dada and Italian futurist production in the early 1970s with Bill Gaglione and leading to interactive and media-inundated parodies; a founding influence on artists' networks and mail art beginning with the publication of the *Banana Rag* and my use of the Image Bank contact lists; and as a widely collected stamp artist.

CS: Those who consider art only in terms of artifact find the artistry involved in your stamps remarkable, but you have written about the limited scope of this image making.

AFB: Careful. I do make images, but the skill, craft, and artistry serve to create interactions and involvements with the audience.

CS: Tell me about the details of the *Proof Positive* exhibit.

AFB: The *Proof Positive That Germany Is Going Bananas* work toured seven cities in Germany in 1993 (including Stuttgart, Berlin, Hamburg, Ulsen, Minden twice in two different venues, Koln, and Mannheim) and in Budapest. I compiled an exhibition of Banana-related newspaper and magazine articles from the German press (over one hundred pieces) blown-up to 11 × 17 and laminated for easy installation. At the openings of these exhibitions, I would appear, in lab coat and badge, and, in German, introduce my research project. I then would walk around the galleries with my clipboard and make appointments for people to come back and take the Roar Shack Banana Peel test. The test materials included fifteen cards, Banana peels on black background, and, in various configurations. The second test was called the Personality Inventory for Banana Syndrome, based on two hundred items from the MMPI, half of which had Bananas replacing some noun in the statement. Everything was translated into German, and the answer forms had the look and feel of an official personality test. I even produced, and distributed to those that participated, a series of *Germany Goes Bananas* stamps published as part of *Artistamps News* [Vol. 6, No. 1, March 1993]. I collected 275 completed tests, and supplemented the testing with videotaped on-the-street interviews. I could ask the questions in German, but could not understand the responses!

CS: What did you do with all the evidence?

AFB: Collecting the evidence, I wrote a scientific report, which I presented the next year at the World Humor and Irony Membership (WHIM) annual conference in Ithaca, New York. In the report I argued that the prominence of Bananas in contemporary German culture and media (as demonstrated in my exhibits and the results of my tests) was a "subliminal plot on the part of Mercedes Benz to sell Bananas." I reached this conclusion by noticing the following "Bananas" connections. The relatively low cost of this exotic product meant it was a good tool for disseminating an idea. The Benz symbol is prominent in every city in Germany, and, that if you push your finger into the end of a slightly unripe Banana, it splits (as does an orange) into three sections, and if you slice through that, *voila,* you have the MB symbol. I actually had some of the results analyzed by a graduate student in psychology. Finally, I documented the project in a limited edition book (six copies—for

my report to the Canada Council which funded the project) including all the source material, translations, tests, photos from the trip, and my concluding essay and report.

CS: Aha, so the *Proof Positive* performances, exhibitions, and documentation made the link from your work to a specific variant of psychoanalysis explicit, but didn't that trajectory begin more than twenty years before?

AFB: Yes, the story of the creation of networked psychoanalysis begins in the late 1960s. Anna Long published "The New School, Vancouver," in an anthology, *Radical School Reform* (1969), about my experiences as a teacher in the New School in Vancouver, and I began looking for alternative pedagogies that led me to psychodrama workshops. In 1969, I went to performance art for a psychodrama workshop. When I returned to Canada and went Bananas, first figuratively and later literally, I soon ended my teaching career and my marriage.

CS: In "The Transformation of Anna Long of Gordon's Beach, BC," in the mass-market *Macleans,* you later described your experience—shared by many during those years—of dropping out of conventional life.

AFB: Yes, so I returned to performance art and spent two years working and studying their particular brand of psychoanalysis and therapeutic liberation. Following that way of life, what became slogans of an alternative lifestyle especially in California, I learned to live in the present moment, to get at repressed pleasures, to appreciate how energy moved (or was blocked) in the body and manifested (in posture, a tight and closed body, by avoiding eye contact, or by speaking in a restricted voice). I learned to use a type of bodily performance as a therapeutic liberation. As I toiled away at various jobs including cooking and massage therapy to afford my years living there, performance art's reputation as a controversial center for countercultural psychedelic liberation increased. Its importance as a cultural phenomenon has only increased even as the adherents to its therapeutic approach have long ago drifted away to est [Erhard Seminar Training], Scientology, or to more sober mainstream existences. Few, if any, critics have seriously considered psychodrama in terms of theatrical performance art, and most simply dismiss the aesthetic or sociopoetic issues with their rejection of its accuracy or psycho-medical value.

CS: I attended an est-based theatrical training session at the Eugene O'Neil Theater Center. There was lots of screaming at me to let go of my psychological (and literal theatrical) props, to get over whatever was holding me back, and to release my true creative energies. How did performance art develop this sort of instant psychoanalysis, a kind of psychoanalysis machine set on liberating energy instead of sublimating it into creativity? I've always been a big fan of sublimation but am fascinated with the development of this liberationist version of analysis.

AFB: The premise of the work on performance art arrived from Fritz Perls. Perls, the developer of Gestalt Therapy, and a student of Wilhelm Reich's (with whom he underwent a training analysis), claimed to have invented psychodrama before others popularized that approach. Perls later gave workshops on performance art in the 1950s and popularized the idea of "being here now," of, that is, living in the present moment. To get at that repressed pleasure, Perls's Gestalt Therapy examined, like Reich, how energy moved, and was blocked, in the body. The blocks were manifested in posture, a tight and closed body, by avoiding eye contact, speaking in a restricted voice. The therapist would locate the blockages and help transform these blockages into adaptive behavior.

CS: Didn't this transformation involve performing the blockages by exaggerating or parodying one's own tight mouth, for example, or shaking legs or twitches.

AFB: Perls's coda was to "lose your mind and come to your senses." Or in terms of what you call networked psychoanalysis, to go Bananas by parodying the bureaucratic codes of the networks our lives exist within: stamps, popular magazines, organizations, governments, corporations, etc. Every time someone hears my name, it sets off what a parody of the sanctimonious seriousness of those who have not gone Bananas.

CS: And in doing so you carry on a particular psychoanalytic lineage. Outside of Reich's and Perls's influence, one could easily imagine a link between moving the body and nonindividualized expressivity found in other traditions like Kathkali Indian ritual theater training or in some training of clowns. In both of these theater-training traditions, the body movements are explicitly *conventional* and ritualized, not a means to liberating individual psychoexpressivity. What you learned was to use precise, even analytic, methods to

parody the confines of everyday life. You were not trying to become a clown or a ritualized dancer. You were formulating a system to free up the communal energies available in systems and networks, that is, forming a networked psychoanalysis as an activism to change how we perform everyday life in mass-mediated culture.

AFB: In what other contexts does this type of analysis make sense?

CS: In terms of the psychoanalytic lineage that you emerge from, political cultural analysis as well as parodic strategies played crucial roles for a number of influential writers and critics. Reich, a star student of Freud's, diagnosed the neurotic roots of fascism, influencing first Theodor Adorno and Max Horkheimer and later Gilles Deleuze and Félix Guattari. In the early 1930s, Reich established the German Association for Proletarian Sex Politics with the support of the Communist Party. The organization soon had forty thousand members. His later work on libidinal healing power of the Orgone Boxes and the notion of a generalized orgasm directly inspired American writers and critics. Paul Goodman, in *Growing Up Absurd* (1960), championed Reich's efforts to release the repressed libidinal energies by disrupting sociopolitical conformity. Saul Bellow, who after undergoing Reichian therapy wrote *Henderson the Rain King* (1959), suggested a way to consider Reich's therapeutic approach in terms of parody. In Bellow's novel, an African witch doctor, who closely resembles a brutal Reichian therapist, unravels the character armor defenses of Henderson, an American traveling in Africa, leaving him physically battered and exhausted. Norman Mailer, who was attracted to Reich's focus on the mystical healing powers of the orgasm, wrote in his essay "The White Negro" (1957) about how blacks, by virtue of their alienation from square white society, were freed from their character armor and ready to experience the center of human experience: the orgasm. The hipster likewise seeks love love as the search for an orgasm more apocalyptic than the one which preceded it.[1] This Beat Generation embracing of Reich was also found in Allen Ginsberg, Jack Kerouac, J. D. Salinger, and William Burroughs.

AFB: Right it was everywhere.

CS: The Beat counterculture of the 1950s and 1960s, and the cultural theorists of the 1970s and 1980s, borrowed from Reich his belief that culture was a negative repressive force that we needed to *howl* against. This was counter

to the Freudian view that culture is a positive outcome created from a struggle between repression and libidinal energies. It was also counter to Freud's belief in a talking cure leading to sublimation rather than a biomechanical or technical release of energies. It was in this cultural context that students and faculty at Black Mountain College built some of the first Orgone Boxes in the late 1940s.

AFB: I remember hearing that some folks tried to build a box in Big Sur.

CS: These experimenters worked not as scientists, but as artists seeking to unsettle social control and sexual repression via an alternative technology and alternative networking systems. They investigated an alternative performance that would become a crucial aspect of what we now think of as performance art. Networked psychoanalysis occupies a similar ground utilizing, as methods of innovation, parody of technical systems and scholarly methods as well as mock lineages of systems of thought. Well, what happened after performance art?

AFB: In 1971, I left performance art and moved back to Victoria, Canada. When I returned to Canada, I started selling large rocks and beach stones as paperweights or door stops. I painted these with geometric designs and set up a table at local gatherings and called myself the "Town Fool of Victoria" as part of my *Town Fool Project* (1971–1972) (figure 11.1). When the first table did not create a lively enough interaction, I set up a second table. This table had a sign that read, "Please Do Touch," and included odd found objects. Soon a third table followed. On that table I had petitions against nuclear testing in Amchitka (an Alaskan island) and a Banana Stories clipboard (for visitors to write down their jokes, songs, anecdotes). In exchange for their stories, they would receive a degree in Bananology. Later these degrees became Master of Bananology certificates, which I sent to participants in my mail art networks. I authenticated the certificate with the seal of Royal Order of Banana. Once the three tables were going, I introduced the idea of the town fool. In my characteristic mix of parody with using (market) systems I was able to contextualize my odd and eclectic offerings for sale as well as raise consciousness about the foolishness of consumerist pursuits by surrounding the purchases in playful network dramas (games about buying and selling) instead of psychodramas.

Figure 11.1 *Town Fool Project,* August 1971–1972. Weekly appearances in costume in Victoria, British Columbia, including many specific events and classes.

CS: You had begun the shift from the psychological self (being here now) to the analysis of links, webs, and networks (being here now and always already).

AFB: The market stand and town fool did not lead to many networking contacts, but it led to an invitation to teach art classes in the public schools for free. This new link to experimental pedagogy also allowed me to distribute my *Banana Rag* both at my tables and in the public schools. It was hand-drawn and printed on a single 8.5″ × 14″ canary yellow sheet (years later in the 1980s I printed it on 11″ × 17″ paper and folded in half to the 8.5″ ×

11″ letter size). The distribution of the periodical would lead to the creation of a larger networked art. I had mailed some copies to friends in Vancouver. The Image Bank, a collective in Vancouver that was engaged in sharing images and project descriptions, got a copy and, then, through one of its members, Gary Lee-Nova, shared their mailing list. I soon began an art-based network with among others Ray Johnson, who had visited the University of British Columbia in 1969, General Idea, people associated with the New York Correspondance School, and local artists including Ed Varney and Chuck Stake. This was the serendipitous start of my engagement in the mail art networks, and I included over a hundred addresses in my mailings. By the early 1980s, the *Rag* had transformed from anecdotes about the town fool to a mail art forum and news source zine.

CS: What happened in San Francisco during the Dadaist and futurist phase of your career?

AFB: In 1973, I moved to San Francisco and joined the Bay Area Dadaists (BAD), including Gaglione, Mancusi, Caravello and Chickadel, who were working on sound poetry as a form of sociopoetic change.

CS: In my book on networked art, I discuss the importance of visual and sound poetry as a crucial link to moving toward networking as works in themselves. To borrow the McLuhanesque language of the time, becoming aware of the medium as the *massage,* one soon became aware of the importance of networks as a poetic and political therapy. Visual, sound, and concrete poetry function as a kind of social massage therapy. What did you learn in San Francisco?

AFB: I had earlier studied batik at the University of British Columbia, but I picked up my graphic-design skills from working first at a small typesetting shop and on the *San Francisco Bay Guardian* where I did design and pasteup. Soon I had my own business: Banana Productions. That business, in turn, helped fund my Banana Olympics (1975 and 1980). At the Olympics staged in San Francisco's Embarcadero Plaza, and later at the Olympic track beside the Surrey (British Columbia) Art Gallery, I hosted these events in Banana costumes. I intended these events to showcase serious athletic competition versus artistic creation. The events sought to involve the audience rather than have them sit as passive observers as in the other Olympics usually broadcast internationally (figure 11.2).

Figure 11.2 Mona Banana Smile Test, April 1, 1973, at Vancouver Art Gallery. Made Polaroid photos of visitors to gallery, using the smile test prop, and displayed them on the wall.

CS: And is this when you started organizing publications like *VILE*?

AFB: While I was in San Francisco and associated with BAD I started publishing *VILE*. The first issue was in January 1974. I started publishing it in reaction to *FILE* magazine's sudden distaste for mail art, and I wanted to create a permanent venue and validation of that mail art activity. *VILE*, as a defiant reaction against the aestheticism advocated in letters appearing in *FILE*, a pioneering publication from Toronto emerging, in 1972, from the artists' mail art networks. Both magazines spoofed the cover and supposed universality and inclusiveness of *LIFE* magazine. The contributions included many

Figure 11.3 Going Bananas fashion contest held in and broadcast by CK VU in Vancouver as an April Fool's Day event, 1982. Photo: Taki Blues Singer.

détourned advertisements from issues of *LIFE* as well as montages of eroticized Bananas. It also included discussions about artists' networks, examples of mail art, visual poems, and illustrated letters to the editor. In 1978, Gaglione and I produced a "Fe-Mail Art" issue including works by Martha Wilson, Alison Knowles, and Yoko Ono.

CS: *VILE* later influenced the publication of *SMILE* (the Neoist work that had multiple versions because it had no single identity that played the role of the pseudonymous editor "Monty Cantsin"). Because it contained addresses for an international group of artists, it contributed to the expansion of mail art networks in the late 1970s. Inadvertently, this expansion also led to more fragmentation, and you focused more on smaller networks while still championing the importance of networking as a form of social change. Recently, you coined the phrase *postal art* to describe networks that limit exchanges to group members and stress the high quality and professional craft in their work. The emphasis in those works is not on networking and making connections.

AFB: I returned to Vancouver, Canada in 1981 (figure 11.3). In 1983, struggling financially, I got a job at Intermedia Press (where I had printed my *About VILE* and still owed them money). I learned the color print techniques that I began using in my International Art Post editions, and learned,

through a process of trial and error, how to make a living making artist stamps. I was able to purchase a Rosback rotary pinhole perforator, and this led to my production of stamps, and to the publication of *Artistamp News,* beginning in 1991 and continuing until 1996. I also worked on collaborative performances. In a parody of a wedding ceremony in my performance *World Series,* I collaborated with my friend (now deceased) Ron Brunette (December 1987, at the Western Front in Vancouver). We were married by the "Sacred Cow" of capitalist society, the GNP. The cow had spots that read, "GNP," and the vows were about consuming as much as possible. When the vows were done, we both knelt and "nursed" on the udder of the cow. In the 1990s through 2003, I started a new interactive series of performances, publishing on mail art, and curating exhibits like the Popular Art of Postal Parody exhibit. In December 1999, I performed *Banana Communion,* in which I performed as the first female pope (Sarenco Art Club in Verona). My most recent media parody, the *Banana Splitz TV Game Show,* was presented for the first (and to date only) time at the Banff Centre for the Arts in December 2001. Included in this last group of performances was my *Proof Positive* experiment that I consider one of my best and most important works.

CS: Its importance may lie in the way the future takes up your work not only as a moment in the history of art or even artists' networks, but also, and more importantly, as the beginning of networked psychoanalysis as a model for activism, research, and everyday life. Your stamp on this lineage is ready to be licked and sent on. We'll leave it to the readers to find out how to address this message.

Note

1. Norman Mailer, "The White Negro: Superficial Reflections on the Hipster," *Dissent* (Spring 1957): 276–293. The essay has been reprinted widely since its initial publication in the late 1950s.

From Mail Art to Telepresence: Communication at a Distance in the Works of Paulo Bruscky and Eduardo Kac

Simone Osthoff

Networks have no centers, only nodes. Much of the experimental art of the 1970s and 1980s developed in points of intersection, cultural hubs, distributed around the world. This article examines one of those hubs, located in Brazil, through the early works of artists Paulo Bruscky and Eduardo Kac. Performing outside traditional art institutions and practices, Bruscky and Kac used systems of circulation and electronic networks to activate public spaces. Their work forged complex relations between place and space and transformed art and life through cultural activism. During this period, both artists approached art without regard for national borders or the categorical boundaries of traditional media. With a shared consciousness of art as an ideological system constituted and validated in large part by official institutions—the studio, art market, museum, gallery, art criticism, art history—Bruscky and Kac eschewed traditional venues and objects, opting instead, from the beginning of their careers, to invent new ones.

This chapter discusses the artists' early works in relation to the political climate in which they operated. Born a generation apart—Bruscky in 1949, and Kac in 1962—their works from the 1970s and 1980s, respectively, marked the beginnings of their careers and contributed to the aesthetics of remote action and interaction. Although both artists were born in Brazil, Bruscky has always been based in that country. Kac, however, spent only the first nine years of his career in Brazil (1980–1988). Based in Chicago since 1989, Kac has emerged in the subsequent fifteen years having the Internet and the international art scene as his natural environment. From 1968 to the late 1980s, Brazil was marked by a deprivation of public freedoms imposed by the military dictatorship, first installed with a coup in 1964. Bruscky and Kac have engaged with art at significant turning points in the Brazilian political-cultural context. Bruscky's work responded to the political repression of the early 1970s; Kac's opened new spaces during the tentative beginnings of political tolerance in the late 1970s.

Bruscky's work is undergoing its first wave of national recognition.[1] Kac's work, first acknowledged internationally, along with a vibrant and influential reputation, enjoys growing recognition in Brazil.[2] Kac was part of the much-celebrated "Geração 80" (the 1980s generation) in Brazil.[3] Contrary to his painter colleagues, whose work enjoyed early critical acclaim as well as national and international market success, Kac's production from the same period took much longer to even be accepted as art. Only in the recent increasingly pluralistic art scene have the accomplishments of both artists

begun to receive deserved recognition. The reductive critical view espoused by most Brazilian art critics and art historians that casts the 1980s in terms of neoexpressionist painting needs revision. Bruscky's and Kac's early works are among the most complex and critical legacies of the 1970s and 1980s, in any node of the global cultural network.

Paulo Bruscky's Aesthetics of Circulation and Reproduction

One of Brazil's darkest periods of state political oppression began in 1968 and extended through the 1970s. During those years, making art, and especially experimental art, in Brazil was a difficult and dangerous proposition.[4] Nevertheless, artists continued to resist authoritarian structures by pushing the boundaries of experimentation and the limits of public freedom. They often chose to circulate their works outside official artistic institutions, perceived by many as being in agreement with the oppressive governmental regime. Many artists, such as Hélio Oiticica and Lygia Clark, chose to spend most of the seventies in exile, continuing to emphasize the participatory, sensorial explorations they had embraced in the 1960s.[5] In 1970 in Rio de Janeiro, Cildo Meireles printed the message *Yankees Go Home* on Coca-Cola bottles—a symbol of American imperialism—and stamped the question *Quem Matou Herzog?* (Who Killed Herzog?)[6] on Cruzeiro notes, returning both bottles and currency to circulation. These works were part of Meireles's series *Insertion into Ideological Circuits,* which employed systems of currency and commodity circulation and distribution to carry subversive political messages. In these works, the scale of the intervention was not the point (the message on a Coke bottle can be seen as being like a message in a bottle thrown into the sea), but the performance of an act designed to "give voice to the void," as art critic Paulo Herkenhoff has pointed out.[7]

In Recife, on Brazil's northeast coast, Bruscky found in the Mail Art movement an alternative venue for art making, participating in shared networks of ideas and gestures of resistance that linked national and international artists. The Mail Art movement bypassed the market of artistic commodities, as well as the salons and biennials that treated art exhibitions like beauty pageants. Bruscky's work engaged with Fluxus's concepts of fusion of art and life. His interest in processes of circulation, reproduction, and distribution yielded performances and interventions that may not always have looked like "art," or even been counted as "art," but that without doubt generated a new thinking that traditional art practices could not articulate.

Mail Art: To and from Recife

Over the last three decades, Bruscky's work has taken many forms and employed various materials, sites, and aesthetic strategies. For him, the great network started with Mail Art in the 1960s. Despite the earlier pioneer examples—from Stephane Mallarmé's poem-addresses on envelopes to Marcel Duchamp's postcards—only in 1960, with Fluxus artists, and in 1962 with Ray Johnson, according to Bruscky, did the international Mail Art movement begin to fully employ the mail system as medium. Mail Art continued to develop throughout the 1970s, connecting Latin American artists not only with one another, but with artists from the Gutai group in Japan and Fluxus artists in the United States and Europe. Bruscky correspondents among artists included Johnson, Ken Friedman (with whom he performed in New York), and Dick Higgins, among others.

Bruscky initially became involved with the Mail Art movement in 1973, not only as a participant, but also as a promoter, organizing international Mail Art exhibits in Recife in 1975 and 1976. Bruscky's archives contain fifteen thousand mail art works and are today an important source of documentation of the movement. The First International Mail Art Exhibit in Brazil, organized by Bruscky and Ypiranga Filho in 1975 in Recife's central post office, was closed by censors minutes after its opening (many Latin American participants included messages denouncing state violence and censorship). Brazil's Second International Mail Art Exhibit in 1976, organized by Bruscky and Daniel Santiago, and again sponsored by the central post office, showcased three thousand works from twenty-one countries. This exhibition was also closed by the police immediately after opening. It was seen only by a few dozen people. Bruscky and Santiago were dragged off to prison by the federal police and detained incommunicado for ten days. The majority of the works in the show were returned to the artists by the police after thirty days; many were damaged, and others were confiscated indefinitely as evidence.

Bruscky was jailed three times, in 1968, 1973, and 1976. After 1976 he received death threats over a period of six months and was constantly followed by the police until he denounced this situation as the theme of a solo show in a Recife art gallery, making public a threat he had been, up to that point, undergoing privately. He was never associated with a political party, and his militancy was first and foremost cultural and artistic, embracing art as "the experimental exercise of freedom."[8]

Communication at a distance, public participation and circulation—concepts central to the Mail Art movement—playfully deployed the rules and regulations of the international mail system, as in Bruscky's series *Sem Destino* (Without Destination and/or Destiny), 1975–1982. Bruscky created artist stamps and messages on envelopes, such as *Hoje a Arte é esse Comunicado* (Today Art Is This Message), a sentence he often stamped on works; used postcards, telegrams, telex; and devised chain letters that produced multiple editions and often boomeranged back to the sender. Though supported by a few art institutions, Mail Art was resisted by others that in the early 1970s displayed no interest in conceptual experimentation. An example of the latter was the rejection by the jury of Bruscky's 1973 installation proposal, which he sent in the form of a telex to the 30th Salão Paranaense, a juried show in the south of Brazil. The missive proposed the following three installations as his entry: the first, a formless pile of all the packing materials from the other artworks arranged in a corner of the exhibition space; the second, all the materials used by the museum cleaning staff (brooms, buckets, water, rags) hanging one meter above the floor; the third, a display over a chair of all the materials used in the installation of artworks (screws, nails, hammers, etc.), along with the title *Don't Touch! These Objects Are Being Exhibited.*

Through Mail Art, Bruscky promoted public happenings, along with encounters among strangers brought about by the correspondence network. An example was the happening Bruscky created in 1977 for the Ricerche Inter/Media Centro Autogestito di Attivita Espressive in Ferrara, Italy. Titled *Re-Composição Postal* (Postal Recomposition), it promoted an encounter among twenty-seven of Ferrara's citizens, who received by mail a section of a work divided by Bruscky into twenty-seven parts to be reassembled by the recipients.

Mental Space, Aural Space, Aero Space: The Sky Is the Limit

While involved with Mail Art, Bruscky simultaneously explored various performance, cinematic, aural, and electronic aesthetics. The multimedia he examined in the 1970s included reproductive technologies (electrography, blueprinting, and fax), along with experimental film and video. In 1970, while working as a hospital administrator, Bruscky developed sound poems based on patients' utterances, moans, and screams and created a series of "drawings" using electrocardiogram, electroencephalogram, and X-ray machines. These graphic images were later incorporated in Mail Art envelopes

and in various performances, including those with fax machines. Bruscky also created sound poems and compiled sound works by other artists, including John Cage, broadcasting them on a mainstream Recife radio station during the winter art festivals of 1978 and 1979.

Emphasizing connections among art, science, and technology, the artist quotes Santos Dumont, the Brazilian inventor and father of aviation, observing that "whatever one man imagines, others can achieve." For Bruscky, it is important to place art in the realm of visionary scientific and technological inventions. This wider cultural horizon for artistic creation allowed him the freedom to pursue large-scale, open-ended projects, such as his 1974 proposition for the creation of artificial aurora borealis (to be produced by airplanes coloring cloud formations). Bruscky placed ads in newspapers to both document and circulate the project while looking for sponsors. These appeared in the *Diário de Pernambuco* (Recife), September 22, 1974; in the *Jornal do Brasil* (Rio de Janeiro) December 29, 1976; and in the *Village Voice,* May 25, 1982. The creation of artificial auroras was finally realized in 1992, not by Bruscky, but by the U.S. National Aeronautics and Space Administration (NASA) as part of environmental research. Approximately sixty artificial miniauroras were created by employing electron guns to fire rays at the atmosphere from the space shuttle *Atlantis.*[9]

From Copy Art to Teleart: Duplication and Transmission, "Today Art Is This Message"

Bruscky's exploration of reproductive technologies in the 1970s and early 1980s, from the use of stamps in Mail Art to photocopiers and fax machines, was rooted in his training as a photographer and his engagement with visual poetry. His performances with photocopiers shared with artists of the 1960s and 1970s an antirepresentational attitude toward art making, a desire to short-circuit the relations between original and copy, as well as the work's inside/outside boundaries (figure 12.1). In this process of unhinging modes of production, representation, and circulation, he underscored how the context in which art operates frames and produces meaning. His criticism of originality in Xerox Art (the name photocopy art received in Brazil) ironically also explored the specificity of the medium, as Bruscky employed reductive and additive processes with a playful and poetic sensibility that expanded the limits and functions of the photocopier. He adjusted and altered the various parts of the machine to orchestrate series of images produced

Figure 12.1 Paulo Bruscky in the act of his "Xeroxperformance" at the Universidade Católica de Pernambuco-Recife, 1980. This performance generated 1,350 photocopies that were filmed in stop motion, creating an experimental film animation under the same title.

with cinematic sensibility. He expanded the machine's narrow depth of field by using mirrors and slide projections below and above the photocopier's flat bed. From his prolific cycle of photocopy art, Bruscky made three Xerofilms, eventually part of his total experimental production of about thirty short films and videos. His Xerofilms were made with stop motion from thousands of Xerox copies produced in performances. For his second Xerofilm, for instance, Bruscky set fire to a photocopier, which documented its own de-

struction in 25 seconds. For this body of work with photocopiers Bruscky, received a Guggenheim Fellowship in 1980 and spent the ensuing year working in New York and various cities in Europe.

Fax Art was another means of mediating distances, conflating the experience of Mail Art with that of Xerox Art while enabling new performances from afar. The first artistic fax transmission in Brazil was executed between Bruscky in Recife and Roberto Sandoval in São Paulo on October 31, 1980. The documentation of this first transmission was exhibited in Arte Novos Meios/Multimeios (New Media/Multimedia Art) at the Fundação Armando Alvares Penteado (FAAP) in São Paulo in 1985.[10] In other fax performances Bruscky incorporated the 1970 electrocardiogram "drawings" of his brain waves and the graphic recorded heartbeats of his electrocardiograms in "direct transmissions of thought" he referred to as *Cons-ciência da Arte* (a title that doesn't translate readily into English but refers to both art's consciousness and science). For Bruscky, the machines registered his "direct drawing process" documenting in graphic form, his thoughts and feelings, brain and heart activity.

Bruscky has maintained an active presence in Recife's cultural scene for more than three decades and continues to work as an artist, curator, and archivist. In works from the 1970s, he approached art with a new agency that is becoming increasingly important to a younger generation of artists. Whether working with the mail system or planning sky art interventions in which airplanes paint the clouds, his performances erupted into public spaces without the sanction of traditional institutions or curatorial authorities, continuously expanding the boundaries of art beyond its traditional frame and producing alternative sites for artistic creation and circulation. Bruscky worked both within and without art institutions, acting directly on the urban environment and often employing the media—such as newspapers, billboards, and radio stations—as venues, artistic media, and forms of documentation. His experimental practices reaffirm art's critical and activist edge while becoming a lesson for critical theorists and independent curators in their rethinking of the boundaries between art making, critical writing, and curatorial practices. In his engagement from Mail Art to Fax Art, Bruscky's work ignored physical distances, performing experimental actions that continuously locate art in the utopian space beyond the medium and beyond national and geographical boundaries.

Eduardo Kac's Porno-Poetry Performances

In 1979, Brazil's military government, under the pressure of public opinion, gave amnesty to all those involved in "political crimes." Political exiles began to return home. As the tight censorship of the 1970s began to erode, so did the polarization between left and right characterized during the period by Che Guevara as the symbol of Latin American liberation versus Coca-Cola, equated with North American imperialism. According to Zuenir Ventura, during the ten years following the declaration of the AI-5 (Fifth Institutional Act, signed in 1968) that closed Congress and suspended all political and constitutional rights, approximately 500 films, 450 plays, 200 books, dozens of radio programs and more than 500 song lyrics, along with a dozen soap opera episodes, were censored.[11]

The country's slow return to democracy in the 1980s was accompanied by a shift in the focus of critical theory, from an essentialist Marxism centered on the problematic of class antagonism and commodity production, to a fresh interest in the formation of the subject—semiotics, psychoanalytical theory, and Foucauldian notions of power—followed by a new understanding of democracy as a task, rather than a gift to be given or taken.[12] This self-critical examination of authoritarian and chauvinistic streaks among the intellectual, political, and urban middle class was marked by two best-selling books written by a journalist returning from a long exile in Sweden: Fernando Gabeira. His first book, *O Que É Isso Companheiro* (What Is This Comrade?) is the autobiographical story of a young intellectual who joins the urban guerrillas in Rio de Janeiro, planning and executing the kidnapping of the American ambassador Charles Elbrick, who is then exchanged for fifteen political prisoners. Not much later the police shot Gabeira in the back, and he was arrested while trying to flee. The wound healed in prison, and he was released in a similar exchange between political prisoners and a kidnapped ambassador, this time Germany's. Gabeira went into exile in Algeria and then Sweden, returning to Brazil under the 1979 political amnesty. Gabeira has since renounced violence, remaining a political activist in the new democratic regime by holding a seat in Congress for the Green party.[13] Gabeira's second book, *O Crepúsculo do Macho* (The Sunset of the Macho) exposed the inherent machismo and homophobia in the leftist movement and in Brazilian society.[14]

At that time, as a young university student in Rio de Janeiro, Kac studied foreign languages, philosophy, and semiotics while working as an artist and

writer. The Poesia Pornô (Porno-Poetry) movement he founded in 1980 helped shape this political context by reclaiming the public space. Kac explained the movement: "The performances from 1980 to 82 had elements of scatology, surprise, humor, subversion, gags, and the mundane. In these poetic performances, the so-called vulgar or bad words become noble and positive. Scatological discourse and political discourse were one and the same and were manifested through cheerful orgiastic liberation."[15] Kac's group performed in public places, such as the beach in Ipanema and the Cinelândia central square, the heart of Rio's downtown bohemian life, where the group performed on Friday evenings for two years (1980–1982). With an emphasis on public participation, the porno-poets staged semantic displacements beginning with the word *pornography*. They transformed misogynist and homophobic labels into sexually liberating expressions in a process analogous to that undergone years later in the United States by the word *nigger*, as flaunted by rap culture, or the word *dyke*, as reclaimed by lesbians. Through humor, the group activated verbal transgressions that were first and foremost playful, as well as sexual, and ultimately political, in a polysemic celebration of life. They operated in the transgressive spirit of the poet Oswald de Andrade who in the 1920s proposed "the permanent transformation of taboo into totem."[16]

Kac called attention to the centrality of the body as a site for cultural inscription and transformation: "In my work in the early 1980s the body was everything. The body was the tool I used to question conventions, dogmas and taboos—patriarchy, religion, heterosexuality, politics, puritanism. The body became my writing medium ultimately."[17] In the artist's next phase of development, the role of the body and its relationship to language would take an unprecedented turn.

Holopoetry: Meaning in Flux and the Viewer in Movement

Whereas Kac's porno-poetry performances questioned political and cultural hegemonies, their language had straight ties to the political process of the early 1980s as well as to a long literary tradition. Kac's interest in experimental poetry, along with his desire to create a new poetic language, led him to search for a new medium. He found it in holography, a medium that had never been explored for poetic expression. Kac was interested in holography's time base potential, which enabled exploration of the inherent instability and flux he perceived in language: "In many of my holograms, time flows back and forth, in non-linear ways. The holographic medium allows

me to work with language floating in space and time, breaking down, melting and dissolving, and recombining itself to produce new meanings."[18] Suspending words in this immaterial space, Kac's holographic poems offered a new field for poetic exploration in an international language. His engagement with holography marked a rupture with the porno-poetry movement and began his exploration of emerging technologies as artistic and epistemological practices with the potential of global reach. He coined the term *holopoetry* to describe the body of work he developed in this medium from 1983 to 1993.[19] As he pushed the tradition of visual poetry beyond the page and beyond three-dimensional physical space, Kac explored holography as a four-dimensional medium, performing reading and writing as a time-based, open-ended process.

Containing words and letters in flux, Kac's holopoems have their meanings created by the viewers' movement and point of view, underscoring the direct relation between knowledge and positionality. As viewers read these images differently, depending on their relative position and movement in relation to the picture plane, these works suggest that location is an important category in signifying practices—in determining what we know, how, and why. Kac's holopoems give form to the dynamics he sees in language and communication processes. For him, meaning is always a process of negotiation that happens through dialogue and shared communication: "Nothing exists until you claim it, until you create your own narrative, until you construct it."[20] This belief drives his emphasis on the interactive and dialogical practices that underlie his telecommunications and telepresence events, which take these explorations into the global network.[21]

Text in the Network and the Network as Medium: Telecommunications and Telepresence before the Web

Created and experienced digitally between 1985 and 1986, Kac's first works on the electronic network were videotexts.[22] He has stated that the early 1980s marked the culmination of the process of dematerialization of the art object and the beginning of the creation of immaterial (digital) art.[23] For him, two landmark events created the cultural conditions for this shift: the popularization of the personal computer and the rise of the global electronic network. Kac's early digital and telecommunication works emphasized process over product, giving form to communication exchanges that involved reciprocity and multidirectionality. Like his holopoems, Kac's videotexts

continued to produce playful interrelations between the activities of writing and reading, addressing a range of different subjects.

Tesão (1985/1986) is a videotext animated poem shown on line and on site as part of the group exhibition Brasil High-Tech, realized in 1986 at the Galeria de Arte do Centro Empresarial Rio in Rio de Janeiro and organized by Kac and Flavio Ferraz (figure 12.2). *Tesão* is a declaration of love to Ruth, whom Kac later married. The three-word sentence that formed this video-text spoke of love in terms of desire. The colorful letters formed slowly on the monitor in a continuous line diagram. After all the letters of the first word had completed their graphic choreography, the screen became blank, and new letters started to form the second word in a similar symmetric, cin-ematic rhythm. A third word was made of solid and colorful letters that overlapped and filled the screen. The letters displayed on the screen in sym-metric designs did not convey meaning as graphic forms in space, but as an-imations in time. As letters and words were formed in slow motion, viewers interpreted the fleeting configurations as changing meaning.

D/eu/s, from 1986, was a videotext animated poem, also part of the Brasil High-Tech exhibition. It was a black and white bar code with numbers and letters on the bottom that appeared in a small area centered on the screen (the proportion of the image to the screen was that of a bar code to a product). When viewers logged on they first saw a black screen, followed by a small, white, centered rectangle. Slowly, vertical bars descended inside the hori-zontal rectangle. At the bottom, viewers saw apparently random letters and numbers, reminding them of conventional bar codes. Upon close scrutiny the viewer noticed that the letters formed the word *Deus* (God). The spacing of the letters revealed *eu* (I) inside *Deus.* The numbers also were not random but indicated the date when the work was produced and uploaded to the Brazil-ian videotext network. The date also offered a second reading: 64/86 brack-ets the years between the military coup in 1964 and the height of public demand for the return of democratic elections in the Diretas Já (Democratic Elections Now) movement, which also coincided with the forward-looking exhibition Brasil High-Tech. The multiple meanings this short poem cre-ated—between humans and God, between God and the commodity label-ing/identity to be read by scanners, and between the public demand for democracy and the utopian promises of the global network (still national at the time)—would be reexamined by Kac years later in his 1997 biotelematic performance *Time Capsule* and in his transgenic work *Genesis* from 1999.[24]

Figure 12.2 Eduardo Kac, *Tesão,* 1985/1986. Videotext (Minitel) digital animation shown online in the group exhibition *Brasil HighTech* (1986), a national videotext art gallery organized in Rio de Janeiro by Eduardo Kac and Flavio Ferraz and presented by Companhia Telefônica de São Paulo. Each column illustrates a sequence running from top to bottom.

Simone Osthoff

Alongside videotexts, Kac's early works with telecommunications, networks, and telepresence that preceded the Web further emphasized dialogic processes occurring in real time. He employed slow-scan TV (a kind of video phone), fax-TV hybrids, and fax performances in process-based works in which the process itself brought certain kinds of meanings to the work, such as a cinematic sense of progression, sequencing, and transformations that included interruptions, delays, and the artist's interferences while images were still being received. These works from the mid- to the late 1980s include *Conversation* (slow-scan TV) and *Retrato Suposto–Rosto Roto* (Presumed Portrait–Foul Face) (fax/TV hybrid).[25]

Conversation was a slow-scan TV event realized at the Centro Cultural Três Rios in São Paulo on November 17, 1987. The slow-scan TV allowed the transmission and reception of sequential still video images over regular phone lines. The series of images that comprised the piece each took from eight to twelve seconds to form. Instead of considering each picture as a cinematic representation, Kac explored the live process of image formation. This was also the principle of *Retrato Suposto–Rosto Roto* (1988), created in collaboration with Mario Ramiro, who at one end of this fax conversation operated a fax machine from a live TV program in São Paulo, while Kac, at the other end, carried out a visual fax dialogue from his studio, thus connecting private and public realms (figure 12.3). (According to Kac, "the basis of this link was a real time operation utilizing the fax as a dialogic medium, in the context of a television broadcast, a unidirectional system of mass communication. The goal was not to create pictures remotely but to explore the interactive, improvisational quality of both personal and public telecommunications media simultaneously, integrating the apparently antagonist media into a single process."[26]

In 1984, Kac started to create telepresence or remote-presence events. These telepresence works mobilized dislocations between place and space, that is, between the work's *literal* site, such as a gallery installation, its *symbolic* or *rhetorical* place, such as the topos of Eden, and the virtual space of the electronic network. These experiences of dislocation between real and virtual spaces are more common than we think, Kac observed: "We have developed concepts about cultures that we have never seen, never experienced. In my telepresence installations, I'm making geographic displacements that reflect that."[27] This complex new geography in which telepresence art operates emphasizes real time over real space, enabling a remote perception of the world

Figure 12.3 Eduardo Kac and Mario Ramiro, *Retrato Suposto/Rosto Roto* (Presumed Portrait–Foul Face), 1988. Telecommunications event between Rio de Janeiro and São Paulo merging fax and live TV. Connecting the public medium of television with the private medium of the fax, this work created a system of feedback based on the continuous exchange and transformation of images. The images in the figure were extracted from the live broadcast realized in 1988.

from the point of view of the other, of the object—through the scale/lenses/ eyes of the telerobot, "in a non-metaphysical out-of-body experience, if you will."[28]

Kac's first telepresence project dates from 1984 and was never realized, as a result of countless technical obstacles. Titled *Cyborg,* the project involved three different Rio de Janeiro galleries—Galleria Cândido Mendes, Funarte, and Escola de Artes Visuais do Parque Lage—and the remote control of sculptural-robotic objects. In 1986 Kac realized his first telepresence work, *RC Robot.* He worked with radio-controlled telerobotics in the context of the exhibition Brasil High-Tech. The artist used a seven-foot-tall anthropomorphic robot as a host who conversed with exhibition visitors in real time (figure 12.4). The robot's voice was that of a human being transmitted via radio. Exhibition visitors did not see the telerobot operator, who was telepresent in the robot's body. Still in the context of the exhibition, the robot was used in a dialogical performance realized with Otavio Donasci, in which the robot interacted with Donasci's videocreature (a human performer with a TV monitor for a head). Through the robotic body, a human (hidden away) improvised responses to the videocreature's prerecorded utterances.

Between 1987 and 1988, still in Rio de Janeiro, Kac drew sketches for two small telerobots to be controlled by participants in two distant cities. The idea was to enable a participant in city A to control a telerobot in city B and vice versa. The ideas explored in these sketches would lay the groundwork for the *Ornitorrinco Project,* Kac's name for the small telerobot he would create with Ed Bennett in Chicago in 1989 (*Ornitorrinco* in Portuguese means "platypus," which as an egg-laying mammal is a hybrid animal). The *Ornitorrinco Project* was developed until 1996 and became increasingly more complex, as Kac employed telecommunications to mediate relations among people, animals, plants, and robots. In his telepresence events, process is produced by all the forces, types of use, programs, glitches, and actions taken by participants, in a web of relationships that unfolds in real time.

Kac's emphasis on dialogue and two-way exchanges disregards essentialist identities while exposing the fragility and fluidity of meaning. His poetic explorations of signifying practices, geographic dislocations, and multipositioned spectatorship examine processes of identity constitution and fragmentation. The activism of his early porno-poetry performances on the Ipanema beach informs the cultural and ethical responsibility that characterizes his critical attitude: "If we don't question how technology affects our

Figure 12.4 Eduardo Kac, *RC Robot,* telepresence work presented at the exhibition Brasil High-Tech, Galeria de Arte do Centro Empresarial Rio, Rio de Janeiro, 1986. Remote participants interacted with gallery viewers through the body of the telerobot.

lives, if we don't take charge, if we don't use these technological media to raise questions about contemporary life, who is going to do it?"[29]

Bruscky and Kac share this sense of responsibility in their engagement with art, which they have advanced primarily not as the production of physical objects, but rather as the examination of ideas, relationships, contexts, and consciousness. The live interventions they created in the 1970s and the 1980s were an integral part of the social, cultural, and political networks that give art meaning. During this period Bruscky and Kac sharpened the edge of artistic discourse by creating critical, humored, and performative cultural interventions—the very practice of freedom.

Notes

1. Paulo Bruscky's work has recently been showcased in various Brazilian exhibitions, roundtable discussions, and important articles such as Ricardo Basbaum's "O Artista Como Curador," in *Panaroma da Arte Brasileira 2001* (São Paulo: Museu de Arte Moderna de São Paulo, 2001); and Cristina Freire, *Poéticas de Processo* (São Paulo: Iluminuras, 1999). A large retrospective exhibit of his work was held at the Observatório Cultural Malakoff in Recife in 2001. Bruscky's videos were screened in 2002 in Recife (Fundação Joaquim Nabuco), Curitiba (Cinemateca de Curitiba), and Rio de Janeiro (Agora). The information about Bruscky's work included in this chapter is based on an interview with the author on May 27, 2002, at Bruscky's Torreão studio in Recife, Brazil.

2. Eduardo Kac continues to enjoy a thriving international career that, entering its third decade, has received attention from the international popular media for his transgenic *GFP Bunny,* inviting controversy and generating discussion in multiple arenas. Some of his less-known early works are being examined in this chapter for the first time. For a comprehensive bibliography and documentation on his career, see <http://www.ekac.org>.

3. This group of artists was showcased in an exhibition titled *2080* (featuring twenty artists of the eighties generation) at the Museu de Arte Moderna de São Paulo, January 24–April 5, 2003. Kac contributed to the show with *Cro-Magnon,* a billboard originally shown in Rio de Janeiro in 1984.

4. The year 1968 marks the beginning of an era of state terrorism in Brazil. On December 13 of that year, the military government issued the AI-5 (Fifth Institutional Act), signed by military President General Costa e Silva. The AI-5 closed Congress and suspended all political and constitutional rights, opening the way to

political persecution, torture, and censorship. Following their interruption by a military coup in 1964, presidential elections were not held again until 1989.

5. For Hélio Oiticica's 1970s production, see Carlos Basualdo, ed., *Quasi-Cinemas* (Columbus, Ohio: Wexner Center for the Arts, 2001). For Lygia Clark's work and writings, see Manuel J. Borja-Villel, Nuria Enguita Mayo, and Luciano Figueiredo, eds., *Lygia Clark* (Barcelona: Fundació Antoni Tàpies, 1998).

6. Vladimir Herzog was a São Paulo investigative journalist who was arrested by the security forces and later found hanging in his cell. The government stated that his death was "a suicide," a claim few, if anyone, accepted. Most people believed he was tortured to death by the Brazilian police and government.

7. Paulo Herkenhoff, "The Void and the Dialogue in the Western Hemisphere," in *Beyond the Fantastic,* ed. Gerardo Mosquera (London: inIVA, 1995), 69–73.

8. The forward-looking Brazilian art critic Mario Pedrosa used this expression in the 1960s to describe the experimental works of Oiticica, Clark, Lygia Pape, Antonio Manuel, and others. Rina Carvajal and Alma Ruiz, eds., *The Experimental Exercise of Freedom* (Los Angeles: MOCA, 1999).

9. William Harwood, "Um vôo em que tudo deu certo," *Jornal do Commercio* (Ciência/ Meio Ambiente), Recife, April 3, 1992.

10. Curated by Daisy Pecinini, this exhibit was one of the few that in the 1980s focused on emergent art engaged with technology. Among other artists, Bruscky participated with his three Xerofilms, in addition to his fax art documentation from the 1980s and a new fax transmission for the show. Kac exhibited three of his holopoems, "Holo/Olho," from 1983, and "OCO" and "Zyx," from 1985.

11. See Zuenir Ventura, *1968 O Ano que Não Terminou* (Rio de Janeiro: Nova Fronteira, 1988), 285.

12. Judith Butler, Ernesto Laclau, and Slavoj Zizek, *Contingency, Hegemony, and Universality* (London: Verso, 2000). The authors discuss the false notion, developed since the 1980s, of an opposition between Marxist theory and Lacanian and deconstructive analysis of the formation of the subject.

13. Fernando Gabeira, *O Que É Isso Companheiro* [What Is This, Comrade?] (Rio de Janeiro: Codecri, 1979). The book became a film of the same title directed by Bruno

Barreto in 1997. (Titled in the English version *Four Days in September,* it received an Oscar nomination.)

14. Fernando Gabeira, *O Crepúsculo do Macho* [The Sunset of the Macho] (Rio de Janeiro: Codecri, 1980).

15. Eduardo Kac, in interview with the author, July 8, 1994, Chicago.

16. Oswald de Andrade, "Anthropophagite Manifesto," in *Art in Latin America,* ed. Dawn Ades (London: South Bank Centre, 1989), 310.

17. Quoted in Simone Osthoff, "Object Lessons," *World Art,* no. 1 (1996): 18–23.

18. Ibid., 20.

19. Eduardo Kac, "Holopoetry," *Visible Language* 30, no. 2 (1996): 184–212 (part of a special issue of the journal edited by Kac entitled "New Media Poetry-Poetic Innovation and New Technologies").

20. Quoted in Osthoff, "Object Lessons," 23.

21. Kac's emphasis on the idea of dialogue is based in part on the philosopher Martin Buber's (1878–1965) notion of relations of reciprocity and intersubjectivity between "I" and "Thou," and relations of objectification between "I" and "It," as well as in the Russian literary critic Mikhail Bakhtin's (1895–1975) discussion of the dialogical function of literature and language.

22. Kac's Web site <http://www.ekac.org> defines videotext as follows:

The videotext system allows users to log on with a remote terminal and access sequences of pages through regular phone lines. This videotext network was a precursor to today's Internet and functioned very much like it, with sites containing information about countless subjects. It also allowed users to send messages to one another (email). Different countries, such as UK, France, Japan, Canada, USA and Brazil, implemented different versions of the videotext concept under their own names. The UK called it Prestel. The Brazilian system was dubbed Videotexto. In Canada it was known as Telidon. In the USA the network was named Videotex. Under the name "Minitel," France implemented a comprehensive videotext network that was widely used throughout the 1980s. In 1984 Minitel terminals were distributed to subscribers free of charge, which helped to further popularize the network.

From 1983 to 1994 (the period of the Internet boom), use of the Minitel grew continuously. In 1995 there were 7 million Minitel terminals in France. Although most countries no longer use videotext, the medium is still employed in France. It is also possible to access the Minitel through the web.

23. Eduardo Kac, "Brasil High Tech, O cheque ao pós-moderno," *Folha de São Paulo,* April 16, 1986.

24. Peter T. Dobrila and Aleksandra Kostic, eds., *Eduardo Kac: Telepresence, Biotelematics, and Transgenic Art* (Maribor, Slovenia: Kibla, 2000).

25. Other related works not examined here are *Three City Link* (slow-scan TV), 1989; *Impromptu* (fax and slow-scan TV), 1990; *Interfaces* (slow-scan TV), 1990; *Elastic Fax 1* (fax), 1991; *Elastic Fax II* (fax), 1994; and *Dialogical Drawing* (telecommunication sculpture) 1994.

26. Eduardo Kac, "Telearte em rede," *O Globo* (Segundo Caderno, Rio de Janeiro), September 4, 1988. See also <http://www.ekac.org/rostoroto.html>.

27. Quoted in Osthoff, "Object Lessons," 23.

28. Ibid., 22.

29. Ibid., 23.

Distance Makes the Art Grow Further: Distributed Authorship and Telematic Textuality in *La Plissure du Texte*

Roy Ascott

Text means tissue; but whereas hitherto we have always taken this tissue as a product, a ready made veil, behind which lies, more or less hidden, meaning (truth) we are now emphasizing, in the tissue, the generative idea that the text is made, is worked out in a perpetual interweaving; lost in this tissue—this texture—the subject unmakes himself, like a spider dissolving in the constructive secretions of its web.

—ROLAND BARTHES, *MYTHOLOGIES*

Preamble

Roland Barthes' canonical statement contains an understanding of textuality that lies at the center of this chapter and indeed informed the project it sets out to describe. The term *telematics* has its origins in the 1978 report to the French president by Alain Minc and Simon Nora concerning the convergence of telecommunications and computers, particularly in business and administration.[1] *Distributed authorship* is the term I coined to describe the remote interactive authoring process for the project *La Plissure du Texte: A Planetary Fairytale,*[2] which is the principal subject of this chapter. My purpose here is to explore the genealogy of the project, how the concept of mind-at-a-distance developed in my thinking, and how the overarching appeal of the telematic medium replaced the plastic arts to which I had been committed as an exhibiting artist for more than two decades.

The project arose in response to an invitation in 1982 from Frank Popper to participate in his exhibition Electra: Electricity and Electronics in the Art of the XXth Century at the Musèe Art Moderne de la Ville de Paris in the fall of 1983. Popper had written previously on my work,[3] and I was confident that his invitation offered a perfect opportunity to create a large-scale telematic event that would incorporate ideas and attitudes I had formed over the previous twenty or more years.

La Plissure du Texte: A Planetary Fairytale (LPDT) sought to set in motion a process by which an open-ended, nonlinear narrative might be constructed from an authoring "mind" whose distributed nodes were interacting asynchronically over great distances—on a planetary scale, in fact. As I examine it in retrospect, I see how a complexity of ideas can create a context for a work whose apparent simplicity masks a generative process that can bifurcate into many modes of expression and creation. It is the bifurcations of ideas specific to the context of *LPDT*—their branching and converging pathways—that I shall initially address in this chapter. The content itself is transparent, insofar as the text in its unfolding is its own witness.

The Pathway to *La Plissure*

It was the psychic systems that I had been studying since the early 1960s—telepathy across oceans, communication with the disincarnate in distant worlds—that led me, a decade later, to formulate ideas of distributed mind and the concept of distributed authorship embedded in *LPDT.* I followed

both the left-hand path and the right in pursuit of my interests in consciousness (I'm thinking here of the role of the left and right hemispheres of the brain in determining linguistic and cultural norms in Robert Ornstein's writings,[4] and of ideas drawn from the Sufism of Idries Shah,[5] Jung's synchronicity,[6] and Charles Tart's studies of altered states of consciousness).[7] I studied J. B. Rhine's work at Duke University on telepathy[8] and J.W. Dunne's theory of time, memory, and immortality[9] (a copy of Dunne's book was in the core library of Buckminster Fuller, whose planetary perspective and structural creativity was a further inspiration to me). I was at home too with kabbalistic and mystical thought, as set out by such writers as Papus,[10] Ouspensky,[11] and the Theosophists, and—at a level of generality but with huge impact on my imagination—John Michell's *A View over Atlantis.*[12]

Michell could be seen, in a sense, as attempting to lift Barthes' veil, "behind which lies, more or less hidden, meaning (truth)," the veil in this instance being the network of ancient sites, inscriptions, and monuments that dot the British landscape where I was brought up. And just as in Barthes' *Mythologies,*[13] Michell drew out meaning from what was apparently random and inconsequential. It was the narratives woven around the Neolithic, ancient, and medieval "spiritual technology" of my home region—Avebury, Silbury Hill, Stonehenge, and Glastonbury—that prepared me, at a very young age, for my subsequent study of esoterica and the sense of the numinous that later I was to find in cyberspace.

Modern science and technology also exerted a huge influence of the thoughts that led to *LPDT. Scientific American* was consulted as frequently as *Art Forum,* quantum physics infected art theory, and the metaphors of biology infiltrated my visual thinking. But it was principally cybernetics that led me to my subject and prepared me for the telematic revelation that was to take over my ideas about art. The works of Ross Ashby,[14] F. H. George,[15] and Norbert Wiener[16] inspired my thinking about networks within networks—semantic and organic—interacting, transforming, self-defining in a way that later narrative nodes could do in *LPDT.* My thoughts about participation and interaction in art were consolidated with Whitehead's issues of organism,[17] Bergsonian notions of change,[18] and McLuhan's ideas about communication.[19] These concerns, amongst others less easily defined, led me inexorably to my project.

As a painter and dreamer, I had always found associative thought more productive to my creative process than strict rationality, but quite early in

my work, systems thinking[20] and theories of growth and form[21] were equally important to me. Process philosophers and systems thinkers are generically optimistic if not explicitly utopian, just as cyberneticians are always in pursuit of the perfectibility of systems. Their outlook is necessarily global in every sense. I was making works in the early 1960s that was semantically open ended and invited viewer participation, such as those that were shown in my first London exhibition of change-paintings and analog structures.

In April 1970, I published "The Psibernetic Arch,"[22] which sought to bridge the apparently opposed spheres of hard cybernetics and soft psychic systems (discovering in the process, for example that parapsychology was being researched in the Laboratory of Biological Cybernetics at Leningrad University). During my tenure as dean of the San Francisco Art Institute in the 1970s, I consulted the tarot and threw the *I Ching* on a regular basis. In this context, Brendan O'Regan, research director at the Institute of Noetic Sciences in Sausalito, California, approached me to participate in a TV documentary. The institute was led by Willis Harman and had been founded by the astronaut Edgar Mitchell. O'Regan had been a senior associate of Buckminster Fuller.

The documentary (destined for coast-to-coast transmission) was to survey the current state of psychic research, including, in my case, an interview with Luiz Antonio Gasparetto, a Brazilian psychic who demonstrated the ability to paint four paintings, each in the style of a different "modern master," simultaneously with his feet and hands. He "incorporated" the personalities of these deceased painters and claimed to "walk and talk with them" on a daily basis. At the filming it seemed that practically the whole of the community of parapsychologists, analysts, therapists, and transpersonal psychologists of northern California was assembled to watch the demonstration.

In the course of this induction into the Bay Area world of the paranormal, I developed a friendship with Jack Sarfatti, one-time associate professor in quantum physics at the University of California at Berkeley and a founder of the Esalen group, said to have influenced the ideas of Fritjof Capra[23] and Gary Zukav,[24] whose books on mysticism and physics were to become widely read. Fred Alan Wolf, author of *Parallel Universes*,[25] among other influential books, was also a part of our meetings. Through O'Regan I was introduced to Jacques Vallée, popularly recognized as a French expert on unidentified flying objects (UFOs), on whom the character played by Francois Truffaut in the movie *Close Encounters of the Third Kind* was based. That great mythic

Hollywood film of the 1970s—even, in my estimation, of the century—appeared to start out as the study of creative obsession, whose raw material was any household rubbish (a perfect metaphor of the Arte Povera of the period), but became an expression of human longing for communication with the cosmos, a metaphor for science in search of meaning in outer space.

Vallée had joined Doug Englebart's lab at Stanford Research Institute in 1971, in which the idea of on-line communities was being explored and in which the development had begun of some basic tools, such as the mouse and an early form of hypertext. When ARPANET opened up in 1972, the momentum accelerated. Some of the behavioral and social effects were quickly recognized. One of Vallée's tasks was to build the first database for the the Network Information Center, which comprised no more than a dozen sites at that point. Later he met Paul Baran, who had invented packet switching at RAND and who was his mentor in a new Advanced Research Projects Agency (ARPA) project to study group communications through computers. In 1973, under ARPA and National Science Foundation funding, Vallée, Roy Amara, and Robert Johansen, based at the Institute for the Future, built and tested the first conferencing network, the Planning Network System (PLANET).

Vallée had founded a company called Infomedia in San Bruno, California, to provide the worldwide network for PLANET, offering access to huge databases and extensive computer conferencing facilities. PLANET was originally designed for use by planners in government and industry, who were unlikely to have any previous computer experience, and so was designed from the beginning for maximum ease of use. Commands were made as simple as possible, and the system was designed to be operated with just a few keys on a specially built portable telecommunications terminal. The PLANET application later evolved into the application Notepad, a global conferencing system that was used by a number of corporate clients such as Shell Oil.

From Psi to Cyb

Although the mystique around Vallée's UFO research was fascinating, I was much more drawn to what was for me at that point the equally mysterious world of computer-mediated telecommunications. Introduced by O'Regan to Vallée's organization and hands on to the technology at the Stanford Research Institute, I found it particularly exciting that Texas Instruments portable terminals, with rubber acoustic couplers to a telephone handset,

enabled the user to connect with the network from just about any public telephone, and in many world capitals, free.

Just as earlier, I had had an awakening flash to the value of cybernetic theory to underpin my "interactive" art practice,[26] so too here I saw in computer networking the possibility for a new connective medium for my art. I already had a sense of its aesthetic potential. Although the direct link between this new communications technology and big business and the military could be darkly problematic, I felt from my very first encounter that telematics could provide the means for enlightened artistic and poetic alternatives.

My first task was to secure funding to set up a network project that could test out my ideas. The National Endowment for the Arts awarded funding, and portable Texas Instruments 765 terminals were dispatched to Douglas Davis, Jim Pomeroy, Don Burgy, and Eleanor Antin, in the United States, and Keith Arnatt, in the United Kingdom. Vallée generously made PLANET available to us for twenty-one days.

By the time this first project (dubbed "terminal art" by the British press) got underway, my base had moved from the Bay Area to the United Kingdom. There my greater access to France enabled me to witness the first steps in the "telematization of society"—at least of business—resulting from Minc and Nora's report: *la programme télématique.*[27] In the context of French culture, my reading now followed a path through the structural linguistics of Saussure[28] and the structural anthropology of Levi-Strauss[29] to Foucault's archaeology of knowledge and on into the semantically ambiguous domains of Derrida and full blown poststructuralism.[30]

In 1978 I presented a postmodern credo at the College Art Association annual meeting in New York on a panel convened by Davis.[31] This drew upon the implications of second-order cybernetics,[32] which reinforced the understanding of interactivity in the creation of meaning by which I had theorized my own art practice. Equally potent at that time was Bateson's *Steps to an Ecology of Mind,*[33] in which the term *mind at large* appears, originally coined by Aldous Huxley in *Proper Studies,*[34] which had been a set book in my grammar school days.

In my thinking at that time, the work of Barthes stood at the center of the literature on semiotics, with its emphasis on how meaning can be elicited from the apparently most trivial or disregarded things. Not withstanding the excellence of Eco's magisterial *A Theory of Semiotics,*[35] or my forays in the 1960s into the pioneering work of Charles Sanders Peirce,[36] it was Barthes'

Mythologies[37] that captured my imagination with its combination of satire, humor, and the deconstruction of myths. In 1977 the Canadian artist Mowry Baden introduced me to *The Pleasure of the Text,* which in my view achieved an unrivaled level of importance in the otherwise jaded academic field of "literary criticism." Barthes also took the tired debate between Marxism and psychoanalysis up a level to a much more human perspective:

No sooner has a word been said, somewhere, about the pleasure of the text, than two policemen are ready to jump on you: the political policeman and the psychoanalytical policeman: futility and/or guilt, pleasure is either idle or vain, a class notion or an illusion. An old, a very old tradition: hedonism has been repressed by nearly every philosophy; we find it defended only by marginal figures, Sade, Fourier . . .[38]

Within the hedonistic literature of these marginal figures, it was precisely Fourier's universal theory of passionate attraction[39] that inspired my utopianism, a passion that extended to the text, that is to say, gave freedom to make (give/receive) narrative pleasure in the open-systems context of nonlinear (asynchronic) time and boundless (nonlocal) space. In short the telematics of utopia: to be both here and elsewhere at one and the same time, where time itself could be endlessly deferred, as indeed could the finality of meaning. I was ready for Derrida's *différance,*[40] seeing difference functioning often as an aporia: difference in neither time nor space, but making both possible.

My interest in signs, in semiotics, and in myths was also fed by Vladimir Propp's study of narrative structure and the morphology of the fairy tale.[41] Propp's investigation of folktales sought a number of basic elements at the surface of the narrative. He showed how these elements correspond to different types of action. His structural analysis of dramatis personae, and his focus on behavior that recognized that actions are more important than the agents, chimed well with the interest that I had in process and system. In the fairy tale, by his account, there are thirty-one functions that are distributed among seven leading dramatis personae: the villain, the donor, the helper, the princess, the dispatcher, the hero, and the false hero (or antihero). I was especially attracted to the idea that each character actually represented a center of action more than a simple persona, and that whatever specifics of a given magical narrative, the protagonist, from a state of initial harmony, follows a sequence of actions: discovers a lack, goes on a quest, finds helpers/opponents, is given tests, is rewarded, or a new lack develops. The question

that suggested itself for *LPDT* with its distributed authorship was: How might the narrative evolve in a more nonlinear way, written from inside the narrative, as it were, with each dramatis persona seen within him- or herself as the protagonist?

Pleating the Text

LPDT was to be a project involving multiple associative pathways for a narrative that would unroll asynchronically according to the centers of action that determined its development. The outcome would be multilayered, nonlinear in all its bifurcations. I had previously set up a project as part of Robert Adrian X's "The World in 24 Hours," an electronic networking event at Ars Electronica in 1982. My project was to have participants at their computer terminals around the world toss coins for the first planetary throw of the *I Ching*. Reflecting on this later, I wrote:

As I recall we got close to number 8, PI Holding Together/Union but the bottom line was -X-, which transformed the reading into number 3, CHU *Difficulty at the Beginning,* which was undoubtedly true. In fact looking at the emergence of networking for art, the offspring of this momentous convergence of computers and telecommunications, the commentary on CHU is particularly apt: *Times of growth are beset with difficulties. They resemble a first birth. But these difficulties arise from the very profusion of all that is struggling to attain form. Everything is in motion: therefore if one perseveres there is the prospect of great success.*[42]

For "The World in 24 Hours," Adrian employed the ARTEX system, an electronic-mail program for artists on the worldwide IP Sharp Associates (IPSA) time-sharing network. It was initiated as ARTBOX in 1980 by Adrian, Bill Bartlett, and Gottfried Bach to offer artists a cheap and simple alternative to IPSA's business-oriented program, with the final version, AR-TEX, being completed a few years later. This was an e-mail network for artists, a medium for text-based telecommunication projects, and a means of organizing on-line events. During the ten years of its operation, about a dozen artists used it regularly, and anywhere from thirty to forty others might be involved at any one time.

I met with Adrian in Vienna to elicit his involvement in *LPDT,* gaining his agreement to manage the complexity of ARTEX as the organizing instrument of the project's communications infrastructure, outlining the

need to use the telematic medium to engender a world-wide, distributed narrative: a collective global fairy tale. With the network as medium, the job of the artist had changed from the classical role of creating content, with all the compositional and semantic "closure" that implied, to that of "context maker," providing a field of operations in which the viewer could become actively involved in the creation of meaning and in the shaping of experience that the artwork-as-process might take. Canadian sponsorship was secured (Adrian was a Canadian national, IP Sharp was a Toronto-based company, and I had been at one time president of the Ontario College of Art), and the Canadian Cultural Center in Paris provided basic funding for the project, accommodation, and a planning base.

On July 13, 1983, I posted on ARTEX a description of the project and a call for participation. At the same time pamphlets and press announcements were circulated. Artists and art groups in eleven cities in Europe, North America, and Australia agreed to join the project.

In November of that year, each participant was allocated the role of traditional fairy tale character: princess, witch, fairy godmother, prince, etc. Beyond the simple idea of a fairy tale, I did not suggest a story line or plot: The artists were simply asked to improvise. The result was that as a result of the differences between time zones and the nature of improvisation, the narrative often overlapped and fragmented, leading into a multiplicity of directions (figure 13.1).

La Plissure du Texte was active on line twenty-four hours a day for twelve days: from December 11 to 23, 1983. With terminals in eleven cities, the network grew to include local networks of artists, friends, and random members of the general public who would happen to be visiting the museum of art space where the terminals were located. Over the three-week period of the project hundreds of "users" became involved in a massive intertext, the weaving of a textual tissue that could not be classified, even though ostensibly the project was to generate a "planetary fairytale" (figure 13.2).

Each participant or group of participants in the process could interact with the inputs of all others, retrieving from the large memory store all text accumulated since they last logged on. The textual interplay was complex, working on many layers of meaning, witty, bawdy, clever, academic, philosophical, entertaining, inventive, shocking, amusing—assimilating the great diversity of cultural contexts, value systems, and intellectual interests of the participants, located in Honolulu, Pittsburgh, San Francisco, Paris,

```
FROM ASCOT TO NEXUS SENT 15.43 20/12/1983

LE MAGICIEN :
UNE GLISSADE D'AUTEURS HORS DU CONTE ET
ET HORS DU SOUPER
WITHOUT END
--------------------
            APRES LES CATACLYSMES QUI DETRUISIRENT
            LES VALEUREUX PARTICIPANTS DE NOTRE SERIE
            ANTI-DALLAS
            APRES LA FIN DE LA BETE SOUS LES TROPISMES
            DU MAGICORDINATEUR
            A
             R
              I
               A
                N
                 R
                  H
                   O
                    D
            REVELE AU MAGICIEN QUE LES ESPRITS AYANT
            VECU DANS UN CONTE DE FEE SONT RELACHES
            DE SON CHATEAU-PURGATOIRE
            PAR LA PROCHAINE GRANDE RHOD (ROUE) ILS
            QUITTERONT LA CORONA BOREALIS ET REGAGNERONT
            LA TERRE
              POUR CAPTER LE RETOUR DES ESPRITS
                POLYEDRIQUES
                  (IL ETAIT SEUL SUR LA PLANETE DES
                    REQUINS AFFAIRES ET DES POILI-
                      TICIENS A-VIDES)
            L'ALCHIMAGE
              MET A  CHAUFFER
                UN ATHANOR   AU SOMMET DE L'ETNA
--------------         --------------------
DU CREUSET MONTE UNE VAPEUR LEGEREMENT PARFUMEE AU
SAFRAN ET DE CETTE MEME COULEUR SOLAIRE
DU CREUSET SORTENT DES ETRES SANS NOM NI FEE
LA GLISSADE INFINIE DES PERSONNAGES DU CONTE
NOW IT'S LATE IN THE NIGHT  I CAN SEE A BEAUTIFUL PASSAGE
OF WHITE TRANSPARENT CLOUDS OVER THE DARK SKY
UNE GIGANTESQUE EXPANSION DE LETTRES UNE GLISSADE D'AUTEURS
EN QUETE D'AUTEURS...
```

Figure 13.1 Sample printout of *LPDT* texts.

Figure 13.2 Narrative center of action: fairy godmother. Students of Norman White at Ontario College
of Art, Toronto.

Figure 13.3 Narrative center of action: the fool. Robert Adrian X and Tom Klinkowstein, San Francisco.

Vancouver, Vienna, Toronto, Bristol, Amsterdam, Alma in Quebec, and Sydney (figure 13.3).

In some instances a dramatis persona would be no more than one or two artists grouped around a desktop computer; in other cases an artist group would meet regularly in its media center to move the narrative along on-line. Others made a full-scale performance, as with the witch in Sydney, where each evening, at the Art Gallery of New South Wales, the evolving narrative text was downloaded and read out to the gathered participants, representing the witch, who in turn collaborated in further production of the text. In almost every case the individual node of the narrative network was itself a hub networking out to other individuals or groups in its region, collectively constituting the mind of the dramatis persona at that location. The Musée d'Art Moderne in Paris was the principal hub, the home of the magician.

La Plissure du Texte was effectively a watershed, a fulcrum point in my work. It showed me the importance of text as the agent of practice, not merely of theory, and it demonstrated the potency of distributed authorship in the creative process. The project passed without comment in the art press, just as the 1986 Venice Biennale international on-line conference project Planetary Network in the Laboratoria Ubiqua, organized by Tom Sherman, Don Foresta, and myself as international commissioners, received no attention. It was too early; the art world would take a long time to catch up. It wasn't until 1989 with my telematic project *Aspects of Gaia: Digital Pathways across the Whole Earth,* installed at Ars Electronica, that for me interac-

tive telematic work was granted a place in the art world. Even then, the festival itself was completely marginal to the orthodox international art fairs at that time.

1989 was the year that the term *interactive art* was inscribed in the canon of practice with such texts as "Gesamtdatenwerk," which I published in *Kunstforum* that year.[43] A year later the Prix Ars Electronic established interactive art as a major category of practice. I instituted the first honors degree in interactive art at Gwent College (which led five years later to the creation of the CaiiA-STAR doctoral program, and then to the *Planetary Collegium*).[44]

Conclusion: From Propp to Popp

This chapter has broadly indicated some of the pathways that led me to *La Plissure du Texte* and to the formulation of a practice that I have theorized as telematic art, a form of "telematic" connectivism. The telematic journey has taken me from Paris to California, from Vienna to Toronto, and from the deepest part of the Mato Grosso in Brazil to Japan, Australia, and Korea. It is a journey propelled by a fascination with myth and with a conjunction of ideas addressing artistic, scientific, and esoteric practices. My interest throughout has been in nonlinear structures and metacommunication, both in respect of online narrative, and in terms of consciousness and nonordinary realities.

As for my current work, there has been a passage, from ideas of mind-at-a-distance invested in nonlinear narrative (including the "centers of action" of Vladimir Propp)[45] set in telematic space, toward the new organicism in biophysics and research into biophotonics of Fritz-Albert Popp.[46] Propp's ideas have long been absorbed in my approach to collaborative process, as I have shown in the structure of *La Plissure du Texte.* Popp's field of biophotonics, which follows the work of Alexander Gurvitch, lies ahead of me, arising initially from my study of shamanic practices in Brazil, and especially the ethnobotany of psychoactive plants. The biophotonic network of light emitted by DNA molecules, as Popp has argued, may enable, through the process of quantum coherence, a holistic intercommunication between cells. So from the emergent planetary network of telematics, to the embodied biophotonic network of living entities, there is the potential for continuity and connectivity, the transdisciplinary aspects of which it is my present purpose as an artist to pursue.

Notes

1. A. Mine and S. Nora, *The Computerisation of Society* (Cambridge, Mass.: MIT Press, 1980).

2. R. Ascott, *XLII Esposizione d'Arte La Biennale di Venezia* (Venice, 1986). Publisher, La Bienalle di Venezia.

3. F. Popper, Naissance de l'ant cinetique (*Origins and Development of Kinetic Art*) (London: Studio Vista, 1968); and *Art—Action and Participation.* Translated from the French by Stephen Bann (London: Studio Vista, 1975).

4. R. Ornstein, *The Nature of Human Consciousness* (San Francisco: Freeman, 1973).

5. I. Shah, *The Way of the Sufi* (New York: Dutton, 1970).

6. C. G. Jung, *Synchronicity* (Princeton: Princeton University Press, 1973).

7. C. Tart, *Altered States of Consciousness* (New York: Wiley, 1969).

8. J. B. Rhine et. al. *Extra-Sensory Perception after Sixty Years* (New York: Holt, 1940).

9. J. W. Dunne, *An Experiment with Time* (London: Faber & Faber, 1927).

10. G. E. Papus, *The Tarot of the Bohemians,* trans. A. P. Morton (New York: Weiser, 1958).

11. P. D. Ouspensky, *In Search of the Miraculous: Fragments of an Unknown Teaching* (London: Routledge & Kegan Paul, 1947) (posthumously).

12. J. Michell, *A View over Atlantis* (London: Sago, 1969).

13. R. Barthes, *Mythologies* (Paris: Seuil, 1970).

14. R. W. Ashby, *Design for a Brain* (London: Chapman & Hall, 1954).

15. F. H. George, *The Brain as a Computer* (Oxford: Permagon, 1961).

16. N. Wiener, *Cybernetics* (New York: Wiley, 1948).

17. A. N. Whitehead, *Process and Reality* (New York: Macmillan, 1929).

18. H. Bergson, *Creative Evolution,* trans. Arthur Mitchell (New York: Holt, 1911).

19. M. McLuhan, *Understanding Media* (New York: McGraw-Hill, 1964).

20. L. von Bertalanffy, *General System Theory* (New York: Braziller, 1986).

21. D. W. Thompson, *On Growth and Form* (Cambridge: Cambridge University Press, 1917).

22. R. Ascott, "The Psibernetic Arch," *Studio International* (London) (April 1970): 181–182.

23. F. Capra, *The Tao of Physics* (London: Wildwood House, 1975).

24. G. Zukav, *The Dancing Wu Li Masters: An Overview of the New Physics* (London: Rider Hutchinson, 1979).

25. F. A. Wolf, *Parallel Universes: The Search for Other Worlds* (New York: Simon & Schuster, 1989).

26. R. Ascott, "The Construction of Change," *Cambridge Opinion* 37 (Cambridge University, UK): 42. January 1964.

27. S. Nora and A. Minc, *The Computerisation of Society* (Cambridge, Mass.: MIT Press, 1980).

28. F. Saussure, *Cours de linguistique generale* (Paris: Payot, 1949).

29. C. Levi-Strauss, *Structural Anthropology* (New York: Basic Books, 1963)

30. J. Derrida, *Writing and Difference,* trans. Alan Bass (London: Routledge & Kegan Paul, 1978).

31. R. Ascott, "Towards a Field Theory for Post-modern Art," *Leonardo 13* (1980): 51–52.

32. H. von Foerster, *Observing Systems* (New York: Intersystems, 1981).

33. G. Bateson, *Steps to an Ecology of Mind* (San Francisco: Chandler, 1972).

34. A. Huxley, *Proper Studies* (London: Chatto & Windus, 1949).

35. U. Eco, *A Theory of Semiotics* (Bloomington: Indiana University Press, 1979).

36. C. S. Peirce, *Collected Papers* (Cambridge, Mass.: Harvard University Press, 1931–1958).

37. Barthes, *Mythologies.*

38. R. Barthes, *The Pleasure of the Text,* trans. R. Miller (New York: Hill and Wang, 1975), 57.

39. C. Fourier, *The Utopian Vision of Charles Fourier: Selected Texts on Work, Love, and Passionate Attraction,* trans. J. Beecher and R. Bienvenu (London: Beacon, 1971).

40. Derrida, *Writing and Difference.*

41. V. Propp, *Theory and History of Folklore,* ed. A. Liberman (Minneapolis: University of Minnesota Press, 1985).

42. R. Ascott, "Art and Telematics: Towards a Network Consciousness/Kunst und Telamatik/L'art et le telematique," in *Art + Telecommunication,* ed. H. Grundmann (Vancouver: Western Front, 1984), 28.

43. R. Ascott, "Gesamtdatenwerk: Konnektivitat, Transformation und Tranzendenz," *Kunstforum* (Cologne) (September/October 1989): 103.

44. R. Ascott, *The Planetary Collegium* (2004), available at <www.planetary-collegium.net>.

45. Propp, *Theory and History of Folklore.*

46. F. A. Popp, *Integrative Biophysics: Biophotonics* (Dordrecht: Kluwer Academic, 2003).

From BBS to Wireless:
A Story of Art in Chips

Andrew Garton

Introduction

From punch card programming to generative sound design, from store-and-forward file sharing to wirefree audio streaming, artists have consistently adopted, adapted, and assimilated technologies in their myriad forms to articulate that which drives their spirited and complex behavior. This chapter is a personal journey, an anecdotal diary of my life with computers, observations on their inevitable coupling via telephony, the theater of activism that this relationship spawned, and the gradual degradation of my physical self as the rate of development in the field of information communication technologies increased.

Since the mid-1970s I have involved myself in numerous independent and community media initiatives in Australia and Southeast Asia: from radio and public-access video in my teens to computer networking in the late 1980s. I spent a good deal of my time producing collaborative media artworks, combining interests in music, performance, and public media. In the past twenty years I have written and performed plays; joined and formed bands; written scores for television documentaries; penned countless songs, piano, and electronic compositions; and experimented with recording and performance techniques—each a journey of their own, each with their failures, successes and lessons learned.

In 1989 I began working with computers and modems, integrating both my artistic and political interests in the then embryonic Pegasus Networks. But my relationship with computers and personal arts practice began much earlier than that.

Punch Cards and U-Matics

Some time in the flared, AM-tuned 1970s, punch cards—thin, blue strips of cards—were the means by which computers could be programmed. Each hole in the card represented a single link in a chain, as powerful as the heavy knots I had watched twist into action, tethering ferries to the wharf at Circular Quay in Sydney. Representing flows of data, each popped hole along a matrix of lines and numbers—routines and functions, inputs and outputs—would set in motion simple calculations once inserted into what must have been the first computer I had laid my hands on.

I recall programming a handful of simple calculator games and writing algebraic formulas. Algebra engaged me, but what remained in the vast domain of mathematics was largely incomprehensible. What I could I learned

Figure 14.1　Andrew Garton, early communicator, 1964–1965. Photo: Alex Garton.

by rote, whereas algebra I could not get enough of. It stimulated the mind of a suburban boy whose world was bound by language (I grew up speaking German), splinter factory fences and traffic (figure 14.1). Algebraic formulas were useful in terms of structuring simple and complex programs, the most popular of which we had at school, and one that some of us would tinker with was *Lunar Landing*. One had to navigate a series of numbers and calculations representing the lunar module, thrust and fuel levels, guide the

module into orbit around the moon, and land it safely while negotiating gravitational anomalies. The computer itself sported a sixteen-digit, green numerical display, but it was more than enough to stimulate our minds, imagining a world beyond the skies of Guildford[1] with thrust and torque at our fingertips. This was probably the only time in my life when I was interested in code as a form of expression. But circumstances in my life at the time hindered this development, and in many ways I am grateful for it. It would be another fifteen years or so before I would be consumed by computers, not for what I could code, but for what I would create and the cultures that would intersect with mine.

Before I was to encounter my next computer, I left school for a world of audio synthesis, radio, and video: a life with analog audiovisual and community concerns. I was compelled by the notion that an informed community may breed informed decisions. Whether it was behind a video camera or radio panel, I found a personal outlet within the rich landscape of community media made possible by the initiatives of the Whitlam government.[2] Although the options were many, I soon had to make a choice between an invisible audience and one I could see. I chose the latter, and with that decision, it would be nearly three years from the day I left the U-matic video editing decks at the Liverpool Video Access Center until I would find myself sculpting the superb functions of the infamous Fairlight CMI. Somehow, at whatever stage in the progression, I always wound up sitting behind something. Be it a typewriter, mixing desk, or keyboard, I would always be bound to this box from which I could manifest the sleepless waves of ideas with little interference, ridicule, or criticism from others (figure 14.2). But I would also be drawn back to collaborations, finding in them both disappointment and conviction to pursue my own ideas.

The first computers I had seen used in any creative context, and well before the Fairlight, were the Ataris and Commodore 64s. I spent my lunch breaks at the local music store, where I would record my first multitrack piece, *Tully's Girl,* on a Fostex 8 Track,[3] most likely. Despite having access to an Atari in the shop, I found using it slow and cumbersome. I had become used to the tactile nature of mixing desks, tape decks, and synthesizers. As much as this intrigued me, I had no intuitive relationship with sequencing software or with MIDI, the core application driving computers and their synchronised patterns to drum machines and other MIDI-compatible devices, and grew to loathe it. However, when I met the Fairlight CMI, I found

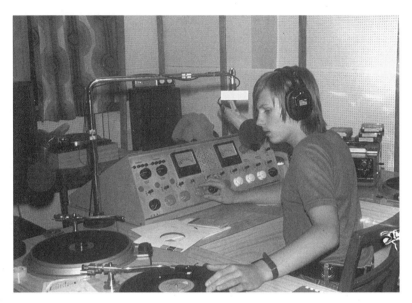

Figure 14.2 Andrew Garton at Liverpool Green Valley Community Radio, 1977 Photo: Jim Tumeth.

a system I could understand, and with liberal access to one, I soon became proficient at sampling and sequencing with it. The Fairlight CMI was perhaps the first digital audio sampler and sequencer combined. One could record a sound to disk and view the waveform on screen. This taught me to listen, to identify the peaks and troughs of individual sounds. This simple link between image and sound is what made the Fairlight so radically different as a musical tool or sound machine. I had spent a couple of years in my late teens recording on a domestic quarter-inch reel-to-reel, planning all my tracks ahead by "hearing" arrangements. Now that I could see waveforms and shape them on screen, I felt I had as much freedom with technology as one would have when near-mastering the piano. The studio would become my instrument, and computers would liberate me from the vanload of equipment I would carry from performance to performance.

Fairlight Forays

Although the Fairlight was a popular tool for songwriters, those wealthy enough to afford one, in 1982 Sydney, within the control room of the Damien Gerrard Rehearsal Studios, we were a long way from anything like the sounds

I had heard from Eno and Bowie, probably the most experimental of the works I was listening to outside of Australian groups like SPK, Makers of the Dead Travel Fast, and No. At the time, I was not necessarily aware that I was creating anything remotely akin to artworks in sound. I was deeply concerned with sound and compositions that contained narrative elements, or rather fragments of the invading world, information flows that we were still learning to filter and yet many were unaware of. I would use spoken-word and radio transmissions or create works that replicated the vast expanse of radio bandwidth that I once explored as a child, moving the dial slowly from left to right and back again, seeking out a world beyond the fibro walls of our two-room home. Voice in its sampled and reprocessed arrangements would be reminiscent of shortwave: fragments of human communication reaching out beyond impossibly distant borders and into the night air, when frequencies were easily found, not buried by the push-button, preset culture of digital technologies.

My first Fairlight pieces, in hindsight, were much like the fragmented dialogue one would hear across continents: whispers from exotic countries, a poetry of language, symphonies of static collisions and electricity stitched together by imagination and the slow turning of a Bakelite dial. Letters and postcards from friend and collaborator David Nerlich, their evocative form depicting impressions of Cairo, London, and Berlin, inspired and informed my earliest collage-based compositions constructed with the Fairlight.

I had yet to travel. Nerlich's writing was an unprecedented link to worlds I could know only through the mastery of his whimsical and laconic pen, drawing the ascent of human history through sandstorms, stone, remnants of ancient power, and the intangible mysteries of the common—countless unknown, unrecorded lives whose blood and bones must surely fertilize that which comes, that which goes. . . . Three pieces were directly drawn from Nerlich's postcards and letters: *As It Should Be, David Goes Too,* and *Set into a Mould.* Each piece began as a series of notes, mostly in the form of poems or haikus drawn from the source material found occasionally in my letter box. Using a simple cut-up technique I would type up the text, then print it out on thermal paper. Each line would be cut out, thrown in the air and reassembled in a random sequence. The final page, with each line stapled to it, would be left in the sun. The words that hadn't faded would then be sampled into the Fairlight, and the resulting composition arranged from these fragments.

The last of my Fairlight compositions were completed in 1986. These were commissioned for the Australian Broadcasting Corporation's documentary *Maximum Liberty,* profiling U.S. Navy personnel during their often controversial stopovers in Sydney.

Vintage Networks

By 1990 I was based in the small alternative community Byron Bay, on the north coast of east Australia, assisting in the establishment of a network that would reach anyone, anywhere in the country for the cost of a local call. Pegasus became the first, and perhaps the most underrated, Internet service provider (ISP) in the country. We must have introduced thousands of people to their first modem, and many to their first computer.

Between 1990 and 1991, I published installments of a novella I had been writing since 1986. In August 1991 it was posted to the newsgroup[4] visionary, whose name was later changed to gen.cyberculture. Around the same time, I produced a "live to Pegasus" reading, *Poets at the Café Byron,* publishing texts to the Internet as they were being read by their authors. These texts were sent to the newsgroup café.byron. I recall that six to eight people were on-line at the time. It was real-time, live-to-text broadcasting. It seems quite primitive, looking back at it now, but at the time it was empowering to simply expand the notion of place: We were in Byron Bay, but our audience was quietly reading our material in locations around the country we would have no hope of reaching otherwise.

During the 1991 Australian federal election, I had a live text-based feed from the Canberra tally room where I was posting updates on Green candidates to the Pegasus newsgroup café.australia. I believe this may have been the first Internet-connected election (and certainly well before it was referred to as the Internet). Pegasus provided me with a base from which I could assist in the practical applications of low-cost networking in Southeast Asia. What I was not able to achieve in Australia I was able to do in Brazil (Earth Summit 1992), Indochina (IDRC PAN Asia Networking Report), Southeast Asia, and the Pacific Islands (Pactok Community Network).[5] I was not alone. I worked with a small number of ex-poets, writers, architects, engineers, mechanics, and musicians: a community of network activists extending the capabilities of computers and modems and their use in the developing world. In some places, I found modems as scarce and as much sought after as legal aid and medicines. My first trip to Sarawak, Malaysia, resulted in a fund-

raising exercise to cover the cost of modems for an indigenous people's network. They really wanted modems!

FIERCE/InterRave

In September 1993 I first visited Sarawak and spent a week allowing myself to be exposed to the social inequities and tragedies that are all too often hidden from the international community. Under the guise of a popular democracy, the Malaysian government had successfully sanctioned, supported, and profited from the felling, extraction, pulping, and trade of 80 percent of Sarawak's primary rain forest—all this in less than twenty years. Along with the rain forest went the traditional lands and self-sustaining livelihoods of many of its indigenous peoples. I am not a politician, I am not a journalist, I am not a member of any activist organization, nor do I donate to any. I have eyes and an inquiring mind, and I think I am a compassionate person. The challenge was to take what I had seen and felt and translate this into something meaningful not only for my own people, but for the people who had to remain in Sarawak to continue their struggle.

In mid-1994, I returned from Sarawak, having been witness during my stay to countless tragic and unreported disparities in Malaysian society. The results of logging in Sarawak and the plight of indigenous tribes such as the Penan were well known. What we were less aware of at the time were the problems resulting from their movement off tribal lands into the cash economy. The basic rights of these people were and still are constantly abused. In addition, the people who work to right this situation do so under threat of imprisonment and harassment as acted out under Malaysia's Internal Security Act. I'll never forget the night I came away from one of our many meetings in Kuala Lumpur, my ears ringing with "modems, modems, modems." Just about everywhere I went, people wanted modems, computers, and telephone lines. Fast, error-correcting modems were certainly in short supply. Nongovernmental organizations (NGOs) often smuggled then into the country, but not often enough. Before returning to Australia, I e-mailed some friends about the possibility of organizing some form of fund raising. I took my Sarawak experience back to Australia and within six weeks of my return launched FIERCE/InterRave, a multifaceted party, performance and symposium and what could be described in current terms as a precursor to today's Net-casts; a text-cast with about forty participants representing the Net-connected world in 1994. The event managed to raise enough money to

purchase three 9600-baud modems that I believe are still in use by NGO workers in Sarawak today.

FIERCE/InterRave began with a small collective of artists and networking experts who gathered over several evenings in Brisbane, Australia. They collaborated to produce an evening showcasing Brisbane's cabaret, band, and performance art communities. It also included what may well have been the first globally Internet-connected dance party (rave): FIERCE/InterRave at Brisbane's Boulder Lodge, a decommissioned cinema, on Friday September 24, 1992. Support for FIERCE was overwhelming. Performers from across Brisbane's creative community, Boulder Lodge, and the Queensland University Students Union donated their services and talents in kind. Sponsors included the Network of Overseas Students Collectives in Australia, 4ZZZ-FM, *Green Left Weekly,* the Environmental Youth Alliance, and Pegasus Networks.

The InterRave network enabled people at the FIERCE event to "jack into cyberspace" and speak to people across the globe. This was made possible with two dial-up connections to Pegasus through which we brought people into our IRC (Internet Relay Chat) channel (#interrave). The nightlong conversations that followed were projected onto two large video screens. Two InterRave booths were constructed in which people were invited to "talk" to international participants. The InterRave cooked all night with people from Norway, Finland, Scotland, Canada, Sydney, Canberra, Melbourne, San Francisco, and of course, the huge number of people who got into it at FIERCE. It became a truly international event. In fact it felt more like the launch of a new type of event. Many people commented, including those who joined us via InterRave, that they had never heard of or been to an event of this kind before. In Brisbane people were saying that Brisbane had never seen anything like it and that it should happen again. Altogether twenty-eight different acts performed on the night, and all of them wanted to do it again.

FIERCE/InterRave was about aiding the indigenous peoples of Sarawak in becoming more informed about the issues that affect them and in sharing that knowledge with others internationally. All proceeds from FIERCE went toward the purchase of modems that were eventually used in resource exchange programs. These programs facilitated information gathering and dissemination to indigenous peoples in remote regions and to their supporters internationally.

From BBS to Wireless

BBSs, or bulletin board systems, were the earliest publicly accessible computers, with the first one going on-line in Chicago on February 16, 1978. The Chicago BBS (CBBS)[6] was based on software written by Ward Christensen and Randy Suess, considered the fathers of public-access networks, at a time when ARPANET (the network of the Advanced Research Projects Agency, and the precursor to the Internet) was in its infancy.[7] These were computers, much like the large Internet networks of today, that people would dial in to, mostly exchanging files such as software, documents, and graphics. Data rates were very slow at the time, commonly three hundred characters per second, and modems were known as acoustic couplers and were mounted onto a telephone hand piece: The ear piece would receive data and the mouthpiece would send it.

There have been several attempts to chart the history of BBSs, the most comprehensive being Hobbes' Internet Timeline.[8] There are bound to be omissions even in this timeline, as BBSs grew from single computers to fully fledged networks, storing and forwarding data from one computer to the next, much like the structure of the Internet, except transfers were scheduled at specific times of the day to make use of cheaper call times, particularly if calls (referred to as polls) were made to interstate or international locations.

One of the largest BBS networks to grow out of the early 1980s, still in use in some countries, is Tom Jennings's FidoNet.[9] I was first introduced to FidoNet in 1991 with the implementation of Pactok. Individual Pactok users would have their FidoNet communications software automatically call their local node at least once a day; the local node would in turn poll the main Pactok computer, the hub, based in Sydney. The Sydney hub would poll Pegasus at regular intervals, providing Pactok users with an international gateway to other types of networks, most notably the Association for Progressive Communications (APC),[10] of which Pactok was an affiliate member of. Networks that operated in this way were known as "store-and-forward" networks. They were reliable, secure, and apart from telephone call charges, relatively cheap to set up and use.

Individual BBSs were the earliest equivalent of a Web site, as they were each set up around communities of interest. Perhaps the first BBS-style network established for international artists was Robert Adrian X's ARTEX, about which telecommunications artist Anna Couey writes:

ARTEX facilitated a number of telematic art events during the 1980s that investigated the collaborative making of text-based works, such as: *La Plissure du Texte: (a planetary Fairytale)*, the collaborative writing of a fairy tale, produced by nodes of artists in Europe, Canada, the United States and Australia, organized by Roy Ascott; and Planetary Network, in which internationally located nodes of artists sent "news" to each other and to a central exhibition node in Venice, Italy."[11]

The BBS model lives on. We can see it in the rapid emergence of blogs[12] and in the syndication of content specific to niche communities. I was personally surprised by the response to TS Wireless,[13] a streaming project initiated in 2002 that provided copyright- and royalty-free music to anyone with access to wireless technologies within a three-kilometer radius of Toy Satellite's transmitting aerial in Fitzroy, Melbourne, Australia. TS Wireless's Melbourne project used Internet tools (Web and audio-streaming servers) to enable access, but the model that grew from the project was very much in keeping with the spirit of the original BBSs. The curious aspect of the project was that many people in Fitzroy were very interested in establishing a connection to the Pegasus Network's service whether it provided Internet access or not. They wanted a local on-line community local information, local music, and opportunities to share ideas, concerns, and stories with people in their own area, regardless of who they were—it just had to be local! At the time of writing, TS Wireless is being relocated and will extend its trial project in collaboration with Melbourne Wireless, a collective of computer technicians and other wireless networking enthusiasts (figure 14.3). Its aims are to identify

- wireless bandwidth limitations;
- ability for users to program streams;
- possibilities for scheduled streams amongst other free2air hosts at international locations;
- interest in self-managed audio stream (social indicators);
- interest in external programming and commissioning of new works;
- management of copyright and royalty issues;
- use as tool within cultural context (i.e., complementing exhibitions and other related events);
- requirements for the addition of video.

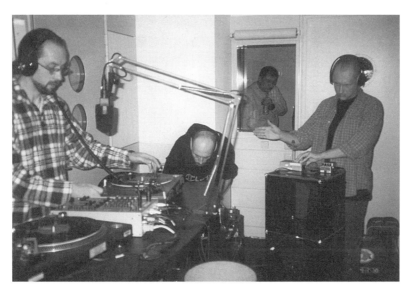

Figure 14.3 Andrew Garton and Sergio Messina performing with Theremins, live to air on Radio 4, ORF, Vienna, Austria, 1997. Theremins drew Andrew back to the notion of wireless communication. He went on to perform with the International Theremin Orchestra led by Elisabeth Schimana. Photo: Ludwig Zeininger.

And Where Do We Go from Here?

Information communication technologies (ICTs) are important, but let us not get too absorbed by them. I would like to quote the writer and cofounder of the first ICT services in the Philippines, Roberto Verzola (figure 14.4):

Because the seductive powers of computers and the Internet are so compelling, they have been drawing precious talents and material resources away from the major intellectual challenges of our time.

These challenges include:

• Persistent poverty in the midst not only of plenty but of scandalous wealth, occurring not only in poor countries but also in the richest.

• Gradual disintegration of societies battered by globalization. In the richest country in the world, there are more prisoners than farming families. In a poor country like the Philippines, more and more mothers and fathers leave their families behind to work abroad in search of decent employment.

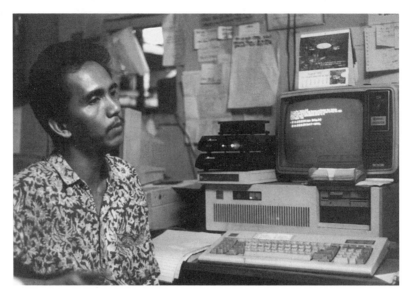

Figure 14.4 Roberto Verzola, founder of the first nongovernmental organization bulletin board service in the Philippines, The Email Centre, 1992. Photo: Andrew Garton.

• Unabated destruction of our ecological base. The ozone layer, our forests, natural habitats, and wildlife species continue to disappear. Our natural world is disintegrating.

• The flood of poisons into our life. Our working and living environment as well as our supply of air, food and drinking water are increasingly polluted by millions of tons of poisons that industries release every year. We are irrationally fouling our only ecological home.

• These are life-and-death issues. Are the world's best intellects working on them? What intellectual challenges occupy our youth today? Web design? Internet programming languages? Hacking? MP3s? Online transactions? Network gaming?

• Much of the online world, virtual reality and cyberspace life is going to be a very expensive diversion from the real pressing problems that humanity should be confronting squarely today.[14]

In late 2000, Toy Satellite produced a video and sound performance titled *SINAWE,* an attempt to understand the deep traditions of Korean folk music and performance and the relationship it attempts to sustain between humans and nature. ICTs sustain ICTs: They do not necessarily sustain people. As such, the life I have created through my art, that which I have lived

within telecommunications networks, and the one placed on microchips at the helm of my generative excursions becomes more and more about the art of living and the pursuit of evocative moments that perhaps only our species can identify.

Epilogue

One sees in the eyes of the new born a horizon of possibilities,

the dreams, hopes and aspirations of a species and the wisdom of its lineage. . . .

Let us not forget, through the intervening years,

despite all that ails us, we are children still,

if only we can but pause to listen, to listen to the silences. . . .

Then perhaps we may be wisdom, wisdom lived.

Notes

1. Guildford is an outer suburb in the urban sprawl of Sydney.

2. The 1972 election in Australia of a Labor government, led by Gough Whitlam, marked the end of twenty-three years of conservative government and the introduction of radical national social reforms, including a national community media access initiative, with community media centers opened across the country.

3. The Foster 8 Track Recorder was an early domestic multitrack tape recorder enabling up to eight individual tracks to be recorded, either simultaneously or independent of one another.

4. A newsgroup is an area on a computer network in which discussion on specific topics takes place.

5. Christine Fogg, "Internet: Pactok—The Pacific Speaks in Cyberspace," *Reportage Media Bulletin* (November/December 1996), available at <http://www.asiapac.org.fj/cafepacific/resources/aspac/pactok.html> (accessed August 2003).

6. Ward Christensen and Randy Suess, "The Birth of the BBS," available at <http://www.chinet.com/html/cbbs.html> (accessed August 2003).

7. The first plan for the network of Advanced Research Projects Agency (ARPANET) was created in 1966 by Lawrence G. Roberts of MIT: "Toward a Cooperative Network of Time-Shared Computers" (October). For more information see Michael Hauben, "Behind the Net: The Untold History of the ARPANET," specif-

ically "Part I: The History of ARPA Leading Up to the ARPANET," available at <http://www.dei.isep.ipp.pt/docs/arpa—1.html>.

8. Hobbes' Internet Timeline, version 7.0 (January 1, 2004), available at <http://www.zakon.org/robert/internet/timeline/> (accessed March 23, 2004).

9. Jerry Schwartz, *The FidoNet Primer* (1995), <http://www.writebynight.com/fidonet.html> (accessed August 2003).

10. The APC's Web site is <http://www.apc.org> (accessed August 2003).

11. Anna Couey, "Cyber Art: The Art of Communication Systems," *Matrix News* (Matrix Information and Directory Services, Inc. [MIDS] 1, no. 4 (July 1991), available at <http://eserver.org/art/art-of-comm-system.txt> (accessed March 23, 2004).

12. A blog is a Web-based personal publishing format, much like a diary or journal, with a variety of interconnectivity options available.

13. Information about TS Wireless is available on the Toy Satellite Web site </http:wireless.toysatellite.org/> (accessed August 2003).

14. Roberto Verzola, from a now extinct post to a Pegasus mailing list.

15

REALTIME —
Radio Art, Telematic Art,
and Telerobotics:
Two Examples

Heidi Grundmann

Introduction

It was suggested that with this text I deliver an eyewitness report of *REAL-TIME*. But while trying to comply with this idea, I realized that my memories of this and many other projects for which I took responsibility as a producer and curator are quite myopic and blurred because I was already busy with other projects during the preparation of *REALTIME* (and the closely connected *CHIP-RADIO*), and I was consumed by the usual horrific anxieties as the helpless curator during the events themselves. So I decided to rely mainly on artists' descriptions of the project and some of its precursors. These descriptions were mostly formulated at the time of the realization of the projects, or shortly thereafter, and should therefore also be interesting examples of the thinking and terminology used at the time.

CHIP-RADIO (1992) and *REALTIME* (1993) are among the most mature and contained projects within a very specific development of radio art during the 1990s. Within this wider development, which from 1994 onward included the extension of the radio space into the World Wide Web and vice versa, those two projects mark high points in what could be described as the exploration of a convergence of telematic art, telerobotics, and radio art.

That it was possible to realize *CHIP-RADIO* and *REALTIME* at all was due to the uniquely Austrian pattern of (mainly institutional) support and access, combined with the configuration of artists involved with the projects, and relationships formed through their experience of earlier art in the electronic space. The strong conceptual grounding of their theoretical and practical expertise in the new technologies and their understanding of the technologies' cultural impact led these artists to the development of elaborate collaborative strategies and the successful application of these strategies in the "occupation" of "found" old and new media spaces and the productive integration of their quite differing personal aesthetical positions and backgrounds.

Institutional Framework

In October 1991, both the Museum of Modern Art in Vienna and the Tiroler Landesmuseum Ferdinandeum in Innsbruck simultaneously served as the site of an international symposium, "The Geometry of Silence."[1] Using the example of radio art, the symposium was dedicated to the theory and practice of an art in the electronic space and included lectures, performances, installations (on site and later in their radio versions) by international artists and theoreticians, among them Robert Adrian X, Roy Ascott, Friedrich

Kittler, Richard Kriesche, Isabella Bordoni and Roberto Paci Dalò, Concha Jerez and Jose Iges, G. X. Jupitter-Larsen, Pool Processing, Mia Zabelka, and, from a much greater distance, Qweck Bure-Soh in Paris and Jon Rose somewhere in Australia. The telephone lines connecting the two museums were provided by the ORF (Austrian Brodcasting Corporation) and by the OPT (Austrian Post and Telecommunications). The ORF support came via the regional studio in Innsbruck and the national cultural channel, Oesterreich 1, with its radio art program *KUNSTRADIO. KUNSTRADIO* also succeeded in persuading the OPT to provide a dedicated digital line linking the two museums, which had to be specially adapted for the new mobile videoconferencing system provided by Siemens for the project. The relentless insistance of one of the participating artists, Mia Zabelka, drove me to persist in the effort to secure such an (at the time) state-of-the-art system. And Mia was right. The videoconferencing system with its unusually large monitor added an important dimension to the connection between the two sites of the symposium and to projects not only by Zabelka herself (figure 15.1), but also by Bordoni and Dalò and others.

Zabelka's teleperformance *Space Bodies*[2] would also have been the first live telematic radio performance using telerobotics in *KUNSTRADIO*'s history—if there had been broadcasting time available at the time of the event. As it was, an adapted radio version was broadcast a few weeks later:

A fantastic idea: two violins, which are played by one and the same person—and what is more—simultaneously and at a spatial distance: with one of the instruments in her hand, the performer is located at Palais Liechtenstein in Vienna, while the other instrument she is playing, is situated at the Ferdinandeum in Innsbruck.

It was the well known violin—and performance—artist Mia Zabelka who realised this uncanny mise-en-scene. By the artistic use of electronic media she has claimed a new reality. Mia Zabelka describes "Space Bodies" as an "interaction of human being, machine and electronic medium in two distant spaces":

At space 1 (Palais Liechtenstein) the artist herself is performing with her violin, in space 2 (Ferdinandeum) an electropneumatic violin is installed. This violin is handled in a way similar to the handling of modern robots. It is equipped with sensors, which are controlled by a computer. Space 1 and Space 2 are connected to each other by a computer network. The "networked" performer and the "networked" music-machine are interacting at a distance by forming an integrated circuit through the respective control of their playing.[3]

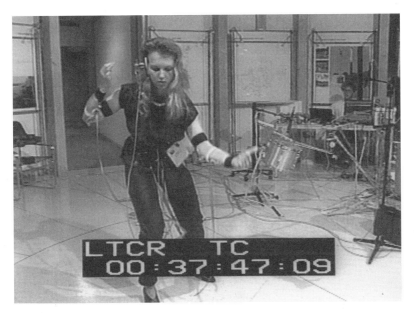

Figure 15.1 Mia Zabelka, performing *CHIP-RADIO* in Salzburg, 1992. Photo: *KUNSTRADIO* Archive, Vienna.

Whereas the cooperation of *KUNSTRADIO* with the museum in Vienna was not continued after "The Geometry of Silence", *KUNSTRADIO*'s cooperation with the Ferdinandeum in Innsbruck resulted in Guenther Dankl (Ferdinandeum media art curator) and myself (producer of *KUNSTRADIO*) acting as principal cofounders of the not-for-profit organization TRANSIT, a unique support structure for the realisation of artistic projects in the electronic space, especially in the space of the mass media radio and television.

TRANSIT was founded in response to the fact that *KUNSTRADIO,* originally meant to be just another late-night "experimental" radio art program had, from its very beginning in 1987, become involved in the organization and production of large-scale international radio art projects and events. Because of *KUNSTRADIO*'s very small budget (appropriate for what was then a forty-five-minute weekly broadcast), this involvement was possible only in ad hoc partnerships with established and well-funded festivals such as the Steirische Herbst in Graz, the Ars Electronica, Festival in Linz, or the Wiener Festwochen in Vienna. TRANSIT was an attempt to institutionalize the model of collaboration between partners with financial resources (in this case

provided by national and/or regional cultural ministries) and those with technical resources and infrastructure (in this case the ORF regional studio in Innsbruck).

CHIP-RADIO

Working in the electronic space, working with contemporary technology entails coming to grips with an environment we are faced with on a daily basis.

—FROM GERFRIED STOCKER'S INTRODUCTION TO THE RADIO VERSION OF *CHIP-RADIO,* BROADCAST ON OCTOBER 1, 1992

CHIP-RADIO was the opening event of TRANSIT. The project had been initiated by Zabelka, and she also brought with her the Swiss sound artist Andres Bosshard, who in turn invited the Polish actor Waldemar Rogojsza. Technical expertise in the use of telcommunications systems, computers, and robotics was supplied by Gerfried Stocker, Hörst Hoertner, and Seppo Gruendler (all from Graz), who had been part of *Puente Telefonico,* the first live telematic radio project produced by *KUNSTRADIO. Puente Telefonico* took place on August 6, 1992, and connected the public interactive sculpture *Sound Poles* by Hoertner and Stocker at Expo'92 in Seville, Spain, with a live radio studio at the ORF Broadcasting House in Vienna. *Sound Poles* consisted of an array of twenty-seven fiberglass poles (up to six meters high) fixed vertically in the floor of the plaza in front of the Austrian pavilion at the exposition. The public was encouraged to "play" the installation, and the resulting movement of the poles was registered by sensors and transmitted to a computer, where it was translated into control signals that triggered sampled sound events that were fed back to the plaza. The installation was connected to a modem so that it could be remotely serviced by the artists via telephone every day from their studio in Graz. The existence of this standing connection made it possible to use the modem for teleconcerts, among them *Puente Telefonico.* For this event, Hoertner, Gruendler, and Josef Klammer were in Sevill and connected via modem with Stocker and his computers, sampler, and sequencers in the live-transmission studio in Vienna. Stocker was able to add new sounds to the sounds triggered from Sevilla in the Vienna studio for the live broadcast and to send his control signals to the *Sound Poles* computer in Spain.

CHIP-RADIO

A simultaneous telematic concert by:

Andres Bosshard, Seppo Gruendler, Gerfried Stocker and Mia Zabelka

October 1, 1992, 10:15 p.m.

Performed live at the regional studios of the ORF in Tyrol, Salzburg, Vorarlberg and broadcast on the programme "Kunstradio–Radiokunst" on Oesterreich 1

Innsbruck/Foyer of the Broadcasting House:

Gerfried Stocker (Sampler)

Waldemar Rogojsza (actor, cues by Andres Bosshard, Dornbirn)

Robot-violin: Martin Riches (played by Mia Zabelka, Salzburg)

Three E-guitars (played by Seppo Gruendler, Salzburg)

Studio 3: Ewald Wabnig: live mix of the "Kunstradio" programme, following a concept by Andres Bosshard

Salzburg/Foyer of the Broadcasting House:

Mia Zabelka (violin, sampler, percussion)

Seppo Gruendler (E-guitar, MIDI saxophone)

Percussion (played by Gerfried Stocker, Innsbruck)

Dornbirn/Foyer of the Broadcasting House:

Andres Bosshard (cassette machinery)

Marimba (played by Gerfried Stocker, Innsbruck)

Synthesizer (played by Seppo Gruendler and Mia Zabelka, Salzburg)

Acoustics: Andres Bosshard

Network Design: Hörst Hoertner

Sound engineers: Ewald Wabnig and Hans Soukup[4]

For *CHIP-RADIO* it was possible to secure three of the regional ORF radio and TV studios as locations. Five of these studios (Graz, Linz, Innsbruck, Dornbirn, and Salzburg) were built from the same plan by architect Gustav Peichl and are architecturally—and therefore acoustically—practically identical. A conspicuous feature of the buildings is a circular foyer three storys high, forming a kind of atrium. The foyer of at least one of these regional studios had already become a "historical" site of telematic events: In 1982 "The World in 24 Hours" (initiated by Robert Adrian X) took place in the Upper Austrian regional studio in Linz. The ORF regional studio foyer has remained a favorite location for networked projects, and

CHIP-RADIO and *REALTIME* each managed to connect three of them in a single project:

The found infrastructure of the data and transmission networks between these locations is occupied by the artists and becomes their most important "instrument," an instrument that facilitates a networked interaction far beyond the parameter of mutual visibility. Each artist can immediately become present at the other locations and exert influence on them. The instantaneous feedback of the telematic activities permits a precise control of the interplay.[5]

The artists used data gloves (Stocker), arm interfaces (Zabelka), a MIDI saxophone (Gruendler), or a graphical interface (Gruendler, Zabelka) to play instruments and robotic devices at other locations. They—and the respective audiences—could see glimpses of the remote participants on video monitors. But what is more, they saw the effects of their movements and actions on the situation at their own space: Marimbas, the violin robot, the drums, the guitars played as if touched by the hands of ghosts. The art historian Romana Froeis wrote in *TRANSIT #1:*[6]

The telematic simultaneous concert CHIP-RADIO rendered processes in the electronic space physically and psychologically perceptible, which per se remain incomprehensible. . . . Salzburg transmitted its spatial acoustic together with the sounds from Innsbruck, to Dornbirn. There they were enriched by the local spatial acoustic and sent on to Innsbruck and so on. The circulation of the loop of spatial sound could have easily turned into an acoustical feed-back situation, if Andres Bosshard had not programmed it as a very differentiated spatial mix.

A short text written by Hoertner, who had been responsible for the network design of *CHIP-RADIO,* concluded:

The main part of the work on this network was determined by software development and the coordination of the protocols of computers and robots. The main problem was the exchange of quite gigantic quantities of data for the requested behaviour in realtime. . . . a successful performance and the transmission of the musical events via radio—both of them of captivating quality—were the answers, which the artists were capable to formulate with the help of this (network-) installation.[7]

Artists as Experts

CHIP-RADIO confronts the distributive mass-media radio with the reality of intercommunicative networks in order to—within this field of tension—arrive at a sounding of the potential of both media.

—ON-LINE PROJECT DESCRIPTION

An important part of the history of electronic music, radio drama, and Ars Acustica was possible only because of the access artists, composers, and authors had to state-of-the-art production studios and to the policy of cultural broadcasting by the national public radios, both in Europe and elsewhere. With their attempt to bring something of the elastic "horizontality" of the networking experience to the rigid, producer-oriented "verticality" of the public-radio institutions, artists began to become interested in gaining access to the administrative and technological infrastructure of transmission itself.[8] This shift also implied a profound change of the relationship between the artists and their counterparts inside the organizations. This relationship required a type of artist/technician/media expert who was capable of motivating engineers, producers, and administrators alike to become allies and/or innovative partners in the realization of art projects, sometimes against considerable resistance by colleagues and superiors. In the first half of the 1990s, these artists often were much more aware of the impact of digitalization on older communication technologies—and on culture and art generally—than most of the professionals inside the big institutions of public broadcasting (or of commercial broadcasting for that matter).

"REALTIME"

December 1, 1993, 11:45 p.m.

A telematic concert-performance in real-time, which takes place simultaneously at the regional studios of the National Austrian Radio and Television (ORF) in Graz, Innsbruck and Linz and is broadcast live on TV and radio.

REALTIME uses all available video-, sound- and data-networks for the interaction of the protagonists present at the three provincial studios. From this interaction the live-broadcasts are produced in real-time. . . . For this purpose, the three studios are connected by a circular data-network.

REALTIME as broadcast on radio is not the stereo-version of the TV sound and REALTIME on the television-screen is not just the image to the sound. The two

per se autonomous broadcasting spaces form a joint location for the medial representation of what is happening.

Graz:
Isabella Bordini—voice, performance
Gerfried Stocker—sound sampling

Innsbruck:
Andres Bosshard—cassette-machinery, live sound mix
Hörst Hoertner—performance
Mia Zabelka—violin

Linz:
Roberto Paci Dalò—clarinets, electronics
Waldemar Rogojsza—voice, performance
Tamas Ungvary—computer music, computer-animation
Kurt Hentschläger—computer graphics
Michael Kreihsl—lighting, TV-production
x-space: Hörst Hoertner, Gerfried Stocker - network design, interface design
Martin Schitter—programming
Andres Bosshard: sound design
Hans Soukup and others: ORF radio and TV engineering[9]

The artists involved in *CHIP-RADIO* and *REALTIME* came from very different backgrounds. I have already referred to Zabelka's earlier projects and her important role in *CHIP-RADIO,* to which she brought Bosshard, just as she introduced the well-known electroacoustic composer and specialist in composer-machine relations Tamas Ungvary, who was teaching in Vienna at the time, to *REALTIME.*

Bosshard had already realized three huge outdoor sound projects prior to joining the *CHIP-RADIO* team, including *Telefonia* (1991), an intercontinental telematic installation connecting Winterthur, the Saentis mountain (both in Switzerland), and New York (with Ron Kuivila).

Gruendler, could be said to represent a second generation of Austria-based telecommunication artists influenced by Richard Kriesche and his conceptual, deeply critical attitudes toward technology and the definition of the role of art and artists in society, whereas Stocker and Hoertner (working together as x-space since 1990) represented a third generation. In 1992–1993, Stocker (as a cocurator) and Gruendler (as one of the main contribu-

tors) were deeply involved in "ZERO—the Art of Being Everywhere,"[10] a year-long project formulated by curator (and arguably first-generation Austrian-based communications artist) Robert Adrian X.[11]

Kurt Hentschlaeger was already working with Ulf Langheinrich on their ongoing project *GRANULAR SYNTHESIS.* An early version, Model 3.02, performed in December 1992, was a TRANSIT production at the regional ORF studio in Innsbruck with the remote live participation of a dancer at the regional studio in Salzburg. Hentschlaeger, as part of the group Pyramedia, had also been involved in the organization of the Austrian participation in the legendary live TV and network project *Piazza Virtuale* by Van Gogh TV at Documenta 9 (the Austrian group also included Hoertner and Stocker and involved ZEROnet, a bulletin board system for artists originally part of "Zero.").

Isabella Bordoni and Roberto Paci Dalò had been pursuing their ongoing project in progress *Giardini Pensili* since 1985 within many media, at many locations, and with the cooperation of many other artists, musicians, and writers. Their multilayered work led them almost automatically into the field of new technologies. By 1993 they were also running the international festival L'Arte dell'Ascolto,' which over the years dealt with a changing notion of an extended (networked) radio art under the impact of new technologies: "In the development of art projects in electronic space today, we cannot avoid the beauty of a continuous interchange between old and new technologies."[12]

Problems of Documentation

Such art-events are unrepeatable, they can only be further generated. That is also why they challenge traditional definitions of concepts such as author, copyright, originality and virtuosity: they lose their authority.
—R. FROEIS

It is physically impossible to experience networked projects that are simultaneously produced in separate locations other than as versions: The project as a whole eludes human perception. This aggravates the already serious problems of documentation and interpretation common to all fugitive, process- or time-based art projects, with the unfortunate result that many distributed telematic projects have been insufficiently documented and hardly

interpreted at all. One such project was the seminal *RAZIONALNIK* (1987), which added the phenomenon of telepresence to the exchange models of simultaneously produced and networked art. *RAZIONALNIK* was initiated, organized, and programmed by Gruendler and Klammer in Graz with partners in Budapest (Gabor Plesser), Ljubljana (Lado Jaksa), and Trento (Claudio Carli) (figure 15.2). Just as with many other projects that were realized within the frameworks of festivals or exhibitions, all that remains[13] is a description of the artists' conception in a catalog published before the event:[14]

Acoustic couplers, samplers (digital storage of nature sounds), synthesizers, personal computers and the international telephone network are the means to connect musicians from different countries. These connections make it possible to realize a concert, whose musicians are not in the same space, but realize a collaborative concert from different countries. They use instruments, which are not producing sounds, but so-called MIDI data. These data are either transformed into sounds by sound modules, or they are converted by computers and acoustic couplers into data which can be transmitted via telephone. At the other end of the line these data are again rendered into MIDI data and after that into sounds. The sound material used consists on the one hand of sampled sound quotations, and on the other hand of traditional synthesizer sounds, produced by all of the musicians. The result can be heard live, in Graz as well as in all the participating locations. Due to the data delays, not one of the locations will offer the same sounds simultaneously. In Graz, the computers will additionally manipulate the MIDI data according to certain algorithms, i.e., the computers not only are converting data, but also take on an important role in the structuring of the concert. Each participant, by his personal choice of sounds, is granted the possibility to render the concert at his local site into a very special version by transforming his own or the MIDI data received from Graz.[15]

The installation of *RAZIONALNIK* in the exhibition Entgrenzte Grenzen (Debordered Borders) did not take place exactly as envisioned in the documentation in the exhibition catalog, just as a planned CD of the project could not be produced because, according to the artist; "out of ideological reasons, the sound-engineer in Graz refused to do the arranged recordings."[16] As it turned out, Carli, in Trento, was not able to participate because of a strike of the Italian post office. Before the event, Gruendler and Klammer, who sometimes called themselves "media-musicians" in analogy to the "media-artists" with whom they frequently collaborated, were obliged to travel to

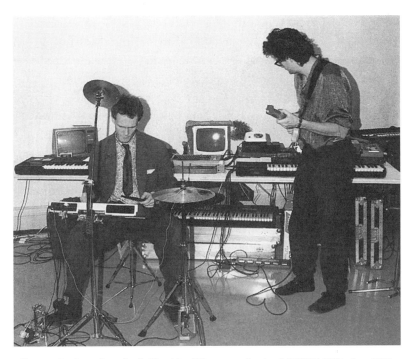

Figure 15.2 Seppo Gruendler (left) and Josef Klammer, performing *RAZIONALNIK* in Graz, 1989. Photo: *KUNSTRADIO* Archive, Vienna.

all the locations of *RAZIONALNIK* to personally brief the participants "due to the newness of the technology. . . . Because of the Coordinating Committee for Multilateral Export Controls (COCOM) list—which prohibited the import of computers into the East—we also had to smuggle acoustic couplers (300 baud) into Hungary. . . . As PTO-approved [Post and Telecommunications, Austria] modems were prohibitively expensive in Austria we smuggled German parts into Austria." From these parts the artists built the modems (1200 baud) for their Commodore C64 computers in Graz. The program to convert the modem data into MIDI was written by Gruendler. During the event, "the slow data rate led to big delays, e.g., a chord would turn into a melody; there were great difficulties in keeping the lines up, we had to redial several time. Most people [in the audience at the Kuenstlerhaus in Graz] believed that we were playing in analogue via telephone."[17]

As a result of the efforts of the artists, *CHIP-RADIO* and *REALTIME*, both of which of course owe a great deal to *RAZIONALNIK*, are unusually

well documented. But although the projects took place with several sound engineers on hand, no separate recordings exist of the two separately fed radio-stereo channels of *REALTIME.* Also, in spite of the clear structure of the two projects with their three equal nodes in one country/time zone and the relatively small number of artists involved, the unique opportunity to document how such networked collaborative projects come about was not pursued, even though it was one of TRANSIT's original aims to develop new approaches to the issues of documentation of (as was known from telecommunication art) basically undocumentable (and unrepeatable) projects. However, x-space took on the task of producing a video from the qualitatively uneven visual material from the three different locations of *CHIP-RADIO,* using the radio version as the soundtrack.[18]

It was this video documentation of *CHIP-RADIO* that provoked the artists to think about the possibility of developing a new project that would directly involve not only radio but television, and soon we began to speculate on the possibility of including one of the two Austrian national TV channels as a further extension of such a project and a "window" to its telematic stage.

Simple sound and/or video recordings of such technically complex and physically dispersed events can never reach beneath the acoustic or optic surface to disclose the events' structural depth, but the emergence of the Internet gave reason for hope that this depth might be revealed. When x-space went on line with its Web server in 1994, it immediately discovered the potential of the World Wide Web, not only as a medium for new telematic radio projects, but also for the documentation of their precursors such as *CHIP-RADIO* and *REALTIME.*

REALTIME

What I remember best is the process of collaboration and the intensive discussions between us as colleagues/friends at long face-to-face meetings most of us had to travel to. This process was as interesting, maybe even more interesting than the result itself.
—KURT HENTSCHLAEGER, 2002

The preparation of *REALTIME* took more than six intensive months. The artists lived and worked at different locations and were obviously in close con-

tact with each other and also with the ORF technicians allocated to the project, especially Hans Soukoup in Innsbruck. The meetings, some of them over entire weekends, led to the collaborative development of the overall concept and many of its details as well as to a distribution of tasks among the artists. Bosshard took on the acoustic design; Dalò became responsible for the "theatrical" production and Hentschlaeger for the graphic design of the live TV program; x-space again got involved in the network design (Hoertner) and the development of remotely controlled instruments and interfaces (Stocker):

With the help of a helmet-like apparatus worn by Hörst Hoertner in Innsbruck, the head movements of the artist were registered by a computer which translated them into digital control codes. Via data lines a robot camera in Linz was directed synchronously to the head movements.

Gerfried Stocker in Graz used data gloves to reach through the electronic space to play robot-instruments and computer-controlled sound sculptures distributed in Innsbruck and Linz.

On the ceiling of each of the three studios a rotor with tubes was installed. The speed of the turning of the motors and thus the pitch and structure of the sounds produced by the tubes could be controlled in real-time via the data network by Roberto Paci Dalò in Linz on his clarinet.[19]

Zabelka in Innsbruck used wrist interfaces to interact once again with Martin Riches' violin robot, which was equipped with a network interface.

An additional "level of reality" extended the interaction of Zabelka's violin with the robotic violin as Ungvary, in Linz, not only controlled sequencers in all three studios with his fingertips, but also used his "Sentograf" to activate an animation program to produce virtual violinists who, via video line and "blue box" tricks, joined the "real" Zabelka and the electromechanical violin robot.

The various "instruments" created for *REALTIME*—and the wide scale of different body movements required to activate each instrument—were deliberately intended to enhance the dramatic power of the images visualizing the relationship between the actions of the performers in one location and their results in distant places. The instruments also elaborated on the concept of the wired "space bodies" to which Zabelka had referred in her earlier performances with her shiny skintight suits evoking female figures in popular

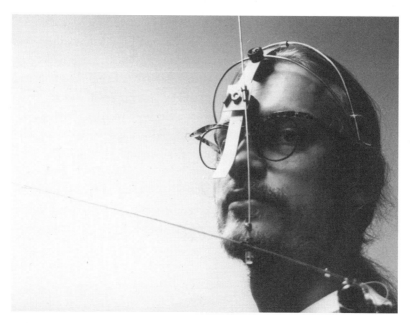

Figure 15.3 Hörst Hoertner, performing *REALTIME* in Innsbruck, 1993. Photo: *KUNSTRADIO* Archive, Vienna.

science fiction. The giant mixing console in front of Bosshard's half-hidden body, Ungvary's assemblage of computers obeying the finest vibrations of his fingertips; the vocoder taped to Bordoni's face that sometimes equipped her with a deep voice, contrasting sharply with the features of her very feminine, almost childlike face; the huge and expressive data gloves at the end of Stocker's arms or Hoertner's "helmet" (figure 15.3)—all had cyborgian qualities. On the other hand, these qualities were ambivalently toned down by the grey retro business suits the male performers wore in response to Dalò's stage instructions:

In REALTIME the image is again not corresponding to the technology. Clearly old fashioned costumes referred to the beginning of television broadcasting, in order to establish a discordance between the image, the sound and the concept as a whole. Roberto Paci Dalò himself, playing the clarinet recalled the old figure of the traditional soloist while the violinist Mia Zabelka with her wired wrists and clad in a waisted dress with a wide skirt acquired a puppet-like quality reminiscent of "The Tales of Hoffmann."

REALTIME

The Transparency of the Medial Space

The great challenge of the project REALTIME lies in the creation of an interface between the different levels and spaces of action, which is equally accessible to the radio, TV and on site-audiences: acoustic and visual entry points for the communication among the protagonists as well as for the intermedia projection of what is happening, into the transmission spaces of radio and TV.

The distributive one-way media radio and TV present special problems:

• the necessity, to represent synchronous parallel processes in real-time,

• to capture the simultaneous collaboration in the three regional studios,

• to condense the constant tele-presence of the performers into a comprehensible tele-representation.[20]

Michael Kreihsl,[21] commissioned by ORF to direct the TV version of *REALTIME,* decided to adhere to a documentary technique to translate the "found facts" of the complex networked events at the three (almost identical) locations onto the TV screen. In his visual narrative he avoided explanatory means: For about half of the program time, the viewers had the impression that what they saw was taking place in only one location. It was only when the director began to use split screens that the three different geographical locations of the protagonists revealed themselves. Kreihsl said he employed this technique because he wanted the viewer "to discover more and more on their own. In this way, s/he is collaborating."[22] Much attention was paid to the lighting of the three studios, which avoided the usual undifferentiated TV atmosphere and worked with high contrasts.

To the layer of "real images" created by Kreihsl's orchestration of the TV cameras, Hentschlaeger added layers of live computer-generated and -controlled "artificial images" as well as graphical elements such as backgrounds, textures, fonts, and masks, thus emphasizing the flat surface character of the screen/window within a much deeper networked architecture of real and virtual spaces. Bosshard navigated the "the complex sound-structure of the event from his own special matrix-mixing-console in Innsbruck via a circular architecture of audio-lines"[23] especially designed by him to link the three locations, to which he added his own spatial loudspeakers to create immersive sound installations for the live audiences in the studios.

He also challenged viewers/listeners to play the role of potential collaborators, in that they were requested to rearrange their TV and radio loudspeakers to realize the full spatial potential of the three audio channels (the mono channel of the TV and the two channels of the stereo radio), which Bosshard fed separately with live sounds:

The atmosphere, the resonance between the three channels creates a space. While on TV only an excerpt can be seen, this space is three-dimensional. Like a hologram. This space-sound evolves, if Oesterreich 1, the radio station is tuned into sstereophonically—for best results in the back, while ORF 1, the TV station, with its one channel sounds in the foreground of the room.[24]

In spite of the innovative nature of *REALTIME* and the project's many new and largely untested elements, the artists, sound engineers and TV crew had only three days (and nights) to prepare the on-site locations, the transmission parameters, and the collaborative virtual network space. After the event, Stocker recalled:

While the TV crew directed by Michael Kreihsl was busy coordinating the positions of the 12 cameras and the lighting of the three entrance halls, and Andres Bosshard, after a process of minute planning, worked—via intercom—and together with sound-engineers of the ORF on the arrangement of loudspeakers and microphones to tune the spaces, the complete level of the interaction of body-interfaces and robots was implemented into the network structure between the studios by Hörst Hoertner, Martin Schitter and myself.

We worked for three days pretty much around the clock and were connected to each other on the different levels of the network. We could hear and see each other at all times, the computers were networked, the software was exchanged and further developed via modem.

A completely unique laboratory-situation evolved. None of us had ever before spent such a long time without interruptions within such a virtual space of immediate tele-presence.[25]

The event itself lasted only thirty minutes, and of course, it was the pressure of TV that dictated such a short (and late) broadcast time (the TV program slot in which *REALTIME* unfolded was)—appropriately—called *Around*

Midnite). The transgression of this dictate of broadcasting times for a series of networked radio projects came a few years later: on air, with the extension of broadcast nodes into different time zones around the globe, which made a twenty-four- or eighteen-hour project framework necessary,[26] and on-line and on site with the streaming technologies of the World Wide Web and their potentially unlimited time frame, as well as the resulting pull from performances to installation-like events.

Although many, like Hentschlaeger, are still awed in retrospect by the networked bandwidth available for *REALTIME*'s visual elements, the project remained essentially outside the traditions of television and especially of so-called multimedia formats. Rather, this and later telematic radio projects reflected the hybridity of networks and mass media, of bodies and machines. And rather than believing in their convergence into one great medium, the artists, just like other specialists in the practice of media, detected an intermedia situation, with processes of constant "remediation" between older and new media—a situation in which each of the loosely and often temporarily collaged channels demands that one pay specific attention to it without losing sight of the channels' essential interconnectivity.

Notes

1. *Die Geometrie des Schweigens* [The Geometry of Silence] (catalog) (Vienna: Museum Moderner Kunst Stiftung Ludwig, 1991).

2. As a precursor to *Space Bodies,* Zabelka had realized *Drahtvenuskoerper* (Wire-Venus-Body, December 1990), a "radio-performance for live-telephone-violin and -voice," in which the artist performed and mixed her material not in the studio from which the program was transmitted, but in a small production studio on a different floor of the broadcasting house in Vienna. Thus, she made use of the wiring between studios in such a building as one part of the infrastructure of her live radio project, which also included telephone lines to transmit the sound of a live violin and/or voices from a distant answering machine. In both performances, as later in *CHIP-RADIO and REALTIME,* the/her body wired/interfaced to machines and networked transmission technology was part of the content of her performance.

3. From the introduction to the radio version of *Space Bodies,* December 12, 1991.

4. From the *CHIP-RADIO* brochure prepared for the Prix Italia, 1993.

5. From the description of *CHIP-RADIO* by Gerfried Stocker. This and other project descriptions can be found at <http://gewi.kfunigraz.ac.at/~gerfried/>, the home page of x-space (Gerfried Stocker/Hörst Hoertner). The x-space homepage is mainly in German; the translations used here are my own.

6. Romana Froeis, "Chipradio," in *TRANSIT #1, Materialien zu einer Kunst im elektronischen Raum,* ed. Heidi Grundmann (Innsbruck, Austria: Haymon Verlag, 1993).

7. Hörst Hoertner, ""Network Design Chipradio" in *TRANSIT #1, Materialien zu einer Kunst im elektronischen Raum,* ed. Heidi Grundmann (Innsbruck, Austria: Haymon Verlag, 1993), 60–61.

8. There are some impressive examples of such a shift toward the use of broadcast transmission technologies prior to the use of computer networks in radio art, among them projects by Max Neuhaus (notably *Radio Net,* 1977) and Bill Fontana. All explored issues of simultaneity and live radio connectivity. s.a.: ZEITGLEICH, German/English. ed.: TRANSIT a.o., TRITON, Vienna, 1994 and <http://kunstradio.at/ZEITGLEICH/>.

9. From the announcement of *REALTIME,* a folder sent out by mail that served as an invitation to onsite audiences in the three performance locations as well as to radio and TV audiences.

10. "Zero" included ZEROnet, a bulletin board system for artists, and produced the symposium ON LINE – Kunst im Netz. s.a. ZERO – the Art of Being Everywhere. Ed.: Steirische Kulturinitiative, 1993, Leykam Buchverlagsgesellschaft, Graz. ON LINE – Kunst im Netz. Catalogue of a ZERO- symposium. German/English Ed: Helga Konrad, Steirische Kulturinitiative. Graz, 1993. ISBN 3-901334-00-9

11. Like that of many other artists, including some of those those involved in *CHIP-RADIO* and *REALTIME,* Robert Adrian X's understanding of the relationship of technology, media, society, and art had been poisoned by the Gulf War.

12. Isabella Bordoni and Roberto Paci Dalò, "Lingua Madre," a paper on opera and digital technology, languages and translation, voice and text and the dangers of radio, in *TRANSIT,* ed. Heidi Grundmann ZEITGLEICH (Vienna: Triton, 1994), p. 111 available at <http://kunstradio.at/ZEITGLEICH>.

13. There is one photograph of the performance in Graz, which was published as an illustration to a text by Richard Kriesche. s. "Im Netz der Systeme," *Kunstforum* 103, (1989). (Catalogue of Ars Electronica Festival, 1989).

14. *RAZIONALNIK* was part of the exhibition/series of events Entgrenzte Grenzen, initiated and curated by Richard Kriesche.

15. Translated from the exhibition catalog: Richard Kriesche, ed., *Entgrenzte Grenzen,* Graz, 1987, "kulturdata", Sackstrasse 22, A 8010 Graz.

16. This and the following quotations in this paragraph are from the transcript of a short conversation in which the two artists tried, in 2002, to recall their project. An e-mail containing the transcript reached me on October 3, 2002.

17. Just as with most of the networked projects of the 1980s and 1990s, what is usually untold is the story of the total self-sacrifice of the artists (and technicians motivated by them) involved in such projects and the resulting exhaustion after the event. With *RAZIONALNIK,* Gruendler and Klammer, who had not slept for four nights, fell asleep at their table at a Graz cafe while having an after-event drink. With *REALTIME,* which I witnessed in the foyer of the regional Broadcasting House in Linz, one of my most lasting impressions is seeing—no doubt in a state of great relief as everything had gone very well—the feet of Martin Schitter, who was asleep on the floor under his computers as soon as the signature tune was played to close off the live event on radio and TV.

18. The audio recording and the video of *CHIP-RADIO* were so impressive that in 1993, the radio version was sent to the prestigeous Prix Italia competition as the official contribution of the ORF in the category of music. The project was also awarded a honorable mention at the Prix Ars Electronica. One year later, in 1994, *REALTIME* was listed second to the Golden Nica for interactive art at the Prix Ars Electronica.

19. The description is a summary of part of the online documentation of REALTIME submitted to the Prix Ars Electronica.

20. This is a quote from the project description of "Realtime" submitted to the Prix Ars Electronica.

21. Kreihsl, at the time a freelance TV producer, in the meantime has become a well-known Austrian theater and film director.

22. Michael Kreihsl, <http://gewi.kfunigraz.ac.at/~gerfried/bio/kreihs2.html>.

23. Andres Bosshard, a quote from the project description of "REALTIME" submitted to the Prix Ars Electronica.

24. Andres Bosshard, in the introduction to the radio version of *REALTIME,* December 1, 1993.

25. Quoted on the x-space Web site <http://gewi.kfunigraz.ac.at/~gerfried>.

26. Horizontal Radio, <http://kunstradio.at/HORRAD/horrad.html>; Rivers and Bridges, <http://kunstradio.at/RIV BRI/index.html>

Part III

Networking Art/Activist Practices

This part of the volume focuses on networking: from metaphor to medium, from the intimate to the global. The chapters here approach networks from political, economic, historical, cultural, and aesthetic perspectives. They foreground the relations between artist/activist networks and wider social, physical, and technical communication networks. Extending the discussion of networks that threaded through earlier parts, these chapters engage with the paradoxes as well as the promises of networking.

It is one of the complexities of networks that they are both metaphorical and physical. The metaphorical pull of networks operated when physical means were not possible and helped give form to the physical when they were, as Fernández signals in her discussion in chapter 16 of the *estridentistas* in Mexico from 1920 to 1930. The metaphors of communication networks, especially transportation and transmission, are significant in the *estridentistas'* literary and visual production, according to Fernández. Using Armand Mattelart's seminal text *Networking the World, 1794–2000* as a point of departure, she argues that the *estridentistas,* important pre-precursors, did not actually have access to the physical technology, but nonetheless, or rather therefore, imagery played an important part in their networks. Although her subject is earlier than the main focus of the book, Fernández's work extends arguments about Futurists raised in the introduction and presents archival material that is a vital reminder of the significance of the imagination—of ideas, tropes, and desires in networking (before and behind, as well as embedded within, technology). Further, her attention to the relation between metaphorical and physical networks helps give a sense of the complex relation between emotional and physical distance; she argues that "loneliness

and despair" grow as "communication networks expand geographical horizons and exacerbate emotional isolation" (349).

From another point of view, looking to Beuys and some of the Fluxus artists among his examples, Ken Friedman argues in chapter 19 that there can also be problems when artists attend to the metaphors and hopes of networks but do not construct networks as sustainable and viable communities. The complexities and, particularly, the paradoxes of networks, both historically and recently, are thus a key focus for Friedman. He notes that various communications networks both dislocate and therefore threaten human culture at the same time as they offer important opportunities for exchange and interaction. For Friedman, this is as true of physical networks, like rivers and road systems, as it is of electronic networks, which have been transmitting information since the telegraph and telephone of the nineteenth century.

Within local contexts, artists and activists have understood and experienced networks in very diverse ways, as has often been a theme throughout the book. This diversity is foregrounded in this part of the volume. Stephen Perkins, for instance, explains in chapter 18 how different the concept of "alternative" network was previously in Eastern Europe as compared to Western Europe. And for many South American artists in repressive regimes, as Perkins elaborates, networking has inevitably been inflected with political imperatives. According to both Friedman in chapter 19 and Sean Cubitt in chapter 20, the question of the geography, politics, and economics of networks is differently framed by the different figures of globalization and internationalism. Cubitt adds that recognition of this will allow us to refigure understandings of modernism. Looking back to modernism, he finds mobile

communication networks involving artists whose activism has been erased from common memory. Similarly, he argues, the forgotten "geographic dilemmas" of the "sources" of modernism need to be recalled to understand the context of the book's distance artists/activists—and its difference from today's context. Cubitt's point about the influence, with modernism, of cultural initiatives from the "peripheries" resonates strongly with Fernández's chapter. Both chapters help undermine notions of centers and peripheries, conceptually and historically.

The culture(s) that held artistic networks together in the period that the book focuses on, which have been broadly canvassed in the volume's first two parts, are further analyzed here by Perkins. With an eye equally to networking and assembling art, Perkins argues in chapter 18 that the notion of democracy defined both relations among networks of assembling artists and their "open" and "alternative" attitudes to establishment institutions—though the specific ways in which this played out depended on the geographic-political location. These artists also, according to Perkins, demonstrated the same playful and often darkly humorous approach to their creative and networked practices as Fluxus and Mail Artists, who also were engaged in networked practices. With an ear to the sonic potential of the network, Chris Brown and John Bischoff also stress in chapter 17 that collaboration and community were important:—both a facilitator and a result of the networked music they were making.

The issue of network as a medium, addressed by a number of telematic artists in Part II, returns here in chapters 17, 19, and 20. For Cubitt in chapter 20, it is the ephemeral and the evanescent that hold the promise of the

network medium's specificity, especially as we look to the future. His exploration of evanescence reframes some of the ideas developed in the earlier parts of the volume about re-jected objects, immateriality, and so on. His discussion also foreshadows, by the way, our return in the volume's conclusion to the relationship between evanescence and memory. Following a different trajectory, in chapter 19 Friedman remembers Dick Higgins's concept of intermedia to expand on the medium aspect of the network. As intermedia worked between and across boundaries—art and art, art and life—it made visible the "space of flows" that characterizes networking for Friedman.

From yet another direction, Brown and Bischoff sonically played (with) the network as a medium, finding in it the "locus and a source for a new kind of music" (373). This collaborative music making went beyond individuals, both as "genius" and as physically bounded: "it is less important that people are interacting from long distances with each other than that they are creating art in which physical proximity and display, the collision of their physical and personal identities, are transcended" (374). Brown and Bischoff found that both musical instruments and networks were fundamentally altered by these distance art practices in The League of Automatic Music Composers and The Hub. The latter, reminiscent of Mail Art, was so named because the members used a computer as a "mailbox to post data used in controlling their individual music systems" (382) and made the data available to the other players to use at will. While the character of the networking—the relation to their computers, one another, and the audience—evolved over time, Bischoff and Brown, like the others they collaborated with, remained fascinated with the added musical dimension of networked computers as

they explored the question "What is the sound of the network?" (384). For them, it was the network—its "sonification"—rather than technology or telepresence that shaped the trajectory of their work as musicians. Their work stresses an important aspect of network not about physical distance, but as a "new instrumentation for collaboration" (389).

It is worth noting, finally, that there are other networks within the book that may not be so evident, including those among the various authors. Some contributors shared their ideas and work with one another in the writing stage. And of course others have been networked for a long time already, through various projects, including and beyond those covered here. Further, as has been clear throughout the book, networking has been important as a *collaborative medium* for many distance projects. As a whole, then, this part of the book underlines and extends the understanding from the previous two parts that networks need to be thought of in their multiplicity, not just in terms of people and machines, materially and emotionally, metaphorically and physically, but also in terms of the articulation of diverse geographic, economic, and cultural locations and artistic practices.

16

Estri-dentistas:
Taking the Teeth out of Futurism

María Fernández

Introduction

In his book *Networking the World, 1794–2000*, Armand Mattelart characterizes communication networks as systems that facilitate the movement of persons and of materials and symbolic goods. Historically, the advent of such networks has been accompanied by utopian discourses. Mattelart asserts: "The communication network is an eternal promise symbolizing a world that is better because it is united. From road to rail to information highways, the belief has been revived with each technological generation, yet networks have never ceased to be at the center of struggles for control of the world."[1] In Mattelart's assessment, systems of communication exhibit a variety of structures: linear, radial, centripetal, and rhizomatic, and need not be interactive to qualify as networks. Thus print (the missionary press), electricity, roads, telegraph, railroad, undersea cable, radio transmission, film, television, satellites, and news services and advertising all figure as networks.[2]

Taking Mattelart's definition as a point of departure, in this chapter, I will examine network imagery specifically of railroads, the telegraph, and the radio in the work of the *estridentistas* in Mexico (1921–1927) as part of the larger project of this book of charting precedents for the discourses and practices of the Internet. I will briefly describe the development of *estridentismo*, as the movement is poorly known in the history of art and literature both in Latin America and abroad. Because many of the *estridentistas* borrowed ideas from European movements, prominently Italian Futurism, I will contrast the two movements to provide a basis for my examination of *estridentista* images of networks. To discuss *estridentismo* only in relation to its adoption of Futurism would be to affirm Eurocentric historical narratives of both literature and technology in which contributions from the "peripheries" figure (if at all) only as poor, unreflective imitations of their metropolitan counterparts. Finally, I will discuss the reception of Italian Futurism in the wider context of Latin America further to illuminate the *estridentistas'* attitudes toward communication networks.

My emphasis on imagery in contrast to materially instantiated networks conforms to the technological limitations of early-twentieth-century Mexico and to the fact that technological discourses often have more to do with the imagination than with actual access. In his seminal essay "Radio Space," Douglas Kahn compared early-twentieth-century representations of radio with the discourses of virtual reality developed in the early 1990s, noting that in both cases artistic responses were primarily rhetorical because the

artist's access to the technology was very limited, even when the technology existed.[3]

In the 1980s and early 1990s, publicists such as John Perry Barlow and Esther Dyson, founders of the Electronic Frontier Foundation, and Nicholas Negroponte, Founding Chairman of the Media Laboratory at the Massachusetts Institute of Technology, heralded the newly popularized technology of the Internet as a new frontier in which unmediated communication among users would foster the development of a radical democracy. Visual artists including Roy Ascott, Karl Loeffler, Kit Galloway, and Sherrie Rabinowitz and critics such as Gene Youngblood forecasted the long-awaited arrival of world peace to the planet, as they believed that the Internet would increase human understanding and collaboration. In Ascott's opinion, computer-mediated networks offered the possibility of "a kind of planetary conviviality and creativity" achieved by no other means of communication.[4] The catastrophic failure of these predictions makes it clear that these ideas were based more on the artists' visions than on properties inherent to the technology.

The *estridentistas'* attitudes toward new technologies differed markedly from the technophilia of their European and Russian Futurist counterparts. In contrast to ingrained assumptions that the *estridentistas* uncritically adopted European vanguard models, I will demonstrate that these Mexicans deliberately translated and filtered Futurist ideas for their own ends. In various writings, Jacques Derrida poetically has argued that meanings in language are fluid, mobile, and often contradictory; thus the definitive meaning of a text is indeterminate. In his texts, the process of translation emerges as both possibility and impossibility, for the translator, though indebted to the original, is the creator of a new work.[5] Similarly, Walter Benjamin proposed that a translation expressed reciprocal relationships between languages and marked a stage of continued life in a work.[6] This suggests that in the translation of cultural material, adoption as well as tergiversation of established meanings can be read not only as the product of naïve imitation and misunderstanding, but also as the result of informed selection.[7] In this discussion it will be relevant to recall that Mexico is peripheral only in retrospect: During the first three decades of the twentieth century, it was a cultural mecca for European, American, Japanese, and Russian artists and intellectuals.[8] Rather than naive third-world others, the *estridentistas* were early-twentieth-century cosmopolitans.

Estridentismo

Latin America's first vanguard movement, *estridentismo,* began in Mexico City in 1921 with a call to Mexican intellectuals to create an art responsive to the modern transformation of the world. The first manifesto, signed by a young poet and law student, Manuel Maples Arce, was printed on a broadsheet and pasted on the walls of Mexico City alongside theater and bullfight posters. The sheet, entitled *Actual número 1* and subtitled *Hoja de vanguardia: Comprimido estridentista (Vanguard Sheet: Estridentista Compression),* consisted of a preface, fourteen points, a photograph of the author, and a "vanguard directory" including the names of prominent Latin American and European artists and intellectuals. The text of the manifesto drew heavily from Italian Futurism and from Spanish *Ultraismo.* From Futurism it borrowed its open antagonism to tradition and the admiration for the machine, and from *Ultraismo* its eclecticism, as it proposed to synthesize a variety of sources.[9] In the preface, the author announces his opposition to the established orders of patriotism, the church and the law: "Death to the Priest Hidalgo, Down with San Rafael, San Lázaro. . . . It is prohibited to post advertisements."[10] After Marinetti, he proclaims, "A moving automobile is more beautiful than the Victory of Samothrace" (III) and urges artists to exalt "the actualist beauty of the machine."[11] Like the Futurists, Maples Arce also declares his love for the literature of advertisements (III), sings to "the aristocracy of gasoline," and argues for the hygienic extermination of "the germs of putrefied literature" (V).

Maples Arce wrote the first manifesto *estridentista* at the beginning of a period of economic and cultural recovery in Mexico. The revolution of 1910 ended the despotic thirty-four-year presidency of General Porfirio Díaz (1876–1910). But revolutionary ideals did not prevent various factions from clashing continuously in pursuit of power. Bloody civil wars devastated Mexico through the second decade of the century. The wars of the revolution, as the whole period is popularly known, continued until 1920, the year Alvaro Obregón became president.[12] During Obregón's regime a massive reconstruction of Mexico's economy, education, and culture began. In 1921, the newly appointed secretary of education, José Vasconcelos, instituted a program of public artistic commissions with the aim of encouraging the creation of a modern, genuinely Mexican art. In contrast to the Europhilic cultural policies of the Díaz regime, Vasconcelos promoted the study of local culture and antiquity and the exaltation of the *mestizo,* the mixed-race Mexican, as the bases for national culture. He would elaborate these ideas in *The*

Cosmic Race (1925). In the same year of the publication of *Actual número 1,* Diego Rivera returned from a prolonged residence in Europe at the invitation of Vasconcelos. José Clemente Orozco and David Alfaro Siqueiros would soon follow. These three artists would later be known as Los Tres Grandes, the three great masters of Mexican muralism.

In 1922, a group of artists and intellectuals joined Maples Arce, and together they constituted the *estridentista* movement proper. These individuals included the writers Germán List Arzubide, Arqueles Vela, Salvador Gallardo, Kyn Taniya, Luis Marín Loya, Febronio Ortega, Miguel Aguilón Guzmán, Gastón Dinner, and Francisco Orozco Muñoz; and the musicians Manuel M. Ponce and Silvestre Revueltas; as well as a group of visual artists including Diego Rivera, Leopoldo Méndez, Germán Cueto, Ramón Alva de la Canal, Jean Charlot, and Fermín Revueltas.[13] The group met regularly in the Café Europa, later named El Café de Nadie (Nobody's Café) and immortalized by Vela's novel of the same name.

The group published three subsequent manifestos in addition to multiple novels, books of poetry, and two *estridentista* magazines: *Irradiador* (Irradiator) in 1923 and *Horizonte* (Horizon) in 1926.[14] The *estridentistas* also held an *estridentista* art exhibition at the Café de Nadie in April 1924. In addition to their activities in Mexico, the group was connected to international networks of their time, as evidenced by the translation into English of Maples Arce's epic poem *Vrbe* (1924) at the behest of John Dos Passos in New York.[15] It was the first book from a Latin American vanguard to be translated into English.

Carlos Noriega Hope, the editor of Mexico City's *El Universal Ilustrado,* and one of *estridentismo*'s "most precious allies," facilitated the *estridentistas'* publications as well as their first use of radio.[16] On May 8, 1923, the newspaper inaugurated a radio station with an evening transmission in which participants included the renowned Spanish guitarist Andrés Segovia, Ponce (who was a composer as well as a musician), the pianist Manuel Barajas, and the diva Celia Montalbán. Maples Arce read his poem "T.S.H.–Telegrafía sin hilos" (T.S.H.–Wireless Telegraphy), the first poem to be read radiophonically in Mexico.[17] The radio station of *El Universal Ilustrado* continued to operate until 1928.[18]

In 1925, the core group of the *estridentistas* moved to Jalapa, Veracruz, under the protection of the governor of the state, General Heriberto Jara. Jara

facilitated the publication of numerous works, including the first issue of *Horizonte,* illustrated by Rivera and Alva de la Canal (1926), and *Poemas Interdictos* by Maples Arce (1927). The latter includes his poem "Song from an Airplane," a humanist reflection on the unification of man and machine.[19]

In September 1927, Jara's government entered a crisis that resulted in his deposition. The *estridentistas* dispersed. Although the *estridentista* movement was tremendously influential for subsequent Mexican art and letters, it was almost erased from history. *Estridentismo* was contradictorily and dismissively described as a movement with radical political leanings or as the product of "a definite middle class liberal mentality" whose adherents argued for social change more as a rebellious gesture than as a reasoned expression of a political philosophy.[20] More specifically, the *estridentistas* were perceived as having made much noise without concrete results.[21]

In the last two decades of the twentieth century there was a flurry of scholarly interest in the *estridentista* movement. *Estridentista* works were compiled and republished; exhibitions and conferences were held to reevaluate their achievements. This sudden appreciation of the work of the *estridentistas* coincided with the introduction of electronic media, especially video, into the Mexican art scene. The precise relation of these two phenomena has yet to be determined; what is certain is that at least some of the artists working in video and digital art at that time recognized *estridentismo* as an important precedent for contemporary Mexican art. Andrea di Castro, a former video artist and one of the founders of the *Centro Nacional Multimedia,* established in 1994 as part of the Centro Nacional de las Artes, was aware of the *estridentistas'* artistic achievements and discourses about technology and acknowledged the need for a video documentary on the subject.[22]

Estridentismo/Futurism

Although *estridentismo* borrowed from Italian Futurism, it deviated from that movement in significant ways, including the artists' attitudes toward violence, the past, patriotism, and women. Marinetti and his circle glorified war and destruction as hygienic measures to eliminate the enemies of Italy as well as the "passeists," the enemies of cultural change. The *estridentistas* focus their disrespectful, often lighthearted attacks on antiquated cultural structures and personalities, specifically the academy and its Spanish professors. In 1923, Arzubide declared:

We fly in airplanes and over heads doleful with tediousness, we sing with the strength of a propeller that defeats the theories of gravity. We are already *estridentistas* and we will stone the houses full of old furniture filled with silence, where the dust eats the advances of light. . . . And bristled with small rays, we will go around giving blows to those sick with indolence.[23]

A similar humor permeates the second *estridentista* manifesto: "The only truth is the *estridentista* truth. To defend *estridentismo* is to defend our intellectual shame. Those who are not with us will be eaten by vultures. . . . We will extinguish the sun with the blow of a hat (*sombrerazo*). Happy New Year."[24]

Instead of employing sophisticated weaponry, the *estridentistas* arm themselves with stones to attack the bored and weak and with a hat to destroy the sun. These gestures seem to mock the horrific massacres and putrefying bodies extolled by Marinetti in *Mafarka, the Futurist* as well as the tanks and deadly gas masks ever present in Marinetti's *Electric War*.[25]

In contrast to the Futurist aversion to the past, the *estridentistas* appropriate it. Arzubide's *El movimiento estridentista* is dedicated to "Huitzilopochtli, manager of the *estridentista* movement." The Mexica god Huitzilopochtli was the legendary founder and patron of the great Aztec city of Tenochtitlan, now Mexico City.[26] In the second *estridentista* manifesto, the threat to extinguish the sun indirectly refers to *nemontemi,* the last five days of the Aztec solar year, a time in which the Aztecs feared the defeat of the sun by the forces of the underworld and consequently the possible end of the era.[27] This irreverent attitude toward the Aztec past ultimately ridicules the sacred status of local antiquity in contemporary Mexican intellectual circles.

Where the Italian Futurists were committed patriots, Maples Arce repeatedly ridicules patriotism in *Actual numero 1*. In his view, nationalistic cultural production "has the odor of barbershops and residues of deep fried foods" (XIV). He recommends: "Let us cosmopolize ourselves. It is no longer possible to remain fixed on conventional chapters of national art" (X).

In contrast to the Futurists' repudiation of women as sentimental objects and despite the existence of misogynistic images, affective references to women are ubiquitous in *estridentista* literature, so much so that List Arzubide describes the *estridentista* years as a "moment syncopated with women" in which "every minute was infected with cinematic parks pierced by circuits of kisses."[28] As will be evident below, these values permeate and affect the *estridentistas*' representations of communication networks.

The City, Railroads, and the Telegraph

Estridentista works bustle with images and sounds of streets, shops, corners, advertisements, radiators, airplanes, cinema, jazz, radio, telegraphs, automobiles, locomotives, factories, and strikes. Some critics have judged the artists' use of these images as irresponsible because the *estridentistas'* city stood in marked contrast to the everyday realities of Mexico.[29] In Luis Mario Schneider's opinion, the effect sought by *estridentista* poets was the creation of images of the ontological, sensorial city, so that representations of the rhythm of the city alluded to the daily life of contemporary man [sic]. The critic Luis Leal explains: "The reality of the estridentistas did not exist. It was the reality that would predominate in the future."[30]

If the *estridentistas* imagine the future, this future is technologically rich and emotionally compromised. In rare occasions utopian versions of the future appear in conjunction with communication networks such as the railroad and the telegraph, but frequently, the celebratory spirit of these images is mitigated by the interpolation of a deep sense of loneliness and despair. In these representations, communication networks expand geographical horizons and exacerbate emotional isolation. These tensions are here exemplified in the writings of Maples Arce, although they are salient as well in the work of other *estridentista* poets.[31]

In the first manifesto *estridentista,* Maples Arce meditates on the effects of modern technologies on the planet:

News is sent by telegraph over skyscrapers, those marvelous skyscrapers so decried around the world. There are dromedarian clouds, and amongst their muscular weavings the electric lift is conmoved.[32] Forty-eighth floor. One two, three, etc. We have arrived. And over the tracks of the open-air gym, the locomotives choke with the kilometers. Steamships smoke towards absences. Everything gets nearer and more distant in the commoved moment. The environment is transformed and its influence modifies everything. Cultural and genetic similarities, profiles and racial characteristics become blurred . . . while under the sun of the present meridians, the psychological unity of the century blooms. (X)

Maples Arce's enthusiasm for the beautiful skyscrapers, the elevators, the telegraph, the immediacy and universality of communication and the unification of humankind is balanced by his awareness that long-distance communication implies separation from familiar people and places. In his poem

"Prisma" (1922), he describes a busy, colorful, yet phantasmagoric urban environment that he experiences from an isolated interior space:

The city rebellious with luminous advertisements
Floats in the almanacs
And further in the afternoon,
A CABLE CAR bleeds to excess on the ironed street.

Insomnia, just like a twining plant
Embraces the green scaffolds of the telegraph
And while noises unlock the doors
The night has diminished licking her memory[33]

In this poem, the telegraph signals the improbability of communication with an absent one. It will not escape the reader's notice that for the *estridentista* poets, absence is almost invariably linked to women. The relations among the city, communication networks, and distance are more explicitly explored in Maples Arce's "Como una Gotera" (Like a Leak), published in the same year:

That farewell, the last one
 Was a scream without exit
The paroxysmal city
Was up to our necks
And an ending [as in cinema] of kilometers
underlined her
anguish
Oh! The iron road!
 A burning of wings
 Trough the telegraph
 Tragic chimneys
 Pierce the sky.

 And the smoke of the factories!

 .

 .

 .

The electric elevator and an intermittent piano complicate the system of the "apartments" house and in the purple scream of the trains I sense the distance.

Behind the back of Absence the telegraph changes its countenance.
Dispatches of emotions bleed my insides.[34]

The foregoing examples demonstrate that the universalist and apparently technophilic rhetoric of the *estridentistas* notwithstanding, images of railroads and telegraphs in *estridentista* literature are predominantly emotional. The technology is used to indicate affective states but fails to provide a private space for the expression of affect: The networks do not connect. This suggests a certain distance from the logic of rationalism and mechanistic instrumentality.

Like Blaise Cendrars and the Russian Futurists, the *estridentistas* recognized emotional and spiritual dimensions in both art and life. In *Actual número 1,* Maples Arce refuted the existence of a monolithic aesthetic, as aesthetic truth was "only a state of an unrolled [*sic*] uncoercible emotion" (I). Despite his admiration for machines, he argued: "Man is not a systematic and leveled clock mechanism. Sincere emotion is a form of supreme arbitrariness and specific disorder." The role of art, he asserted, was to fill a spiritual function at a given historical moment (II). In contrast to the Italian Futurists, Maples Arce declared himself against all "-isms," proposing "a quintessential and purifying synthesis" of all modern tendencies, "not because of a false conciliatory desire—syncretism—but because of a rigorous esthetic and spiritually urgent conviction" (VII). Even if Maples Arce's distrust of rationalism was "unoriginal," that is to say, it was an attitude that he *shared* with other early-twentieth-century artists and intellectuals, it is prescient of critical discourses associated with poststructuralism. His demands for both heterogeneity and integration anticipate the celebration of "hybridity" in postcolonial studies of the 1980s and "aesthetics of the border" in more recent currents of contemporary art and culture.[35]

Radio as a Communication Network

Multiple scholars in addition to Mattelart identify radio as a communication network. In fact, in the literature of the early twentieth century, radio was interchangeable with other networks, such as wireless telegraphy, wireless telephony, wirelessness, and other auditive phenomena.[36] Douglas Kahn

notes that "it was common to think of wirelessness in terms of *communication* because it existed prior to the redundancies of contemporary mass media."[37] Like other networks, radio inspired discourses of universal harmony through connectivity. In his often-cited *Radio of the Future,* Velimir Khlebnikov predicted not only that radio would provide nutrition and heal and physically strengthen the labor force, but also that it would bring about the spiritual unification of mankind: "The radio of the Future—the main tree of consciousness—will open up a knowledge of countless tasks and unite all mankind. . . . Around the clock from this point on the globe, flocks of news items from the life of the spirit scatter like the spring flight of birds. In this stream of lighting birds, the spirit will prevail over force, good advice over intimidation."[38]

In 1928, Giacomo Balla speculated that in the future radio would have the ability "to multiply life by reducing the effort of animal life to its lowest and to speed up a hundredfold the creative work of genius? The network of communications, simplified and multiplied, would lead the intensity of life into an atmosphere which is for the moment inconceivable."[39] These early predictions about radio resonate today in ideas of collective intelligence, collective memory, collective conscience, and the global brain enabled by the Internet.[40] Thus discourses of radio transmission provide important historical precedents for the discourses of digital networks.

Radio in Estridentista Literature

Radio is one of the most frequently referenced "communication networks" in the work of the *estridentistas,* not only in their literature, but also in their painting and photography.[41] In *estridentista* literature, images of this technology seem to be the most futuristic when compared to the emotional and quotidian quality of the representations of telegraphs and railroads. But these "futuristic" images pale in comparison to the utopian pronouncements about radio of the Italian and Russian Futurists. There is no Mexican approximation to Khlebnikov's *Radio of the Future* (1921), Marinetti and Pino Masnata's "La Radia" (1933), or Balla's pronouncements cited previously.[42]

Radio was a new technology, contemporary in its arrival to Mexico with the introduction of *estridentismo.* The first government-owned radio station in Mexico was established in 1921 as part of the celebrations of the centenary of Mexican independence from Spain. As multiple enthusiasts experi-

mented with the technology and transmitted from their homes, in 1922 a national association of radio was instituted. One year later, this organization merged with the Center for Engineers and the Central Club of Mexican Radio and became the National Mexican Association of Radio. In *estridentista* literature, radio appears principally as an index of modernity.

In Vela's novel *El Café de Nadie* (1926), Mabelina, the protagonist, describes an encounter with Androsio, one of the clients of the cafe: "With the attitude of a dressmaker or window-dresser who adopts the most fashionable posture, he untied and tied again the ribbon that fastened my shoes, successively praising the color of my stockings and ascertaining their quality. Caressing my legs, he asked me if I wore garters of the latest fashion with a radio case or with someone's photograph."[43] Here, the radio is represented as a fashion item for the cosmopolitan elites. In List Azurbide's fictitious description of his first meeting with Maples Arce, radio is similarly invoked to indicate radical modernity: "He offered me his hand and invited me to the café—The Café de Nadie?—No to the Café Multánime where the waitresses order things by radio and the pianola plays music intercepted by Martian concerts."[44]

In the same text, List Arzubide claims that the radio facilitated Maples Arce's recovery from an unhappy love affair as he introduced him to a young woman listener in the neighboring city of Puebla during the opening transmission of the station of the *Universal Ilustrado*.[45] It is likely that as in other parts of his book, List Arzubide mentions the radio here only to indicate Mexico's changing social conditions.

Radio also figures prominently (along with cinema) in Vela's novel *La Srita. Etcétera.* In this instance, references to various modern technologies illustrate the dramatic effects of urban life on the individual and his social relations. The novel's narrator observes: "The nearly mechanical life of modern cities was gradually transforming me. . . . I was like a reflector operating in reverse, luminously projecting the sights around me to the unknown concavities of my sensibility." He notices that his partner has also changed: "When the lift finally let us out I found myself in front of her. I observed her thoroughly and I was stupefied to find that she was also mechanized. . . . Her movements were straight lines, her words were resurrected by a delicate phonographic needle . . . her breasts, trembling with amperes. . . . Her voice had the telephonic noise of feminism." He goes on to describe his interactions

with her: "We listened to each other from a distance. Our receptors silently interpreted by hertzian contact what could not be expressed by the fluttering of lips."[46] Here, bodies and communication have become radiophonic. Marinetti may have provided the ground for these preoccupations as he had warned that new technologies, "the telegraph, the telephone, and the gramophone, the train, the bicycle, the motorbike, the car, the ocean liner, the dirigible, the airplane, the cinema, the great daily newspaper" would exercise a "decisive influence" on the human psyche.[47] The mechanization of the human body in Vela's novel is also reminiscent of earlier European novels with similar themes such as *L'Eve future* by Villiers de l'Isle-Adam (1884).

In other *estridentista* writings, radio is evoked to emphasize the nearness of all places on the planet, a nearness that provokes unsettling cacophony and magnifies the isolation of the poet. This is a marked contrast to discourses of networks extolling the virtues of connectivity and virtual communities, such as an 1846 proposal to link American and European capitals with a gigantic submarine and overland magnetic telegraph network so that "all the inhabitants of the earth would be brought into one intellectual neighborhood and be at the same time perfectly freed from those contaminations which might under other circumstances be received."[48]

A fragment of Maples Arce's "T. S. H.–Telegrafía sin hilos" illustrates this point:

> Loneliness
> > is a balcony
> > open to the night.

> Where is the nest
> of this mechanical song?
> The insomniac aerials of memory
> pick up the wireless
> messages
> of some unthreaded farewell.

> .

> .

> .

> My heart
> suffocates me in the distance.

Now it is the "Jazz-Band"
from New York;
the synchronic ports
blossoming with vice
and the propulsion of motors.

The madhouse of Hertz, of Marconi, of Edison
The phonetic brain shuffles
The western perspective
Of languages
Hallo!

A golden star
Has fallen in the sea.[49]

In Kyn Taniya's poem *RADIO* (1924), written one week after the death of his father, radio sounds acquire supernatural, spiritual qualities. As in Maples Arce's "T.H.S.," the poet is isolated among disembodied voices and sounds:

Midnight Frolic

Silence
Listen to the conversation of words
In the atmosphere
There is an unbearable confusion of earthly voices
And strange, distant
Voices
Hairs stand on end from the friction of the hertzian waves
Gusts of electric wind whistle in one's ears
Tonight
To the black rhythm of the jazz-bands from New York
The moon will dance a fox trot
IF THE MOON AND JUPITER AND VENUS AND MARS
AND SATURN WITH ITS GOLDEN RINGS
The planetary system will be a badly combined "ballet" corps
Revolving at the rhythm of a musical light.

I will have to wear a dress coat
But who will be my partner in this astral "midnight-frolic"?[50]

Both Kyn Taniya and Maples Arce locate the phenomenon of radio within a greater cosmic order, which adjusts to meet the demands of new social conditions. Their poems conflate figures of transmission and vibration: platonic, harmonic conceptions of the universe and concrete, embodied experiences of multiplicity and disorder introduced by new technologies of communication.[51] According to Douglas Kahn, vibration is best amplified in nineteenth-century ideas of synesthesia, the notion that "the operations, affects and objects of perception corresponded to one another." Transmission, by contrast, "could situate objects and bodies in inharmonic, noisy, and terrestrial relations without consuming their autonomy."[52]

As a result, in these poems, radio enables a global spiritual network yet not necessarily a reassuring one. Contact with distant places fails to "unify human kind" (Khlebnikov) or even to encourage collaboration.

More hopeful and instrumental references to radio appear in Xavier Icaza's dramatic text *Magnavoz*, published in 1926.[53] Icaza was inspired to write *Magnavoz* on his return to Mexico after a year's absence. He found the country full of contradictions, "weak and strong, full of mediocrity and genius."[54] The text begins by describing the process of national reconstruction: Mexicans work and save; the country pays its debts; schools of Mexican painting, literature and philosophy are being established. Finally, Mexico is gaining an identity. But the Mexican people do not think or study; they are only interested in popular music, dance, and games. In the narrator's opinion, most of Mexico's "offspring" live a "vegetative existence."[55] Suddenly, gigantic loudspeakers (magnavoxes) located in the craters of Mexican volcanoes Popocatepetl and Ixtlaccihuatl as well as at the apex of the Pico de Orizaba (Mountain of Orizaba) begin to transmit the voices of wise men who attempt to advise the Mexicans.

At Popocatepetl, Vasconcelos speaks from the New York station KDY, but the Mexicans refuse to listen. Romain Rolland speaks from the Alps to recommend "a Christian doctrine of loving cooperation." The Mexican Alfonso Reyes follows, but his speech is interrupted. The Italian journalist Luigi Barzini is heard from the loudspeaker located at Ixtlaccihuatl suggesting that

Mexicans emulate the economic examples of the United States, Argentina, Brazil, and Chile; Lenin recites Marx's *Capital* from the Pico de Orizaba, and Shakespeare intervenes to suggest that Mexicans are empty talkers: "words, words, words." Finally, Diego Rivera loudly addresses the crowd from the Pyramid of the Sun at Teotihuacan unaided by any technology. It is this speech that captivates the crowd. Icaza describes this moment:

Diego Rivera yells at the crowd from the pyramid of the sun. He strikes the heights of the pyramid with his walking stick creating sparks. "That one [Shakespeare] is right—he repeats—We should not talk. . . . We must do things. We must create. We must be Mexicans. Death to Paris! Down with the francophiles who are without caste! We must expel them! Let's learn form the pyramid builders. Let's continue their interrupted work. Let's achieve Mexican works. We must be of our country. We must express Mexico.

Rivera descends with sure steps holding a thick walking stick, his head held high, and the crown applauds. Groups of people perform local indigenous and colonial dances around him.[56]

Magnavoz fuses the real-time, interactive qualities of telephone communication with radio transmission to construct a public forum in which multiple participants can converse with one another at a distance and simultaneously be heard by a multitude. Attempts to reach wide audiences began in the late nineteenth century as telephony was used to transmit concerts and plays to select theaters and homes.[57] Telephone transmission, however, necessitated that the performers be in the same location, and the nineteenth-century listener could not participate in the performance. In its ability to link participants in multiple geographical spaces, *Magnavoz* anticipates contemporary teleconferencing as well as various forms of textual communication via the Internet. Ironically, in Icaza's narrative, it is not communication technologies, but the rhetoric of nationalism, that brings Mexicans together. Icaza wrote *Magnavoz* as the *estridentista* movement was waning, and among the *estridentista* corpus the work is rare in its nationalistic approach.

A Radiophonic Style

Some recent forms of computer art rely on the visual and generative properties of code to construct literary, visual, and procedural works of art. The

influential Net art duo Jodi utilizes and deconstructs conventions used in computer programming and communication on the Internet. Jodi writes "reflexive" code, which functions as code and can also be read as commentary on code culture.[58]

Just as today's Net art employs essential elements of computer communications as a source for artistic creation, early-twentieth-century vanguards championed a style of writing based on the properties of the telegraph. Proponents of the telegraphic style maintained that the economy of telegraphic writing captured the essence of language. In the 1920s, the literary qualities associated with telegraphy were transferred to radio in general.[59]

For Marinetti, the telegraphic style was a by-product of the "wireless imagination," the free expression of images or analogies with "unhampered words and with no connecting wires of syntax and with no punctuation."[60] As John White, among others, has demonstrated, Marinetti's free-word telegraphic style differed vastly from the conciseness and clarity of language required in actual telegrams.[61] Like some aspects of Net art, it was a code that appeared as what it was not.

The *estridentistas* did not adhere to any one version of the telegraphic style but declared the necessity of employing an "efficient and radical method" of writing (V). In the second manifesto, they defined poetry as a "successive explanation of ideological phenomena through equivalentist [*sic*] images orchestrally systematized."[62]

In *estridentista* works, the writers suggest "radio style" with strings of minimalist and idiosyncratically punctuated or unpunctuated sentences. The first issue of *Irradiador* (1923) attempts to capture the spirit of the city using a sequence of short sentences and phrases:

Irradioscopy [*sic*]. The city is full of installations of dynamos, gears and drill holes. The speaking facades impudently scream their showy colors from one sidewalk to the next. Moctezuma Beer and El Buen Tono [cigarettes]. Ford Spare Parts. Bayer Aspirin vs Langord Cinema. . . . Farewells set their sails. . . . Algebraic schematization. Jazz Band, petroleum, New York. All the city cracking, polarized in the radiotelephonic antennas of an improbable station.[63]

Kyn Taniya's poem *RADIO* includes free-word passages as well as sentences arranged in verse form that read as radio newscasts. The following two examples illustrate this tendency.

. . . IU IIIUUU IU . . .

LAST BREATHS OF HOGS DECAPITATED IN CHICAGO
ILLINOIS CLAMOR OF NIAGARA FALLS IN THE CANADIAN
BORDER KREISLER REISLER D'ANNUNZIO FRANCE ETCETERA AND
THE JAZZ BANDS FROM VIRGINIA AND TENNESSEE
POPOCATEPETL'S ERUPTION ON THE VALLEY OF
AMECAMECA AS WELL AS THE ENTRY OF BRITISH
BATTLESHIPS TO THE DARDANELLES AND THE NOCTURNAL
GROAN OF THE EGYPTIAN SPHINX LLOYD GEORGE WILSON
AND LENIN AND THE ROARS OF THE PLESIOSAUR
DIPLODOCUS THAT BATHES EVERY AFTERNOON IN THE
PESTILENT SWAMPS OF PATAGONIA GANDHI'S
IMPRECATIONS IN BAGDHAD THE CACOPHONY OF THE
BATTLE FIELDS OR THE SUNNY SANDS OF SEVILLE
SATIATED WITH THE INTESTINES AND BLOOD OF BEASTS
AND THE MAN BABE RUTH JACK DEMPSEY AND THE
PAINFUL HOWLS OF THE BRAVE FOOTBALL PLAYERS WHO
KILL EACH OTHER WITH KICKS BECAUSE OF A BALL

ALL OF THIS COSTS NO MORE THAN A DOLLAR
FOR ONE HUNDRED CENTS YOU WILL HAVE ELECTRIC EARS
AND YOU WILL CATCH THE SOUNDS THAT ROCK IN THE
KILOMETRIC HAMMOCK OF THE WAVES
IU . . . IU III UUU IU . . .

Numbers
1 star
Lost the last race
And had to walk

Kentucky
3 blacks were lynched
and died in a blue cry

1 poet conductor is balancing over the cables
of the interplanetary 3226

Paris

1 Englishman just killed his lover

in room 723

1934

for 100 more years man will

dance jazz.[64]

Because these works draw partially on Dada and on the conventions of ab-
breviated communications over a network, they lack the narrativity of tra-
ditional literature and at first sight appear nonsensical. Also indebted to
Dada, Net art has also been judged as unintelligible. Tilman Baumgärtel ex-
plains: "The symbols dancing on the screens of web sites that seem so in-
comprehensible at first glance are ways of using the computer that are just
as legitimate as a word processor. They may not offer the same 'usefulness'
but that doesn't make them impermissible."[65]

Lacking generativity, Futurist and *estridentista* poetry differ greatly from
Net art. Yet the adoption by artists of conventions essential to communica-
tion in their contemporary networks is comparable.

Futurism in Latin America

The discussion in this chapter so far suggests that the *estridentistas* main-
tained an enthusiastic but cautious relation to the possibilities offered by
communication networks. In their writings there are few unrestrained spec-
ulations or utopian expectations, and there is no blind faith in the redemp-
tive qualities of new technologies. This reticence is analogous to early
responses to the utopian promises of the Internet by diasporic artists and
scholars, contributions seldom acknowledged in discussions of contempo-
rary networks but assimilated in discourses of "the digital divide" and recent
attempts to include experiences from the non-West in discussions of net-
working.[66] To understand the *estridentistas'* attitudes, it is crucial to situate
the movement within wider Latin American discourses, especially the re-
ception of Futurism in Latin America.

Allegedly, the first Spanish translation of Marinetti's *Futurist Manifesto*
appeared in the magazine of the university in Tegucigalpa, Honduras, only
a few months after the original publication of the manifesto in French.[67] Re-
gardless of the primacy of this Spanish translation, intellectuals from various

Latin American countries published responses to the *Futurist Manifesto* in the same year. Most of these responses were strongly critical, though not altogether dismissive. In an extensive response to Marinetti written and published in Buenos Aires in April 1909, the Nicaraguan poet Rubén Darío recognized Marinetti's talent and praised his determination to open new horizons. He noted, however, that the cult of war was a very old literary theme, already present in Pindar and Homer, and judged the manifesto as impetuous and excessive.[68] Similarly, the Mexican poet Amado Nervo, writing in August 1909, characterized the Futurists as noisy adolescents who were saying little new and added, "As an old fox, I am not scared of fires, and screams, or adolescent cannibalisms. All of that ends up in the armchairs of the academies and on professors' platforms."[69] He warned, however, that artists should be attentive to some aspects of the manifesto:

In their innocent chatter my friends the futurists constantly repeat two things that are important for us to retain:

First. The poets must sing to the spectacle of modern life. Everything is worthy of inspiration, everything is poetry: the automobile, the airplane, the transatlantic and the battleship, the factory and the store. . . .

Second. Let's not overvalue the past. The past is really already dead. Let's utilize its lessons and once this is done, let's walk in a straight path towards the future. If the futurists limited themselves to saying only that, they would not be saying anything new but at least they would be saying something intelligent.[70]

Ironically, one of the most acerbic critics of the Futurists was the Chilean Vicente Huidobro, an influential vanguard poet celebrated in both Europe and Latin America.[71] In 1914, Huidobro wrote:

And one good day, Mr. Marinetti decided to found a new school: Futurism. New? Not really. . . .

All of that singing to temerity, to courage, to audacity, to gymnastic steps, to blows on the face is too old; if not, Mr. Marinetti would do well to read the *Odyssey* and the *Iliad*. . . .

And now, all that talk of declaring war on women, besides being a cowardly act improper to men as vigorous as the futurists, is enormously ridiculous (*una gran ridiculez*).

As Rubén Darío has well said: What is more beautiful? a beautiful nude woman or a tempest? A lily or a cannon shot?

But Mr. Marinetti prefers the automobile to the common nudity of a woman. This behavior is proper of a young child (*Esto es una qualidad de niño chico*): the little train above all. Agú, Marinetti.[72]

Marinetti visited Brazil and Argentina in 1926. In São Paulo, a crowd protesting against his aesthetic ideas and his association with fascism prevented him from delivering his lecture. In Buenos Aires he was received politely but with some reserve. The editors of the most important vanguard magazine of the period, *Martín Fierro*, welcomed his arrival with open arms "as a gesture of cordial hospitality" yet clarified that "our sheet has nothing to do with Marinetti, the political man."[73] In the opinion of scholar Nelson Osorio, these early receptions of Futurism counter the widespread stereotype of the automatic and passive acceptance of European ideas in Latin America and anticipate issues raised in contemporary criticism.[74] Given the multiplicity of critical responses to Italian Futurism in Latin America and within Mexico itself, the *estridentistas* must have adopted aspects of that movement with ample knowledge of its limitations. Like most other Latin American artists and intellectuals, they maintained a measured distance from Marinetti's politics and belligerent rhetoric.

Conclusion

Estridentismo corresponds to a period in which the Mexican government began to sponsor a national revitalization of the arts. As the program that Vasconcelos promoted was one of modernist nationalism, the *estridentistas* reached for provocative aspects of the European vanguards of the previous decade to argue for a revitalization of literature in a more worldly direction. Their humorous references to the Futurists' cult of war and to the Aztec past were indirect ways of mocking both the Europeans' excesses and the restricted official visions of a nationalistic Mexican modernity. The *estridentistas'* translations and adaptations of Futurist discourses were selective and considered.

In *estridentista* literature, images of communication networks served a dual function: to indicate Mexico's modernity and to elicit reflection on the possible personal, affective, and social costs of that modernity. This stance was rooted not in naïveté or Luddism—as "third world" critiques are often cast—but in the artists' willingness to engage conditions of mutability and to inhabit multiple cultural spaces. If, as some theorists propose, the cosmopolitanism of our times is no longer predicated on Europeanism, ration-

ality, progress, and the myth of the nation, this investigation of *estridentista* literature would lead us to ponder if it ever was.[75] And if, like the *estridentistas,* we all had been more critical of utopian representations of communication technologies, "the twilight of the digeratti" and the development of critical network theories in our own era might have arrived sooner.[76]

Notes

All translations from Spanish are by the author.

1. Armand Mattelart, *Networking the World, 1794–2000,* trans. Liz Carey-Libbrecht and James A. Cohen (Minneapolis: University of Minnesota Press, 2000), viii.

2. Mattelart, *Networking the World.*

3. Douglas Kahn, "Radio Space," in *Radio Rethink: Art, Sound and Transmission,* ed. Daina Augatitis and Dan Lander (Banff, Alberta: Walter Phillips Gallery, 1994), 95.

4. Roy Ascott, "Art and Telematics: Towards a Network Consciousness," in *Telematic Embrace: Visionary Theories of Art, Technology and Consciousness,* ed. Edward Shanken (Berkeley and Los Angeles: University of California Press, 2003), 187.

5. Jacques Derrida, *Dissemination,* trans. Barbara Johnson (Chicago: University of Chicago Press, 1981); *The Ear of the Other: Otobiography, Transference, Translation,* ed. Christie V. McDonald, trans. Peggy Kamuf (New York: Schocken, 1985); and *Monolingualism of the Other, Or, The Prosthesis of Origin,* trans. Patrick Mensah (Stanford, Calif.: Stanford University Press, 1998).

6. Walter Benjamin, "The Task of the Translator," in *Illuminations,* ed. Hannah Arendt, trans. Harry Zohn (New York: Schocken, 1978), 71–72.

7. These issues are discussed at length in María Fernández, "The Representation of National Identity in Mexican Architecture: Two Case Studies (1680 and 1889)," Ph. D. diss., Columbia University, 1993.

8. Edward Weston, Tina Modotti, Sergei Eisenstein, Andre Breton, Isamo Noguchi, D. H. Lawrence, and Leon Trotsky are included in the long list of visitors to Mexico during this period.

9. Luis Mario Schneider, ed., *El estridentismo: Antología,* vol. 23 of *Cuadernos de humanidades* (Mexico, D.F.: Universidad Nacional Autónoma de México, 1983), 5.

10. All quotations from *Actual número 1* are taken from a reprint published in Nelson Osorio, ed., *Manifiestos, proclamas y polémicas de la vanguardia literaria hispanoamericana* (Caracas, Venezuela: Biblioteca Ayacucho, 1988), 101–107. Hereafter, the sections of *Actual número 1* will be referenced in Roman numerals in parentheses in the body of the text.

11. All excerpts from *estridentista* and other Latin American texts have been translated from Spanish by the author.

12. Mexico's political instability during this period was fueled by foreign interests. See Friedrich Katz, *The Secret War in Mexico* (Chicago: University of Chicago Press, 1983).

13. Luis Mario Schneider, ed., *El estridentismo: Mexico, 1921–1927* (Mexico D.F.: Instituto de Investigaciones Estéticas, Universidad Nacional Autónoma de México, 1985), 18. Several of these men held other occupations in addition to writing. For instance, Gallardo was an established physician who also engaged in literary activities. Kyn Taniya's diplomatic career took him to Europe and the United States.

14. The second manifesto was published in Puebla in 1923, the third one in Zacatecas in 1925, and the last one in Tamaulipas in 1926 on the occasion of the third National Student Congress. For reprints of the manifestos and various writings by the estridentistas see Schneider, *El estridentismo: Mexico, 1921–1927*.

15. Manuel Maples Arce, *Metropolis* (New York: T.S. Book Company, 1929). A series of responses to List Arzubide's *El movimiento estridentista,* from intellectuals from various parts of Latin America, published as an appendix to the book suggest links with contexts outside Mexico. Germán List Arzubide, *El movimiento estridentista* (Mexico D.F.: Secretaría de Educación Pública, Dirección General de Publicaciones y Medios, 1986).

16. Stefan Bacin, "Estridentrismo mexicano y modernismo brasileño: Vasos comunicantes," in *El estridentismo: Memoria y Valoración* (Mexico: Universidad Veracruzana, Centro de Investigaciones Lingsto Literarias/Fondo de Cultura Económica, 1983), 42.

17. The poem (1923) was later published in 1927 in Maples Arce's *Poemas interdictos.*

18. "History of the Radio, Mexico," *Revista Mexicana de Comunicación* (Fundación Manuel Buendía), available at <http://www.cem.itesm.mx/dacs/buendia/seminario/mejial.html>.

María Fernández

19. Schneider, *El estridentismo: Mexico, 1921–1927,* 31. The poem is reproduced in the same text, 297ff. *El Café de Nadie* (1926), by Vela, and two books by Arzubide, *El viajero en el vértice* (1926) and *El movimiento estridentista* (1928), were also published in Veracruz.

20. Dawn Ades, *Art in Latin America: The Modern Era, 1820–1980* (New Haven: Yale University Press, 1989), 132–133; Vicky Unruh, *Latin American Vanguards: The Art of Contentious Encounters* (Berkeley and Los Angeles: University of California Press, 1994), 15; Bacin, "Estridentrismo mexicano y modernismo brasileño," 35; Schneider, *El estridentismo: Mexico, 1921–1927,* 34.

21. Xavier Villaurrutia, "Entremés: El estridentismo," in *La poesía de los jóvenes de México: Obras,* 2nd ed. (Mexico, D.F.: Fondo de Cultura Económica, 1996), 827 (cited in Maria Aparecida da Silva, "Vida y muerte de las vanguardias poéticas: José Gorostiza," available at <http://www.ucm.es/info/especulo/numero15/gorostiza.html>.

22. Andrea di Castro, interview with María Fernández, Mexico City, April 1996.

23. List Arzubide, El *Movimiento Estridentista,* 12. The *estridentistas'* revitalization of literature involved the use of language in novel ways. Words are employed in unusual contexts, creating new meanings. For instance, in the poem "Prisma" by Maples Arce, the sentence "A park with a handlebar breaks down in the shade" (*un parque de manubrio se engarrota en la sombra*) seems nonsensical even in Spanish. In my English translations I have tried to conserve as much as possible of the *estridentistas'* innovations. Thus the reader should expect peculiar sentences and word usage. The translations do not observe the original page layout.

24. *Manifiesto estridentista número 2,* in *Manifiestos: proclamas y polémicas de la vanguardia literaria hispano americana,* ed. Nelson Osorio (Caracas, Venezuela: Biblioteca Ayachucho, 1988), 126.

25. For a commentary on the Futurist's cult of violence, see John White, "Futurist Primitivisms," chap. 5 in *Literary Futurism: Aspects of the First Avant-Garde* (Oxford: Oxford University Press, 1990), 288–358.

26. The word *Mexica* refers to the inhabitants of the city of Tenochtitlan. The word *Aztec* refers to the Nahuatl speakers of the Valley of Mexico from the thirteenth to the sixteenth centuries.

27. The Aztecs believed in an eternal cycle of birth, destruction, and rebirth. According to Aztec histories, the world had been destroyed four previous times. The Aztec empire represented the fifth sun or the fifth era.

28. List Arzubide, *El Movimiento estridentista,* 47. Arqueles Vela and Kyn Taniya demonstrate a conflicted and sometimes dismissive attitude toward women. See, for instance, Arqueles Vela, *La Srita. Etcétera,* reprinted in Schneider, *El Estridentismo: Mexico, 1921–1927,* 95–98; Arzubide, *El movimiento estridentista,* 27. In his famous poem "Airplane," Kyn Taniya declares his intention of taking with him "the most voluptuous" of his women to explore the sky but only after extracting their brains so that they become "tender and obedient bitches." The poem is reproduced in Schneider, *El Estridentismo: Mexico, 1921–1927,* 161.

29. Raul Leiva, cited by Luis Leal in "Realidad y expresión en la literatura estridentista," in *El estridentismo: Memoria y valoración,* ed. (Mexico D.F.: Universidad Veracruzana, Centro de Investigaciones Lingsto Literarias/Fondo de Cultura Económica, 1983) 74. For a survey of Mexican life and society in the modern era, see M. González Navarro, *La vida social,* vol. 4 de *Historia moderna de México,* ed. Daniel Cosío Villegas (Mexico D.F.: Editorial Hermes, 1955–1972).

30. Luis Leal, "Realidad y expression en la literature estridentista," in *El estridentismo: Memoria y Valoración,* 78.

31. See note 33.

32. The word *conmover* is employed frequently by the *estridentistas* to denote both emotion and movement.

33. Manuel Maples Arce, "Prisma," in *Andamios Interiores: Poemas Radiográficos* (1922), reprinted in Schneider, *El estridentismo: Mexico, 1921–1927,* 73.

34. Maples Arce, "Como una Gotera," in *Andamios Interiores,* 81. List Arzubide expressed similar views in his poem "Los pasos divergentes I" (Divergent Steps I):

In what hungry night
did this saltish scream
 rain
in my hands?

I pointed my ticket
toward all the horizons
And the city scattered through the telegraph
 We measured with our burning
 arms
 the walls of the tunnels
and a missing locomotive
screamed asking the distance for help
 its message dragged the memory
over the 400 kilometers of absence.

Germán List Arzubide, "Los pasos divergentes I," in *El viajero en el vértice* (1926), reprinted in Schneider, *El estridentismo: Mexico, 1921–1927,* 254.

35. The *antropofagia* movement in Brazil also sought to integrate tendencies traditionally viewed as incompatible. Like many cosmopolitan artists in the last thirty years, the antropofagists promoted cultural cannibalism as a political act. For a historical exploration of *antropofagia,* see *Núcleo Histórico: Antropofagia e Histórias de Canibalismos* [Historical Nucleus: Antropofagia and Histories of Cannibalisms], vol. 1 of *XXIV Bienal de Sao Paolo,* (Sao Paulo: Fundacao Bienal de Sao Paulo, 1998). Maples Arce's ideal of "a purifying synthesis" is comparable to theories of *mestisaje* popular in his time. See Nikos Papastergiadis, "Tracing Hybridity in Theory," in *Debating Cultural Hybridity: Multi-cultural Identities and the Politics of Anti-racism* ed. Pnina Werbner and Tariq Modood (London and Atlantic Highlands, N.J.: Zed, 1997). Although discourses of originality have been long discredited in the critique of Western art, they resurface with a vengeance in evaluations of artists and critics characterized as "marginal." Often, these individuals have been educated in elite institutions in the United States and Europe, yet figure as primitives or at best as provincials in cultural criticism. Reevaluating dichotomies such as centrality versus marginality is urgent to the project of decentering Eurocentrism. See Dipesh Chakrabarty, *Provincializing Europe: Postcolonial Thought and Historical Difference* (Princeton: Princeton University Press, 2000).

36. Kahn, "Radio Space," 95.

37. Ibid., 111.

38. Quoted in John White, *Literary Futurism,* 149.

39. Quoted in White, *Literary Futurism,* 152.

40. Pierre Levy, *L'intelligence collective, pour une anthropologie du cyberspace* (Paris: La Découverte, 1994). See also Roy Ascott, "Art and Telematics"

41. See *El estridentismo: Un gesto irreversible* (Mexico, D.F.: Consejo Nacional para la Cultura y las Artes, Instituto de Bellas Artes, Museo Nacional de la Estampa, 1998) and List Arzubide, *El movimiento estridentista,* 55, 77, 89.

42. White, *Literary Futurism,* 150–152; Gregory Whitehead, "Out of the Dark: Notes on the Nobodies of Radio Art," in *Wireless Imagination: Sound, Radio, and the Avant Garde,* ed. Douglas Kahn and Gregory Whitehead (Cambridge, Mass.: MIT Press, 1992), 256–258; F. T. Marinetti and Pino Masnata, "La Radia" (1933), in *Wireless Imagination,* 265–268.

43. Arqueles Vela, *El Café de Nadie: Novelas* (Jalapa, Veracruz: Ediciones Horizonte, 1926), reprinted in Schneider, *El Éstridentismo: Mexico, 1921–1927,* 227.

44. List Arzubide, *El Movimiento estridentista,* 13–14.

45. Ibid., 21.

46. Vela, *La Srita. Etcétera,"* 95–96.

47. Marinetti, *Teoria e invenzione futurista,* ed. Luciano De Maria (Milan 1968), 57, quoted in White, *Literary Futurism,* 302.

48. Professor Alonzo Jackman, letter to the Woodstock [Vermont] *Mercury,* quoted in Carolyn Marvin, *When Old Technologies Were New: Thinking about Electric Communication in the Late Nineteenth Century* (Oxford: Oxford University Press, 1988), 201. For early 1990s discourses of virtual communities, see Howard Rheingold, *The Virtual Community: Homesteading on the Electronic Frontier* (Reading, Mass.: Addison-Wesley, 1993).

49. Manuel Maples Arce, "T.S.H," in *Poemas Interdictos* (Jalapa, Veracruz: Ediciones Horizonte, 1927), reprinted in Schneider, *El estridentismo: Mexico, 1921–1927,* 304.

50. Kyn Taniya, *RADIO: Poema inalámbrico en trece mensajes* (Mexico: Editorial Cultura, 1927), reprinted in Schneider, *El estridentismo: Mexico, 1921–1927,* 181.

51. The persistence of platonic notions of the universe in the 1920s among the Mexican intelligentsia may have been strengthened by Vasconcelos's publication in 1915 of Pythagoras's *A Theory of Rhythm,* in which Pythagoras adhered to the belief that the universe was a harmonious musical whole.

52. Douglas Kahn, "Introduction," in *Wireless Imagination: Sound, Radio, and the Avant-Garde,* ed. Douglas Kahn and Gregory Whitehead (Cambridge, Mass.: MIT Press, 1992), 14–15, 20.

53. Icaza subtitled *Magnavoz, "Discurso Mexicano" (Mexican Speech),* but as John Brushwood and Vicky Unruh note, it includes farcical and theatrical elements. Unruh, *Latin American Vanguards,* 50–51.

54. Xavier Icaza, *Magnavoz* (Xalapa, Mexico, 1926), 13.

55. Ibid., 25.

56. Ibid., 40-41.

57. Marvin, *When Old Technologies Were New,* 209–210.

58. Florian Cramer, "Discordia Concors: www.jodi.org," in *install.exe-jodi* (catalog for exhibition, Kunst und Neue Medien, Basel, September 18–October 27, 2002, and BuroFriedrich, Berlin, January 31–March 16, 2003) (Berlin: Christoph Merian Verlag, 2002), 66–81.

59. White, *Literary Futurism,* 148.

60. Marinetti, *Teoria e invenzione futurista,* 63, quoted in White, *Literary Futurism,* 171.

61. Marinetti, *Teoria e invenzione futurista,* cited in, 165–166.

62. *Manifiesto estridentista número 2,* 125.

63. "Irradiación Inaugural," *Irradiador: Revista de Vanguardia* (1922), included in the fourth estridentista manifesto (1926), reprinted in Schneider, *El Estridentismo: Mexico, 1921–1927,* 54.

64. Kyn Taniya, *RADIO,* 185, 187.

65. Tilman Baumgärtel, "The Inability to Understand," in *install.exe-jodi* (catalog for exhibition, Kunst und Neue Medien, Basel, September 18–October 27, 2002, and BuroFriedrich, Berlin, January 31–March 16, 2003) (Berlin: Christoph Merian Verlag, 2002), 62.

66. María Fernández, "Electronic Media and the Globalization of Culture," Paper presented at the Third International Symposium on Electronic Art, Sydney, Australia, November 9, 1992. Parts of this essay were published six years later when such criticism had become more popular (María Fernández, "Digital Imperialism," *Fuse* 21, no. 4 [1998]: 37–45, and "Postcolonial Media Theory," *Third Text* 47 [Summer 1999]: 58–73, expanded version, *Art Journal* 58, no. 3 [Fall 1999]: 58–73). Olu Oguibe, "Forsaken Geographies: Cyberspace and the New World 'Other,'" paper presented at the Fifth International Conference on Cyberspace, available at <http://www.telefonica.es/fat/eoguibe.html>, later published in *Trade Routes: History and Geography* (catalog of the Second Johannesburg Biennale) (Johannesburg: Greater Johannesburg Metropolitan Council/The Prince Claus Fund, 1997) and in *Frequencies: Investigations into Culture, History and Technology,* ed. Melanie Keen, (London: Institute for International Visual Arts, 1998).

67. Nelson T. Osorio, *El futurismo y la vanguardia literaria en America Latina: Cuadernos* (Caracas, Venezuela: Centro de Estudios Rómulo Gallegos, 1982), 19, 21.

68. Ruben Darío, "Marinetti y el futurismo," reprinted in Nelson T. Osorio, *El futurismo y la vanguardia literaria en America Latina: Cuadernos* (Caracas, Venezuela: Centro de Estudios Rómulo Gallegos, 1982), 45ff.

69. Amado Nervo, "Nueva Escuela Literaria," reprinted in Nelson T. Osorio, *El futurismo y la vanguardia literaria en America Latina: Cuadernos* (Caracas, Venezuela: Centro de Estudios Rómulo Gallegos, 1982), 51–55, 52.

70. Ibid., 54.

71. Huidobro is the author of *Altazor* (1931), a futuristic epic in which the poet, represented by an omnipresent voice, surpasses the human limitations of body, time, and space. The voice predicts that in the future, there will be cities as large as a country where "man," reduced to the significance of an ant, will be a cipher that "moves, suffers and dances." There will be no meat to eat, as "the machines killed the last animal." Vicente Huidobro, *Altazor* (Madrid: Visor, 1973), 32. Also see Walter D. Mignolo, "La figura del poeta en la lírica de la vanguardia," *Revista Iberoamericana* 48, nos. 118–119 (January–June 1982): 134–135.

72. Vicente Huidobro, "El futurismo," reprinted in Nelson T. Osorio, *El futurismo y la vanguardia literaria en America Latina: Cuadernos* (Caracas, Venezuela: Centro de Estudios Rómulo Gallegos, 1982), 57–60. "Agú" is an onomatopoeic interpretation of a child's first sound.

73. Quoted in Osorio, *El futurismo,* 26.

74. Osorio, *El futurismo,* 10.

75. Osorio, *El futurismo,* 6. See also Timothy Brennan, *At Home in the World: Cosmopolitanism Now (Convergences-Inventories of the Present)* (Cambridge, Mass.: Harvard University Press, 1997).

76. Geert Lovink, *Dark Fiber: Tracking Internet Culture* (Cambridge, Mass.: MIT Press, 2002), 2–18.

Computer Network Music Bands: A History of The League of Automatic Music Composers and The Hub

Chris Brown and John Bischoff

Introduction

Chris Brown

Many preindustrial musical traditions share the concept that the sound produced by the bodies of living things expresses their spirits: the drum skin or the horn speaks with the voice of the animal it came from, or the xylophone speaks the voice of the trees in the forest. The musician's role is to bring these voices out, allowing them to speak for themselves about the nature of the world.

Twentieth-century composers like Edgard Varese, John Cage, and Harry Partch reconnected with this idea in their use of materials like sirens, brake drums, and wine bottles, employing the raw, unaltered sounds produced by found objects discarded by their industrial culture that expressed the unique qualities of that culture's character. Each sound expresses the spirit of its own physical body, and all of these are uniquely worthy of musical attention. This point of view refreshed the music of a culture that had completely rationalized and limited its own musical resources, opening it to the noise that changed both instrumentation and means of organization.

As industrial culture moves from a physical to an electronic basis, does this approach still apply? Analog electronic technology remains physical even while it focuses on a shrinking physical scale: Instruments like electric guitars and turntables zoom in on the vibrations picked up microscopically from above the points of wire-wound magnetic pickups or through contact with tiny etchings in vinyl. But with digital technology, the source of the medium has become purely symbolic: All sounds are generated by collections and interactions of sets of numbers. Samples themselves may be images derived from physical objects, and when they are used to drive loudspeakers, the air itself becomes the vibrating body; but this is a medium in which the shaping of those images and air is accomplished at root by mathematical or symbolic functions, and these functions have no body. The spirit, or poetry, of computer music gives voice to a nonphysical reality. It is the sonification of data, a genie with the ability to change shape at will, that moves from one physical body to another at the speed of light.

The network is the locus and a source for a new kind of music. The network provides the new technological way that representations of sounds, like all other physical forms, can be manipulated collaboratively, transcending the physical boundaries of individuals. Music in Western culture since the Renaissance has been primarily a celebration of the individual as genius:

composer, virtuoso, rock star. A contrasting approach is exemplified by Southeast Asian gong music traditions, like Javanese *gamelan,* in which the focus is the group, and individuals strive to blend seamlessly and anonymously within it. In a way similar to *gamelan,* computer network music is an expression of systems and architectures of connection created by individuals collaborating with each other, centering not on individual personalities, but on the cultural macroorganisms revealed in their interaction. It involves a *distancing* of the physical connection between sound and individual body. This is perhaps the original and more important meaning of *distance* within the network medium: It is less important that people are interacting from long distances with each other than that they are creating art in which physical proximity and display, the collision of their physical and personal identities, are transcended. Computer network music aims to reveal the voice of the system itself, the sound of the *network instrument.*

This chapter tells the story of two experimental bands that pioneered the use of networked computers in live performance: The League of Automatic Music Composers (1978–1982) and The Hub (1985–1995). The San Francisco Bay Area in the 1970s and 1980s was fertile ground for composers experimenting with the use of microcomputers as musical-instrument automata. For musicians of that time and place, it was but a small step from the practice of acoustic music realized by the rigorous application of algorithms, including chance (Cage), stochastic (Iannis Xenakis), or minimalist processes (Steve Reich), to the application of similar methods by machines in live electronic music. Concurrent with the flowering personal computer industry in the Bay Area, access to the new digital technologies and to the people who developed them was perhaps the best in the world. The local technology community included both the older generation of successful engineers and entrepreneurs who had developed the vacuum tube and transistor and a younger breed of grassroots experimenters, who saw the personal computer as the harbinger of a utopian society built on the principles of free and open access to information and a comprehensively designed environment based on embedded intelligence.

Musically, this was also the environment that gave the world New Age music, a watered-down and commercialized version of the musics based on modes and drones that Pauline Oliveros, Terry Riley, and LaMonte Young invented here during the late fifties and early sixties. But West Coast music making also included a freewheeling, noisy, improvisational edge left over

from the countercultural revolutions of the sixties. Defiantly noncommercial and practiced by musicians coming from classical, free jazz, or experimental-rock backgrounds, it favored compositions that changed with each performance, textures that emphasized a simultaneous multiplicity of voices, and a practice based on collaborative, communal, or group-oriented activities. Another ingredient in this musical stew was the influence of the West Coast tradition of the composer as instrument builder (Partch, Lou Harrison, and Cage) that emphasized taking control of the means of making music itself, including the tuning systems and the instruments. Why *not* extend this approach to the new electronic technologies? Finally, the lack of significant opportunities on the West Coast for the support and presentation of art music made composers in the Bay Area more likely to embrace underground, experimental aesthetics. Since the audience was so diffuse, and opportunities for careers so futile, why not spend one's efforts following the potential of fantastic ideas, rather than worrying about the practical applications of those ideas within traditional musical domains?

Both The League of Automatic Music Composers and The Hub (figure 17.1) came about as associations of computer music composers who were also designers and builders of their own hardware and software instruments. They approached the computer network as a large, interactive musical instrument in which the data-flow architecture linked independently programmed automatic music machines, producing a music that was noisy, surprising and often unpredictable and was definitely more than the sum of its parts.

The League of Automatic Music Composers

John Bischoff

The League of Automatic Music Composers came about through a confluence of technological change and radical aesthetics. In the mid-1970s, composers active in the experimental music scene centered loosely at Mills College in Oakland, California, were greeted by the arrival of the first personal computers to hit the consumer market. These machines, called microcomputers because of their small size compared to the mainframes of academia and industry, could be bought for as little as $250. Their availability marked the first time in history that individuals could own and operate computers free from large institutions. To the composers in this community it was a milestone event. Steeped in a tradition of experimentation,

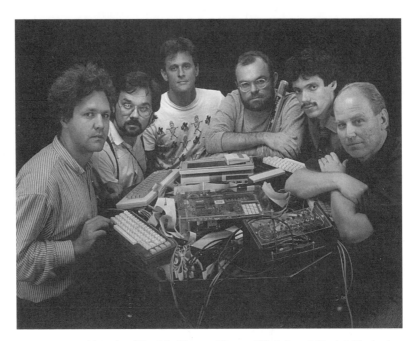

Figure 17.1 A publicity shot of The Hub with some of its gear, Mills College, Oakland, California, circa 1988. From left to right: Chris Brown, Scot Gresham-Lancaster, Mark Trayle, Tim Perkis, Phil Stone, and John Bischoff. Photo: Jim Block.

they were busy at the time building home brew circuits for use in "live" electronic music performance. The behavior of these circuits often determined the primary character of the music. The idea of using the electronic system itself as a musical actor, as opposed to merely a tool, had started with composers like David Tudor and Gordon Mumma. A natural continuation of Tudor and Mumma's example could also be found in the local composers who performed with self-modifying analog synthesizer patches as well. One of these players was the late Jim Horton (1944–1998). Horton was a pioneering electronic music composer and radical intellectual who was first out of the blocks in purchasing one of the new machines: a KIM-1 in 1976. Horton's forward-looking enthusiasm for the KIM quickly infected the rest of the community. In a short time many of us acquired KIMs and began teaching ourselves to program them in 6502 machine language. Programs were entered directly into the KIM's single kilobyte of memory via a hexademical keypad and saved onto audiocassette—the cheaper the cassette machine the

better. Loading programs back into the KIM's memory from cassette was a notoriously flaky proposition often requiring frequent retuning of the control circuit onboard the KIM. There was a strong feeling of community among the composers who were learning to program these tiny computers. This shared spirit was particularly helpful when it came to getting a foothold on the more esoteric, and sometimes pesky, aspects of KIM-1 operation.

An informal discussion group sprang up during this time. A number of us got together on a regular basis to listen to the music we were creating, some of it made by our KIMs and some by analog circuitry in conjunction with other instruments. There was much discussion about new musical ideas as well. In addition to Horton and myself, the group included composers Rich Gold, Cathy Morton, Paul Robinson, and Paul Kalbach, among others. I remember a discussion one evening in which Horton talked excitedly about the possibility of building a "silicon orchestra": an orchestra of microcomputers linked together into an interactive array. The concept sounded impossibly far out to me at the time. In 1977 Gold and Horton collaborated on a piece in which they linked their KIMs together for the first time in a performance at Mills College. Gold interacted with his artificial-language program, while Horton ran an early algorithmic piece based on the theories of eighteenth-century mathematician Leonhard Euler. Early in 1978, Horton and I developed a duo piece for our KIMs in which the occasional tones of my machine caused Jim's machine to transpose its melodic activity according to my "key" note. I recall that these initial computer-to-computer linkages took us hours to develop and debug as we experimented with different methods of transmission, each method often requiring us to learn a new technical facet of the KIM. Typically, connections were made via the eight-bit parallel ports available on the KIM's edge connectors. In such a case, the program on the receiving end would either periodically check the port for new data or more casually retrieve whatever data were there when it looked. At other times we connected via the KIM's interrupt lines, which enabled an instantaneous response, as one player could "interrupt" another player and send a burst of musical data that could be implemented by the receiving program immediately.

In the spring of 1978 the three of us—Gold, Horton, and I—played as a networked trio at the Blind Lemon, an artist-run space in Berkeley started by composer and instrument builder Erv Denman. David Behrman, who had moved west to become Co-Director of the Center for Contemporary Music

at Mills, joined us later that year in a Micro-Computer Network Band performance on November 26, 1978, again at the Blind Lemon. We did a four-track recording of similar material that was edited down for one side of an EP and released on Lovely Music in 1980. By that time the group had become The League of Automatic Music Composers. The new group name was in part a reference to the historical League of Composers started by Aaron Copland and others in the 1920s. It also sought to convey the artificial-intelligence aspect of the League's activities as we began to view half the band as "human" (the composers) and half "artificial" (the computers). As stated in the program for the *Ear Magazine* Benefit Concert (March 28, 1980, at New College in San Francisco), "the League is an organization that seeks to invent new members by means of its projects."

In the spring of 1979, we set up a regular biweekly series of informal presentations under the auspices of the East Bay Center for the Performing Arts. Every other Sunday afternoon we spent a few hours setting up our network of KIMs at the Finnish Hall in Berkeley and let the network play, with tinkering here and there, for an hour or two. Audience members could come and go as they wished, ask questions, or just sit and listen. This was a community event of sorts, as other composers would show up and play or share electronic circuits they had designed and built. An interest in electronic instrument building of all kinds seemed to be "in the air." The Finnish Hall events made for quite a scene as computer-generated sonic landscapes mixed with the sounds of folk-dancing troupes rehearsing upstairs and the occasional Communist Party meeting in the back room of the venerable old building. The series lasted about five months, as I remember.

By 1980 Gold and Behrman had left the group to pursue other projects, and composer Tim Perkis joined the band. Tim had been a graduate student in video at California College of Arts and Crafts in Oakland and was an active player in local *gamelans*. Perkis, Horton, and I continued extensive development of the fledgling network music form between 1980 and 1982 and held concerts all around the Bay Area, including a performance at New Music America in 1981 at the Japan Center Theater in San Francisco. Don Day also brought his Serge Modular analog synthesizer into the group for a time. During this period we would spend months working up a concert (figures 17.2 and 17.3).

At our Shafter Avenue house in Oakland, an entire Sunday afternoon would consist of setting up our computer systems in the living room and

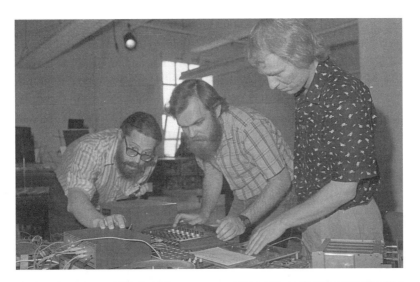

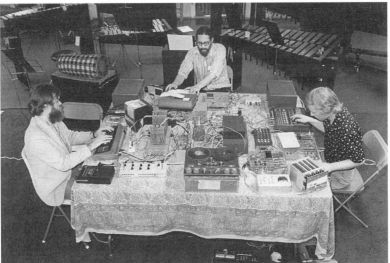

Figure 17.2 The League of Automatic Music Composers preparing for a concert at Fort Mason, San Francisco, 1981. From left to right: Jim Horton, Tim Perkis, and John Bischoff. Photo: Peter Abramowitsch.

Figure 17.3 The League of Automatic Music Composers performing at Fort Mason, San Francisco, 1981. From left to right: Tim Perkis, Jim Horton, and John Bischoff. Photo: Peter Abramowitsch.

laboriously connecting them. As we desired more flexibility in configuring interconnections between machines, we started to use "solderless socket" strips to patch our port pins together rather than hard-soldering them—an electronically dangerous method, as one misaligned connector could blow out an entire port. With wires running everywhere and our computer programs finally debugged, we would eventually get the system up and musically running. For two or three hours we played, tuning our systems, and listening intently as our machines interacted. When surprising new areas of musicality appeared, we took notes on the parameter settings of our individual programs with the hope that recalling those settings in concert would yield similar exciting results. The structural form of our concerts was essentially an agreed-upon series of such settings, the moment-to-moment details, of course, always remaining in interactive flux.

In 1982 the League joined forces with the electronic-music band The Rotary Club to develop a concert of works under the name Rota-League. The Rotary Club, which consisted of a younger generation of graduate students who had just finished at Mills, built its performance style around an automatic switching box designed by member Brian Reinbolt. Using an industrial timing wheel scavenged at a local surplus outlet, Reinbolt interfaced the switching box with the wheel in such a way that the turning wheel would affect the configuration of switches in an ongoing fashion. As the band members played, their sounds were routed through the switching box and chopped into a stunning, real-time collage of bits and pieces. The results fit well with the League's devotion to algorithmic music structures coupled with live human interaction. The combined group Rota-League performed an evening of music in September of that year at Ed Mock's studio in San Francisco, with the performers including Sam Ashley, Kenneth Atchley, Ben Azarm, Barbara Golden, Jay Cloidt, and Reinbolt.

Around 1983 Horton developed severe rheumatoid arthritis, and performing became difficult for him. The League's activities slowed to a halt, and the group finally disbanded later that year.

The League didn't produce network "compositions" as such, but rather whole concerts of music. We didn't give titles to these concerts—we thought of them as public occasions for shared listening. Initially, we let the networked stations run on their own in performance, unattended, and retired to the sidelines to listen along with the audience. After a while it seemed more fun to perform along with the network, so we began to sit around our large

table of gear, adjusting parameters on the fly in an attempt to nudge the music this way or that.

League members generally adapted solo compositions for use within the band. These solos were developed independently by each composer and were typically based on algorithmic schemes of one kind or another. There was a distinctly improvisational character to many of these, as the music was always different in its detail. Mathematical theories of melody, experimental tuning systems, artificial-intelligence algorithms, improvisational instrument design, and interactive performance were a few of the areas explored in these solo works. More often than not, the composer designed real-time controls so that a human player could adjust the musical behavior of the algorithm in performance. These "openings" in the algorithm became important features when the solo was being adapted within the network band context: They were natural points at which incoming data from other players could be applied. The solos, played simultaneously in the group setting, became interacting "subcompositions," each sending and receiving data pertinent to its musical functioning. In actual practice, at the start of a new project members would begin with an informal meeting over coffee at a local cafe where we would throw around ideas for linking subcompositions together. One composer might say: "My program generates elaborate melodic structures—does anyone have pitch information to send me?" Another might respond: "Yes, I generate occasional sustained tones—how about if I send you the pitch I'm playing encoded as a frequency number?" The first person might respond: "Yes, I could retune my melodies to that frequency whenever it comes in." And so the structure of interconnections would be created a link at a time.

Listening to the combined result, one hears independent musical processes at work—each station has its distinct musical viewpoint—along with the coordination of those processes through a real-time choreography of data flow. The whole can be seen as a kind of expanded polyphony, though in this case a polyphony of "musics" rather than "notes." And just as in traditional polyphony, the League's music makes use of many styles of vertical alignment among parts—from strictly synchronous, to closely proximate, to distantly related in time:

What we noticed from the beginning was that when the computers were connected together it sounded very different from pieces just being played simultaneously. If you imagine four pieces of music together at the same time, then coincidental things

will happen, and just by listening you make some musical connections. But by actually connecting the computers together, and having them share information, there seems to be an added dimension. All of a sudden the music seems not only to unify, but it seems to direct itself. It becomes independent, almost, even from us.[1]

[The League] sounded like a band of improvising musicians. You could hear the communication between the machines as they would start, stop, and change musical direction. Each program had its own way of playing. I hadn't heard much computer music at the time, but every piece I had heard was either for tape or for tape and people, and of course none of them sounded anything like this. I felt like playing, too, to see whether I could understand what these machines were saying.[2]

The Hub

Chris Brown

In the early 1980s I was a fan of the music of the League and the Rota-League, while my own music was changing from its focus on homemade electro-acoustic instruments toward an involvement with computers. In 1986 Bischoff, Perkis, and I began producing experimental music concerts at galleries and community music spaces, and in the summer of 1986 we decided to produce a minifestival at The Lab, a converted church building on Divisadero Street in San Francisco devoted to automatic music bands. The festival featured performances by a collection of composers working with computers who were collaborating in duos and trios, connecting their computers in various ways in networks to share sound, control data, or both. We called the festival THE NETWORK MUSE—Automatic Music Band Festival.

Bischoff and Perkis called their duo performance The Hub, because they were using a small microcomputer as a mailbox to post data used in controlling their individual music systems, which was then accessible to the other player to use in whatever way and at whatever time he chose. This was the beginning of the band The Hub: The other composers who joined to become The Hub were also performing on different nights in different groups using uniquely different network architectures. After the festival, using the stand-alone computer to serve as a mailbox for a group (which Perkis had initiated) seemed like the best way for all of us to continue. The original KIM-based hub had four UARTS to allow four players to network using 300-baud serial connections. Perkis and Bischoff soon began to use the KIM hub in a trio with Mark Trayle called Zero Chat Chat.

In 1987 composers Nic Collins and Phill Niblock invited members of The Hub to create a performance that would link two performance spaces (Experimental Media and The Clocktower) in New York City, to exemplify the potential of network music performance to link performances at a distance. This commission was the impetus for the six of us (Bischoff, Perkis, Trayle, Scot Gresham-Lancaster, Phil Stone, and I) to begin to collaborate as a group. Two trios performed together in each space, each networked locally with one of two new, more robustly built, identical hubs, and the hubs communicated with each other automatically via a modem over a phone line. Each trio performed music that sounded different from that performed in the other space, but data generated from each ensemble were shared within The Hub, so the trios were informationally linked. This was the premiere concert of The Hub.

The New York City debut of The Hub was a success and provided a notoriety for the group that launched a ten-year career. But the beginning of the band was a commission for a musical stunt, which became both a blessing and a curse. The idea of having musicians play with one another from distant locations was then, and has been ever since, of considerable interest to promoters, publicists, and audience. Kyle Gann's *Village Voice* review titled "Musica Telephonica" emphasized the idea of the physical disconnect, the capability of creating music without being physically present, "phoning it in."[3] But the band itself was always far more interested in the aspects of performer interactivity, algorithmic complexity, and the web of mutual influence that the network provided. The network was a way for computer musicians to create a new kind of musical ensemble that allowed them to interact in ways that were unique to their medium. We were interested in the sound of idiosyncratic, personal computer music instruments that could influence, and be influenced by, one another. The Hub became a way to extend compositional ideas from the solo electronic performer to an ensemble, creating a new form of chamber music. (The fact that the chamber could be expanded in distance was not entirely irrelevant, but never really the point.) It was also part of The Hub's mission to point the development of computer music away from the paradigm of dominance to one of creative anarchy. To quote Perkis:

I see the aesthetic informing this work as perhaps counter to other trends in computer music: instead of attempting to gain more complete control over every aspect

of the music, we seek more surprise through the lively and unpredictable response of these systems, and hope to encourage an active response to surprise in the playing. And instead of trying to eliminate the imperfect human performer, we try to use the electronic tools available to enhance the social aspect of music making.[4]

Yet what Perkis later called "the gee-whiz aspect" never really escaped us. Constructing and coding were the way we practiced and were "the chops" that were required to make the music happen. But as in any music, the mechanics need to be transcended to reach to the aesthetic goal; and in the technology-dominated context that fed our publicity engine (modest though it was), it became hard to get the audience, much less ourselves, to always focus on the musical issues. The real musical work The Hub was able to achieve can nevertheless be described as the sound of individual musical intelligences connected by networked information architectures. What is the sound of the network? It goes beyond whatever sound-producing means we as artists chose in voicing the compositions we made to the ways in which those individual voices interacted with one another. These modes of interaction were themselves the specifications for Hub compositions: A Hub piece was defined as a protocol defining the types of musical information to be automatically shared within the group and the means of sharing it among the members. Each composer was responsible for programming his unique computer/synthesizer instrument to communicate within these protocols. The progression of the ideas that formed a few of these compositions trace the development of the group and can be heard on the group's two CD releases, *The Hub* and *Wreckin' Ball* (both on Artifact Recordings and available through <www.cdemusic.org>.)

The common memory provided by the twin-hub hardware was the new musical resource explored first by the group. In effect, this was a simple server-client architecture in which requests from each player to read or write to common memory were responded to by the two linked servers. There was a nonuniform latency to this process, which could be up to one second because the two servers had to update a mirror of each other's memories over a 9600-baud connection, but the group made designs that were forgivable of temporal precision, and this in turn affected the music's character.

Trayle's "Simple Degradation" exemplified the idea of using the hub's common memory to contain information that all players used to directly control the sound output of their systems. Its interactive architecture was

one way: Mark conducted the ensemble electronically by feeding information to the hub that governed the behavior of all the other players. At the same time, as in most Hub pieces, the instructions specified only one aspect of the sound each player could produce, in this case the moment-to-moment volume:

One performer generates and processes a waveform, simulating the response of a plucked string. This waveform is then broadcast on the computer network, the other performers using it for amplitude modulation (loudness variation). The rate at which the waveform is played back by the performers is determined by the performer who generated the waveform. The performers are free to choose whatever timbres and pitches they wish. The waveform may only be used for amplitude modulation. Pitch may only change after one complete cycle of the waveform.[5]

A much more demanding protocol for using the shared memory resource that the hub provided was created by Stone for his piece "Borrowing and Stealing." Its subject and title anticipated what would eventually become the battleground for networked musical technologies: the plunderphonic reality that digital information as symbolic representation of sound is all too easily and perfectly replicated, and that such information cannot really be owned, but to be kept alive must be continually transformed:

Melodic riffs are composed by individual participants and sent to the Hub's shared memory, where they become fair game to be appropriated by the other participants. A "borrowed" (or "stolen," depending on one's perspective) riff may then be transformed in any of a multitude of ways, and replayed. The transformed riff is in turn sent to the Hub and made available to the other players. In this way, musical information flows instantly and reproducibly among the members of the ensemble without regard for copyright, attribution, or other proprietary notions.[6]

Other works used the common memory for text communication. In Gresham-Lancaster's "Vague Notions of Lost Textures," each player wrote text messages to his own data area in the hub and could read all other players' data areas, scanning for new messages. The topic of conversation in this primitive chat room was the coordination of the improvised music around a formal shape: a simple ramp of increasing note density, timbral brightness, and amplitude that peaked at around 80 percent of the prearranged duration

of the piece, followed by a smooth return to a texture of low density, brightness, and amplitude, where the music stopped. Chats kept track of the progress of the band through this shape and were often used to describe the character of the music that resulted, providing a running commentary on how the performance was going. During the band's New York premiere, the audience was free to wander around, observing the band's evaluation of its own performance on the computer screens of the band's members.

A virtuosic elaboration of this text communication system occurred in 1989 when The Hub joined with San Francisco composer, writer, and performance artist Ramon Sender in a piece called "HubRenga." Ramon was already collaborating with poets on the Bay Area's pre-Web network The Well, extending concepts from the traditional Japanese collaborative poetry form called *renga,* which is related in its syllabic structure to haiku. In renga, the participants trade writing lines, linking each line to the next using common themes. With the support of a grant from the InterArts Program of the National Endowment for the Arts, we produced a poetry/music/radio performance on KPFA, the flagship Pacifica radio station in Berkeley. The KPFA program guide describes the performance:

Tonight's show is a live performance from KPFA's sound studio of "HubRenga," an audience-interactive, music/poetry piece made possible by the communication between two computer networks. The collaborators in the creation of this piece are Bay Area computer music band The Hub, novelist and musician Ramon Sender, and poets from the poetry conference of The Well. During the performance poets will submit poetry to the piece through the Well. At KPFA, Ramon, as moderator, will browse through the submissions as they come in, reading them aloud as a part of the music. One Hub member will be also receiving the texts on his computer, which will be programmed to filter it for specific "key words" that have been determined in advance of the performance to trigger specific musical responses from The Hub. During the performance, poets will be listening to the piece over the radio while they are shaping it through their communication with The Well. The purpose of the piece is to create with this technology a situation in which a large network of collaborators is tied together from various remote locations in creating an interactive performance.[7]

The Hub pieces described so far were performed with two more robustly built hubs, using standard RS-232 serial communications.[8] Most of us were also increasingly using MIDI communications devices to control our indi-

vidual instruments. In 1990 Gresham-Lancaster obtained an Opcode Studio 5 MIDI interface, which combined the functions of a computer interface, MIDI patch bay, processor, and synchronizer in a single box. It quickly became clear to him that it could be programmed to function as a MIDI version of the hub, which would allow faster, more flexible messaging among computer players than our home-built RS-232 hub provided. This would also implement the concept of the group on a standard music technology platform, which we hoped would make our work more open and accessible to other musicians. But as electronic musicians everywhere eventually find out, upgrading the system meant either changing the existing music so that it could play on the new instrument or else creating a new repertoire made specifically for it. We took the latter route, but changing the messaging system also changed the kind of music we made. The MIDI-hub worked as a switchboard, not as common memory. Instead of a server containing messages in any possible custom format, the MIDI-hub provided the ability for each player to send any other player any MIDI message tagged with an identifier of who had sent it. No longer was it up to each musician to read information left by other players, but instead, messages would arrive in each player's MIDI input queue unrequested. And if information was needed it had to be requested individually from each player, who was required to respond immediately. This networking system was more private, enabling person-to-person messaging, but broadcasting to the whole group was more problematic. Messages were exchanged more quickly and with temporal precision under the MIDI-hub, leading to an intensity of data traffic that was new in the music.

Perkis's "Waxlips" (1991) exemplified this newer MIDI-hub music, in that it sought to directly sonify the architecture of its networking system:

"Waxlips" was an attempt to find the simplest Hub piece possible, to minimize the amount of musical structure planned in advance, in order to allow any emergent structure arising out of the group interaction to be revealed clearly. The rule is simple: each player sends and receives requests to play one note. Upon receiving the request, each should play the note requested, and then transform the note in some fixed way to a different note, and send it out to someone else. The transformation can follow any rule the player wants, with the one limitation that within any one section of the piece, the same rule must be followed (so that any particular message input will always cause the same new message output). One lead player sends signals indicating

new sections in the piece (where players change their transformation rules), and jump-starts the process by spraying the network with a burst of requests. The network action had an unexpected living and liquid behavior: the number of possible interactions is astronomical in scale, and the evolution of the network is always different, sometimes terminating in complex (chaotic) states, including near repetitions, sometimes ending in simple loops, repeated notes, or just dying out altogether. In initially trying to get the piece going, the main problem was one of plugging leaks: if one player missed some note requests and didn't send anything when he should, the notes would all trickle out. Different rule sets seem to have different degrees of "leakiness," due to imperfect behavior of the network, and as a lead player I would occasionally double up—sending out two requests for every one received—to revitalize a tired net.[9]

What is left out of the above description is that the playing of "notes" really did not imply what it usually does in terms of tuned pitches. The actual "notes" could be any mapping of MIDI note numbers to sounds of any kind. But "Waxlips" was still used as "tune-up piece" for The Hub in its tours of the early 1990s: what was tuned was the integrity of the hub's interconnections and software. Once the piece reached a state at which it would continue to generate its barrage of sounds without the necessity of providing further input to the system, we knew that everything was functioning correctly. We often stood up from our computers at this point and walked around the stage or concert hall, just listening, like other members of the audience, to the musical automaton.

Afterword

Chris Brown

At The Hub's premiere in New York City in 1987, there were a number of "techies" in the audience who commented to the band afterward about the primitive nature of our serial communications network and asked us why we were not using Ethernet instead. Although we were aware of that technology, it was simply not within our means at that early date, as the hardware and software that supported it were not yet available for our personal computers. This story emphasizes an important point about The League of Automatic Music Composers and The Hub: We were musicians first, and technologists second, and so we implemented solutions that were practical for musicians in our time and place. As such, we were the first (as far as we

know) to make interactive, live electronic music in a computer network, and despite the primitive nature of that network, we were the first to experience its potentials and its problems.

One of those problems is distance, in at least two senses of the word. First, a distancing of person from instrument: As instruments and ensembles get more complex, the observable connection of people with their own sound becomes difficult to maintain. Computer music instruments are at their best when they take on a life of their own, surprising their creator/performers with a liveliness and character that cannot be predicted; but there remains a need to guide them directly, to nudge their behavior in this direction and the next with gestures, and to hear the results of those gestures immediately. A computer network mediates those gestures further, and a disconnect takes place that can alienate the player, and the audience, from interaction with the music.

Another problem has to do with physical distance: The Hub's first concert, and the publicity we got from it that fueled our career of over a decade, happened because of the public's fascination with the idea that musicians can play with one another in spite of being physically separated by great distances. But our own interests were actually never really aligned with concerns about telepresence. We were more interested in a sonification of the network: in the ways that networking changed the music, rather than in creating the means for networks to be transparent to it. The audience, and grants available for research into a sonification of the network, were definitely smaller than if we had embraced this distance issue. In fact, a failed attempt in 1997 to reproduce the group's music on the Internet became the swan song of the Hub: "Points of Presence," a live performance produced by the Institute for Studies in the Arts at Arizona State University, linked members of the Hub at Mills College, the California Institute for the Arts, and Arizona State. We succeeded only in performing ten minutes or so of music with the full network: The technology, and physical distance, had defeated the music.

The music of the League of Automatic Music Composers and The Hub was a *local* music, made by individual composers fascinated by the musical implications of musicians sharing information in a network. It was never intended to facilitate physical distance from each other, even though the technologies that we explored would allow it. Rather, we were exploring a new instrumentation for collaboration, and we chose to make a music that reflected the

nature of our instruments. We collaborated in real time, but also in the design of the systems that made the connections and interactions between the flow of our automatically generated musics. The success of our music required that each composer give up the desire to control every detail of the resulting sound, and it delighted us most when the systems took on a life of their own. We were conducting musical experiments, and the music that resulted was the result of a process we embraced.

Notes

1. John Bischoff, quoted in Dale Peterson, *Big Things from Little Computers* (Englewood Cliffs, N.J.: Prentice Hall, 1982), 20.

2. George Lewis, quoted in Curtis Road, *Composers and the Computer* (Los Altos, Calif.: Kaufman, 1985), 79.

3. Kyle Gann, "Musica Telephonica," *Village Voice,* June 23, 1987, p. 83.

4. Liner notes to The Hub's first CD, *The Hub: Computer Network Music* (Artifact Recordings 1002, 1989).

5. From Mark Trayle's score for "Simple Degradation," copyright 1987 by Mark Trayle.

6. From Phil Stone's score for "Borrowing and Stealing," copyright 1987 by Phil Stone.

7. Text from KPFA-FM "Folio" program guide, September 1989, copyright 1989 by The Hub.

8. These were constructed using *SYM* microcomputers, an upgraded descendant of the *KIM*.

9. Tim Perkis, from the liner notes to *Wreckin' Ball* (Artifact Recordings 1008, 1994).

Assembling Magazines and Alternative Artists' Networks

Stephen Perkins

Fluxus people created a new form of internationalism. . . . Before Fluxus existed you had Schools . . . located in specific geographical centers . . . with Fluxus you had for the first time an international situation . . . it was individuals spread out all over the world. The artists never needed to move to the same city. . . . For the first time in history we as artists were able to stay in contact, work, exchange and develop our ideas even if we were living far from each other. For the first time an international network was built up by artists themselves.

—Eric Andersen, "About Fluxus, Intermedia, and So . . ."

In a curious coincidence, both Fluxus and Ray Johnson's New York Correspondence School were given their names in 1962. For Fluxus artists the etymological origins of *fluxus* in change and flux suited their purposes admirably, since they shared little in the way of a common front and indeed viewed their heterogeneity as a positive attribute. Johnson, who had participated in a number of Fluxus events, would continue to practice his idiosyncratic and enigmatic correspondence art activities through the postal system until his untimely demise in 1995. Neither Fluxus nor the New York Correspondence School could be defined as avant-garde movements in the historic sense of the term, and yet they positioned themselves as alternatives to, and outside of, the established art world of the period. What unites both are the new networking and communication strategies that they pioneered, both of which account for the continued existence of these artists' communities into the present.

The establishment of innovative communication networks was not only the purview of artists during this period, for a parallel development was being forged by a new generation of computer scientists. The 1960s was the decade in which the early technological and conceptual foundations were laid for what would become the Internet. One of the key players in this period was the computer scientist J. C. R. Licklider. In a 1960 paper titled "Man-Computer Symbiosis,"[1] Licklider reconsidered the stereotype of the computer as a number-crunching machine and expressed the hope that "in not too many years, human brains and computing machines will be coupled together very tightly, and that the resulting partnership will think as no human brain has ever thought and process data in a way not approached by the information-handling machines we know today."[2]

In another paper coauthored with Robert W. Taylor in 1968 and titled "The Computer as a Communication Device,"[3] Licklider turned his attention to a subject that had preoccupied him for some time: the potential of networked computers to create "interactive *communities* of geographically separated people"[4] that furthermore "will be communities not of common location, but of *common interest*."[5] Up to this time only small groups of researchers within universities and research labs had managed to establish networked computer communication within their own respective institutions. It was not until September 1969, with the development of interface message processors, which allowed different remote systems and programs to communicate with one another, that a prototype of the Internet was successfully tested from the University of California at Los Angeles across a four-node

network of participating institutions.[6] There still remained technical and programming problems to be solved, but the number of network nodes and amount of network traffic would increase exponentially year after year.[7]

Fluxus provided a pivotal early model in the establishment of alternative artists' networks throughout the 1960s, and Johnson's utilization of the postal system in the creation of his own network of correspondents would, by the early 1970s, have expanded far beyond him into an independent and self-sustaining network of its own. Both of these networking models were part of a larger challenge directed at research into the nature and purpose of artistic activity and an interrogation into the instrumentality of the art object itself. The deemphasizing of the "objectness" of the artwork and a foregrounding of its conceptual and social processes provided a fertile environment for what would come to be known as the "intermedia" or "expanded" arts.[8] Coupled with the democratizing tendencies adopted from the sociopolitical upheavals of the 1960s was a strong desire to construct open and participatory networking structures that could exist independent of, and in opposition to, the hierarchical nature of the traditional art world institutions.

The *NET* Manifesto

Whereas artists in the West were clear on what they were proposing an alternative to, for artists in the former Eastern Europe, what constituted "alternative" was something altogether different. Piotr Rypson, a Polish artist, states:

Alternative to the existing establishment naturally meant something fundamentally different than in the West: there could have been no discussion or strategy aimed against the art market and its institutions, since no real market of that kind existed (thus the point of departure of Conceptual Art in USA and Western Europe has been largely missed in Eastern Europe in the late sixties and seventies). Instead of capitalist reality—and the art object-as-commodity-discourse—it was the communist state and communist ideology that provided the framework for most of [sic] alternative art practices.[9]

One manner in which Polish artists challenged the state was through the establishment of alternative galleries. Starting in the mid-1960s, these so-called "authors' galleries" not only existed to challenge communist ideology but served as bridges in networking with other like-minded artists both

nationally and internationally. It is from this milieu that an important manifesto was published that outlined a new strategy of networking for alternative artists. Titled *NET,* it was written by Jaroslaw Kozlowski and Andrzej Kostolowski, respectively a Polish director of an alternative gallery and a critic. Published in 1971, it was reissued in 1972 and mailed to 189 international artists who were "invited to be co-curators of the NET." It states:

- A NET is open and uncommercial.
- Points of NET are: private homes, studios and any other places where propositions are articulated.
- These propositions are presented to persons interested in them.
- Propositions may be accompanied by editions in form of prints, tapes, slides, photographs, catalogues, books, films, handbills, letters, manuscripts etc.
- NET has no central point and any coordination.
- Points of NET are anywhere.
- All points of NET are in contact among themselves and exchange concepts, propositions, projects and other forms of articulation.
- The idea of NET is not new and in this moment it stops to be an authorized idea.
- NET can be arbitrarily developed and copied.

NET's insistence upon a noncommodified exchange, and its promotion of an antihierarchical communication model that positioned networking as a central feature of its open strategy, marks it as a defining statement in the search for new models in the construction of alternative cultures.[10]

Artists' Periodicals and Assembling Magazines

One important medium that was significantly affected by these new attitudes and that played a key role in consolidating these networks was the periodical. Periodicals had played similarly important roles within the historic avant-garde throughout the twentieth century; indeed, it could be argued that they are a prerequisite in establishing avant-garde credentials. By the mid-1960s a number of innovative periodicals had initiated a break from the traditional model of the periodical as a repository for the reproduction of text and images to one in which a work's appearance in print marked the final stage in a conceptual and artistic process. Fluxus periodicals illustrate well

the expansion of the idea of the periodical, and two in particular, *Fluxus 1* (1964) and *Fluxus II* (1968), both assembled by Fluxus impresario George Maciunas, offered new and interactive performative-based experiences for the viewer/participant. *Fluxus 1* was comprised of bolted manila envelopes inside of which were the artists' works, and *Fluxus II* was a box that contained two- and three-dimensional objects. These expanded formats were developed not merely for innovation itself, but to offer solutions to the difficulties inherent in presenting and distributing experimental and intermedia works that fell between conventional media.

At the end of the 1960s, an important new genre of periodical emerged that responded to the needs of alternative artists for new contexts in which to display their works and as structures capable of facilitating community among these artists' networks. These publications have come to be known as "assembling magazines," after a well-known American example called *Assembling,* and it's surprising that their thirty-year history has been largely neglected by historians of the period.[11] Once again it is intriguing to note the historical parallels between the development of artists' networks and those being developed by computer scientists. In the following section I make the claim that the first of these periodicals was initiated in 1969, the same year that the first prototype of the Internet was tested. Common to both the development of artists' and computer scientists' networks were earlier small-scale experiments carried out among localized groups of friends and colleagues. Significantly, the first ARPANET experiment and the periodical experiment described subsequently, for the first time in each case, convincingly demonstrated the potential for creating large-scale networks.[12]

Omnibus News

In 1969 three aspiring underground magazine publishers in Munich (Thomas Niggl, Christian d'Orville, and Heimrad Prem) circulated an open invitation to interested individuals to submit their contribution to a periodical; contributions were to take the form of fifteen hundred printed copies of a single-page submission. Each contributor was to be responsible for the cost of generating his or her own submission, and all submissions would be accepted with no editing or censorship. Published the same year under the title *Omnibus News,* the periodical consisted of approximately 200 bound pages and is a weighty and substantial publication. The front and back covers reproduce a number of particularly grisly photographs from the aftermath of

a collision between a bus and a train. The dark humor embodied by this visual play on the periodical's title is suggestive of the iconoclastic attitude that informed the editor's choice of this publishing strategy. This theme is further expanded in d'Orville's editorial in the frontispiece, in which he speculates upon the experimental, and unpredictable, nature of the publishing model that the trio had initiated:

My interest in OMNIBUS NEWS shows itself first in my curiosity to discover what could develop out of the possibility of such a sheet-compilation. The heterogeneous and the accidental, the important and the unimportant. Moreover I am interested in knowing whether there is the formation of a common tone, of generalities and connections, or whether it might be silly to even ask this. . . . One thing is for sure: the experimental aspect of OMNIBUS NEWS should through the conscious elimination of conventional values and elimination of thematic directions, find a place within the opposition to the official artworld.[13]

In return for their collaboration, each contributor received ten free copies of the completed periodical, which they were encouraged to "sell or give away as gifts." With this strategy the editors had constructed a publishing model that included its own built-in distribution system, through which they hoped to "attain the greatest possible circulation." The editors further proposed that the distribution of the remaining copies include cafes, spas, the libraries of military barracks, and old people's homes, in order that "their intended function as a luxury item can best be appreciated."[14] D'Orville, in his editorial, further speculates on the extent to which this informal distribution system might encourage others (artists and nonartists) to step up for a ride on this new periodical *Omnibus:*

A further curiosity is geared toward the system of distribution. Does the unofficial and non-commercial distribution lead to a manifold reaction and thus to a readiness to participate, which will make possible a second edition with a similar but also very new and dynamic tension? It is exactly the expansion to people who up to this point did not want or could not participate, which awakens my interest. Everybody can be their own editor. No general achievement-expectation thus should keep the individual from experimenting. The publishers are only the compilers and organizers of OMNIBUS NEWS.[15]

Omnibus News contains a varied assortment of visual, literary, and theoretical texts, printed works, proposals for actions, documentation, and reproductions of extant works created in a variety of media. A visual and textual smorgasbord, the works are printed on assorted pages of differing colors and weights. At the end of the periodical is a three-page listing of the contributors' names and addresses. The alphabetical sequencing of this list reflects the only structuring device that the editors used in compiling the periodical's pages. A survey of the contributors list reveals submissions from eight countries, with an 82 percent majority from Germany.[16] For reasons that remain obscure, the editors would not repeat this publishing experiment and periodicity itself would become another convention to be discarded.

Omnibus News's radical restructuring of the space of the periodical, its inversion of the traditional hierarchy of editor and contributor, coupled with its process, as opposed to a quality-oriented strategy, must also be understood within the larger cultural context of Germany in this post-1968 period. Indeed, a strong argument could be made for *Omnibus News* as an embodiment of the principles that would later be put forward in Joseph Beuys's Organization for Direct Democracy, which grew out of his struggles with the administration at the Dusseldorf Art Academy and was extended to address issues in society at large. In Beuys's statement of the aims of this organization, he proposes an expanded role for art, which is reflected in the networked model of participation that *Omnibus News* embraced:

Only art is capable of dismantling the repressive effects of a senile social system that continues to totter along the deathline: to dismantle in order to build A SOCIAL ORGANISM AS A WORK OF ART.

This most modern art discipline—Social Sculpture/Social Architecture—will only reach fruition when every living person becomes a creator, a sculptor or architect of the social organism.[17]

Beuys's concept of "social sculpture" is mirrored in *Omnibus News's* disassembling of the traditional hierarchical model of the periodical and its adoption of an open and cooperative editorial policy. Craig Saper, a historian of networked art, has coined the term *sociopoetic* to describe this model of periodical publishing that utilizes "social situations or social networks as a canvas."[18]

Ace Space Company

Assembling magazines would proliferate in North America at the turn of the decade in conjunction with the expansion of the correspondence art network. Two early examples were published by Dana Atchley through his Ace Space Company (later Spaceco). Atchley, a graduate of Yale University, formed Ace Space when he assumed the position of assistant professor in the Visual Arts Department at the University of Victoria in British Columbia. Ace Space initially served as a means of bridging the geographic divide between Atchley and his friends in the United States, and later it served as an umbrella under which he presented multimedia projects. The company, he wrote:

has worked to primarily develop structures capable of creating gestalt communities whose members reflect technically and conceptually diverse points of view. A consistent motivating factor has been to connect these people and their energies and to maximize the flow of information while minimizing differences that often hinder such exchanges. There have been three constants: Nothing is for sale. No rights are reserved. Nothing is rejected.[19]

This open and participatory ethos parallels *NET* in its paradigmatic and utopian model for constructing an alternative communications culture. In this regard, Atchley further states that "this departure from the normal editorial/economic structures has proved to be very liberating and, although it does not obviate existing institutions, it does provide a direct and economically feasible alternative."[20]

Two of the earliest projects that Atchley undertook through Ace Space were *Notebook 1* (1970) and *Space Atlas* (1971). These assembling periodicals, which he described as "community notebook(s),"[21] resulted from his call, circulated among his network of friends, to send him 250 copies of printed pages. The only stipulation was that the works had to fit the format of a three-ring binder. When assembled, *Notebook 1* contained works by sixty contributors; the entire run was then distributed evenly among its participants. By the time *Space Atlas* was compiled a year later, Atchley's call for works had broadened exponentially, and 120 contributors from seven countries now participated. *Space Atlas* was distributed in the same manner as *Notebook 1*. Atchley was also keenly aware of the role these publications played in transacting community in this early phase in the establishment of

the correspondence art network: "Both projects served to keep me in touch with many people and also enabled me to make new contacts. One of the most important results was that the contributors were able, ex post facto, to initiate new friendships and exchanges through their mutual inclusion in the notebooks."[22]

Soon after he completed *Space Atlas,* Atchley's position at the university was terminated. Funded with a grant from the Canada Council for the express purpose of delivering the remaining copies of *Space Atlas* to contributors, he would enter a new phase in the Ace Space Company's activities. Atchley would spend the next ten years presenting multimedia performances across the North American continent.

Other Assemblings

Omnibus News, Notebook 1, and *Space Atlas* are just three early examples of assembling publications that merge, in their structure and operational methods, a critical reformulation of artistic practice and the desire to create new structures capable of maintaining this new communication and networking culture. A number of other assembling periodicals started during the early 1970s. The most influential and long lasting was the New York–based *Assembling* (1970–1987); the contemporaneous *8 × 10 Art Portfolio* (1970–1972) adopted an unbound structure of loose pages in a folio. With the proliferation of international contacts in this period, and in response to the difficulties in accessing printing technologies in totalitarian societies, assemblings would fill a vital role for South American alternative artists. Most notable among these periodicals are *Hexa'gono* '71 (Argentina, 1971–1975), *Ovum* (Uruguay: 2nd series, 1973–1977) and *Punho* (Brazil, 1971–). *Ovum*'s editor, Clemente Padin, writing about the advantages of the assembling model for artists living in repressive regimes, relates that he chose this particular format in response to

the needs of communication provoked by censorship and outrage at the dictatorship imposed in our country since June 1973. On one side the urgent need of making public the crude violations of human rights which our people suffered and, on the other, which prevented me from publishing anything on my own (with the exception of *Ovum*'s cover). That situation made me imagine the cooperative editing system. Almost the whole thing (500 copies) was sent to other countries because of the strict control wielded by the armed forces.[23]

The networked model of collaboration and communication would serve a more urgent need for Padin a couple of years later. In 1977, after having published five issues of *Ovum,* he and fellow artist Jorge Caraballo were arrested and later convicted in a military court for attacking "the morale and reputation of the army."[24] Shortly thereafter Caraballo was released, but Padin remained in prison until November 1979. As word of their arrests and imprisonment circulated through the network, an intensive letter-writing campaign was waged seeking their release. Of these efforts to secure his freedom, Padin later commented that

once more, networking proved that it is not just a simple sui-generis association of artists whose only aim is the diffusion of his works with a view to future insertion in the artist's market but also a worldwide networking creative association, above all joined by moral and ethical principles. People, who among other things, create and enrich the networking and are also able to compromise their well being and security on behalf of freedom and other human beings' lives.[25]

Commonpress

A further development in this participatory publishing model was initiated by the Polish artist Pawel Petasz. In 1977, Petasz circulated a flyer within the international correspondence art network soliciting works for the first issue of *Commonpress* (1977–1990). According to the flyer,

Commonpress is a conception of the periodical edit [*sic*] by common effort. Possible realization of this conception would let to overcome [*sic*] such difficulties as print and distribution expenses, nothing to say [*sic*] about the danger of commercialization . . . each of the participants would be obliged at least ONCE to collect materials, to edit and print as well as to distribute the edition among the other artists taking part in his edition at ones [*sic*] own charge.[26]

After publishing the first issue, Petasz remained the coordinator of issue numbering. Each new editor, after an initial consultation with Petasz, would be free to organize his or her issue on a theme of their choice. No editorial selection would take place, and the editor was obliged to reproduce each submitted work in the required number of copies at their own expense. Through *Commonpress,* Petasz endeavored to set in motion a perpetual periodical machine that was entirely dependent upon the network for its continuation. Indeed, *Commonpress* could be defined as a meta-assembling, since its continuation

was possible only within a preexisting network of potential editors. At the time of its demise, about sixty issues had been published, substantially realizing Petasz's original concept of publishing a periodical through a networked community's "common effort."

Reading Assemblings

Commonpress and the assemblings that I discussed earlier in the chapter present some unique differences when compared to the traditional "little magazine." Their open structure results in an unpredicable accumulation of seemingly unrelated and heterogeneous material, in comparison to their historical counterparts. For even though little magazines are themselves composed of fragments, it has always been in the context of an "editorial forging of provisional links between disparate materials."[27] No such integrative impulse is evident in the pages of assemblings, and their multiplicity resists the closure of normative interpretation. Their hermeticism yields only when they are understood in the context of the sociopoetics of the networks through which they have come together. Each issue functions as a momentary snapshot of the network, and like snapshots they are "read in a *context which is continuous with that from which the camera removed it.*"[28] And although this feature serves to exclude the outsider (as in a family album), for the participants, their inclusion consolidates their membership within the network and provides reassurance of its continued existence.

Assembling magazines became a permanent fixture in the correspondence art network, and they continue to function as important sites through which community is transacted and sustained.[29] Although individual issues have been transferred to the Web, no one to my knowledge has utilized this open editorial strategy to create a totally virtual assembling magazine.

Artforum

In conclusion, mention should be made of a further innovative periodical model developed by Petasz, in which he significantly expands the conceptual underpinnings of the assembling periodical. In the early 1980s Petasz started publishing *Artforum.*[30] Contributors to this "bimonthly magazine of mail art and ephemeral art" received issues that were composed of a single sheet of hand-made paper on which a typewritten "table of contents" lists all the submissions contained in a particular issue. Petasz's humorous play with the title of his humble magazine and its influential art world counterpart

masks a deeper and more ironic wit. On closer examination it becomes apparent that *Artforum* is quite literally manufactured from its contributors' submissions, for Petasz has taken all the submitted works, pulped them, and proceeded to make single sheets of hand-made paper. The print run for each issue was determined by the number and size of the "ingredients," as listed in the table of contents. Petasz's transformation and subsequent weaving of the contributors' works back into the network serves as a compelling example of the larger mission of assembling periodicals: transacting community and perpetuating alternative artists' networks.

Notes

1. J. C. R. Licklider, "Man-Computer Symbiosis," available at <http://memex.org/licklider.html>; originally published in *IRE Transactions on Human Factors in Electronics,* HFE-1 (1960): 4–11.

2. Ibid., 2.

3. J. C. R. Licklider and Robert W. Taylor, "The Computer as a Communication Device," available at <http://memex.org/licklider.html>; originally published in *Science and Technology* Vol 76 (April 1968): 21–31.

4. Ibid., 30.

5. Ibid., 38.

6. This prototype was called ARPANET. The Advanced Research Projects Agency (ARPA) was a Defense Department agency.

7. For a detailed account of the birth of ARPANET, see Ronda Hauben, "The Birth and Development of the ARPANET," in *Netizens: An Anthology,* ed. Michael Hauben and Rhonda Hauben, available at <www.columbia.edu/~rh120/>.

8. A relevant survey of artists working in this intermedia genre can be found in the special "expanded arts" issue of the New York magazine *Film Culture* (no. 43, Winter 1966), edited by the filmmaker Jonas Mekas.

9. Piotr Rypson, "Mail Art in Poland," in *Mail Art: Eastern Europe in International Network,* ed. Katrin Mrotzek and Kornelia Röder (Schwerin, Germany: Staatliches Museum, 1996), 88.

10. Jaroslaw Koslowski and Andrsej Kostolowski, *NET1* (Poznan, Poland: self-published, 1972), unpaginated. This edition is a facsimile published by Soft Geometry Publications (Cologne, Germany, 1993). The original *NET* statement is a mimeographed publication with one cover sheet, an inside sheet with listing twenty-six artists' names, the one-page statement, and then seven pages with a list of twenty artists by name, address, and country.

11. Two of the first exhibitions devoted to assembling magazines took place in the United States in 1996–1997. The first was curated by me at Subspace Gallery in Iowa City in 1996 and featured thirty-eight titles. The second was curated by Craig Saper at the University of Pennsylvania Library in Philadelphia in 1997 and showcased forty-three titles. Saper's *Networked Art* (Minneapolis: University of Minnesota Press, 2001) examines assembling magazines in the broader context of networked art.

12. An example of an assembling periodical that was produced from within a small friendship network was the Paris based *Eter*. The first two issues were published in 1966 and featured works produced by friends of the editor, Paul-Armand Gette. Alice Hutchins, an American artist living in Paris and part of Gette's circle of acquaintances, described his operational method for gathering works: "[I]t was friends that you asked, or friends of friends. It was like an alternative gallery. These often weren't sold to people, they were just sent out." Quoted in Estera Milman, "Circles of Friends: A Conversation with Alice Hutchins," *Visible Language* (Winter/Spring 1992): 205.

13. Christian d'Orville, "Marginal Comments," trans. Curt Germundson, *OMNIBUS NEWS*, no. 1 (1969) (unpaginated).

14. All quotes up to this point in this paragraph are from the page in *OMNIBUS NEWS* credited to Nikolaus Jungwirth of Germany. This sheet reproduces the editor's original call, reasons for publication, and details of submitting work, and the financial aspects of the project. Along either side of the text are assorted slogans, including "Drop a full load into the Omnibus," "Sprinkle sugar in the Omnibus tank," and "Pee on the Omnibus wheels." Translation of this page by Scott Thompson, W.B. Research Syndicate, San Francisco.

15. D'Orville, "Marginal Comments."

16. Foreign contributions came from Austria, Denmark, France, Holland, the Netherlands, Switzerland, and the United States.

17. Quoted in Caroline Tisdall, ed., Joseph Beuys (New York: Guggenheim Museum of Art, 1979), 265.

18. Saper, *Networked Art,* xiv.

19. Dana Atchley, *Space Pack, 1971–72,* n.p., n.d.: Ace Space Company), in Crane/Friedman Papers, Alternative Traditions in the Contemporary Arts, University of Iowa, Iowa City.

20. Ibid.

21. Ibid.

22. Ibid.

23. Clemente Padin, "Assembling Magazines: *Ovum's* Saga," in *Assembling Magazines: International Networking Collaborations,* ed. Stephen Perkins (Iowa City: Plagiarist Press, 1996), 29.

24. Geoffrey Cook, "The Padin/Caraballo Project," in *Correspondence Art,* ed. Michael Crane and Mary Stofflet (San Francisco: Contemporary Arts Press, 1984), 371.

25. Padin, "Assembling Magazines," 30.

26. Pawel Petasz, information flyer for *Commonpress,* no. 1, n.d., in Artworks and Bookworks Collection, Alternative Traditions in the Contemporary Arts, University of Iowa, Iowa City.

Strictly speaking *Commonpress* was not an assembling periodical in the purest sense of the term. Although the editors used the same structure of accumulation as in assembling periodicals a significant difference was that each contributor submitted only one piece of work, which the editor then had the task of reproducing in the required number of copies. Thus, artists contributing to *Commonpress* relinquished one crucial feature: their control over the process of reproduction.

27. David Bennett, "Periodical Fragments and Organic Culture: Modernism, the Avant-Garde, and the Little Magazine," *Contemporary Literature* 30, no. 4 (1989): 481.

28. John Berger, "Photography and Memory," *New Society,* August 17, 1978, p. 359.

29. For a listing of assembling magazines published between 1969 and 1987, see Géza Perneczky, *A Háló* [The Network] (Budapest: Héttorony Kladó, 1991), 253–255. (This book also includes a complete listing for *Commonpress*.)

30. *Artforum* was begun in 1980. However, as a result of the imposition of martial law in Poland in December 1981, completed issues were not distributed until 1983. Petasz was unable to provide me with authoritative dates and figures regarding its publishing history. The complete title for this periodical is *Artforum International: Bimonthly Magazine of Mail and Ephemeral Art.*

The Wealth and Poverty of Networks

Ken Friedman

Networks in a Space of Flows

There is no question that networks have become a central focus and conceptual metaphor of activity in the late twentieth century. The interesting question is why this is so, and why it has happened now. In many senses, networks have become typical, even emblematic, of many kinds of processes in the world. These processes are often hailed as a step toward democracy, equality of opportunity, access to resources, and appropriate governance of the world's resources. All of these characterizations are reasonable. Nevertheless, networks offer no simple solutions to the world's problems. In the course of solving some problems, networks introduce challenges and problems of their own. The network society is an overlay wrapped around different kinds of societies and cultures, linking them and connecting them. The network society reshapes older societies, sometimes destroying them.

The first networks were physical. The rivers, irrigation canals, and road systems of the ancient hydraulic empires were networks. So were the maritime fleets and courier systems of the first nation-states, as well as the railroads and canals of the modern industrial states. When we think of networks now, we think of the electronic and electromechanical systems of our modern world. These networks transmit information. They began with the telegraph and telephone networks of the nineteenth century, moved through radio and television, and now embrace the global environment of the Internet, satellite systems, and more. However, networks remain physical as well, as we still use roads, railway systems, and even canals.

From the earliest times, the social and economic power of physical networks was visible to those who built and controlled them. This was certainly clear to the Sumerians and the Romans. As networks increased their speed and reach, their power multiplied in interesting and unpredictable ways. Robert Hooke wrote the first technical description of a semaphore as early as 1684.[1] By the late 1700s, the semaphore was used to develop semaphore telegraph systems, first in France, then in England. In 1794, one member of the French government hailed the new invention that made "distances between places disappear in a sense."[2] This statement found an intriguing echo two centuries later in a book on today's digital network, *The Death of Distance: How the Communications Revolution Will Change Our Lives.*[3] With its clumsy wigwag signal arms and the limits of light and weather, the semaphore telegraph is primitive by today's standards. In its own time, it furthered revolutions of many kinds: military, communicative, and economic. It shortened the time

that a message took in crossing France from weeks to hours. Making market information available at distant points also forced uniformity of weights and measures, with significant effects on equality and access to markets that had previously been dominated locally by feudal landlords and dominated at a distance by monarchs and merchants. The semaphore telegraph network was followed by the electrical telegraph, electrical networks of other kinds, and the telephone, each time with surprising results. These were often linked to such phenomena as light urban railways or automobiles in reshaping the societies into which they were introduced. At the same time that these innovations shifted cultures in a democratic direction, they often homogenized the cultures that they transformed, in Carolyn Marvin's words, "annihilating space, time, and difference."[4]

Today's networks have equally significant properties. They tie distant individuals together, enabling them to structure and maintain far-flung organizations and communities. They make it possible to shift the locus of control in organizations away from a center or toward it. They permit teams and virtual organizations to work together in new and creative ways. They create special effects by virtue of their linking functions, generating network externalities and increasing returns for some innovations. They also speed the death of traditional ways and uncompetitive innovations or simply evaporate them.

The power of networks is twofold. The network society is constructed around information and the space of flows. This space is now synonymous with networked cyberspace. Although building cyberspace is a technological program, it is also a social and cultural project. The networked space of flows shifts the energies of business and changes the gearing ratios on the wheels of commerce. More than anything else, it changes the quality and structure of the physical world in which we live.

The space of flows moves through channels of communication laid down by geography. The political and geographic landscapes of the world establish the physical space within which the world of networked cyberspace is anchored. Because the space of flows is linked with the physical world, it ultimately becomes physical in importance, bending and stretching the social and economic world around it. In their union, these worlds create strange new morphologies.

Intermedia and Media Convergence before the Internet

The space of flows became visible in the arts well before the Internet emerged as a channel for communication. By the 1950s, artists such as Nam June Paik and Wolf Vostell were working with television and dreaming of artist-controlled broadcast media. In the early 1960s, Paik called for a new utopia through television,[5] in a series of manifestoes that resembled many of the features that would later typify the Internet and the World Wide Web.

One of the most important developments was neither a medium nor a manifesto, but an essay looking at the history and philosophy of media. The essay was Dick Higgins's landmark "Intermedia,"[6] published nearly four decades ago. The first artwork to formally bear the designation *intermedia* was a delightfully simple artifact, created when Higgins published an artwork titled *Intermedial Object #1* (figure 19.1).[7] This work took the form of a performable score that resembled the event scores and instruction pieces of Higgins's colleagues in the international laboratory for experimental art, design, and music known as Fluxus.

Intermedial Object #1 was an invitation to construct an object for which Higgins established nine parameters: size, shape, function, craftsmanship, taste, decoration, brightness, permanence, and impact. For each of these, he set a scale of numbers from one to ten, locating the object at some point along the scale. The scales that Higgins used for each parameter made the piece especially delightful and entertaining. For size, Higgins set 1 as "horse" and 10 as "elephant," locating the object at 6. He set taste with "lemon" at 1 and "hardware" at 10, placing the object at 5, and permanence with "cake" at 1 and "joy" at 10, with the object at 2. The ninth parameter, impact, was unusual, with two scales, adding an x-axis to the earlier single-line y-axis. The first scale was "political" at 1, "aesthetic" at 10, the second "political" at x1 and "humorous" at x10. He located the object at 8 and x7.

The invitation to construct an object to fit this model was followed by an invitation to send photographs and movies of resulting objects to the publisher of Higgins's work, Something Else Press. *Intermedial Object #1* has continued to surface in different incarnations over the years. It was last seen in Geneva in a 1997 exhibition.[8] In this playful, poetic, and partially impossible way, Higgins exemplified and published one of the first works of art to bear the formal designation *intermedia*. Higgins coined the term *intermedia* at the end of 1965 to describe art forms that draw on several media and grow into new hybrids.

Figure 19.1 John M Armleder and Patrick Lucchini, *Intermedial Object No. 1* (for Dick Higgins), 1977. Wood, glass, sand, and light bulb; model (scale: 1/10th). 425 × 164 × 264 mm. Genève, Mamco (Dépôt Jean-Pierre Favre). Dick Higgins's *Intermedia Object No. 1* (1966) as realized from Higgins's original score by John Armleder and Patrick Lucchini, 1977. Photo: François Lagarde. Courtesy Cabinet des estampes (Ecart Archives), Geneva.

The term, included in a famous 1966 essay,[9] described an art form appropriate to artists who felt that there were no boundaries between art and life. For a philosophy that denied the boundary between art and life, there could be no boundaries between art form and art form. Higgins used the word to describe the tendency of an increasing number of the most interesting artists to cross the boundaries of recognized media or to fuse the boundaries of art with media that had not previously been considered art forms. Intermedia is an art that lies on the edge of boundaries between forms and media. Intermedia also exists between art forms and non–art forms. It is sometimes difficult to imagine an intermedia form before it is created, but many can be imagined in theory.

While intermedia is often confused with multimedia, it should not be. The important distinction between intermedia and multimedia is the melding of aspects of different media into one form. When different forms merge, we see an intermedia form. The success of intermedia is seen in the coherence

of mergers that give rise to new forms. The most successful intermedia forms will eventually cease to be intermedia. They will develop characteristics of their own. They will finally become established media with name, history, and context.

In an important conceptual sense, intermedia was a precursor to media convergence in much the same way that art networks before the Internet era were precursors to today's network art. The conceptual and physical convergence of earlier media took on a new dimension in the virtual reality of the digital world. This convergence is powerful both because it permits the birth of new media forms, and because the intersection of the digital world with the physical world makes these new media powerful in physical and cultural terms.

Globalization—and Some of Its Discontents

The restructured conceptual and social realm that is visible in the space of flows is mirrored by the phenomenon known as globalization. For some arts activists, the concept of globalization is akin to the Fluxus concept of globalism.[10] This idea is distinct from internationalism and the competition of multiple nations, and it recognizes that we live on a single planet, a world in which the boundaries of political states may not be identical with the boundaries of nature or culture. In metaphorical terms, globalism is an expression of the idea that national boundaries are problematic in some senses, meaningless in others. In the most important issues, there are no boundaries. A world inhabited by individuals of equal worth and value requires a framework that allows each individual to fulfill his or her potential. This demands a democratic polity within which each person can decide how and where to live, what to become, and how to do it.

Two aspects of globalization reveal deep contradictions in achieving this goal. Globalization enables the growth and power of large, multinational corporations. It is difficult for lone individuals or groups of individuals to compete against this power. It is equally difficult to demand universal law without developing a global context within which law applies equally and universally to all human beings.

The difficulty that artists have had in contributing substantively to global democracy involves two challenges. The first challenge requires understanding the nature of globalization and its discontents in a deep enough way to make a difference. The second involves offering solutions that embody the

necessary and sustainable energy for durable networks. In this, most artists have failed to offer more than elegant metaphors. Although these metaphors move beyond poetry or painting to social sculpture and interactive projects, they fail to meet the needs of sustainable engagement.

Joseph Beuys's Free International University is a case in point. Although the project engaged artists and the art world, occasionally interesting a wider public, Beuys never accepted the necessary discipline of moving beyond a metaphorical social network to generate a durable community. He never attended to the realities of building required for a university-like organization dedicated to learning. Beuys floated proposals, launched campaigns, and enjoyed a certain measure of public acclaim for his good intentions. He left the university itself in the hands of artists and dealers who never followed through on the initially promising idea. As a result, the Free International University was never a functioning network. It was a metaphor. The sad case of Beuys is that he was one of the few artists who had access to resources that could have brought the metaphor to life. The difficulty was that he never committed himself in an existential sense to the artistic metaphor he proposed.

Other cases were more quizzical. Robert Filliou's notion of the Eternal Network was not a call to action, but something between a metaphor and a description of what Filliou believed to be an emerging social reality. Filliou intended it as a genuine description, but the fact is that the Eternal Network functioned primarily on a metaphorical level. In one sense, this is not a problem. Filliou developed his concept of "The Eternal Network" in terms of the human condition rather than art. Filliou held that the purpose of art was to make life more important than art. That was the central idea of the Eternal Network.

In the years since Filliou coined the term, the idea of the Eternal Network has taken on a life of its own, signifying a global community of people who believe in many of the ideas that Filliou cherished. This community is fluid, composed of people who may never meet one another in person and who do not always agree on their concepts of life and art. Those facts do not diminish the reality of an ongoing community, but the community is diffuse and weak. Although this community has exchanged ideas for over three decades, the community has relatively few durable engagements other than artistic contact. The metaphor is powerful. The reality is not, and the Eternal Network remains locked in the art world, where it does little to make life more important than art.

The concept of the Eternal Network leads any thoughtful observer to alternate between optimism and cheerful resignation.[11] It is easy to be cheerful, simply because this metaphor of the global village has survived for as long as it has. In a healthy sense, the Eternal Network foreshadowed other networks that would become possible later using such technologies as computer, telefax, electronic mail, and the World Wide Web. It also foreshadowed a poverty of commitment and a failure to establish the existential commitment and social memory that leads to durable action for change. I will discuss this problem later. For now, let us return briefly to the issue of globalism in Fluxus.

In suggesting a world with no restrictions, Fluxus suggests a world in which it is possible to create the greatest value for the greatest number of people. This finds its parallel in many of the central tenets of Buddhism. In economic terms, it leads to what could be called Buddhist capitalism or green capitalism.

Buddhist capitalism is the metaphor of economic structures that join the productive power of free markets to an ethical sensibility that respects the human value of all social and cultural groupings, large and small. Nam June Paik's *Utopian Laser Television* manifesto pointed in this direction.[12] Although Paik failed to offer a workable solution to the challenge of democratic each-to-all broadcasting, his proposal came oddly close to predicting the everywhere-available world of broadcasting via the World Wide Web. Paik's manifesto proposed a new communications medium based on hundreds of television channels. Each channel would narrowcast its own program to an audience of those who wanted the program without regard to the size of the audience. It would not make a difference whether the audience was made of two viewers or two billion. It would not even matter whether the programs were intelligent or ridiculous, commonly comprehensible or perfectly eccentric. The medium would make it possible for all information to be transmitted, and each member of each audience would be free to select or choose his own programming based on a menu of infinitely large possibilities.

Even though Paik wrote his manifesto for television rather than computer-based information, he effectively predicted the worldwide computer network and its effects. As technology advances to the point at which computer power will make it possible for the computer network to carry and deliver full audiovisual programming such as movies or videotapes, we will be

able to see Paik's *Utopian Laser Television*. That is the ultimate point of the Internet, with its promise of an information-rich world.

Nevertheless, information is not enough. As Buckminster Fuller suggested,[13] it must eventually make sense for all human beings to have access to multiplex distribution of resources in an environment of shared benefits, common concern, and mutual conservation of resources. One of Fuller's proposals for ensuring human rights and free access to all resources was abolishing the principle of national sovereignty. Put another way, Fuller argued for a form of globalism.

To understand the potentials and perils of globalism, we must avoid confusing specific actors or actions with "globalization." The often-cited examples of McDonald's and a metastasized Disneyworld are one aspect of globalization. They are not the whole of it. Second, we must avoid confusing effects with causes. The problematic symptoms of globalization are not causal factors. It is futile to blame globalization or even global capitalism for some of these symptoms. Third, we must understand and describe causes to know what the real problem is. If not, we merely describe symptoms, attributing them to the problem of our choice.

Globalism is sometimes superior to local or regional sovereignty. The first great movement to end the slave trade in America came from the nineteenth-century forces of "globalization." Britain and Europe outlawed chattel slavery long before the United States was ready to do so. Southern aristocrats argued for what they euphemistically labeled the "special institution" based on local democracy and individual rights. They claimed that abolitionism was an illegal attempt to interfere in a local arrangement between traders and plantation owners going about their business. Chattel slavery still exists today under other names. Many who engage in slavery still resist efforts to end the slave trade in the name of local sovereignty against globalization.[14]

Globalization created the United Nations, the Universal Declaration of Human Rights, the Hague Court, and other social goods. It takes centuries to bring about constructive change, and one of the greatest forces of resistance to constructive change involves locally enfranchised powers. In many cases, the same forces that shape problems also bring solutions, and the virtues of many solutions entail problems and crises of their own. The loopholes through which corrupt multinational corporations slip are neither the result nor the cause of globalization. They are the result of a regime of international law dating to the fifteenth and sixteenth centuries. Under this law,

the local sovereign is prime. Sovereigns may do as they will for any purpose within their sovereign jurisdiction.

Multinational corporations do not subvert local governments as the result of globalization. It is the lack of an appropriate global regime that makes this possible. A multimillion-dollar bribe is pocket money to corporations that pay out hundreds of millions a year in dividends and executive salaries. Bribing a local strongman with ten million or twenty million dollars in a Swiss bank—or paying it legitimately while knowing it will be stolen—is the cost of doing business under the fifteenth-century laws governing relations between and among nations. Every story of globalization has two faces.

The Wealth and Poverty of Networks

The historical, conceptual, and physical nature of networks and networked art bring us to consider the meaning and impact of art networks today—both their potentials and their problems. So far, we have examined the technical opportunities made possible by networks. We have not examined the social dimensions of the network society, at least not more than to note the social and cultural effects of such phenomena as globalization or earlier network technologies.

Rather than consider the large-scale challenges of the network society, we will consider the more specific social and cultural dimensions of art networks in the light of general network properties. In examining the potentials and problems of art networks, we will ask why they achieved so much at the same time that they failed to fulfill so many of the hopes held out for them. The answers to these questions involve six basic issues: generative capacity, productive capacity, sustainability, commitment, memory, and learning.

One of the most visible aspects of failed networks is the failure to invest the resources and energy required for maintenance. When an individual stops maintaining a Web site, links go dead. When an organization stops maintaining a server, a node vanishes from the Internet. Organizations fail when individuals and communities fail to support them, and history is the long story of organizations, societies, and cultures that vanished because of maintenance problems or the lack of energy. Sometimes they fail when energy imports cease. At other times, they fail in the face of competitive forces.

Art networks thrive in a dialectical tension between change agency and the stable system of public and private support that makes networks possible. This metaphorical power is one of the true generative capacities of art.

Nevertheless, I wonder about the failure of so many art networks to generate or develop a sustained dialogue with the world around them. As it is with so many stories, this story can be told many ways, and I find myself thinking about this failure from several positions. From all positions, however, it remains the case that social structures and the organizations we build—formal and informal—are also a technology. In this area, the technology of artistic networks has failed to demonstrate the sustainability and resiliency that one might wish of a social agency that makes claims to social innovation.

One aspect of the problem involves productive capacity, the ability (or inability) of art networks to generate the resources needed to survive and grow while also generating the resources required to fulfill a goal or mission. Some art networks purposely never made the attempt. The mail art network is a case in point. It has always consisted of individuals who interact with one another in voluntary coalitions and short-term projects. One or two mail art projects briefly took on an institutional life in an effort to become durable institutions; this was particularly true in Canada, where Image Bank, Western Front, and General Idea became institutionalized through government funding in an era in which Canada was a center of arts patronage. Nevertheless, these institutions depended on external resources, the same resources that supported museums and festivals, and they never developed their own productive capacity.

In contrast, many Fluxus projects sought to develop productive capacity in several ways. These primarily included publishing ventures such as George Maciunas's Fluxus multiples publishing programs, Dick Higgins's Something Else Press, Beau Geste Press in England, or some of the Fluxus West ventures. There were also cooperative housing and community-building projects, commercial ventures such as Implosions or Festivals, and a few attempts to create research foundations organized for the study and promulgation or intermedia and Fluxus. Despite some good efforts and durable results, we failed to create the kind of productive capacity that would sustain the ventures themselves. I will tell this story another time. Here I will simply note that productive capacity requires interacting with a larger world so that resources come in as well as going out. It is one thing—and difficult enough—for an individual artist to do this. It is another and far more difficult matter for a network to develop the productive capacity for long-term survival.

The sustainability of a network flows from the productive capacity of the system or from the willingness of individuals to support its generative capacity. This requires existential commitment of a kind that is extremely rare. So far, there has been no example of an art network that demonstrates the sustainability and resilience of most successful social networks. Some art networks have survived longer than expected: Fluxus is a case in point. This has to do with unusual factors, and one of these is the fact that some members of the network have always been willing to generate and contribute resources in excess of the network's own productive capacity. What is unusual about Fluxus, in contrast with most art networks, is that this condition has prevailed for over four decades.

Memory is one condition of successful network. There are three kinds of social memory at work in most networks. These parallel the different kinds of memory seen in individual human beings. One kind of social memory is short-term or immediate transaction memory. The specific individuals or members of a network (or any organization) rely on short-term memory to work together. This is seen in teams, virtual organizations, and current processes. It might be comparable to short-term memory in human beings.

A second kind of social memory is medium-term memory. This is the memory of current and recent knowledge distributed through the network organization, whether it is formal or informal. This memory is closely linked to organizational learning, even in informal social groupings. At this level, networks process information into knowledge. Workable social memory is embodied in individuals. The working knowledge of any network is what human beings know and remember. This requires a robust distinction between social memory (knowledge) and the facts recorded in documents or held in knowledge technology systems (information). The knowledge of individuals is information for the organization as a whole until it is transmitted widely enough to be known by a reasonably broad constituency. Only then does it become social knowledge.

The third kind of organizational memory is long-term memory. This involves a deep understanding of the reasons for which something is done and of the relationship between activities and the ultimate purposes for which they were created. Most networks tend to be very bad in this area. At this level, behaviors are often disconnected from memory. For this reason, valuable practices may be sacrificed or neglected because no one knows why these practices exist. Paradoxically, useless activities may continue for nearly the

same reason. They may be retained and continued on the false assumption that they are valuable. This is so in spite of—or because of—the fact that no one knows why they began.

There may even be a fourth kind of memory, embedded so deeply as to be almost subconscious. This includes memories so central to a network's early foundation and way of being that they are part of the culture. It also includes memories of activities on which no formal documents ever existed. These memories are linked to behaviors for reasons long lost, reasons that can no longer be uncovered.

The first kind of memory corresponds to know-how, the second to know-what, the third to know-why, and the last to a kind of existential quality of being. The kinds of processes that a network can understand and the goals it can achieve are always linked to kinds of understanding it embodies. This understanding is lodged in social memory. The behavioral context within which individuals operate in a network and the processes they are permitted to develop are also linked to culture and to social memory.

Learning depends on memory. One reason that art networks so often fail to achieve the goals for which they are established is that they do not remember long enough to learn enough. Networks often have enough short-term and middle-term memory to achieve notable results and specific works, but the social and cultural change implicit in activism requires more.

Networks offer important advantages. At the same time, the shift to networks in organizational structures and thinking introduces difficulties. This is a topic that has been developed beautifully by the sociologist Richard Sennett and one that is rarely discussed in an art community for which the word *network* represents only benefits and no drawbacks. Five years ago, Sennett examined the consequences of flexible organization in work life.[15] In earlier books, Sennett had examined problems of social life in contemporary industrial democracies. He studied conscience, authority, public life, and—notably—the continuing problem of class. In his 1998 book, *The Corrosion of Character: The Personal Consequences of Work in the New Capitalism,* he examined what happens when organizations move from long-term commitments to short-term network structures, and he examines the consequences that arise as the bonds of social life and work life are loosened in comparison with earlier systems.

The challenges of existential commitment and memory that art networks face in seeking to generate social transformation occur in working life when

today's flexible organizations relax the bonds that ought properly to generate solidarity and engagement. The meaning of career and life work changes dramatically in networked societies, and this involves troubling effects of alienation and disconnection as much as it engenders freedom and personal choice. The stability and sense of belonging that comes with tradition is balanced in a dialectical tension with the fluidity and freedom that arise as traditions weaken. On the one hand, the individual gains power against the group and personal freedom rises. On the other, social group support for individual human beings vanishes as loose temporary aggregations of individuals meet to pursue short-term personal interests on a project-oriented basis.

This chapter has considered human and social aspects of networks by studying their physical and technical properties, examining how these properties affect art networks in the global knowledge economy. It seems to me that art networks are a hopeful phenomenon in a complex world. The open question is whether these networks can achieve their purposes. Recovering the history of past networks can help us to learn from what they achieved. It is equally important to examine the problems and unresolved challenges of these networks to learn from what failed.

Notes

1. Patrice Flichy, *Dynamics of Modern Communication: The Shaping and Impact of New Communication Technologies* (London: Sage, 1995), 7.

2. Ibid., 9.

3. Frances Cairncross, *The Death of Distance: How the Communications Revolution Will Change Our Lives* (London: Orion Business, 1998).

4. Carolyn Marvin, *When Old Technologies Were New: Thinking about Electric Communication in the Late Nineteenth Century* (Oxford: Oxford University Press, 1988), 191–231.

5. Nam June Paik, "Utopian Laser Television," in *Manifestoes,* ed. Dick Higgins and Emmett Williams (New York: Something Else Press, [1962] 1964).

6. Dick Higgins, "Intermedia," *Something Else Newsletter* 1, no. 1 (1966): 1–6; reprinted in *Multimedia: From Wagner to Virtual Reality,* ed. Randall Packer and Ken Jordan (New York: Norton, 2001), 27–32.

7. Dick Higgins, *Intermedial Object #1* (New York: Something Else Press, 1966); *Foew&ombwhnw: A Grammar of the Mind and a Phenomenology of Love and a Science of the Arts as Seen by a Stalker of the Wild Mushroom* (New York: Something Else Press, 1969), 22.

8. Lionel Bovier and Christophe Cherix, *L'irrésolution commune d'un engagement équivoque: Ecart, Genève, 1969–1982* (Geneva: Mamco et Cabinet des Estampes, 1997), 65–66.

9. Higgins, "Intermedia"; *Foew&ombwhnw*, 11–29.

10. Ken Friedman, "A Fluxus Idea," in *The Electronic Superhighway: Travels with Nam June Paik*, ed. Nam June Paik and Kenworth W. Moffett (New York: Holly Solomon Gallery, Seoul: Hyundai Gallery, and Fort Lauderdale: Fort Lauderdale Museum of Art, 1995, 87–97), 41, reprinted as "Fluxus and Company," in *The Fluxus Reader*, ed. Ken Friedman (Chichester, England: Academy Editions, Wiley, 1988), 237–253; "Cuarenta Anos de Fluxus," in *Fluxus y Fluxfilms, 1962–2002*, ed. Berta Sichel in collaboration with Peter Frank (Madrid: Museo Nacional Centro de Arte Reina Sofia, 2002) 41–83, 60–65.

11. Ken Friedman, "The Early Days of Mail Art: An Historical Overview" and "Eternal Network," in *Eternal Network: A Mail Art Anthology*, ed. Chuck Welch (Calgary, Alberta: University of Calgary Press, 1995), 3–16 and xiv–xvii.

12. Paik, "Utopian Laser Television."

13. Buckminster Fuller, *Critical Path* (New York: St. Martin's, 1981), 198–266; *Earth, Inc.* (New York: Doubleday Anchor, 1973), 175–180.

14. Anti-Slavery International "Anti-slavery Homepage" (2003), available at <http://www.antislavery.org/> (accessed February 10, 2003); iAbolish, Web portal of the American Anti-Slavery Group (2003), available at <http://www.iabolish.org/> (accessed February 10, 2003).

15. Richard Sennett, *The Corrosion of Character: The Personal Consequences of Work in the New Capitalism* (New York: Norton, 1998).

20

From Internationalism to Transnations: Networked Art and Activism

Sean Cubitt

The sources seized on by modernists like Picasso and Matisse were exotic, anthropological, and inspired by anticolonial political, and cultural movements in faraway countries. At the same time, the mutual dependency of tradition and modernity, of power and resistance, spread across the globe as modernism became hegemonic from Chandigarh to Freetown. In many respects these problems have remained. But their permutations, most of all in the evolution of networked art practices from mail to Net art, have in some ways produced an entirely new scenario.

Peripheral Modernism

The question posed some years ago by Raymond Williams, "When was modernism?"[1] has become more a question for this collection of "Where was modernism?" The answer is neither "at the center" nor "everywhere." And if, in the old modernist nightmare, "the center cannot hold," it is not because of the barbarian beasts slouching to Bethlehem, but because the center itself is too weak, and more especially because centrality as an organizing principle has served its time. The baroque courts of the absolute monarchs are no longer the foci of all culture. In a certain way, they never were. The splendor that was Greece and the glory that was Rome raveled up their excellence from the scatterlings of empire, as all centers have from Ur to the Meiji. Civilization may be the triumph of the centripetal, but art and invention have always surged from the periphery.

Coming at it from another direction, there is scarcely a book on modern art that doesn't sport Picasso's *Demoiselles d'Avignon* on its cover. Of course, the canonical status of this work has a great deal to do with the ownership of the piece: it belongs to the New York Museum of Modern Art. But it is also a hugely significant canvas, memorial to a shift in European sensibility in 1907. Everyone knows, I suppose, about Picasso's long hours studying African and Pacific Islander arts in the anthropological Musée de l'Homme in Paris. Many recognize too the reaching back into the ancient arts of the Iberian Peninsula and the folk arts of the artist's native Cataluña. What is less widely acknowledged is the reason why the man was interested in this old stuff. David Craven's excavation of the Latin American origins of the word *modernismo*[2] describes the Nicaraguan poet Rubén Darío and the Mexican painter Diego Rivera in Barcelona at the turn of the twentieth century, both partners in a project whose major political theorist was the revolutionary José Martí. Their concept was of an art, a culture, and a polity founded not on

Greece, but on the indigenous histories of Latin America. Lest this seem in turn a narrow imitation of the nationalisms that inspired Dvorak and Sibelius, recall that Bolívar's nationalist revolutions had succeeded long before the Northern and Eastern European nationalist movements reached their cultural and popular peak. Rather, imagine the impact on the artists of Cataluña, think of Gaudí's slogan, "Originalidad es volver al origen" (Originality comes from the return to origin). What the Latinos brought to Europe was the concept of seeking roots in the ancient world, without the narrow definitions of the ancient that held in the academies of beaux arts. Modernism is a peripheral invention.

Vernacular and high architecture has not ceased to raid the storehouses of the orient, from flat rooves to cinema decor. Matisse's raids on Moroccan decorative arts still inspire fashion houses, popular musicians, and designers. Debussy's fascination with *gamelan* stands at the beginning of twentieth-century formal music as Pound's translations from the Chinese stand at the root of English-language modernist poetics. From "Ubangi Stomp" to *The Matrix,* Africa, Asia, and Latin America have driven the popular arts.

If there is a change at all in this configuration, it occurs in the precise ways that trade and commerce, inspiration and exploitation, governance and ordnance shape the infrastructures of global dialogue. There can be little denying that in some sense, throughout the last hundred years, the contemporary has always seemed to be elsewhere. The Southern Hemisphere looks to the old colonial capitals for legitimation; they in turn look to New York and Los Angeles, and they to the Old World again, or to proofs that their works are genuinely global in appeal. But just as the oppression of women has altered from the epoch of domestic servitude to the hours of reality TV, the specifics of intercultural dialogue and expropriation are no longer what they were.

International Solidarity

The art of networks is by definition an ephemeral form. And yet, one afternoon in the early 1970s, blinking in the sunlight, I came out from a screening of Kozintsev's magisterial film of *King Lear* to find my university town papered with Chilean solidarity posters, bearing the pierced-dove emblem that Picasso had first drawn for the Republicans in the Spanish Civil war forty years earlier. The poster is an urgent thing. It must take its place in the legible city of advertising, among the commercial billboards and the community notices, and like them it must face up to the brevity of its life span. Its

task is to arrest now, to remind briefly, and to be replaced as soon as its efficacy fades with familiarity. Like the three-minute pop song, it must appeal on first sight and not outstay its welcome. It demands of artists that clarity in communication that so often art rebuffs, favoring a longer savoring of its messages and methods.

Activist art has also another virtue: that it is by and large cheap to reproduce in quantity and easy to transport. Film, for example, is too expensive in both ways, so that though there are many political films, there are few activist ones, activism in audiovisual media being far more closely associated with video, which, in turn, is in every way a more ephemeral medium (and so also far less highly prized). Like video, posters are easily bundled, easily smuggled, easily copied and proliferated, and easily disposable once their work is done.

This peculiar property of evanescence, evoked since Baudelaire as of the essence of modernity, so rarely focuses the artistic imagination that it is all too often flicked out of account in archives and collections. The instability of cheap inks and papers, like that of magnetic media generally, dissuades archivists, and curators are only too ready to shuck another burden from already overcrowded schedules, storage, and budgets. And yet these fleeting things persist. At their most prestigious, like Picasso's mural for the Spanish pavilion at the 1937 Paris World Fair, a rush job painted between April 26 and the June opening of the show, fast works solidify a moment of commonality into a form that reverberates for years, in this case in the form of *Guernica*. The republican posters that Picasso and fellow surrealist Miró designed are less familiar, fading memories. Yet they too can recirculate.

John Berger, trying to trace, in a way similar to Raymond Williams, the lost radicalism of early modernism, accuses Picasso or his admirers of transforming the loose and personal allegory of *Guernica* into a generalized humanitarianism.[3] Perhaps something similar could be said of the pierced dove redeployed decades later, and no doubt in other places, at other times, for other campaigns, and no doubt many of them with less connection to the politics of antifascism. That these works also have a towering emotional appeal is, on the other hand, indisputable, not least in view of the evidence of repeated attempts to damage or destroy *Guernica* since its move from New York to Madrid after the death of Franco. Through the dark years of the Spanish dictatorship, that painting kept alive the memory of the war crime on which it was founded, as in many respects it helped to maintain, through the

cold war, the possibility of a political practice of art that was all too often suborned to the ideological project of refined and abstracted modernism.

The poster's central attraction lies in its ease of publication, for it is a public art engaging in a public service. More complex, because more subtle, but also because more personal, is the development of book and especially mail art. Pavel Büchler, a formative figure in the Mail Art movement, tells a little anecdote of his time in Czech prisons. The big treat shared by prisoners and guards alike was movies, best of all Karl May westerns from East Germany, shot in Mongolia, with towering Aryan heroes riding the range on tiny steppe ponies, their heels dragging in the grass. These somewhat enforced connections across the Eastern bloc are deeply suggestive of the nature of mail art: that it is a world of communications in which, unlike the poster, the art is addressed privately and circulates in quasi-anonymous envelopes, for instance, through the prison system of the old Czechoslovakia.

In the early 1990s, I found myself on the Black Isle, across the Moray Firth from Inverness, for an event forming part of the first Fotofeis Scottish festival of photography. The Highlands and Islands Council, recognizing even before the opening of the World Wide Web that the future of their depopulating region depended on electronic communication networks, had facilitated a group of artists with disabilities to produce an event of international fax art. Within a few minutes of the official start, faxes were coming in with poems, drawings, documents, photographs, and memorabilia from every continent (including, with some fanfare, Antarctica). Other experiments followed: John Roberts worked to develop a Pan-European ansaphone art project. Oscar Friedl in Chicago ran a show of stamp art, in which all the participating works had to arrive under their own (illegitimate) stamp, many of them sexually, politically, or ethically invigorating and illegal in the countries they came from or passed through. The older mail art still kept its devotees, especially among the Fluxus group, for whom these knotty, personalized artworks become important channels for sharing a culture of disarray and reconjuncture.

Fluxus was—is—the last of the revolutionary vanguards. Its inspiration derives, in its typically circuitous route, from the First International convened by Marx and Engels and has its shadow in Beuys's call for a Fifth International of artworkers dedicated to a society of creativity.[4] The term *"international"* has always been dialectical, drawing into needle-sharp focus the contradiction between the global nature of work and its national gover-

nançe. That Fluxus still appeals is testament to the enduring power of nationhood in discourse. Likewise, it speaks to the resilience of that old communist belief in the final solidarity of the oppressed. Its mechanisms, like those of international socialism, are the bonds of solidarity. Yet what are they? What are the claims made by the Spanish or the Chilean dove? Mail art especially seems to revivify for another sphere of labor the early-eighteenth-century beginnings of trade unionism in the corresponding societies mapped by E. P. Thompson,[5] and to evoke once more the power of resistance to the old adage of power, "divide and rule."

Both the poster and in its very different way mail art address modern society as agora, as the interface of public and private in which personal concerns meet their expression in dialogue with other persons and their particular interests. The poster spills into public space the anguish and anger of the singular artist, whose task of the hour is to subordinate to the political their usual individuality, but who is prized especially because of their individuality as a contributor to the cause. As Adorno notes in *Aesthetic Theory*, artists are hedged in by reality, which is their raw material, and among the real, individuality, however much it is a social construct, is a boundary, a given, upon which and through which they are condemned to work.[6] Both public and interpersonal art operate at the level of the interface between the personal and the political, raising that boundary as their own ground, their raw material as well as their canvas and their gallery. In this way they devote themselves to resistance, by refusing the grounds of sociality that are on offer to them.

But that act of resistance is proper only to the era of the political, the era of the international. The nation-state belongs exactly to that agora of the public/private and is exactly political in the sense that its key institutions—treaties, agencies like UNESCO (the United Nations Scientific, Educational, and Cultural Organization) and the International Broadcasting Union, performative institutions like the Court of Human Rights—are political, possible agencies framed in the heat of dispute in which power and resistance are what is in play.

Our times are different. Resistance to the political has become the hallmark of the corporations, and the power of the nation-state is on the wane, in many instances already definitively over. Where Benjamin proposed the politicization of aesthetics against the aestheticization of politics,[7] today we face the commercialization of aesthetics up against the aestheticization of

commerce. The dialectical powers of resistance have no place in a world in which politics is a residual and marginal activity instantly convertible into salable items, attitudes, and lifestyles. The public world has been privatized, the private world all but erased in the assimilation of populations as data images in the information banks of marketeers. In the days of the First International, the lost times when production was the dominant mode of capital, Marx could argue with conviction that the economic was the strategic core of oppression. Between the wars, the political subsumed and transformed the economic, an effect that rolled on and still guides the internal workings of the command economy in the United States, where the arms industry is the last to challenge the media as highest earner. Gradually in the postwar period, and with increasing virulence since the conversion of stock markets to twenty-four-hour trading at the end of the 1980s, commerce has assumed the role it always looked for: the commanding heights of an integrated global market.

Globalization, Cosmopolitanism, and Mediation

Lenin famously defined communism as socialism plus electricity, in a time when the largest force for infrastructural renewal was still the state. Before that, back in Marx's time, transport technologies were the most significant engines of internationalization. The postwar period has made one immense change to the infrastructure. Today information, broadly conceived, can travel faster than human beings or tangible commodities. As Schumpeter long ago argued of transport, increased speed was not a matter of more horses, but of the invention of steam. The qualitative shift from transport to communication requires of us a very different understanding, and one that is as yet hard to focus, even a decade after the introduction of the Web. In the brief moments we allow ourselves to envisage the future, it looks entirely like the present, only more so: more bandwidth, bigger corporations, fewer local and more global retailers, manufacturers, products or tastes. The attack on the Pentagon on September 11, 2001, far more than the more spectacularly mediated destruction of the World Trade Center, is the first inkling we have that there may yet be another future.

Although Sub-Saharan Africa, the Andes, the Caribbean and Central Asia are to all intents and purposes excluded from the infrastructure of communication, they are also by the same token excluded from the circulation of wealth, which, in the form of electronic cash flows, is indistinguishable from

information, art, and education. As if whole populations were surplus to the requirements of global commerce, as if the commitment to profit no longer need pay even lip service to the well-being, even the survival, of the poor, but only to the dutiful payment of dividends. The option on tradition as resistance to modernity (and the two are mirror effects of one another) evaporates when communication processes entirely uninterested in the real—in any case definable as that which is outside e-commerce and the electronic-media circuits—detour around resistance. Nor is nomadism a defense. While the Fortune 500 proliferate mobile headquarters, no one of which is geographically vulnerable, the numbers of enforced migrants leaps, from two million in 1975 to twenty-seven million twenty years later under the care of the U.N. High Commission for Refugees.[8] NAFTA border controls, Fortress Europe, and John Howard's Australia enact legally what street vigilantes enforce illegally: the brutalization of the poor immigrant. Nomadism is a privilege of the wealthy.

The era of cultural exclusion is over, replaced by an inclusive art world and inclusive popular media. The infamous Magiciens de la terre exhibition broke the barrier defining art as the exclusive property of the Western tradition, only to baffle it with touristic exoticism, reducing shamanic ritual to sources for the West's art, a demonstration of pluralism in globalization, and a shift toward Balibar's "neo-racism"[9] based no longer on biology, but on supposedly irreducible cultural difference. The smorgasbord of cuisines and art forms, musics and cinemas, far from challenging the West's hegemony, expands it as the universal tastemaker that, since Kant, it has assumed itself to be. No longer metropolitan, the culture of the nomadic corporate elite is cosmopolitan, not so much because it replicates its home culture wherever it goes—like the old imperial civil service—but because it swallows and digests difference as such.

It is in this vein that we need to understand the new networks and their arts and how the network artist needs to reconsider and redefine what it is that they can hope to achieve. The political options are largely unpalatable: Mugabe's land reforms, the Islamist revolution, the claims of indigeneity from Serbia to Fiji. It is tempting to follow the old reformist line of the Second International: to claim that the only way forward is to propel the machinery of capitalism into even more rapid development in the faith that it will of its internal contradictions produce the terms for global socialism. Lenin's intellectual sleight of hand, persuading the Bolsheviks that the

intervening moment of capitalism could be compressed into a matter of months, was a necessary countervention: The Great War was too madly destructive to be borne with as a necessary phase of the dialectic. We have to know that much the same is true of our world: that the indicators of lifestyle—basically destructive consumerism—are purchased at the expense of immiserated offshore workers, half a century of proxy wars, devastating famine and ecological disaster, the degradation and ethnocide of inner urban populations in the metropolises, and on and on and on. The stunted physical development of two generations will alone take fifty years to repair; the damage to the environment at least another hundred. Any kind of intervention today requires urgency and action. At the same time, the world cannot afford certainty, the unquestioned faith in right that powers dictatorship, even the dictatorship of deep ecology or movements for indigenous rights.

In the narrow world of art, the critique of the commodity reached a startling height in the conceptual art movement. Yet that art is already collected and collectible. The erasure of the object turns out to be a foreshadowing of the end, not of history, as Fukuyama has it, but of geography, as Virilio spotted. Conceptualism was assimilated because it was ahead of the game, and that is the function of art today. Of course, a great deal of what is traded in the art markets is old masters, and the imitations of old masters, today's lions all too often imitators of a moment that Duchamp overcame after 1912's *Fountain* by going on to build his absurd, poignant, laughable masterwork *The Large Glass.* Stuck in the moment of the ready-made, Koons, Hirst, and Rist are ninety years out of date. Other artists, almost all far less well known, make work that smacks of the new century: Some have been making it for years. Each reader will have their own names in mind: These are the ones for whom the task is not the making of objects that will hold in themselves some intrinsic and long-lasting worth, but the process of working itself, the imaginative leap out of the present into the realm of possibility, the otherness of a future that by definition does not yet exist. The contemporary artist no longer makes things, not least because the object relation, which is also that which subjects subjects to objects, is no longer the central relation between people.

In Marx's famous epithet, relations between people appeared to them in the fantastic guise of relations between objects. That is no longer the case. For a brief period between the Wall Street crash and the Bretton Woods Agreement, relations between people appeared in the startlingly cosmetic

guise of the service industries. Now the mystery has deepened. Relations between people now appear in the chimeric guise of relationships between data flows, and specifically between those flows that encode the lightning-swift dashes of e-capital from here to there, from existence to spectacular disappearances in the WorldCom and Enron bankruptcies. Warhol's art, slightly late, parodied the state of affairs governing the service economies of the 1950s. Not surprisingly, by the end of his career, his art had become a service industry itself. Western art that for a brief moment at the end of the nineteenth century had taken on the role of philosophy in inquiring into the status of the world and our knowledge of it followed philosophy's linguistic turn by devoting itself to self-definition. LeWitt's dissolution of the object and the service was a necessary step toward the self-annihilation of a cultural practice that, deprived of representation, no longer understood what it was to undertake.

That new task is mediation. The more money draws to itself the function of universal signifier, universal equivalent, universal commodity, and universal communicator, the more important it is to intervene there where the power of empire works, in its form and through its activities. The reason meaning has become so hard to pin down is that it has been assimilated, along with its constitutive differences, into the data flows of global finance capital. The spontaneous orders that the complex and chaotic operations of the worldwide electronic trade in currencies and debt produce are not accumulations of wealth, despite what we are told by digital lifestyle magazines, but typhoons of inexplicable loss and failure. The higher orders of organization spontaneously generated by the weather system are usually destructive of human lives: Much the same appears to be true of the uncontrolled workings of the global finance-scape. Houses are not made by sitting waiting for emergent coherence to produce bricks and doorframes from trees and rocks. A process of work is required.

Work too has been devalued. Little is left of the dignity of labor, little of it even in the work of artists preparing works for the international market. The glory of the network artist derives fundamentally from the ephemerality of his or her work, the necessity to keep on making, to keep one step ahead, or more if possible. Working without product is only the first step in this process, working at the level of ideas. Today meanings are all too swiftly reabsorbed into the repertoire of sensations, just as techniques are reenameled

and passed on as consumables. The work that the network artist undertakes is to help us see through to the next moment, ahead of capital, the moment in which relations between people appear to them in the guise of relations.

In the era of international solidarity, people came first. The bombed civilians of Guernica, the mutineers of Kronstadt, the embattled North Vietnamese claimed our solidarity because of their difference, and beneath that, their similarity. Today that difference is not so much erased as hidden. As Bauman argues, the more liberty the elite has to travel, the more the poor are condemned to stay home.[10] One consequence is that the miseries of the last factory workers and raw-materials producers are removed geographically from the sites of retail and consumption, the specificity of their work bathed in the indifference of logo-branded goods and services, and their existence, like ours in the wealthy world, stripped to statistics, digitized and traded, as power companies trade customers. Value itself is obscured in the vast arithmetic of stock exchange transactions, the vast geometry of the Web.

In the age of the global corporation, relations come first. People are not even termini but nodes through which income and expenditure, meanings and opinions, use and exchange pass, refocused surely, even individualized (in the same degree that mass-produced automobiles are customized), but never arrested in a discrete identity. It is not that we have no bodies, but that those bodies are no longer the defining media of our relationships. The face to face is a privileged moment of access in a working week of remote and mediated conversations. Insofar as electronic money is the dominant communicative medium of our time, the medium that most thoroughly links every human being on the planet into mutual dependency, datanets are the fundamental ground of the human future. That they are profoundly inhuman is our greatest possibility for a future other than the present.

The network artist is not a person. A person authors, takes responsibility for their work. But in electronic networks, authorship is already far more profoundly shared with the medium than is the case even with the poet working in a language that antedates her, the painter working with colors and canvases someone else has manufactured, the cineaste working with cameras and film stock designed and built by strangers. The network is more than raw material: It is the very stuff of the work. Network art is intrinsically of its medium, whereas postal art is only carried by the mails. And to the extent that network arts require the participation of users, it is the user who must take responsibility for the work that's made. Every artist in this

book, and probably every reader of it, has humbled themselves to the role of participant. This is a profoundly social act, an act of self-abnegation. It is also an act in which there is a deep and increasing partnership with the machinery of mediation. To this extent alone the Second International line is correct: There is no resistance to the global; on the contrary, what is required is to drive the global onward, to insist on its logic, which is to bring the whole of humanity, without exception, into mutual dependence.

As a writer and teacher, I wish I could say that these networks will be verbal. They will not. Language, especially the English language, has become a censoring device, a gadget for blocking communication, as surely on-line as at the immigration barrier. In both cases an accent, aural or written, is an idiolect too far, a legitimated cause for stoppage. Power today, like wealth, derives from intervening in flows of communication, hoarding and amassing data streams, withdrawing information from the freedom of the fiber. The logic of the data stream includes the eradication of privacy through cookies, databases, market research, and preference surveys. It points unmistakably to the end of private property. In what sense is "my" money ever truly "mine"? In the same sense that "my" opinions are largely the fruit of "my" networks, I can lay some sort of privileged claim to some portion of the usufruct, but where it is and how I might lay hands on it is bafflingly opaque. Land belongs to the one who tills it; networks belong to those who work them, and it is the network that will be what human nature was. After the word, and the accents that distinguish nation from nation, locality from locality, comes the act of interrelating, the mutuality of making. Two folks who cannot share a sentence can fix a bridge together or build a road. The network artists, whatever else they do, also make roads and bridges, new connectivities, other dependencies. After the transnationals have demolished the last shards of nationhood, there will remain the transnations of those who have established, distinct from the cosmopolitan elite, those mutually constructed linkages that traverse the globe as diasporan musics do, always remade in every port they come to. The millions born into exile work not in a state of rootlessness, but in a world of relationships, diffident, difficult, fraught, fragile; nonetheless a world, a transnation of those displaced by the end of geography, offered the chance to make a world after history. The old art of objects and even of ideas pales into the past: We have the future to build, and it will be global, networked and utterly new, or it will not be the future at all.

Notes

1. Raymond Williams, "When Was Modernism?" in *Art in Modern Culture: An Anthology of Critical Texts,* ed. Francis Frascina and Jonathan Harris (London: Phaidon, 1992), 23–27, reprinted from *New Left* Review no. 175 (1989): 48–52, from a lecture given March 17, 1987.

2. David Craven, "The Latin American Origins of 'Alternative Modernism,'" in *The Third Text Reader on Art, Culture and Theory,* ed. Rasheed Araeen, Sean Cubitt, and Ziauddin Sardar (London: Continuum, 2000), 24–35.

3. John Berger, *The Success and Failure of Picasso* (Harmondsworth, England: Penguin, 1965), 162–165.

4. Joseph Beuys, "I Am Searching for Field Character," in *Art in Theory 1900–1990,* ed. Charles Harrison and Paul Wood (Oxford: Blackwell, [1973] 1992), 902–904.

5. E. P. Thompson, *The Making of the English Working Class* (Harmondsworth, England: Pelican, 1963).

6. Theodor Adorno, *Aesthetic Theory,* ed. Gretel Adorno and Rolf Tiedemann, trans. Robert Hullot-Kentor (London: Athlone, 1997), 41–42.

7. Walter Benjamin, "The Work of Art in the Age of Mechanical Reproduction," in *Illuminations,* ed. Hannah Arendt, trans. Harry Zohn (New York: Schocken, 1969), 217–251, 242.

8. Cited in Zygmunt Bauman, *Globalization: The Human Consequences* (Cambridge, England: Polity, 1998), 86–87.

9. Etienne Balibar (trans. Chris Turner), "Is There a 'Neo-Racism'?" in Etienne Balibar and Immanuel Wallerstein, *Race, Nation, Class: Ambiguous Identities* (London: Verso, 1991), 17–28.

10. Bauman, *Globalization: The Human Consequences,* 86.

Conclusion

Annmarie Chandler and Norie Neumark

Remembering precursors . . .

The refrain "before the Internet" resounds through this book. It is not just a chronological marker; it also reveals a certain tension in writing about the Net's precursors. How much should one discuss the relevance of the Internet to a particular distance art or activist project? Many contributors initially felt obliged to address this issue but then expressed a certain relief at not having to shape their discussion around the present and, instead, to try to understand projects on their own terms and in their own contexts. Ultimately their discussions do more than preview or even recontextualize the Net—and more than just assert that "we did the same thing, but first." The projects they engage with, whether they realized their plans, intentions, and dreams or not, more importantly make available a sense of still open possibilities and potentials for distance art and activism.

It is not our aim here to rehearse the introductory arguments or to summarize the contributors' chapters, which would risk reducing their diversity and specificity. Rather, we would like to indicate briefly where the book might speak to current practices and concerns. We ourselves came to the project each with her own artist/activist experiences and particular interests in Mail Art and telematic art. What we found, through the engagements with the contributors in the book, was how much these projects' virtualities exceeded the way they are often remembered through the actuality of the Internet. We were delighted to find how much more extensive the practices were than we had anticipated. Each chapter would also bring to light unexpected distant connections among artists, and everyday conversations with artist/activist friends and acquaintances would reveal further implications in their networks. To hear offhandedly from a Sydney-based artist friend that he had aerograms from his correspondence with Mail Artist Ray Johnson that we might like to have a look at was wonderful and in a certain way not surprising (figure 1). At the distance of Australia, we were, had to be, and had been very connected.

For us as editors, an impetus for this book has been that of the *memory* of the pre-Internet period. It seems ironic at a time when "memory" is often high on new media artists' agendas that there has been such a forgetting of this past. As the chapters came in with their wealth of archival material, the sense of the extent of this forgetting grew. It seems that what can be publicly remembered is only what was directly realized by the Net, not the excess, the multiplicity, the potential, and the difference that lies outside its web. But

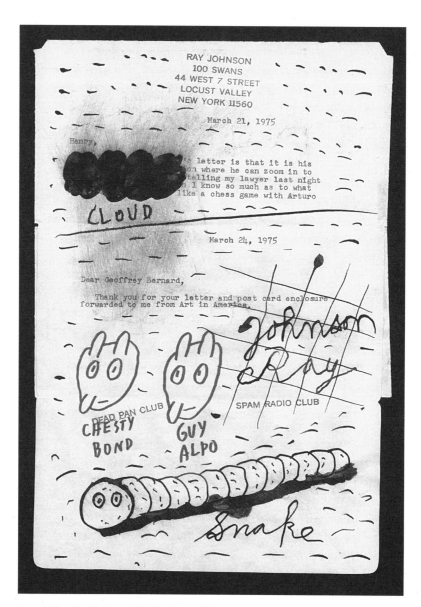

Figure 1 Aerogram to Geoffrey Barnard from Ray Johnson, July 7, 1975. Courtesy of Geoffrey Barnard.

the question of *how* to remember projects such as these is not straightforward, and it touches on one of the fundamental dilemmas of a book like this. What does it mean to archive and remember things that were, by definition, so often ephemeral and evanescent? Although we have relied on artists' and activists' memories as well as their archives, we would not present memory as some simple truth: Memory itself is evanescent and plastic.

Adding to the evanescence of memory are the lacunae and exclusions of writing and editing. It is always impossible to include and detail everything. There are numerous relevant and exciting projects, both involving the writers here and involving others, that space would not allow us to include. The more we became immersed in the pre-Internet period, the more we realized we could only sample it, but never fully represent its richness of works, ideas, and networks. Networks also produced some of the most vibrant tensions in writing about distance art/activism, just as they had in the past projects themselves. Having asked contributors to write about projects that involved extensive and at times difficult collaborations and collectivities, we were gratified by their engagement with this sometimes tricky task. What has emerged very powerfully for us is the way that collaboration and networking provoked highly creative artistic and political projects that defi(n)ed distance.

Another vibrant and productive tension evident in this volume has been that *between* technology and art and activism. Using cutting-edge technology cuts several ways. There was a common wound among the artists portrayed in the volume of the technology refusing to realize the artists' vision. Significantly, however, this was not an overwhelming problem to these artists/activists, who were not technology driven. Their involvements with technology, as with "communication," were complicated by their conceptual and process- rather than object-driven approaches to their work. It thus becomes very clear through the projects examined in the volume how inadequate technological determinism is for understanding distance art and activism. Instead, the approaches to technology in these projects were driven more by concepts, networks and social relations—actual and potential.

There were, for some artists in the book, particularly cutting issues of using technologies that were implicated in Big Science, Big Military, and Big Industry, too. Although the approaches were similarly conscious, responses varied, both over time and between individuals. It is noteworthy that it was

not just activists who faced up to this issue, but artists as well. We have currently become all too accustomed to the obligatory references to "those who don't have access," a phrase that often merely serves as an alibi for going on as we were (so long as one notes an awareness—that seems enough). To act on the concern about "access" generally signals the step out of a clearly demarcated artistic realm into the separate world of politics. For these distance artists, however, such demarcations did not prevail. Commitment to a more "democratic" practice was not a moral(istic) position but an invigorating stimulus to playful inventiveness, even for the least "political" artists. This is not to deny the tensions in this period between artists and activists (who were sometimes the same people). What seems provocative for the present, however, is that the tension was so often productive within projects and also across projects and between media. It has been striking, then, that activism during this period was not merely nonmoralistic, but that artistic questions and concerns and desires articulated the political for all the distance art/activists here.

Another reminder that the chapters in this volume have provided is how old the idea of the "new" is. In each era, the "new" plays a specific role, to carve out territory as well as to provide the energy that throwing off the weight of tradition can require. However, pursuit of the "new" risks becoming a tradition itself, heavy and obligatory, if it refuses access to its precursors, the "new" of the recent past. That some of these precursors have been almost excised from public memory is not a result of their failure so much as some shortsighted need for today's new media art and activism to preserve a sheen as unique, original, and unprecedented. That this sheen also can serve the market needs of capitalism makes it all the more of a worry. For the distance artists/activists in this volume, it was, instead, a pleasure and an imperative to trouble capitalism's markets and commodities as definers of art and social relations. While most of their work could be called groundbreaking and said to have redefined the potential and the practices of media art, they were driven less by some obligation to the "new" and more by the desire to engage in the challenges and paradoxes of distance media art/activism.

Distance is . . .

As noted in the introductions to each of the volume's parts and recalled in numerous chapters, the distance art and activist projects discussed in the book ranged across vast spaces and encompassed very different ideas of space and

distance. For some, distance was literal and geographic; for others, it was more a way of understanding relations, between one another and their media. Today Virilian dromological speed has not so much shrunk this distance, we would suggest, as deflected political and academic interest elsewhere, to the global/local dichotomy. Nonetheless, in the realm of the everyday, distance persists and it is felt and responded to: E-mails that tell the receiver of the sender's weather serve the same need to phatically establish the connection that we used to feel in long-distance phone calls ("What's the time there?").

As many of the book's chapters have discussed, distance art and activism was for the artists/activists also about social and cultural *relations* and human networks. These artists/activists' views and practices were varied in intention and realization. Although the answers they came up with were different, the questions that "distance" posed for them were often similar, leading these artists/activists to plumb the liminal spaces between contradictory desires and practices, such as public/private, objects/networks, and of course, art/activism.

Distance as a "unifying" figure brings together a range of projects—from low-tech Mail Art to high-tech telematic works; from sneakernet to sonified networks; from assembling art to radio art; from the metaphorical to the mediated—without subjecting them to a single explanatory theoretical concept or technological explanation. Distance provides a common reference point without undermining the richness of diverse understandings and approaches to it. It is an enabling figure for an interdisciplinary approach to art/activism. And rather than starting from and ending up with the present conceits of the Internet or new media, distance opens the way to engage with projects in their own terms, in their diversity, and in their complexity.

Timeline

Date	Event	Venue(s)	Artist(s)	Description	Author(s)
1921	Manuel Maples Arce's first manifesto *Actual número 1*, appears in Mexico City	Mexico	*Estridentistas*	Various literature over the period 1921–1927, notable for use of modern communication network imagery (telegraphs, radio, railroad, etc.), particularly in poetry, that responded critically to European futurisms.	Fernández
1955	Ray Johnson undertakes early mail art activities	New York City	Ray Johnson	Johnson had a substantial mailing list (of some two hundred art world and popular culture figures) to whom he begins sending moticos, cutouts on black paper resembling modern hieroglyphics. These mail art activities became known as The New York Correspondance School in 1962.	Held
1961	Planning begins for *Fluxus* magazine		George Maciunas and Dick Higgins	Conceived partly in response to the perceived need for a distribution mechanism for artists' work. In 1964 and 1968, Fluxus periodicals *Fluxus I* and *Fluxus II* appeared, assembled by Maciunas. The idea of the periodical expanded, offering new and interactive performative-based experiences for the viewer/participant. *Fluxus yearbooks, yearboxes,* and *Fluxkits* were also published.	Perkins, Smith

Date	Event	Venue(s)	Artist(s)	Description	Author(s)
1962	"Utopian Laser Television" manifesto	New York City	Nam June Paik	Proposed a new communications medium based on hundreds of TV channels, with each channel narrowcasting to an audience of those who want it, without regard to the size of the audience.	Friedman
1962–1963	Yam Festivals and Yam Festival Delivery Event	New York City metropolitan area	George Brecht and Robert Watts, coordinators	Festivals were a series of events in a "loose format that would make it possible to combine or include an ever-expanding universe of events." In the delivery event, it is announced that the coordinators will "assemble a work and arrange delivery to you or an addressee of your choice."	Held
1968	Dial-a-Poem	New York City	John Giorno	Answering machines function as a venue for "randomly accessible creative expression."	Sumner Carnahan
1969	Omnibus News appears	Based in Munich	Contributors from eight countries; Thomas Niggl, Christian d'Orville, and Heimrad Prem, editors	Interested individuals are invited to submit copies of their single-page contributions, which were accepted with no editing or censorship. The contributions were then assembled into a periodical of approximately 200 bound pages. Copies were distributed back to artists and via other channels	Perkins

Date	Title	Location	Who	Description	Source
1969	*Automatic Painting Machine No. 1*	Japan	Computer Technique Group (CTG), a group of artists and engineers	Input came from microphones (sound) and photocells (light), plus paper punch tape and manual programming. The movement of a dancer is transformed into input. Output was a painting produced by a device with four spray nozzles moving across a canvas.	Drucker
1969	Telex art	Canada	N.E. Thing Co., Ltd. (Iain and Ingrid Baxter)	Registered "company" used telex to establish a "virtual identity" as well as to send instructions to remote galleries and museums on how to set up its pieces.	Baumgärtel
April 7–30, 1969	The Last Correspondance Show exhibition	Art gallery of California State University, Sacramento	Ray Johnson's New York Correspondance School correspondents	Exhibition showcasing the New York Correspondance School	Held

Date	Event	Venue(s)	Artist(s)	Description	Author(s)
September 1969	Prototype of the Internet (ARPANET) successfully tested	University of California at Los Angeles and participating institutions	Researchers and Scientists at the participating institutions	Development of interface message processors allows different remote systems and programs to communicate with one another. (The ARPA in ARPANET was the Advanced Research Projects Agency of the Department of Defense.)	Perkins
January 1969–July 1994	Duration Piece No. 13	Primarily U.S.	Douglas Huebler	One hundred one dollar notes were circulated accompanied by a letter saying that anyone sending the note back to Huebler will receive $1,000 in return.	Braun
1970	Labyrinth	Jewish Museum, New York City	Ted Nelson and Ned Woodman	Interactive catalogue for Jack Burnham's Software exhibition. Early hypertext system allowed participants to browse, gather information about the exhibit, then print out an individually profiled search record.	Drucker
September 20–October 6, 1970	Ray Johnson: New York Correspondance School exhibition	Whitney Museum of Art	Ray Johnson's New York Correspondance School correspondents; Ray Johnson and Marcia Tucker, cocurators	Exhibition included everything sent to the museum in response to an invitation Johnson sent out to his correspondents.	Held

Date	Event	Location	People	Description	Reference
1970–1971	*Notebook 1* (1970) and *Space Atlas* (1971) appear	U.S. and Canada	Dana Atchley, editor	Described as "community notebooks assembling." The first of these periodicals contains works by 60 contributors; the second comprise 120, from seven countries. Copies of each were distributed evenly among contributors.	Perkins
1971	NET manifesto published	Originated in Poland	Jaroslaw Kozlowski (a director of an alternative gallery) and Andrzej Kostolowski (a critic), authors	Outlined a new strategy of networking for artists in which an open strategy of networking is central. Mailed to 189 international artists, who are invited to be cocurators of the proposed NET. Reissued in 1972.	Perkins
1971–1972	*Town Fool Project*	Victoria, British Columbia, Canada	Anna Freud Banana	Tables set up at local gatherings combining parody with market systems. Included distributing degrees in Bananology, via mail art networks, and playful network dramas about buying and selling.	Saper
1972	Media Suitcase installation	documentas, Kassel, Germany	Gottfried Bechtold	Collection of various media, ranging from photography and slide through to Super 8 and unrecorded videotape; buyers were directed to use the videotape for filming, thereby extending the archive.	Braun

Date	Event	Venue(s)	Artist(s)	Description	Author(s)
1973	Telexed proposal for installation at 30th Salão Paranaense	Brazil	Paulo Bruscky	Proposal for conceptual art experiment for juried show rejected.	Osthoff
1974	Artists' Stamps and Stamp Images, exhibition	Simon Fraser University, Burnaby, British Columbia, Canada	James Felter, organizer	First exhibition of artist postage stamps, featuring approximately 3,000 stamps and stamp images by 35 artists and seven artists groups from nine countries.	Held
January 1974	First issue of *VILE* published	San Francisco	Anna Freud Banana	Response to Toronto-based *FILE*'s sudden distaste for mail art (both magazines spoofed *LIFE*). Later influences publication of *SMILE*.	Saper
1974–1982	Advertisements for creation of artificial aurora borealis	Brazilian and U.S. publications	Paulo Bruscky	Ads placed in newspapers to circulate and document a proposed project to create an artificial aurora borealis, using airplanes to color cloud formations.	Osthoff
1975, 1976	First (1975) and Second (1976) International Mail Art Exhibits	Central post office in Recife, Brazil	Paulo Bruscky and Ypiranga Filho, organizers (first show); Bruscky and Daniel Santiago; organizers (second show); participants in second show included artists from 21 countries, comprising 3,000 artworks	Both shows were closed by censors minutes after opening.	Osthoff

1975, 1980	Banana Olympics staged	San Francisco's Embarcadero Plaza; Olympic track beside Surrey (British Columbia) Art Gallery	Anna Freud Banana	Events sought to involve the audience and to showcase athletic competition versus artistic creation.	Saper
1975–1982	Series Sem *Destino* (Without Destination and/or Destiny)	Brazil	Paulo Bruscky	Included artist stamps and messages on envelopes, postcards, telegrams, telex, chain letters.	Osthoff
1977	Happening promoted through mail art	Ricerche Inter/Media Centro Autogestito di Attivita Espressive, Ferrara, Italy	Paulo Bruscky	27 citizens of Ferrara received by mail a section of a work by Bruscky, divided into 27 parts, to be reassembled by the recipients.	Osthoff
1977	*Satellite Arts (The Image as Place)*	U.S. East and West Coasts, linked via NASA satellite	Kit Galloway, Sherrie Rabinowitz and Mobilus dancers	The first use of audiovisual composite imaging for a performance-based telecommunications telecollaboration and an emulation of immersive and virtual-image space/place. Dancers in outdoor locations were linked, over four days, in a performance space "with no geographical boundaries."	Chandler, Drucker

Date	Event	Venue(s)	Artist(s)	Description	Author(s)
1977	Flyer circulated soliciting artists' work for new assembling magazine, *Commonpress*	Varied with participants	Various; Pawel Petasz, central coordinator of issues	Further development in models of participatory publishing, with participants each taking a turn at collecting materials, editing, printing and distributing issues, at their own expense. More than 60 issues were published between 1977 and 1990.	Perkins
1977	Early performance of networked computer music	Mills College, Oakland, California	Jim Horton, Rich Gold	KIM computers linked together for a performance in which Gold interacted with his artificial-language program while Horton ran an early algorithmic piece.	Brown and Bischoff
1978	Duo for KIMs developed	—	Jim Horton, John Bischoff	Occasional tones of one machine caused other to transpose its melodic activity accordingly.	Brown and Bischoff
1978	"The Form: 1970–1979" distributed.	Palo Alto, California; Union City, California; Mills College Art Gallery Oakland, California	Melody Sumner Carnahan, Michael Sumner; participants included Richard Kostelanetz, Andy Warhol, John Cage, Ed Ruscha, John Baldessari, Ruby Ray, Dick Higgins, Throbbing Gristle, and Vito Acconci	Form comprising a list of the years 1970–1979, each followed by a blank line, was distributed to 100 work colleagues, friends, and relatives, as well as strangers (artists, writers, politicians, etc.) Recipients were asked to fill it in and return it. Completed forms eventually became a book, *Form*, and were displayed in a 1980 exhibition.	Sumner Carnahan

Spring 1978	Performance of networked computers	Artist-run space The Blind Lemon, Berkeley, California	Jim Horton, John Bischoff, Rich Gold	Networked trio of computers. Other performances followed. Trio evolved into group, The League of Automatic Music Composers.	Brown and Bischoff
1978, 1979	Broadcast of sound poems and sound works by various artists	Recife, Brazil	Paulo Bruscky, initiator; sound works by various artists, including John Cage	Broadcast on mainstream Recife radio station during winter arts festivals.	Osthoff
Spring 1979	Biweekly presentations of performances using networked computers	Finnish Hall, Berkeley, California, under auspices of East Bay Center for the Performing Arts	The League of Automatic Music Composers	Presentations over the course of five months offered audience "computer-generated sonic landscapes" and allowed participation by other artists. Following conclusion of this series of presentations members of the group continued to develop the network music form, playing widely around the Bay Area.	Brown and Bischoff
1979	PacRim Slow Scan Project	Vancouver	Bill Bartlett, organizer, with other artists	Satellite link via slow-scan and the NASA ATS-1 Peacesat network.	Braun
1979	"Interplay" computer communications conference	Toronto, Vienna	Bill Bartlett (Toronto), Robert Adrian X, Richard Kriesche, Heidi Grundmann, and Gottfried Bach (Vienna)	Studio at Austrian TV is set up and news is read live in a radio program transmission, *Art Today.*	Braun

Date	Event	Venue(s)	Artist(s)	Description	Author(s)
Early 1980s	*Banana Rag* begins operating as mail art forum and news source zine	Vancouver, British Columbia, Canada	Anna Freud Banana	Hand-drawn and -printed periodical distributed via mail networks. Associated with mail art network.	Saper
1980	Manifesto of Mail Art "considerations" issued	—	California mail artists Lon Spiegelman and Mario Lara	Manifesto stated a number of considerations in mounting mail art shows, to reiterate the tenets of the movement.	Held
1980	*Hole-in-Space, A Public Communication Sculpture*	New York (Lincoln Center) and Los Angeles (Broadway department store, Century City)	Kit Galloway, Sherrie Rabinowitz	Live satellite communications were used over three days to create a new social space linking public on the streets of the two cities, each interacting with the public in the other city via screens in shop windows.	Chandler, Baumgartel
February 16, 1980	Artists' Use of Telecommunications Conference	San Francisco Museum of Modern Art and Museum of the 20th Century in Vienna	Organized by Bill Bartlett and Carl Loeffler; participants from Austria included Robert Adrian X, Ernst Caramelle, Valie Export, Richard Kriesche, Helmut Mark, and Peter Weibel	Participants in Vienna, Tokyo, Vancouver, Hawaii, New York, Boston, and San Francisco were brought together using IP Sharp APL Timesharing System and either a worldwide teleconference linkup or slow-scan TV and Audiolink.	Braun

Date	Event	Location	People	Description	Source
October 31, 1980	Artistic fax transmission	Recife and São Paulo, Brazil.	Paulo Bruscky, Roberto Sandoval	Transmission took place between Bruscky in Recife and Sandoval in São Paulo, Documentation of the transmission was exhibited in Arte Novos Meios/Multimedios (New Media/Multimedia Arr), FAAP, São Paulo, 1985. Other fax performances incorporated Bruscky's earlier electrocardiogram "drawings," etc.	Osthoff
1980–1982	Poesia-Porno (Porno-Poetry) movement	Performances around Rio de Janeiro, Brazil	Eduardo Kac and others	Public performances attempted to transform misogynist and homophobic labels into sexually liberating expressions through "semantic displacements."	Osthoff
1980–1981	Publication of periodical *Artforum* begins	Poland	Various contributors to each issue and Pawel Perasz	Contributors to this magazine of mail art and ephemeral art receive issues consisting of a single sheet of homemade paper on which is typed a "table of contents" listing the submissions that have gone into the issue—literally, in this case, as Perasz pulps the contributions and produces the paper on which the contents list is printed. The print run for each issue is determined by the number and size of contributions. Title is a play on that of the influential art world publication. *Art Forum.*	Perkins

Date	Event	Venue(s)	Artist(s)	Description	Author(s)
1981	Paper Tiger Television appears on Manhattan cable	Public-access cable channels across the United States	Collective comprising artists, activists, and academics, early initiators and participants included Dee Dee Halleck, Diana Agosta, Pennee Bender, Caryn Rogoff, Shu Lea Chang, Martha Wallner, and Tuli Kupferberg; critics presented included Herb Schiller, Joan Braderman, Donna Haraway, Harry Magdoff, and Murray Bookchin.	On a shoestring budget, half-hour critiques of mainstream media programming were shot and tapes distributed to supporters in various U.S. cable systems for playback. Copies found their way to several dozen public-access stations in different locales.	Drew
1981	Negativland begins broadcasting its audio collage weekly on *Over the Edge*	KPFA-FM, Berkeley, California	Don Joyce and other group members	Diverse radio practice featuring range of sonic materials and repurposing of found sound, for which the group was sued in 1991, under copyright law.	Joyce
1982	Versions of "Star Dust" broadcast in on-air assembling	KPFA-FM, Berkeley, California	Melody Sumner Carnahan, host; Sarah Vaughan, Willie Nelson, Hoagy Carmichael, John Bischoff, and unnamed others who submitted versions	Various versions of Hoagy Carmichael's 1929 song "Star Dust," the most recorded song in history, are aired in a four-hour program.	Sumner Carnahan

1982	Radio Polybucket open	Tokyo	The earliest mini-FM station in Japan. Evolved into Radio Home Run, which broadcast until 1996, then was reactivated as an Internet radio station, Net.RadioHome Run.	Tetsuo Kogawa and students	Neumark and Chandler
1982	M.U.S.I.C. (Marvelous Unlimited Sounds in Concert) festival	On Broadway theater, San Francisco	Three-night festival happening bring together wildly divergent trends in music and performance.	Melody Sumner Carnahan and Barbara Golden, various performers, including Lou Harrison, Arto Lindsay, Joan La Barbara, John Giorno, Maggi Payne, Jay Cloidt, and Sam Ashley	Sumner Carnahan
September 1982	Rota-League concert	Ed Mock's studio, San Francisco	Using an automatic switching box interfaced with a timing wheel, The Rotary Club's sounds were routed and chopped into real-time collages of bits and pieces, results that fit well with The League's combination of algorithmic music structures and live performance.	The League of Automatic Music Composers and electronic-music band Rotary Club; performers included Sam Ashley, Kenneth Atchley, Ben Azarm, Barbara Golden, Jay Cloidt, and Brian Reinbolt	Brown and Bischoff

Date	Event	Venue(s)	Artist(s)	Description	Author(s)
1982	Telematic event: "The World in 24 Hours,"	Ars Electronica	Robert Adrian X	Electronic networking event in the Upper Austrian regional studio in Linz. Artists in 16 cities on three continents were linked for 24 hours.	Ascott, Grundmann, Braun
December 11–23, 1983	*La Plissure du Texte: A Planetary Fairytale*	In the exhibition Electra: Electricity and Electronics in the Art of the Twentieth Century, Musee Art Moderne de la Ville de Paris	Roy Ascott and artists participating in 11 cities in Europe, North America, and Australia, Frank Popper, curator	Collaborative storytelling project involving computer conferencing network of artists using ARTEX, an electronic-mail program. Project was active on-line 24 hours a day for 12 days.	Ascott
1983–1993	Holopoetry	—	Eduardo Kac	Holographic poems featured words and letters in flux, turning reading into a time-based, open-ended process.	Osthoff
1983–1984	Answering machine "site"	Burning Books, San Francisco	Patrick Sumner and others, including Jon Livingston, Michael Peppe, and Sheila Davies	A short, specially commissioned audio work was made available to those who dialed the number provided on a series of 12 postcards distributed to advertise the site; each week, a different work was offered.	Sumner Carnahan

1984	*Electronic Cafe-84*	Five Los Angeles restaurants, Los Angeles Olympic Arts Festival, Los Angeles. Museum of Contemporary Art	Kit Galloway, Sherrie Rabinowitz	A multimedia, telecollaborative network was created among five family-owned restaurants (in Los Angeles's Korean, Hispanic, African, and beach communities). Venues were linked using a variety of technologies, including slow-scan, phone link video systems; electronic writing tablets; computers; printers; and video screens. First public use of a storage-and-retrieval pictorial database.	Chandler
1984	*Cyborg*	—	Eduardo Kac	Kac's first telepresence project was to involve three different Rio de Janeiro art galleries and the remote control of sculptural objects. Not realized, as a result of technical obstacles.	Osthoff
1984	Controversy surrounding the exhibition Mail Art Then and Now	Franklin Furnace, New York; Wooster Gallery, New York	Various artists; Ronny Cohen, curator	New York mail artist Carlo Pittore noted that not all the works sent to the show were on display in the exhibition, held at Franklin Furnace. An open letter was sent from Pittore to Cohen regarding this, and protests, panel discussions at New York's Wooster Gallery, and a special edition of *Umbrella* on the subject followed.	Held

Date	Event	Venue(s)	Artist(s)	Description	Author(s)
1985	Les Immatériaux exhibition	Centre Pompidou, Paris	Various conceptual artists, preconceptual minimalists, and Marcel Duchamp; Jean-François Lyotard, cocurator	Works exhibited covered such diverse topics as art and philosophy, automation and microelectronics, telecommunication and computerization. An on-line conference was conducted on Minitel as part of the exhibition.	Baumgärtel
1985–1986	*Tesão, D/eu/s*	Exhibited in Brasil High-Tech, Galeria de Arte do Centro Empresarila Rio, Rio de Janeiro	Eduardo Kac; Kac and Flavio Ferraz, exhibition organizers	Animated poems on videotext system, where users logged on from a remote terminal and accessed pages through regular phone lines.	Osthoff
1985–1986	First series of the public-access television network Deep Dish TV uplinked	In collaboration with Boston Film and Video Foundation	Various	The series comprised ten one-hour programs on topics such as labor, housing, racism, and Central America. Videos made by activists and artists were spliced into a themed program. A zine with the contact addresses of participating U.S. video activists accompanied the tapes. The programs were offered free to public-access organizations and were downlinked by over 186 stations.	Drew

1986	Decentralized Worldwide Mail Art Congresses	Various international locations	Various	More than 80 conventions of mail artists held, celebrating and examining the meaning of mail art.	Held
1986	RC Robot	Brasil-High Tech, Rio de Janeiro.	Eduardo Kac	A seven-foot-tall robot conversed with visitors in real time. (Robot's voice was that of a human transmitted via radio.) Robot was also used in performance with Otavio Donasci's videocreature	Osthoff
1986	"Planetary Network"	Venice Biennale	Tom Sherman, Don Foresta, and Roy Ascott, international commissioners	Slow-scan TV, fax, and computer network project.	Ascott, Braun
1986	The Guests Go Into Supper produced	Burning Books, San Francisco	John Cage, Robert Ashley, Yoko Ono, Laurie Anderson, Charles Amirkhanian, Michael Peppe, and K. Atchley	A 384-page anthology features the texts, scores, and ideas of seven living American composers who use words in their music.	Sumner Carnahan
Summer 1986	THE NETWORK MUSE—Automatic Music Band Festival held	The Lab, a converted church in San Francisco	John Bischoff, Tim Perkis, and Chris Brown, organizers	Minifestival devoted to automatic music bands featured different groups of composers performing, using different network architectures. A number of these composers joined together to form The Hub.	Brown and Bischoff

Date	Event	Venue(s)	Artist(s)	Description	Author(s)
1987	Premiere concert of The Hub.	Experimental Media and The Clocktower, both in New York City	John Bischoff, Tim Perkis, Mark Trayle, Chris Brown, Scot Gresham-Lancaster, and Phil Stone	Networked music performance between two venues. One trio of networked computer musicians performed together in each space; networked locally with an identical Hub; the two hubs communicated with one another via a modem over a phone line, connecting the two trios informationally across the distance.	
1987	*RAZIONALNIK*	In the exhibition Entgrenzte Grenzen (Debordered Borders), curated by Richard Kriesche, Graz, Austria	Seppo Gruendler and Josef Klammer (Graz), initiators, organizers, and programmers; with partners Gabo Plesser (Budapest), Lad Jaksa (Ljubljana), and Claudio Carli (Trento)	The phenomenon of telepresence added to the exchange models of simultaneously produced and networked art.	Grundmann
November 17, 1987	*Conversation*	Centro Cultural Três Rios, São Paulo	Eduardo Kac	Slow-scan TV event. Series of sequential still video images transmitted across telephone lines to explore live process of video formation.	Osthoff

Date	Title	Location	Artist(s)	Description	Source
December 1987	*World Series* performance	The Western Front, Vancouver, British Columbia, Canada	Anna Freud Banana and Ron Brunette	Marriage performance in which the artists were married by the "Sacred Cow" of capitalist society, taking vows to consume as much as possible.	Saper
1988	*Retrato Suposto–Rosto Roto* (Presumed Portrait–Foul Face)	São Paulo	Eduardo Kac and Mario Ramiro	Visual fax dialogue between Kac (in his studio) and Ramiro, who operated a fax from a live TV program in São Paulo.	Osthoff
1989	*Aspects of Gaia: Digital Pathways across the Whole Earth*	Ars Electronica	Roy Ascott	Telematic project installation in two parts: (1) computer graphic images installed in tents, contributed by networkers around the world, able to be manipulated by participants. These presented a "bird's-eye" view. (2) Tunnel that participants entered on their backs by means of a small, railed vehicle. Signs from various networkers displayed thoughts and ideas in the tunnel.	Ascott
1989	*Ornitorrinco Project*	Presented in many shows internationally	Eduardo Kac and Ed Bennett	Small telerobot created in Chicago. Developed versions employed telecommunications to mediate relations among people, animals, plants and robots. Initial sketches were begun in 1987, and the project remained in various stages of development through 1996.	Osthoff

Date	Event	Venue(s)	Artist(s)	Description	Author(s)
1989	"HubRenga"	KPFA-FM, Berkeley; supported by a grant from the InterArts Program of the National Endowment for the Arts	The Hub joined by Ramon Sender and other poets from the Bay Area's pre-Web network, The Well.	During this poetry/music/radio performance, poets submitted renga poetry via The Well. Ramon Sender, as moderator, read the pieces aloud. One Hub member also received the texts on his computer, which filtered for preprogrammed keywords, triggering specific musical responses from the Hub. Poets also listened to the piece over the radio while they were shaping it through The Well.	Brown and Bischoff
December 1990	*Drahtvenuskoerper* (Wire-Venus-Body)	Vienna	Mia Zabelka	A radio performance for live-telephone violin and voice.	Grundmann
1990, 1995	Interart Box Number: Project Mail Art exhibition	Garage in Miramar District (1990), El Museo Nacional Palacio de Bellas Artes (1995)	Pedro Juan Gutiérrez, curator	First exhibition of Mail Art in Cuba. In 1990, Gutiérrez mounted a small show for a week in someone's garage. The 1995 show, by contrast, was held in the most prestigious museum of fine arts in the country, attracting 700 participants from 45 countries. The two shows exemplified the increase in mail art exhibitions, across a variety of new geographic areas, in the 1990s.	Held

1990–1991	Performances via Pegasus	Australia	Andrew Garton and others	Pegasus was the first Australian Internet service provider. Performances included live text readings, *Poets at the Café Byron*. The 1991 federal election had updates on Green candidates sent to a Pegasus newsgroup.	Garton
Fall 1990–1991	Gulf Crisis TV Project	In conjunction with Deep Dish TV Network and WYBE, Philadelphia	First series included the work of over a hundred producers from dozens of U.S. locations	Videos documenting local anti–Gulf War events, featuring interviews with dissident experts, intellectuals, and artistic and cultural critiques, were produced. The programs were uplinked to the Deep Dish TV Network and so reached hundreds of local cable stations. Wide distribution of tapes was also encouraged, and the network also linked to video collectives internationally.	Drew
1991	*Telefonia*	Winterthur and the Saentis mountain (both in Switzerland) and New York	Andres Bosshard, Ron Kuivila	An intercontinental telematic installation connecting the three sites, one of several huge outdoor sound projects Bosshard realized before joining the *CHIP-RADIO* team.	Grundmann
1991–1996	Publication of *Artistamp News*	Vancouver, British Columbia, Canada	Anna Freud Banana	Publication devoted to the field of artist stamps.	Saper

Date	Event	Venue(s)	Artist(s)	Description	Author(s)
1992	Decentralized World-Wide Networker Congresses	Various international locations	Various	Mail artists reached out to others interested in long-distance artistic communication, in a new series of congresses in the same spirit as the 1986 Decentralized World Wide Mail Art Congress.	Held
August 6, 1992	*Puente Telefonico*	*Sound Poles* sculpture in Seville, Spain; *KUNSTRADIO*, ORF, Vienna	Hörst Hoertner, Gerfried Stocker, Seppo Gruendler, and Josef Klammer	The first live telematic radio project produced by *KUNSTRADIO Puente Telefonica* was a teleconcert between the public interactive sculpture *Sound Poles* (installed by Hoertner and Stocker) at Expo' 92 in Seville and the ORF studio in Vienna. The public could "play" the installation, and sensors transmitted movement to a computer, which triggered sampled sounds that were fed back to the plaza where the sculpture was installed. A modem allowed the artists to service the installation from their studio in Graz. For this event, artists were both in Seville and in the Vienna studio, where new sounds could be added to those triggered in Seville.	Grundmann

Date	Event	Location	People	Description	Reference
October 1, 1992	*CHIP-RADIO*	Salzburg, Innsbruck, and Dornbirn, Austria	Mia Zabelka, Andres Bosshard, Waldemar Rogojsza, Gerfried Stocker, Hörst Hoertner, and Seppo Gruendler	A simultaneous telematic concert, performed live among three regional ORF radio and TV studios and broadcast on *KUNSTRADIO. A TRANSIT* production.	Grundmann
December 1992	Early version (Model 3.02) of *GRANULAR SYNTHESIS* performed	Innsbruck and Salzburg Austria	Kurt Hentschlaeger and Ulf Langheinrich	Included the remote live participation of a dancer at ORF's Salzburg studio. A TRANSIT production.	Grundmann
1992–1993	"ZERO"—The Art of Being Everywhere"	Austria	Robert Adrian X, Gerfried Stocker, and Seppo Gruendler	Year-long project includes ZEROnet, a bulletin board system for artists, and produces the symposium "ON LINE—Kunst im Netz."	Grundmann, Braun
1993	*Proof Positive That Germany Is Going Bananas* performance	Canada Council; toured eight German cities and Budapest	Anna Freud Banana and Specific Research Institute of Canada	Included testing German gallery goers for "Banana Syndrome."	Saper
September 1993	FIERCE/InterRave	Brisbane, Australia	Andrew Garton and various performers, networking experts, and artists	A fundraising event that raised money to buy modems for nongovernmental organizations in Sarawak, Malaysia. Included an Internet Relay Chat channel, with conversations from around the world projected onto video screens.	Garton

Date	Event	Venue(s)	Artist(s)	Description	Author(s)
December 1, 1993	*REALTIME*	Graz, Innsbruck, and Linz, Austria	Isabella Bordoni, Gerfried Stocker, Andres Bosshard, Hörst Hoertner, Mia Zabelka, Roberto Paci Dalò, Waldemar Rogojsza, Tamas Ungvary, Kurt Hentschläger, Michael Kreihsl, Martin Schitter, Hans Soukoup, and others	A telematic concert performance in real time, taking place simultaneously at three regional studios of the National Austrian Radio and Television (ORF) and broadcast live on TV and radio.	Grundmann
1994	Mail-Art: Netzwerk der Künstler exhibition	PTT Museum, Bern, Switzerland	H. R. Fricker, Günther Ruch, and M. Vançi Stirnemann, curators	One of several shows of mail art mounted in postal museums throughout the world in the 1990s. Work was drawn from the curators' collections and included an opening-day fax project.	Held.
1995	Mail-Art Memorabilia exhibition	Musée Postal, Brussels	Various	Works exhibited were drawn from the archive of Belgian mail artist Guy Bleus.	Held
1996	Net.RadioHomeRun started	Japan	Tetsuo Kogawa and members	Internet radio station that grew out of mini-FM station. Radio Home Run, after the members became separated in different locations.	Neumark and Chandler

1999	Independent Media Center established	Seattle	—	Realized the "emancipatory possibilities of a universal computer media network . . . unfettered by corporate gatekeepers."	Drew
December 1999	*Banana Communion* performance	Sarenco Art Club, Verona	Anna Freud Banana	Performed as first female pope.	Saper
December 2001	*Banana Splitz TV Game Show*	Banff Centre for the Arts, Banff, Alberta, Canada	Anna Freud Banana	Included earlier *Proof Positive* performance/experiment	Saper

Contributors

Roy Ascott is the founding director of the international research network Planetary Collegium (CAiiA-STAR), Professor of Technoetic Arts at the University of Plymouth (England), and Adjunct Professor in Design/Media Arts at the University of California at Los Angeles. He conducts research in art, technology, and consciousness and edits *Technoetic Arts*. He pioneered the use of cybernetics and telematics in art at the Venice Biennale and Ars Electronica, among others. His most recent publication is *Telematic Embrace: Visionary Theories of Art Technology and Consciousness,* edited by Edward A. Shanken (University of California Press, 2003). The address of his Web site is <http://www.planetary-collegium.net/people/detail/ra>.

Anna Freud Banana began her art career producing batik fabrics and wall hangings but switched to conceptual/performance work with her *Town Fool Project* in 1971. Through the *Banana Rag* newsletter, she discovered the International Mail Art Network (IMAN) which supplies her with banana material, a sense of community, and affirmation of her conceptual approach. Whether publishing or performing, her intention is to activate her audience and to question authorities and so-called sacred cows in a humorous way. International Performance/Events and exhibitions on walls, from 1975 to present, are detailed at <http://users.uniserve.ca/~sn0958>.

Tilman Baumgärtel is a Berlin-based independent writer and critic. His recent publications include *Games. Computerspiele von KünstlerInnen Ausstellungskatalog* (Games. Computergames by artists. Exhibition Catalogue) (2003); *Install.exe: Katalog zur ersten Einzelausstellung des Künstlerpaars Jodi bei Plug-In,*

Basel, Büro Friedrich, Berlin, und Eyebeam, New York (Catalogue for the first solo show of the art duo Jodi at Plug-In, Basel, Büro Friedrich, Berlin, and Eyebeam, New York) (2002); *net.art 2.0 Neue Materialien zur Netzkunst / net.art 2.0* (New Materials toward Art on the Internet) (2001); *net.art Materialien zur Netzkunst* (2nd edition, 2001); *lettische Ausgabe: Tikla Maksla* (2001).

John Bischoff is a composer and electronic musician and is Studios Coordinator at the Center for Contemporary Music at Mills College. He is coauthor of a previous chapter on the League of Automatic Music Composers that appears in *Foundations of Computer Music* (MIT Press, 1985). His music is available on Lovely Music, Frog Peak Music, Centaur, 23Five, and Artifact Recordings. The address of his Web site is <www.johnbischoff.net>.

Reinhard Braun is a freelance author of many publications, lectures, and scholarly works, as well as curator of numerous exhibition projects, on the history and theory of photography and media. He has collaborated on many projects with artists in the field of media. Currently, he is head of the association MiDiHy <http://midihy.org>, which has launched several projects on the cultural impact of media technology. The address of his Web site is <http://braun.mur.at>.

Chris Brown is a composer, pianist, and electronic musician who is also the Co-Director of the Center for Contemporary Music at Mills College in Oakland, California. He has released recordings of his music on Tzadik, Ecstatic Peace, Sonore, and Artifact Recordings. The address of his Web site is www.cbmuse.com.

Melody Sumner Carnahan is author of three story collections and a biography and is a founding editor of Burning Books. For the past twenty years, she has worked with composers and artists, providing texts for live performance, audio recordings, film, and video. She has received commissions and awards from artists and organizations including New American Radio, the Australian Broadcasting Corporation, Experimental Intermedia Foundation, and the National Endowment for the Arts, as well as an Independent Publishers Award for Audio-Fiction for *The Time Is Now.* Further information is available at <www.burningbooks.org>.

Annmarie Chandler is Director of the Emerging Field in New Media and Digital Culture at the University of Technology in Sydney. She is a researcher in the media arts and develops cross-disciplinary educational programs in the digital arts and sciences.

Sean Cubitt is Professor of Screen and Media Studies at the University of Waikato in New Zealand. He has published widely on contemporary arts, media, and culture. He is the author of *Timeshift* (1991), *Videography* (1993), *Digital Aesthetics* (1998), *Simulation and Social Theory* (2001), and *The Cinema Effect* (2004) and coeditor of *Against the Grain: The Third Text Reader* (2002) and *Aliens R Us: The Other in Science Fiction Cinema* (2002).

Jesse Drew is a media artist, writer, and educator whose work seeks to challenge the complacent relationship between the public and new technologies. He is currently Associate Director of Technocultural Studies at the University of California at Davis. The address of his Web site is www.redrocket media.com

Johanna Drucker is the Robertson Professor of Media Studies at the University of Virginia. Her published titles include *Theorizing Modernism* (Columbia University Press), *The Visible Word* (University of Chicago), and *The Century of Artists' Books* (Granary Books).

María Fernández is an art historian whose interests center on postcolonial studies, electronic media theory, Latin American art, and the intersections of these fields. She received her Ph.D. from Columbia University, New York, in 1993. She has published essays in numerous journals, including *Art Jour-*

nal, Third Text, nparadoxa, Fuse, and *Mute.* With Faith Wilding and Michelle Wright she edited the anthology *Domain Errors: Cyberfeminist Practices* published by Autonomedia in 2002. She teaches in the Department of the History of Art at Cornell University.

Ken Friedman is Professor of Leadership and Strategic Design at the Norwegian School of Management in Oslo and at Denmark's Design School in Copenhagen, where he works on knowledge economy issues as well as philosophy and theory of design. He has published articles and books on management and organization, information science, and art. He is also a practicing artist and designer who was active in the international laboratory of designers, artists, and architects known as Fluxus.

Kit Galloway was a member of the legendary European multimedia troupe VIDEOHEADS. He has exhibited at the Biennial de Paris at the Musee d'Art Moderne in Paris, the American Culture Center in Paris, the National Museum of Modern Art in France, Experimental 5 at the Cinematique Royale de Belge in Belgium, and the Serpentine Gallery in Great Britain. He is cofounder of Electronic Cafe International.

Andrew Garton is a composer/producer who worked extensively on the establishment of early Internet-related services in Australia, the Pacific Islands, and Southeast Asia. He is cofounder and Artistic Director of Toy Satellite, a nonprofit multidisciplinary arts collective. He is also a Director of the Australian-based Community Communications Online and council member of the global Association for Progressive Communications. His Web sites are <http://www.toysatellite.org/agarton/> and Community Communications Online (c2o) <http://www.c2o.org/>.

Heidi Grundmann has worked as cultural reporter, art and theater critic, editor, and program producer at the ORF (Austrian National Radio/ Television) since the 1970s. In 1987 she created the radio program *KUNSTRADIO-RADIOKUNST* (original artworks for radio). She has been involved in many telematic art projects and has organized and curated several international symposia and exhibitions related to art practice in the electronic media, especially radio, TV, and the Internet. She lectures and writes on art and new media and has been the editor of several publications in these areas, such as *Art & Telecommunication.*

John Held, Jr., directs Modern Realism Gallery and Archives in San Francisco, California, which speciales in relics and documents of the twentieth-century avant-garde. He has prepared Mail Art collections for the Getty Research Library in Los Angeles and the Museum of Modern Art in New York. His papers are in the Archives of American Art at the Smithsonian Institution in Washington, D.C. He is the author of *Mail Art: An Annotated Bibliography* (Scarecrow Press, 1991).

Don Joyce is a member of Negativland, which has been recording music/audio/collage works since 1979, producing a weekly three-hour radio show (*Over The Edge*) since 1981, hosting a World Wide Web site since 1995, and performing live on occasional tours throughout the United States and Europe. In 1984, Negativland coined the term *culture jamming,* a phrase often used to describe the work of many different media artists and activists. The address of Negativland's Web site is <www.negativland.com>.

Tetsuo Kogawa is Professor of Communication Studies in Tokyo Keizai University's Department of Communications and is known for his blend of criticism, performance, and activism. He introduced free radio in Japan and has written over thirty books on media culture, film, city and urban space, and micropolitics. The address of his Web site is <http://anarchy.k2.tku.ac.jp>.

Norie Neumark is Associate Professor of Media Arts and Production at the University of Technology in Sydney. She is a new media and sound and radio artist and theorist. She collaborates on installations, net art works, and CD Roms as part of Out-of-Sync <www.out-of-sync.com>. Her sound and new media works, including *Shock in the Ear,* have won awards and been exhibited in Australia, Europe, and the United States.

Simone Osthoff is Assistant Professor of Critical Studies in the School of Visual Arts at Pennsylvania State University. A Fulbright Scholar in 2003, her publications include chapters in *Women, Art, and Technology,* edited by Judy Malloy (MIT Press, 2003); *Corpus Delecti: Performance Art of the Americas,* edited by Coco Fusco (Routledge, 2000); and *Diaspora and Visual Culture,* edited by N. Mirzoeff (Routledge, 2000).

Stephen Perkins is the curator and director of the Lawton Gallery at the University of Wisconsin–Green Bay. He recently received his Ph.D. in art history from the University of Iowa, Iowa City, with a dissertation titled *Artists' Periodicals and Alternative Artists' Networks: 1963–1977*. Recent publications include "Fluxus Periodicals: Constructing a Conceptual Country," *Performance Research,* 7(3), 2002, UK.

Sherrie Rabinowitz co-founded Optic Nerve, one of the earliest experimental video production groups. She is a producer of award-winning videos and has exhibited at the National Video Festival in Washington, D.C.; the New York Avant Garde Festival; KQED-PBS Television in San Francisco; the Berlin Film Festival; and the American Culture Center in Paris. She began a lifelong collaboration with Kit Galloway in telecommunication art in 1975. In 1987, they cofounded the Electronic Cafe International <http://www.ecafe.com>, which has produced a long-range series of pioneering tele-collaborative and network-based art and community projects. They both received Guggenheim Fellowships in 1999.

Craig Saper is Professor and Coordinator of the Texts and Technology doctoral program <textsandtech.org> at the University of Central Florida. He has published two books: *Artificial Mythologies: A Guide to Cultural Invention* (1997) and *Networked Art* (2001). Other recent publications appear in *Directed by Allen Smithee* (2001), *Deleuze and Space* (2004), *Journal of Religious and Cultural Studies,* and *Rhizomes.net.* Further information is available at <http://www.textsandtech.org>.

Owen Smith is a Professor of Art History and Digital Art at the University of Maine in Orono, where he is also Director of the New Media Program. He is a specialist in alternative art forms and has a particular interest in all things Fluxus. In 1998, he published the first full historical consideration of early Fluxus, *Fluxus: the History of an Attitude,* and more recently coedited a special issue of *Performance Research* devoted to Fluxus (Vol. 7, no. 3, September 2002). His own artworks have been exhibited widely and can be seen on-line at <http://www.ofsmith.com>.

Index

Acconci, Vito, 68, 85, 234, 452

Ace Space Company, 399, 400

Actual número 1 (Maples Arce), 345–346, 348, 351, 364, 445

Adjuncted Dislocations II (Export), 74

Adrian, Robert, 289–290. *See also* Adrian X, Robert

Adrian X, Robert, 28, 77–79, 81, 82–83, 289–290, 292, 315, 319, 323, 453–454, 458, 467

Ambrosino, Guy, 241

Amirkhanian, Charles, 239

Andersen, Eric, 129, 392

 Opus 13, 129

Anderson, Laurie, 239

Arizona State University, 389

ARPANET, 286, 307, 396, 403n6, 403n7, 448

Art & Language, 14

Artaud, Antonin, 14–15, 208

ARTBOX, 79, 289

Art by Telephone, 48, 238–239

ARTEX (Artists' Electronic Exchange Program), 78, 81–83, 289–290, 307–308, 458

ART-FLUXUS ART-AMUSEMENT (Maciunas), 132. *See also* Fluxus

Artforum (Petasz), 402–403, 406n30, 455

Artifact Recordings, 384

Artists' Use of Telecommunications, The, 78, 454

Artistamp News (Anna Freud Banana) 248, 258, 465

Artistamps, 104, 106

Artist postage stamps, 106, 450

Ashley, Robert, 227–228, 239, 241n2, 243n6, 461

Ashley, Sam, 237, 380, 457

Ascott, Roy, 51–52, 59n53, 75, 80–82, 141–142, 146, 308, 315, 344, 458, 461, 463, 470

 Aspects of Gaia: Digital Pathways across the Whole Earth, 292, 463

 Laboratoria Ubiqua, 81, 292

 La Plissure du Texte: A Planetary Fairytale, 146, 282–283, 290, 292–293, 308, 458

 Planetary Network, 81–83, 292, 308, 461

 Ten Wings, 80, 458

Aspects of Gaia: Digital Pathways across the Whole Earth (Ascott), 292, 463

Assemblings, 13, 98, 234, 400, 402

Assembling (Kostelanetz), 234, 243n7

Commonpress (Petasz), 98, 401–402, 405n26, 406n29, 452

Smile, 98

Atchley, Dana, 399–400, 449

Notebook I, 399–400, 449

Space Atlas, 399–400, 449

Atchley, Kenneth, 239, 380, 457, 461

Audio collage, 177, 182, 186, 456, 474. *See also* Radio collage

Automatic Painting Machine No. 1, 41–42, 447

Azarm, Ben, 380

Bach, Gottfried, 78, 289, 453

Baldessari, John, 234, 235

Banana, Anna Freud, 140, 142, 149, 247, 248, 449–451, 470

Artistamps News, 248, 249, 258, 465

Banana Communion, 258, 469

Banana Olympics, 255, 451

Banana Splitz TV Game Show, 258, 469

Banana Syndrome, 247, 249, 467

Banana Rag, 248, 254, 454, 470

Encyclopedia Bananica, 248

Mona Banana Smile Test, 256

Proof Positive That Germany Is Going Bananas, 247, 249–250, 258, 467

Town Fool Project, 253–254, 449, 470

VILE, 149, 248, 256–257, 450

World Series Performance, 258, 463

banzai, 193, 195

Barthes, Roland, 146, 282–284, 287–288

Bartlett, Bill, 78, 289, 453–454

Baumgärtel, Tilman, 27–29, 360, 470

Baxter, Iain, and Ingrid, 66–67, 447

N.E. Thing Co., Ltd. (NETCO), 29, 65–67, 447

Bechtold, Gottfried, 28, 73, 449

Media Suitcase, 73–74, 449

Video Installation, 74

Behrman, David, 377–378

Bell Labs, 9, 38, 55n14,

Bense, Max, 46, 51

Beuys, Joseph, 39, 248, 337, 398, 414, 428

Bill, Max, 46

Bischoff, John, 31, 150, 237, 338–339, 375–376, 379, 382–383, 452–453, 456, 461–462, 471. *See also* The Hub; The League of Automatic Music Composers; Rota-League

HubRenga, 386, 464

Black Mountain College, 89, 253

Bleus, Guy, 106, 468

"Blue" Gene Tyranny, 237

Bosshard, Andres, 318–320, 322, 327–30, 465, 476–468. See also *CHIP-RADIO; REALTIME*

Braun, Reinhard, 27–29, 31, 141, 150, 471

Brecht, George, 39, 94, 124–125, 128, 130, 132, 133, 446

Event Score, 130

Games and Puzzles, 125, 128

Water Yam, 124

Word Event, 133

Breer Robert, 43–44

Self-Propelled Styrofoam Floats, 43

Bronson, AA, 92. *See also* General Idea

Brown, Chris, 31, 150, 338, 339, 373, 376, 382, 388, 461–462, 471. *See also* The Hub

Bruscky, Paulo, 140–141, 143, 261–267, 277, 277n1, 278n10, 450–451,453, 455. *See also* Fax Art, Mail Art, Xerox Art

Hoje a Arte é esse Comunicado (Today Art Is the Message), 264–265

Index

Bruscky, Paulo (*continued*)
 Re-Composição Postal, 264
 Sem Destino, 264, 451
 Xerofilms, 266
 Xeroxperformance, 266
Bull, Hank, 200, 202
Burch, Kathleen, 239–240, 242n4,
 244n12
Burnham, Jack, 35, 43–44, 48–49,
 51–52, 57n32, 57n34, 59n53, 448.
 See also Postformalism software
Burning Books, 236–241, 458, 461,
 472

Café de Nadia, El (Vela), 346, 353
Cage, John, 15–16, 51, 90, 119, 127,
 133, 141, 206, 231, 234, 237, 239–
 240, 241n2, 242, 243n6, 247, 265,
 373–375, 452–453, 461
California Institute of the Arts, 389
Carnahan, Melody Sumner, 141–142,
 227–244, 452, 456–457, 472. *See
 also* Burning Books; M.U.S.I.C.
 The Form 1970–1979, 235–236, 239,
 452
 The guests go in to supper (with Sumner
 and Burch), 239–240, 461
 The Time Is Now, 228, 239, 242n4, 472
Carrión, Ulises, 93, 110
Center for Contemporary Music, Mills
 College, 227–228, 237, 377, 471
CHIP-RADIO, 84, 145, 315, 317–322,
 325–326, 331, 332n11, 333n18,
 465, 467
Cloidt, Jay, 237, 380
Cohen, Ronny, 102–104, 459
Collins, Nic, 383
Commonpress (Petasz), 98, 401–402,
 405n26, 406n29, 452. *See also*
 Assemblings

Computer Technique Group, 41, 447.
 See also CTG
Conceptual Art, 14, 44, 48–50, 57n34,
 65, 66, 74–77, 394, 432, 450
conceptual artists, 65, 460
conceptualism, 14, 32, 36, 45, 47–50,
 432
Conversation (Kac), 273
Cook, Rustie, 234–235
Copland, Aaron, 378
Corner, Phil, 120, 124, 127
Correspondence art, 97–98, 100, 247,
 393, 399–402. *See also* Mail Art
Crane, Mike, 98, 100, 113n36
CTG, 41–42, 447. *See also* Computer
 Technique Group
Cubitt, Sean, 337–338, 472
Customer Is Always Right, The (Klinkow-
 stein), 80
Cybernetics, 36, 46, 51, 284–285, 287,
 470
Cyborg (Kac), 275, 459

Dada, 12, 14–15, 17, 89, 98, 140, 142,
 234, 236, 243, 248n8, 360
Dalò, Roberto Paci, 316, 322–323,
 327–328, 468
Danto, Arthur C., 92, 94, 97
Davies, Sheila, 239
Davis, Douglas, 14, 287
Day, Don, 378
Deep Dish TV (DDTV), 143, 147,
 211, 213–216, 218, 220, 222–223,
 460, 465
Deleuze, Gilles, 3, 208, 252
Denman, Erv, 377
Derrida, Jacques, 8, 15, 64, 146, 287–
 288, 344
D/eu/s (Kac), 271, 460
Dial-a-Poem (Giorno), 238, 446

Dirty Water (Vautier), 126

Distance art, 3–4, 10–11, 17–18, 24n42, 26, 31–32, 141, 149, 339, 439, 441, 442–443

Distance art/activism, 3, 11, 14, 17–18, 26, 31, 148, 150, 441–442

Distance art and activism, 3–4, 10–11, 17, 26, 32, 439, 441

Distributed authorship, 78, 167, 283, 289, 292

Drew, Jesse, 143, 147, 150, 202, 472

Drucker, Johanna, 27, 30, 472

Duchamp, Marcel, 45, 65, 89, 98–99, 130, 263, 432, 460

Duration Piece No. 13 (Huebler), 76, 448

Electronic Cafe-84 (Galloway and Rabinowitz), 147, 164, 171, 459, 475

Encyclopedia Bananica (Anna Freud Banana), 248

Epistemic Videotechnology (Weibel), 74

Estridentismo, 343, 345, 347–348, 352, 362

Estridentistas, 27, 336, 343–344, 346–349, 351–352, 358, 360, 362–363, 364n14, 365n23, 366n32, 445

Eternal Network, 89–90, 94–95, 100, 102, 110, 414–415. *See also* Filliou, Robert

Euler, Leonhard, 377

Event Score (Brecht), 130

"Exemplativist Manifesto, An," (Higgins), 122

exemplativist works, 123

Expanded Cinema (Youngblood), 37, 74

expanded cinema, 75, 77

Export, Valie, 74, 75, 78, 454

 Adjuncted Dislocations II, 74

 Facing a Family, 75

Facing a Family (Export), 75

Fault Press, The, 234–236, 243n8

Fax Art, 106, 267, 278n10, 428

Fernández, María, 27, 336, 338, 472

FidoNet, 78, 82, 307

FIERCE/InterRave, 148, 305–306, 467

FILE, 94, 256, 450

Filliou, Robert, 89, 90, 92, 94, 102, 110, 127, 414. *See also* Eternal Network

Fischer, Hervé, Art and Marginal Communication, 91, 113n36

Fluxchess (Shiomi), 125. *See also* Fluxus

Flux Clippings (Friedman), 126. *See also* Fluxus

Flux Corsage (Friedman), 128. *See also* Fluxus

Flux ESP Kit (Riddle), 128. *See also* Fluxus

FLUXFILMS, 125. *See also* Fluxus

FLUXKIT, 125. *See also* Fluxus

Fluxlist, 117. *See also* Fluxus

Flux Mail-Order Warehouse, 131. *See also* Fluxus

Fluxshoe, 95, 100. *See also* Fluxus

Fluxstamps (Watts), 125 *See also* Fluxus

Fluxus, 4, 7, 18, 27, 28–31, 39, 42, 45, 47, 74, 77, 89, 92, 99–100, 106, 117–136, 141, 143, 149, 192, 203, 205–206, 248, 263, 337–338, 392–396, 411,413, 415, 418–419, 428–429, 445, 473, 475

Fluxus I, 125, 395–396, 445. *See also* Fluxus

Fluxus II, 395–396, 445. *See also* Fluxus

Fluxus West, 99, 418. *See also* Fluxus

Fluxus Yearbooks, 121, 445. *See also* Fluxus

FLUX YEARBOX 2, 125. *See also* Fluxus

Flynt, Henry, 124
Form 1970–1979, The (Carnahan),
 229–236, 239, 452
Forresta, Don, 81, 292, 461
Foucault, Michel, 3, 73, 287
Friedman, Ken, 99, 113n36, 121, 124,
 126, 128, 130, 263, 337, 339, 473
 Flux Clippings, 126 (*see also* Fluxus)
 Flux Corsage, 128 (*see also* Fluxus)
Froeis, Romana, 145, 320, 323
Fuller, Buckminster, 37, 55n11, 92,
 284–285, 416
Futurism, 12, 14–15, 89, 142, 236,
 445
 Italian, 11–12, 343, 345, 347, 361–
 362
 in Latin America, 360
 Russian, 11–12

Gaglione, Bill, 113n36, 248, 255, 257
Galloway, Kit, 36, 61, 140, 143, 146,
 153–158, 160, 163–165, 167–168,
 171–172, 344, 451, 454, 459, 473,
 475
 Electronic Cafe-84 (with Rabinowitz),
 147, 164, 171, 459, 475
 Hole-in-Space (with Rabinowitz), 62,
 146, 153–154, 163–165, 167, 169,
 454
 Satellite Arts (The Image as Place) (with
 Rabinowitz), 146, 153–154, 156–
 158, 160, 162–163, 451
 Satellite Communication Sculpture, A
 (with Rabinowitz), 153
Games and Puzzles (Brecht), 125, 128
Garcia, David, 80
 Late Times Extra, 80
Garton, Andrew, 141, 144, 148, 300,
 302, 309, 465, 467, 473. *See also*
 Toy Satellite

Gekko, 80
General Idea, 92, 94, 255, 418
"Geometry of Silence, The," 315, 317
Gift of Tongues (Williams), 129
Gins, Madeline, 241
Ginsberg, Allen, 238
Giorno, John, 237–238, 446, 457
 Dial-a-Poem, 238, 446
Giveaway Construction (Knowles), 129
Gold, Rich, 377–378
Golden, Barbara, 237–238, 380
Gresham-Lancaster, Scot, 383, 385,
 387
Gruendler, Seppo, 318–320, 322, 324,
 325, 333n17, 462, 466–467. See
 also *CHIP-RADIO; RAZIONALNIK;
 REALTIME*
Grundmann, Heidi, 78, 145, 149–150,
 453, 473
Guattari, Félix, 84, 144, 199, 200–
 201, 208, 252
Guests go in to supper, The (Carnahan,
 Sumner, and Burch), 239–240, 461
Gulf Crisis TV Project, 143, 148, 211,
 216, 217–218, 220–221, 223, 465
Gutiérrez, Pedro Juan, 104, 464

Haacke, Hans, 48, 66
 News, 66
 Visitors' Profile, 48
Halleck, Dee Dee, 200, 211, 217, 456
Halprin, Ann, 158–159
Halprin, Lawrence, 158
Harrison, Charles, 14
Harrison, Lou, 237, 375, 457
Heflin, Lee, 130
 Ice Trick, 130
Held, Jr., John, 27, 29–31, 107, 474
Hentschlaeger, Kurt, 323, 326–327,
 329, 331, 467

Higgins, Dick, 13, 15–16, 117, 119–127, 129, 234, 263, 339, 411–412, 418, 445, 452
"Exemplativist Manifesto, An," 122
Intermedial Object #1, 411–412
Hoertner, Hörst, 318–320, 322–323, 327–328, 330, 332, 466–468. See also *CHIP-RADIO; REALTIME*
Hoje a Arte é esse Comunicado (Today Art Is the Message) (Bruscky), 264–265
Hole-in-Space (Galloway and Rabinowitz), 62, 146, 153–154, 163–165, 167, 169, 454
Holopoetry (Kac), 269, 270
Horton, Jim, 376–380, 452–453
Hub, The, 339, 374–376, 382–389
Huebler, Douglas, 44, 75–76, 448
Duration Piece No. 13, 76, 448

Icaza, Xavier, 356–357, 369n53
Magnavoz, 356–357
Ice Trick (Heflin), 130
Image Bank, 92, 95, 99, 248, 255, 418
Immatériaux, Les, 28, 29, 62–65, 68–69, 69n4, 460
Information, 43–44. *See also* McShine, Kynaston
Information art, 45, 47, 66
inside-outside (Kriesche), 75
Instruction No. 2 (Patterson), 126
Interart Box Number: Project Mail Art, 104, 464. *See also* Gutiérrez, Pedro Juan
Intermedia, 13, 15, 30, 37, 121, 125, 126–128, 130, 135, 150, 257, 329, 331, 339, 392, 394, 396, 403n8, 411–413, 418, 472
intermedial, 126–127
Intermedial Object #1 (Higgins), 411–412

Intermedial Object No. 1 (for Dick Higgins) (Armleder and Lucchini), 412
International Cyclopedia of Plans and Occurrences, An, 99–100

Johnson, Ray, 89–92, 94–100, 104, 255, 263, 393–394, 439–440, 445, 447–448. *See also* New York Correspondance School
Joyce, Don, 140, 144, 149, 456, 474

Kac, Eduardo, 140, 147, 261–262, 268–277, 278n10, 279n21, 279n22, 455, 458, 459–463
Conversation, 273
Cyborg, 275, 459
D/eu/s, 271, 460
holopoetry, 269, 270, 248
Ornitorrinco Project, 275, 463
RC Robot, 275–276, 461
Retrato Suposto-Rosto Roto, 273–274, 463
Tesão, 271–272
Kahn, Douglas, 343, 351, 356
Kalbach, Paul, 377
Khlebnikov, Velimir, 352, 356
Kittler, Friedrich, 6, 63, 316
Klammer, Joseph, 318, 324–325, 333n17, 462, 466
Klein, Yves, 40, 89
Void, 40
Klinkowstein, Tom, 80, 292
Customer Is Always Right, The, 80
Knowles, Alison, 129, 134, 257
Giveaway Construction, 129
Performance Piece #8, 134
Kogawa, Tetsuo, 140, 144–145, 150–151, 191, 457, 468, 474. *See also* Mini-FM

Kostelanetz, Richard, 231, 234,
242n6, 243n7, 247, 452
Assembling, 234, 243n7
Kostolowski, Andrzej, 395, 404, 449
Kosugi, Takehisa, 129, 206
Theater Music, 129
Kozlowski, Jaroslaw, 395, 404, 449
KPFA-FM radio, 177, 184, 237, 386,
456, 464
Krauss, Rosalind, 68
Kriesche, Richard, 28, 75, 78, 316,
322, 333n14, 453–454, 462
inside-outside, 75
KUNSTRADIO, 145, 149, 316–319,
325, 328, 466–467, 473
Kyn Taniya, 346, 355–356, 358,
364n13, 366n28

La Barbara, Joan, 237
Laboratoria Ubiqua (Ascott), 81, 292
Labyrinth, 35–36, 448
Lara, Mario, 101, 454
Last Correspondance Show, The, 95, 447
Late Times Extra (Garcia), 80
League of Automatic Music Composers,
The, 339, 374–375, 378–379, 388–
389, 453, 457, 471
Levine, Les, 44
Live Wires, 44
Lewis, George, 237
Lewitt, Sol, 41, 433
Licklider, J.C.R., 393
Lippard, Lucy, 14, 65
List Arzubide, Germán, 346, 348, 353,
364n15
Live Wires (Levine), 44
Loeffler, Carl, 78, 82, 344, 454
Lovely Music, 378
Lyotard, Jean-François, 29, 62–64, 68,
460

Maciunas, George, 39, 117–121, 124–
125, 131–133, 206, 396, 418, 445
ART-FLUXUS ART-AMUSEMENT
132 (*see also* Fluxus)
Maeda, Toshiyuki, 200–201, 204
Magnavoz (Icaza), 356–357
Mail Art, 3–5, 7–8, 21n11, 30, 39, 42,
75, 77, 89–95, 97–104, 106–110,
131, 141–143, 149, 234, 243n8,
247–248, 253, 255–258, 262–265,
267, 339, 402, 418, 428–429, 439,
443, 445, 449–451, 454–455, 459,
461, 464, 466, 468,470, 474
Mail Artists, 7, 27, 29, 31, 89, 92, 94,
101–103, 105–107, 109–110, 140,
338, 461, 466, 468
Mail Art Then and Now, 102, 459. *See
also* Cohen, Ronny
Manet, Edouard, 229
Maples Arce, Manuel, 345–351, 353–
356, 364n15, 365n23, 367n35, 445
Actual número 1, 345–346, 348, 351,
364, 445
"Como una Gotera," 350
Poemas Interdictos, 347
"Prisma," 350, 365n23
"T.S.H.-Telegrafía sin hilos," 346,
354–355
Vrbe, 346
Marinetti, F. T., 345, 347–348, 352,
354, 358, 360–362
Marx, 131, 357, 428, 430, 432
First International, 428, 430
Lenin, 357, 359, 430–431
Leninist, 192
Marxism, 268, 288,
Marxist, 14, 131, 192, 278,
Marxistic, 131
Second International, 431, 435
Mayakovsky, Vladimir, 11, 22n22

McLuhan, Marshall, 7, 13–14, 16, 37, 67, 155, 255, 284

McMahon, Terrence. *See* Teuty, Ian

McShine, Kynaston, 43–44

Media Suitcase (Bechtold), 73–74, 449

Meireles, Cildo, 262

Merleau-Ponty, Maurice, 144, 195, 196–197

Microradio, 191, 202

Mills College, 375–378, 380, 389

Mills College Book Arts Program, 228, 235, 239

Mini-FM, 144–145, 151, 191, 192, 197–200, 202–203, 205, 207, 209, 457, 468

Minitel, 64, 81, 272, 279–280, 460

Mobile Image, 62, 153, 163–164, 167. *See also* Galloway, Kit; Rabinowitz, Sherrie

Mobilus, 159, 160, 451

Morton, Cathy, 377

Mumma, Gordon, 376

M.U.S.I.C.: Marvelous Unlimited Sounds in Concert, 237, 457

Mutants, The, 236

Mystery Food (Vautier), 124

National Aeronautics and Space Administration (NASA), 156–158, 160, 162, 265, 451, 453

Negativland, 140, 144–145, 149, 177–181, 183, 187–189, 456, 474

Nelson, Ted, 35, 53n2, 448

Neo-Dada, 122, 206

NET (Kostolowski and Kozlowski), 395, 399, 404, 449

N.E. Thing Co., Ltd. (NETCO), 29, 65–67, 447. *See also* Baxter, Iain, and Ingrid

Networked art, 26, 35, 43, 51, 247, 248, 255, 324, 398, 404n11, 417, 425, 462

News (Haacke), 66

New York Correspondance School, 90, 92, 94–96, 99, 106, 255, 393, 445, 447–448. *See also* Ray Johnson

New York Correspondence School, 89–90. *See also* Ray Johnson

Niblock, Phill, 383

Notebook I (Atchley), 399–400, 449

Oldenburg, Claes, 58, 121

Oliveros, Pauline, 243n6, 374

Omaha Flow Systems, 99–100

Omnibus News, 396–398, 400, 404n14, 446

Ono, Yoko, 58n46, 125, 206–207, 239, 240, 257, 461

Opcode, 387

Opus 13 (Andersen), 129

Ornitorrinco Project (Kac), 275, 463

Osthoff, Simone, 31, 140–141, 143, 147, 474

Otaku, 193–194, 197–198

Over the Edge, 145, 177, 184–186, 188, 189, 456, 474

PacRim Slow Scan Project, 78, 453

Paik, Nam June, 46, 124, 129, 131, 411, 415–416, 446
 Utopian Laser Television, 415–416, 446
 Zen for Film, 129

Paper Tiger TV, 143, 200, 211–213, 220, 223, 456

Paper Tiger West, 202

Patterson, Ben, 124, 126, 129
 Instruction No. 2, 126
 Questionnaire, 129

Payne, Maggi, 228, 237

PCM (pulse code modulation), 9–10, 22n20

Pegasus, 148, 299, 304, 306–308, 465

Peppe, Michael, 239

Performance art, 45, 74, 145, 150, 195, 197–198, 203, 205–206, 208, 247–248, 250–251, 253, 306

Performance artists, 196, 203, 206, 208, 218, 316, 386

Performance Piece #8 (Knowles), 134

Perkins, Stephen, 31, 143, 337–338, 475

Perkis, Tim, 376, 378–379, 382–384, 387, 461–462

Waxlips, 387–388

Perls, Fritz, 251

Petasz, Pawel, 401–403, 406n30, 452, 455

Commonpress, 98, 401–402, 405n26, 406n29, 452

Pittore, Carlo, 103, 459,

Planetary Network (Ascott) 81–83, 292, 308, 461

Plissure du Texte: A Planetary Fairytale, La (Ascott) 146, 282–283, 290, 292–293, 308, 458

Poesia Pornô (Porno-Poetry) movement, 269, 455. *See also* Kac, Eduardo

Popper, Frank, 283, 458

P-Orridge, Genesis. *See* Throbbing Gristle

Postformalism, 36, 44–45, 47–48

Postformalism software, 35, 43, 448

Proof Positive That Germany Is Going Bananas (Anna Freud Bananas), 247, 249–250, 258, 467

Propp, Vladimir, 288, 293

Prueitt, Melvin, 38, 51

Questionnaire (Patterson), 129

Rabinowitz, Sherrie, 36, 62, 140, 143, 146, 153–158, 160, 163–165, 167, 171–172, 344, 451, 454, 459, 475

Electronic Cafe-84 (with Galloway), 147, 164, 171, 459, 475

Hole-in-Space (with Galloway), 62, 146, 153–154, 163–165, 167, 169, 454

Satellite Arts (The Image as Place) (with Galloway), 146, 153–154, 156–158, 160, 162 163, 451

Satellite Communication Sculpture, A (with Galloway), 153

Radio art, 3, 149,-150, 202, 207–208, 315–317, 323, 332n8, 443

Radio collage, 177, 185. *See also* Audio collage

Radio Home Run, 191, 199–201, 204, 457, 468. *See also* Kogawa, Tetsuo

Radio of the Future, 352. *See also* Khlebnikov, Velimir

Radio party, 202, 205

Radio PolyBucket, 191, 198–199, 457. *See also* Kogawa, Tetsuo

Ray, Ru B. (Ruby), 234

RAZIONALNIK, 324–325

RC Robot (Kac) 275–276, 461

REALTIME, 84, 315, 320–322, 325–331, 331n2, 322n11, 333n17, 333n18, 468

Re-Composição Postal (Bruscky), 264

Reinbolt, Brian, 380

Retrato Suposto-Rosto Roto (Kac) 273–274, 463

Riddle, James, 128

Riley, Terry, 228, 374

Rota-League, 380, 382, 457

Rotary Club, The, 380, 457

Rubber stamp art, 106

Ruscha, Ed, 234

Rypson, Piotr, 394

Saper, Craig, 4, 13, 140, 142, 398, 404n11, 475

Satellite Arts (The Image as Place) (Galloway and Rabinowitz), 146, 153–154, 156–158, 160, 162–163, 451

Satellite Communication Sculpture, A (Galloway and Rabinowitz), 153

Saunders, George, 227

Sayre, Henry, 14, 23n33, 23n34

Scheer, Edward, 15

Search and Destroy magazine, 229

Seawright, James, 46

 Watcher, 46

Sem Destino (Bruscky), 264, 451

Sender, Ramon, 386

Shannon, Claude, 6–7, 22n19

Sharits, Paul, 124–125

Shiomi, Mieko (Chieko), 125, 206

Siegert, Bernhardt, 6–7, 9–10

Situationism, 39

Situationist International, 14, 89

SMILE, 98, 257, 450

Smith, Owen, 27, 30–31, 475

Sociopoetic, 13, 248, 250, 255, 398, 402

Software, 35, 43, 448

Sonami, Laetitia, 228

Sound Poles (Hoertner and Stocker), 318, 466

Space Atlas (Atchley), 399–400, 449

Space Bodies (Zabelka), 316

Srita. Etcétera, La (Vela), 353

Stamp art, 247, 428

Stamp artist, 248

Stein, Gertrude, 17, 241, 242n6

Steina (Vasulka), 239

Stocker, Gerfried, 82, 318–320, 322–323, 327–328, 330, 332n5, 466–468. See also *CHIP-RADIO; REAL-TIME*

 Sound Poles, 318, 466

 ZERO—The Art of Being Everywhere (with Robert Adrian X), 82, 323, 467

Stockhausen, Karlheinz, 124, 242

Stone, Phil, 383, 385

Suess, Randy, 307

Sumner, Melody Carnahan. *See* Carnahan, Melody Sumner

Sumner, Michael, 141, 227–241, 242n4, 452

Surrealism, 15, 142, 206, 236

"Systems Esthetics" (Burnham), 43

Telematics, 109, 146, 283, 287–288, 293, 470

Tesão (Kac), 271–272

Teuty, Ian (Terrence McMahon), 234, 243n8

Theater Music (Kosugi), 129

Thing, The, 83–84

Throbbing Gristle, 234, 235, 237

Time Is Now, The (Carnahan), 228, 239, 242n4, 244n11, 272

Tone, Yasunao, 206

Town Fool Project (Anna Freud Banana), 253–254, 449, 470

Toy Satellite, 144, 308, 310, 473

TRANSIT, 317–318, 323, 326, 467

Trayle, Mark, 382–384

Tucker, Marcia, 95–96, 448

Tudor, David, 206, 242, 376

Umbrella, 103–104, 459
Utopian Laser Television (Paik), 415–416, 446

Vallée, Jacques, 285–287
Vasulka, Woody, 239
Vautier, Ben, 124, 126
 Dirty Water, 126
 Mystery Food, 124
Vela, Arqueles, 346, 353, 354
Video art, 62, 75, 77, 155, 158, 218
Video artists, 68, 347
Video Installation (Bechtold), 74
VILE (Anna Freud Banana), 149, 248, 256–257, 450
Virilio, Paul, 7, 63, 432
Visitors' Profile (Haacke), 48
Void (Klein), 40
V TRE, 125

Walkup, Kathy, 235, 239
Warhol, Andy, 234
Watcher (Seawright), 46
Water Yam (Brecht), 124
Watts, Robert, 89, 94, 106, 124–125, 446
 Fluxstamps, 125
Waxlips (Perkis), 387–388
Weibel, Peter, 74, 78, 454
 Epistemic Videotechnology, 74
Welch, Chuck, 102
Western Front, 92, 258, 418, 463
Whitehill, Theresa, 239
Whitney Museum of American Art, 94–97, 99–100, 104, 220, 448
Wiener, Norbert, 46
Williams, Emmett, 127, 129
 Gift of Tongues, 129
Woodman, Ned, 35, 448
Word Event (Brecht), 133

World in 24 Hours, The (Adrian X), 79–81, 83, 141, 289, 319, 458

X. *See* Adrian X, Robert
Xanadu, 35–36
Xerofilms (Bruscky), 266
Xerox Art, 265, 267
Xeroxperformance (Bruscky), 266
x-space, 322, 326–327. *See also* Hoertner, Hörst; Stocker, Gerfried

Yam Festival, 94, 446,
Young, La Monte, 119, 374
Youngblood, Gene, 37, 51, 153, 161, 164, 344

Zabelka, Mia, 316- 320, 322, 327–328, 464, 467–468. See also
 CHIP-RADIO; REALTIME
 Space Bodies, 316
Zen for Film (Paik), 129
ZERO—The Art of Being Everywhere (Adrian X and Stocker), 82, 323, 467
ZEROnet, 82–83, 323, 332n10, 467
Zines, 89, 93, 98, 106, 149